Drawing
THE HEAD AND HANDS

ALSO BY ANDREW LOOMIS

THREE-DIMENSIONAL DRAWING

CREATIVE ILLUSTRATION

FIGURE DRAWING FOR ALL IT'S WORTH

FUN WITH A PENCIL

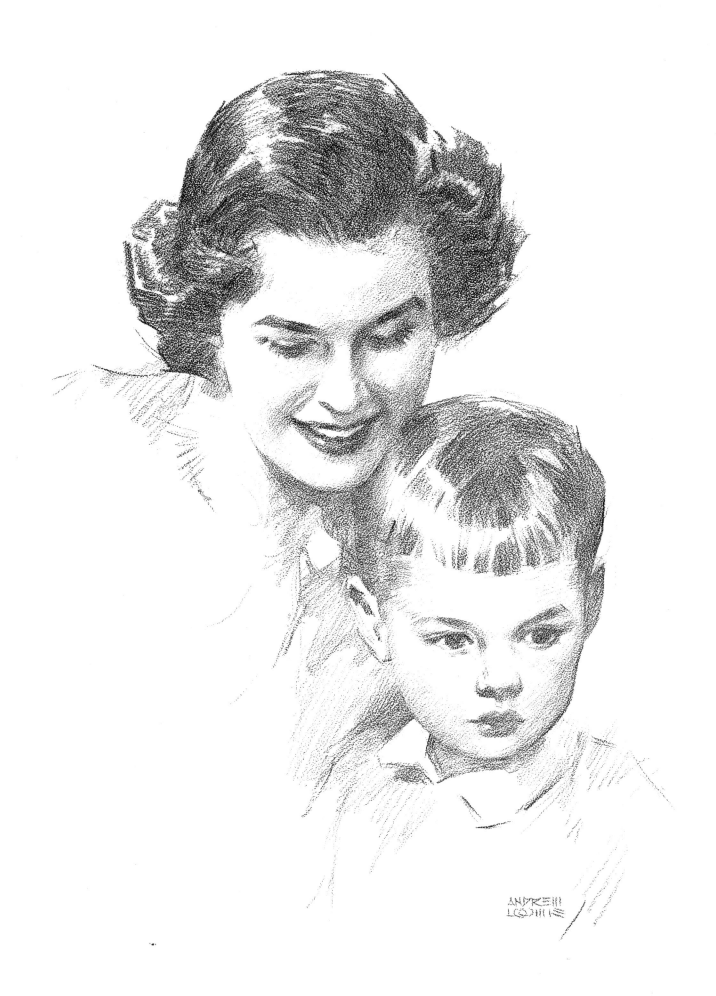

Drawing

THE HEAD AND HANDS

BY

ANDREW LOOMIS

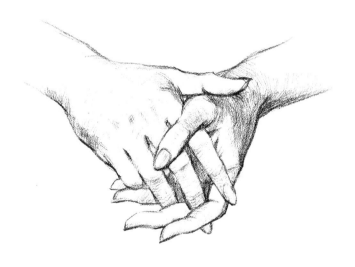

Drawing The Head And Hands
ISBN: 9780857680976

Published by
Titan Books
A division of Titan Publishing Group Ltd.
144 Southwark St.
London
SE1 0UP

This edition: October 2011
16 17 18 19 20

To receive advance information, news, competitions, and exclusive offers online, please sign up for the Titan newsletter on our website: **www.titanbooks.com**

Did you enjoy this book? We love to hear from our readers. Please e-mail us at: **readerfeedback@titanemail.com** or write to Reader Feedback at the above address.

A CIP catalogue record for this title is available from the British Library.

Printed and bound in China.

May I here express my appreciation for the valuable assistance in the preparation of this volume given me by my beloved wife, Ethel O. Loomis.

CONTENTS

(Illustration pages are indicated by italics)

CONTENTS

Drawing

THE HEAD AND HANDS

A Short Chat with the Reader

How FORTUNATE it is for the human race that every man, woman, and child is tagged with an individual and identifiable face! If all faces were identical, like the labels on a brand of tomatoes, we would be living in a very mixed-up world. When we think of it, life is mainly a continuous flow of experiences and contacts with people, different people. Suppose for a moment that Jones, the egg man, was the exact counterpart of Smith, the banker; that the face across the table might be that of Mrs. Murphy, Mrs. Goldblatt, or Mrs. Trotsky—you couldn't be sure which. Suppose all the faces in the magazines and newspapers and on television were reduced to one male and one female type, what a dull thing life would be! Even if your face has not been your fortune, even if it is far from beautiful, still, nature really gave us all a pretty good break, for at least we are individuals and can each be thankful for having a face, good or bad, that is undeniably our own.

This individuality of faces can be an intensely interesting study for anyone, and especially for anyone with the slightest talent for drawing. Once we begin to comprehend some of the reasons for the differences, our study becomes all-absorbing. Through our faces, nature not only identifies us but tells the world a good deal more about each of us.

Our thoughts, our emotions and attitudes, even the kind of lives we live, register in our faces. The mobility of the flesh—that is, the power of expression—adds more than mere identity. Let us give more than casual attention to the endless procession of faces moving in and out of our consciousness. Setting aside the psychological and emotional phases of expression, we can express in simple language the basic technical reasons for the smile, the frown, and all the variations that we call facial expression. We say that a person can look guilty, ashamed, frightened, content, angry, smug, confident, frustrated, and a host of other ways too numerous to tabulate. A few embedded muscles attached to the bones of the skull provide the mechanics for every expression, and these muscles and bones are not complicated or difficult to learn! What a wealth of interest lies within!

Let me say at the beginning that to draw a head effectively is not a matter of "soul searching" or mind reading. It is primarily a matter of interpreting form correctly in its proportion, perspective, and lighting. All other qualities enter the drawing as a result of the way that form is interpreted. If the artist gets that right, the soul or character is revealed. As artists, we only see, analyze, and set down. A pair of eyes drawn constructively and in correct values will appear to be alive because of craftsmanship, not because of the artist's ability to read the sitter's soul.

The element that contributes most to the great variation of identities is the difference in the shapes of the skull itself. There are round heads, square heads, heads with wide and flaring jaws, elongated heads, narrow heads, heads with receding jaws. There are heads with high domes and foreheads, and those with low. Some faces are concave, and others convex. Noses and chins are prominent or receding. Eyes are large or small, set wide apart or close together. Ears are all kinds of shapes and sizes. There are lean faces and fat faces, big-boned and small-boned ones. There are long lips, wide lips, thin lips, full lips, protruding lips, and equal variety in the sizes and shapes of noses. You can see that, by cross multiplication of these varying factors, millions of different faces will be produced. Of course, by the law of averages certain combinations of factors are bound to reappear. For that reason people who are not related sometimes closely resemble each other. Every artist has

11

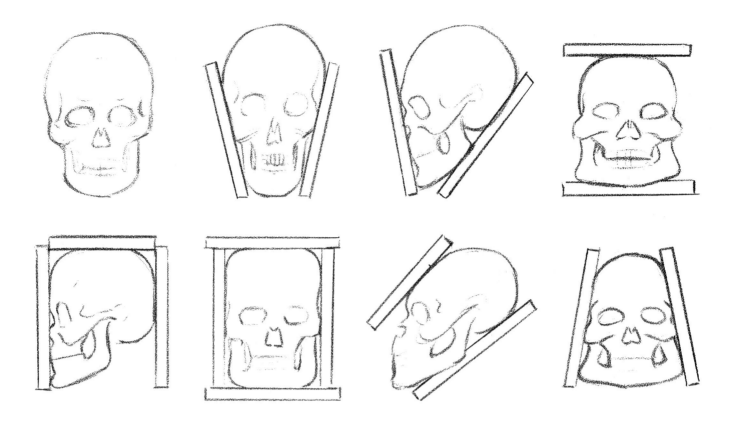

had the experience of being told by someone that a head he has painted or drawn looks like that person or like an acquaintance or relative of the speaker.

For the artist's purpose, the simplest plan is first to think of the skull as being pliable and having taken a certain shape as a result of pressures—as if one squeezed a rubber ball into various shapes without changing its actual volume. Although skulls have a great variety of shapes, actual measurements tally very closely, which means that the volume is about the same and only the shape is different. Suppose we model a skull in soft clay, then, between boards, press it into various shapes. Thus out of the same volume we can make a narrow head, a wide head, flaring jaws, and all the other types. How heads got to be this way is not our problem, which is only to analyze and thus determine the type of skull in the particular head we wish to draw. Later, when you become more familiar with the construction of the skull, you will be able to show these variations so successfully that you will be able to draw practically any type you choose and make it convincing.

At the same time you can set down understandingly any type before you. By the time you understand how the flesh is distributed over the bones of the face, you will be able to vary the expression of the same head. The thing to remember is that the skull is fixed in position, and, with the exception of the jaw, immovable, and that the flesh is mobile and ever-changing, and also affected by health, emotion, and age. After the skull is fully matured, it remains the same through life and is a structural foundation for the varying appearance of the flesh. Therefore the skull is always the basis of approach, and all other identifying features are built into or upon it.

From the skull we get the spacing of the features, which is more important to the artist than the features themselves. The features must take their proper places in our construction. If they do, we have little trouble in drawing them. Trying to draw the features without having located them properly is an almost hopeless task. Eyes do strange things; mouths leer instead of smile; faces take on weird and unholy expressions. In trying to correct a face that appears to be out

of drawing, the chances are that we will do just the wrong thing. Instead of moving an eye into its socket, we trim down a cheek; if a jaw line is out, we add more forehead. We should know, in first laying in the outline, that the whole head is in construction. This I am sure you can learn from the pages that follow.

The big difference between the completely amateur attempt and the well-grounded approach is that the beginner starts by setting eyes, ears, noses, and mouths into blank white space, surrounded by some sort of an outline for the face. This is drawing in the two dimensions of height and width only. We must somehow get into the third dimension of thickness, which means that we must draw the whole head as it exists in space and build the face upon it. By doing so we are able not only to place the features, but also to establish the planes of light and shadow, and, further, to identify the humps, bumps, and creases as being caused by the underlying structure of muscle, bone, and fat.

To help the beginner to start out with this third dimension, many approaches are suggested by various teachers. Some use an egg shape; others a cube or block. Some even start with one feature and start building the form out around it until the whole head is encompassed. However, all these involve many chances for error. Only the front view of the head looks like an egg, and even that gives no line of the jawbone. In profile the head is not like an egg. As for the cube, there is no accurate way of setting the head into it. The head is totally unlike a cube from any angle. The only value the cube has in drawing heads is to help set the construction lines into perspective, as you will learn later.

It seems more logical to start with a shape that is basically like the skull, one that is simple to draw and is accurate for purposes of construction. This can be done by drawing a ball resembling the cranium, which is round but flattened somewhat at the sides, and attaching the jawbone and features to it. Some years ago I hit upon this plan and made it the basis of my first book, *Fun with a Pencil.* I am happy to say that the plan was received with great enthusiasm and is now widely used in schools and by professional artists. Any direct and efficient approach must presuppose the skull and its parts and its points of division. It is just as reasonable to start drawing a wheel with a square as it is to start drawing a head with a cube. By cutting off corners and further trimming the square you could eventually come out with a fairly good wheel. You could also chip away the cube until you had a head. But at best it's a long way around. Why not start with the circle or ball? If you can't draw a ball, use a coin or a compass. The sculptor starts with a form of the general shape of the face attached to the ball of the cranium. He could not do otherwise.

I present this simple plan in this volume since it is the only approach that is at the same time creative and accurate. Any other accurate approach requires mechanical means, such as the projector, tracing, the pantograph, or using a squared-off enlargement. The big question is really whether you wish to develop the ability to draw a head, or whether you are content to use mechanical means of projecting it. My feeling is that, if the latter were the case, you would not have been interested in this book. When your bread and butter depends upon creating an absolute likeness, and you do not wish to gamble, make the best head you can by any means possible. However, if your work is to give you joy and the thrill of accomplishment, I urge you to aim at the advancement of your own ability.

The drawings on pages 14 and 15 show the possibilities of developing all kinds of types out of the variations of skulls. After you have learned to set up the ball and plane, you can do almost anything you please with it, fitting all parts into the construction by the divisions you make across the middle line of the face. You have at your disposal jaws, ears, mouths, noses, and eyes, all of which may be large or small. The

ROUND SQUARE NARROW WIDE

NARROW JAW HIGH DOME LOW DOME FAT

THIN RECEDING BROW PROTRUDING BROW FLAT BACK

BIG NOSE, LOW DOME SQUARE JAW RECEDING JAW HIGH DOME, SMALL JAW

HEAVY JAW ROUND BONE CONCAVE BONE ANGULAR BONE

DEVELOPMENT OF A NARROW HEAD

A WIDE HEAD

SQUARE

HEAVY BONED, FLARING JAW

ROUND

RECEDING JAW

DIFFERENT FEATURES ATTACHED TO THE SAME CRANIUM

15

cheekbones may be set high or low, the upper lip may be long or short, the cheeks full or sagging. By different combinations of these, you can produce an almost endless variety of characters. It will be great fun for you to experiment.

Although the construction of any head involves more or less the same problems, this book is divided into sections on drawing men, women, and children of various ages. As we shall see, though the technical differences are slight, there is considerable difference in approach and feel-

ing. The technical problems are explained in Part One, and the knowledge acquired from that is applied in the later sections on heads.

To be able to draw hands convincingly is also very important to the artist, and in this field too there is little material available. So Part Five has been included to help you understand the principles of construction on which realistic rendering of hands must be based.

Now let's get to work in earnest.

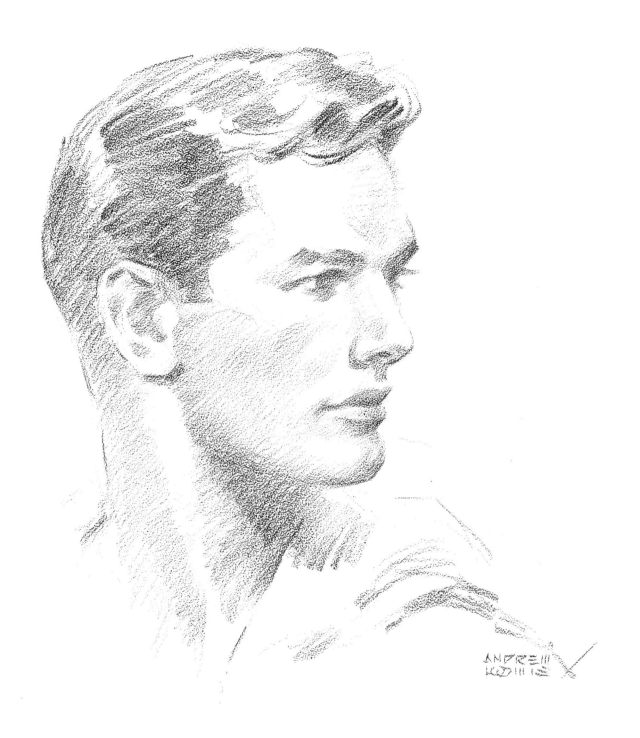

Part One: Men's Heads

Part One: Men's Heads

LET US BEGIN by establishing our common objective. You may be interested in drawing as a hobby. You may be an art student attending drawing classes. You may be a young professional, out of school, striving to better your work so that it will bring in more income. Perhaps you studied art many years ago and now have the time and incentive to take it up again. Perhaps you are well established in the field of commercial art, where competition is formidable, and are looking for something that will help you hold your place and, if possible, keep you moving forward. Whichever category you are in, this book will be helpful to you, because it provides practical knowledge of the techniques of drawing heads, both for the complete beginner and to help the more advanced artist in those most frustrating moments when the head he is drawing seems to refuse to do his work justice.

There must be a genuine basic motive behind any genuine effort. Ask yourself quite honestly, "Why do I really want to draw heads and draw them well?" Is it for the satisfaction of personal accomplishment? Does it mean enough to you to give up time from other things in order to learn? Do you hope someday to sell your work and make it your means of livelihood? Would you like to draw portraits, girls' heads for calendars, illustrations for magazine stories, the people in advertisements? Do you want to improve your drawing of heads to help sell your work? Is drawing a form of relaxation to you, helping to relieve tension and clear your mind of worries and other problems? Search quietly and thoroughly for this basic motive, because if it is powerful enough, it will give your efforts the strength to withstand discouragement, disappointment, disillusionment, or even seeming failure.

May I add one suggestion? Whatever your motive, try not to be impatient. Impatience has probably been a bigger stumbling block in the way of real ability than anything else. Doing anything well, I'm sure, means hurdling obstacles of one kind or another most of the way to the goal. Skill is the ability to overcome obstacles, the first of which is usually lack of knowledge about the thing we wish to do. It is the same in anything we attempt. Skill is a result of trying again and again, applying our ability and proving our knowledge as we gain it. Let us get used to throwing away the unsuccessful effort and doing the job over. Let us consider obstacles as something to be expected in any endeavor; then they won't seem quite so insurmountable or so defeating.

Our procedure will be a little different from that of the usual textbook. In general, textbooks seem to confine the material solely to problem and solution, or to technical analysis. That, in my own belief, is one of the reasons why textbooks are so difficult to read and digest. Every concentrated creative effort involves a personality, since skill is a personal matter. Since we are dealing not with organic material like nuts and bolts, but with human qualities like hope and ambition, faith or discouragement, we must throw out the textbook formulas and consider personal achievement as the basic element of our planning. An instructor would not be very helpful if he gave his students only the words of a textbook, all cold hard fact, without feeling, without praise or personal encouragement. I cannot participate in all your personal problems, but I can certainly remember my own, and assume that yours will not be greatly different. Therefore this book anticipates the solution of these problems even before you meet them. I believe that is the only way to handle this type of subject effectively.

There is an element of joy in doing what you

have proved to yourself to be right. It is my job here to give you the working materials with which to make your own effort successful rather than to show that anyone can succeed. Success comes only with personal effort, aided by whatever knowledge the individual can apply along with the effort. If this were not true, we would be able to do anything in the world simply by reading books. We all know this is not true. There are books on almost any subject. Their value depends upon the amount of knowledge they contribute and on how well it is absorbed and put into practice.

To draw heads well, the artist must detach his mind from the sitter's emotional qualities and develop an objective viewpoint. Otherwise he could go on drawing the same head forever, almost each moment noting a subtle change of expression, or a different mood in the subject. One face can vary in a thousand ways, and a drawing must show the effect of a single instant. Let him think of the head as only so much form in space, like a piece of still life rather than as an ever-changing personality.

To the beginner there is a certain advantage in drawing from a cast, or from a photograph, for at least the subject is not moving and he can regard it objectively. It is logical that our book begin purely from an objective approach with a form most like the average head, with average features and average spacings. Individual characteristics are much too complicated until we are able to tie them into a basic structure, one that is reasonably sound and accurate. Let us fix in our minds that the skull itself is the structure and all the rest merely trimmings.

Anatomy and construction can appear dull, but not to the builder. It might be dull to learn how to use a saw and hammer, but not when you are making a building of your own. It may be hard to think of the head as a mechanism. But if you were inventing a mechanism, it would never lack interest. Just realize that the head must be a good mechanism in order to be a fine head, and you will draw it with as much interest

as you would have in putting a part into a motor which you wanted to give a good performance.

It is evident, then, that we need to start with a basic shape that is as nearly like the skull as we can get it. Looking at the cranium, we see it most nearly like a ball, flattened at the sides and somewhat fuller in the back than the front. The bones of the face, including the eye-sockets, the nose, the upper and lower jaw, are all fastened to the front of this ball. Our first concern is to be able to construct the ball and the facial plane so that they operate as one unit which may be tipped or turned in any manner. It is of utmost importance that we construct the head in its complete and solid form, rather than just the visible portion of it. Naturally we cannot see more than half the head at any time. From the standpoint of construction, the half we cannot see is just as important as the visible half.

If you look at Plate 1, you will note that I have treated the ball as if the under half were transparent so that the construction of the whole ball is made evident. In this way the drawing on the visible side of the head can be made to appear to go all the way round, so that the area we cannot see can be imagined as a duplicate of what we do see. An old instructor of mine once said, "Be able to draw the unseen ear," which, at the time, puzzled me no end. I later realized what he meant. A head is not drawn until you can feel the unseen side.

It must be obvious from the preceding that it is impossible to draw the head correctly by starting with an eye or nose, oblivious of the skull and the placement of features within it. One might as easily try to draw a car by starting with the steering wheel. In all drawing no part can be as important as the whole, and the whole is always a fitting together of proportionate parts. We can always subdivide the whole into its parts, instead of guessing at the parts, hoping they will go together in the proper proportions. For example, it is easier to know that the forehead is one-third of the face, and what its position is on the skull, than to build the skull from

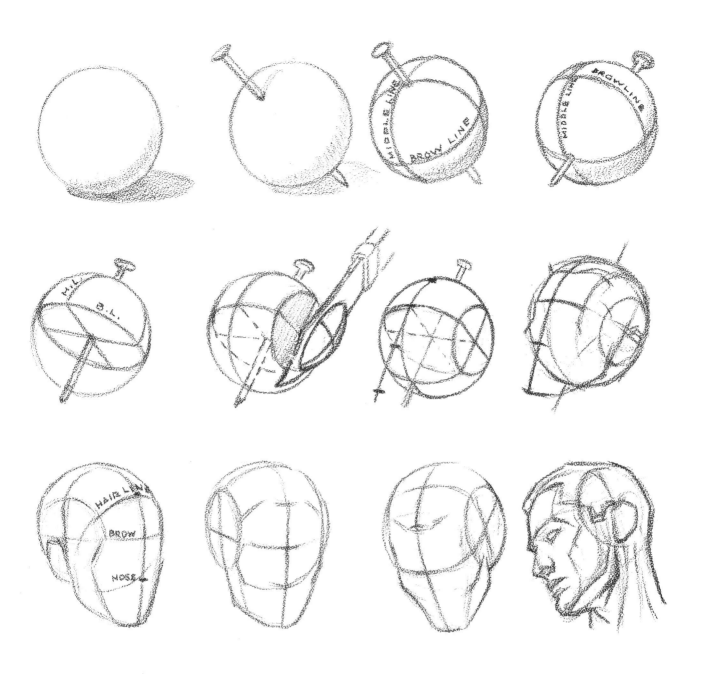

PLATE 1. The basic shape is a flattened ball

The cranium is more like a ball than anything else. To represent the ball as a solid sphere, we must establish an axis, like the nail through the ball at the top. Through the centers established by the axis, we can divide the ball into quarters and again at the equator. Now if we were to slice off a fairly thin slice on each side, we will have produced a basic shape that very closely matches the cranium. The "equator" becomes the brow line. One of the lines through the axis becomes the middle line of the face. About halfway up from the brow line to the axis, we establish the hairline, or the top of the face. We drop the middle line straight down off the ball. On this we mark off two points about equal to the space of the forehead, or from brow line to hairline. This gives us the length of the nose, and below that the bottom of the chin. We can now draw the plane of the face by drawing in the jaw line, which connects about halfway around the ball on each side. The ears attach along the halfway line (up and down) at a distance about equal to the space of from the brows to the bottom of the nose. The ball can be tipped in any direction.

21

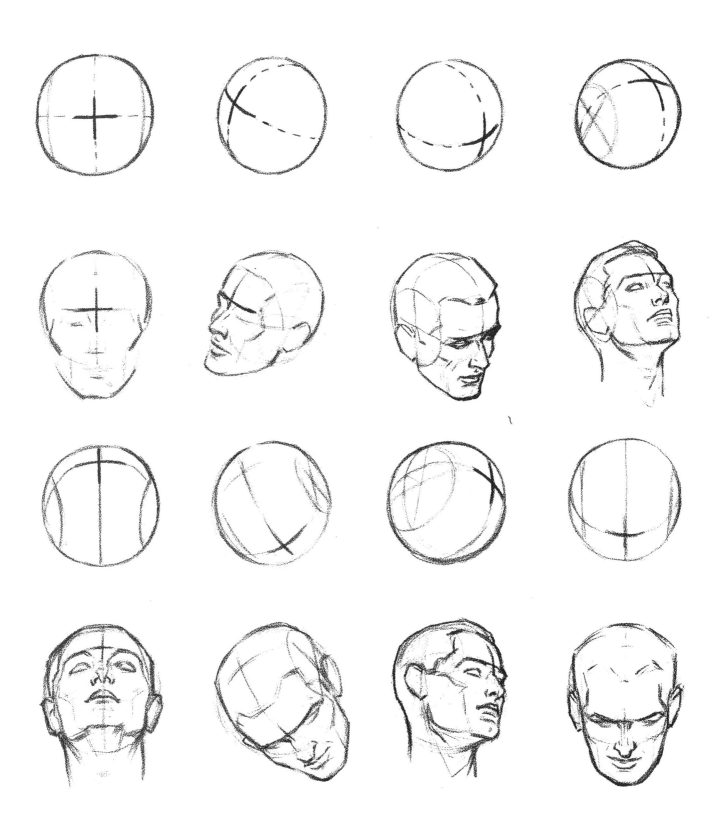

PLATE 2. The all-important cross on the ball

The "cross," or the point where the brow line crosses the middle line of
the face, is the key point of the construction of the whole head. It deter-
mines the position of the facial plane on the ball, or the angle from which
we see the face. It is easily spotted on the model or copy. By continuing
the line up and down, we establish the middle line of the whole head.
We draw the two sides of the face and head from this line. By continuing
the brow line around the head we can locate the ears.

the forehead. Perhaps we have always thought of the head so much in terms of belonging to a definite individual that we have never considered it in a mechanical sense. It perhaps never occurs to us that a smile is a mechanical principle in action, as well as evidence of a beaming personality. Actually the mechanics involved in a smile are the same as those used in a drawstring on a curtain. The string is attached to something fixed at one end, and to the material at the other. Pulling the string buckles the material. The cheek plumps out in the same way. The working of the jaw is like a hinge or a derrick, but the hinge is of the ball-and-socket type. The eyes roll in their sockets like a ball bearing held in place. The eyelids and the lips are like slits in a rubber ball, which naturally close except when they are pulled apart. There is a mechanical principle beneath every expression put into action by the brain. Underlying the flesh of the face are muscles which are capable of expansion and contraction, just like all the other muscles of the body. We discuss this interesting material in more detail later.

We start drawing the head by establishing points on the ball and on the facial plane. Both the ball and the facial plane must be subdivided in order to establish those points. No matter how much you draw, how skilled you get to be, how well trained your eye becomes, you will always have to begin by building the head correctly, just as a carpenter, no matter how long he has worked, always measures a board before he cuts it. Construction of the face and head depends upon establishing the points of measurement. Any other way is bound to be guesswork, which is a gamble any way you take it. For the one time you guess right, there are many inevitable mistakes.

The most important point in the head from which to build the construction of the face is the point immediately above the bridge of the nose, between the brows. This point remains always fixed and is indicated by the vertical line of the nose and the crossline of the brows. On the ball this is the junction of the "equator" and "the prime meridian," the two lines that cut the ball in half vertically and horizontally. All measurements spring from this point. About halfway up from this point to the top center of the head we get the hairline, and have therefore spaced off the forehead. Dropping down an equal distance below the crosspoint, we get the length of the nose, since the distance from the tip of the nose to the brows is, on an average, equal to the height of the forehead. Measuring the same distance down, we get the bottom of the chin, for the distance from the bottom of the chin to the base of the nose equals the space from there to the brows, and from that point to the hairline. So it's one, two, three spaces, all equal, down the middle line of the face. See Plates 3 and 4. I suggest you take paper and pencil and start drawing these heads, tipping them in every possible direction. This can well be your first real period of study. What you do now will affect everything you do from here on. Plate 4 will give you an idea of how to place the features properly. The placement is more important than the drawing of the features themselves. At this stage it is not too important that the details of the features be correct. Get them to fall within the construction lines, so that the two sides of the face seem to match, whatever the viewpoint.

The next time you work with this book, turn to Plate 5, which is a simplified statement of the bone structure. No one detail of the bone structure is of great importance, but its total shape is of paramount importance. Within the shape we must locate the eye-sockets, spacing them carefully on either side of the middle line. We locate the two cheekbones opposite each other, and the bridge of the nose, which must lie on the middle line at the top and extend out from the middle line at the bottom. We locate the corner of the jaw and bring the jaw line down to the chin. Every head must be constructed so that all the features balance on the middle line. Plate 6 gives you more of the actual appearance

and placement of the bones. Note how in these drawings you are aware of the construction all around the head. I personally try to get the feeling that these are not outlines, but the edges of solid forms that I could slide my hand around. Do you feel as if you could pick up these heads with your two hands and that you would find them just as solid in back as in front? That is what we are working for just now.

Plate 7 shows the action of the head on its pivot point at the top of the spine and at the base of the skull. We must remember that this pivot is well inside the roundness of the neck and deep under the skull. It does not have a hinge action but a rotating action from a point a little back of the center line of the neck. So when the head is tipped backward the neck is squeezed and bulges somewhat, forming a crease at the base of the skull. When the head is tipped forward, the larynx or Adam's apple is dropped down and hides itself within the neck. In the lateral movements there is a strong play of the long muscles which attach to the skull behind the ears and down in front to the breastbone between the collarbones. At the back are the two strong muscles which attach to the base of the skull to pull the head backward. To get a head to sit properly on the neck requires some knowledge of anatomy, which is discussed later.

Some artists like to think of the head as being built of pieces which will fit together and fall into place to give the understructure of the head. See Plate 8. This is especially helpful in suggesting the third dimension, that of thickness, in your drawing. Much too often the face is drawn as something flat. We must consider the roundness of the muzzle—the two jaws as they come together. Because it is lost in the fleshiness of the face, we may forget the sharp curve of the teeth behind the lips. This is even more pronounced in animals, to which a sharp deep bite may make the difference between life and death. Think of the front teeth as choppers and the back teeth as grinders. The fangs, or what we call eyeteeth in human beings, are what an animal uses to hang on with, or to slash and tear. To impress upon yourself what the roundness of this area really is like, take a bite out of a piece of bread and study it. You will probably never draw lips flatly again. We must also remember that the eyes are round, though most of the time we see them drawn flatly, like a slit in a piece of paper. The eyes, nose, mouth, and chin all have this three-dimensional quality, which cannot be sacrificed without losing the solidity of the whole head.

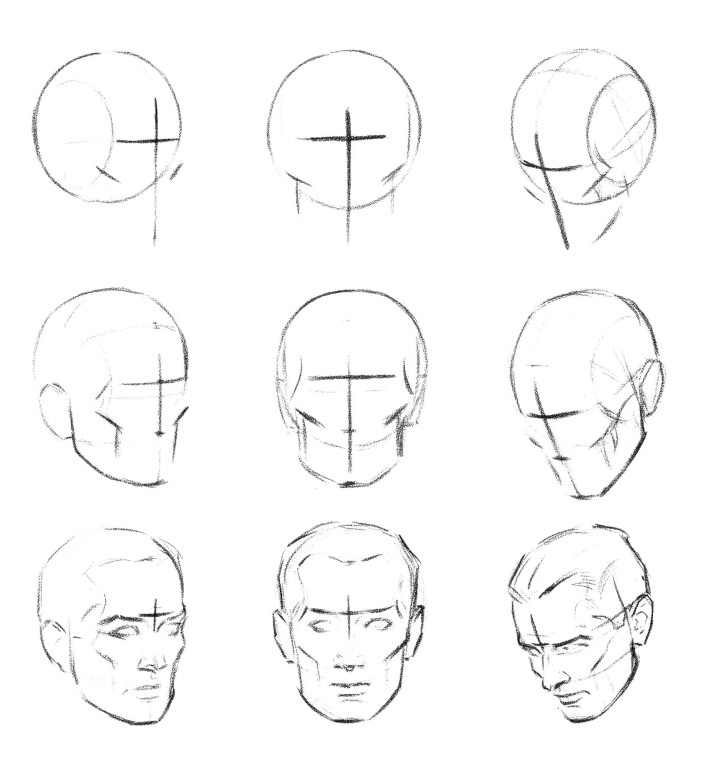

PLATE 3. The cross and the middle line determine the pose

Get out your pencil and pad.

It is most important to begin at once to practice setting up the ball and facial plane. Do not worry too much now about the features. This is simply construction, which you will probably use for the rest of your life. Establish the cross. Try to think of the construction all around the head, so that the jaws attach halfway around on each side. Remember that the eyes and cheekbones are below the brow line. The ears are about parallel with the lines of the brows and that of the nose. The cross almost suggests the face below. With this approach we can start drawing the whole head in any pose.

25

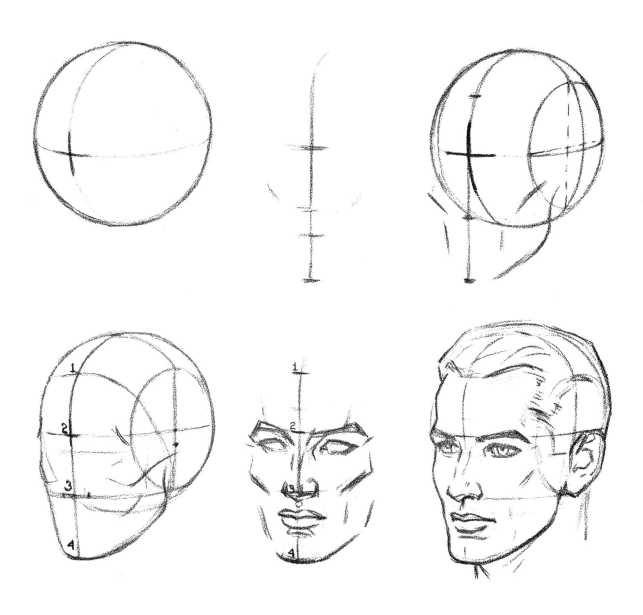

PLATE 4. Establishing the middle line

Start placing the features carefully.

If you have worked out the ball and plane and its divisions you will not
have too much trouble in placing the features. However, you should
realize that a feature will never fit on a head until it is placed correctly
and in line with the construction lines of the whole head. Every artist must
be prepared for a certain amount of struggle with construction, so do not
allow yourself to get discouraged. Every head anyone draws depends on
construction, just as much as every building, every car, every other three-
dimensional object does. That is what the artist's job really is in learning how
to construct things in three dimensions on a two-dimensional surface. We
have to think of each thing we draw in its entirety and see how its dimensions
appear to us from our particular viewpoint. Representation in three dimen-
sions calls for knowledge and study. But such knowledge is no more difficult
than that required for any other field. No matter how great your talent,
talent has to work with knowledge to do anything well. When the search
for particular knowledge becomes pleasant as well, half the battle is won.
Construction need not worry you; it comes with practice.

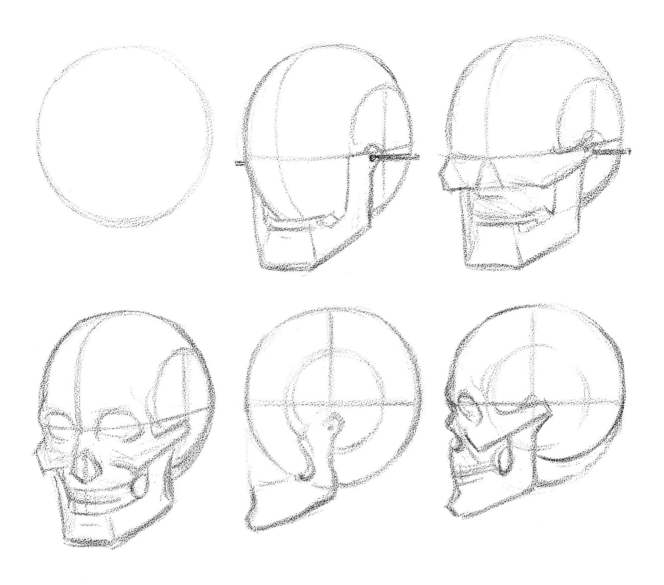

PLATE 5. Simplified bone structure

At this point it will help a great deal in constructing the head to have a
fairly clear idea of the bone structure. Though we do not see the bones
in detail, we must think of them as the framework of the head. All the
division points of the head are related to the bones, not to the flesh. The
reason we chose the ball and plane as an approach now becomes apparent,
for our approach is the skull itself, simplified and made understandable.

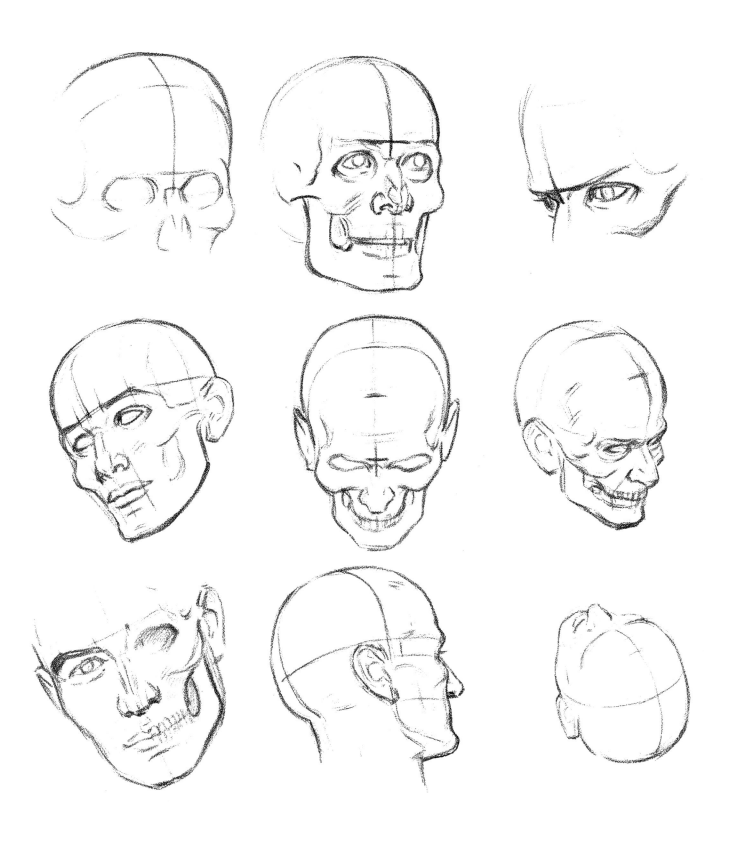

PLATE 6. The bony parts within the construction

Here we look at the bones more closely, realizing that, with the exception of the cheeks, all the flesh of the head lies over bone and is influenced by the shape of the bone. This simplifies our problem considerably, for except for the jaw the bones of the skull are all in a fixed position and move only as the whole head moves. Only the flesh around the eyes, the cheeks, and the mouth are capable of separate movement.

28

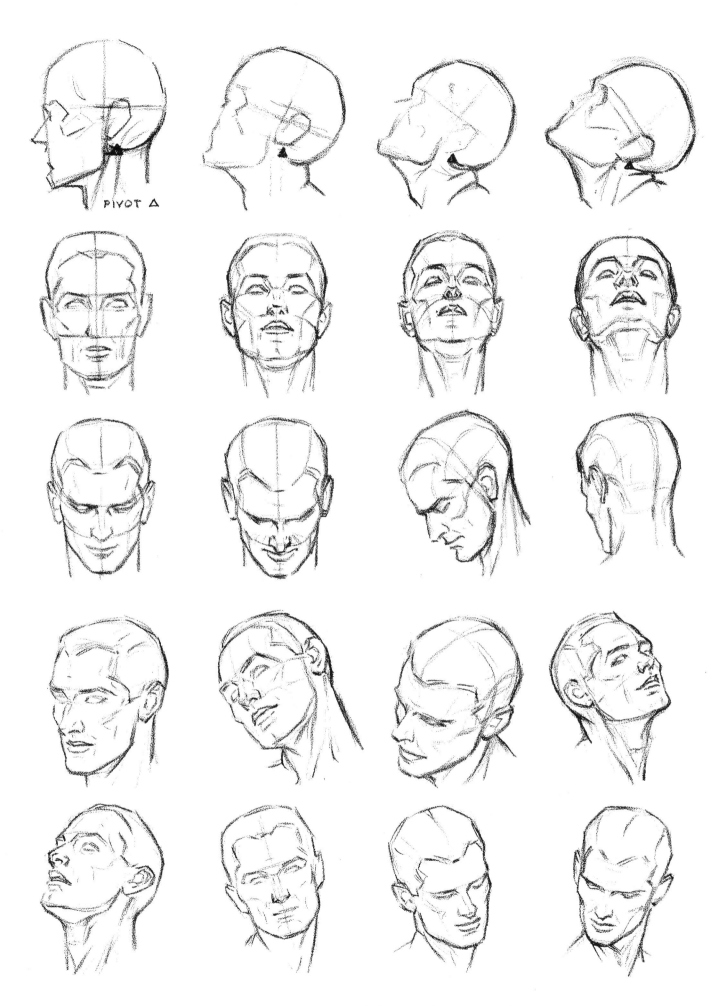

PIVOT △

PLATE 7. Action of the head on the neck

29

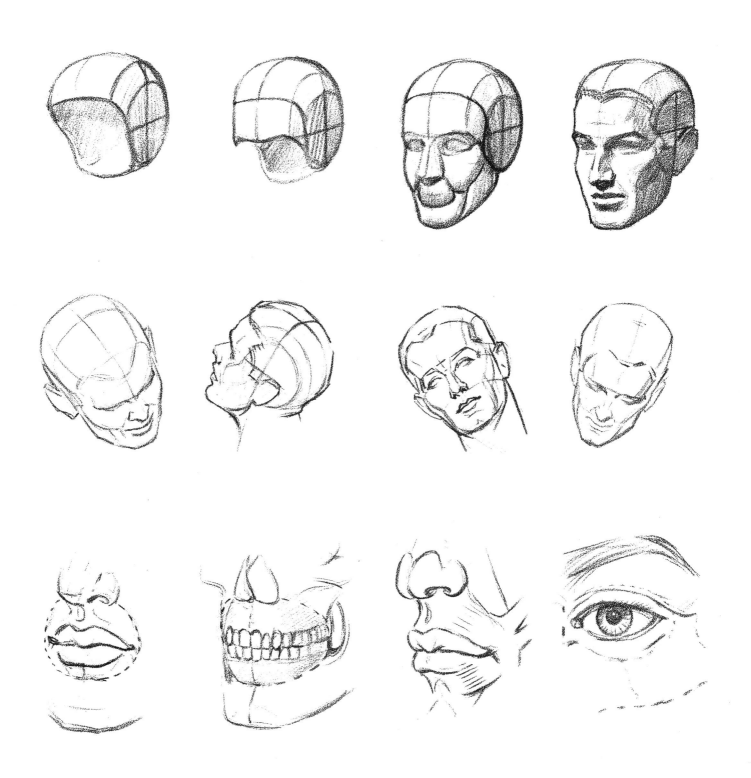

PLATE 8. Building the head out of pieces

If we think of the head as made up of separate pieces fitted together, we find the pieces shaped and put together as they appear in the drawings in the top row. Note the rounded piece which would contain the lips. We refer to this part of the skull as the "muzzle." In drawing the mouth we must make it fit around the curve of the upper and lower jaws and the front teeth. Too often the mouth is drawn as if it were flat against a flat surface. In the bottom row the three drawings at the left show the lips and the structure under them. The eye must also lie in its socket, as shown at the right. The eyelids operate much like the lips in closing over a rounded surface.

30

PLANES

We began by considering the head as round. This is logical, because it is much more round than square. However, one of the later discoveries in art was the fact that incessant roundness can become almost boring, and that a combination of roundness with squareness can produce a vigor of execution which many of the old masters lacked. The effect of roundness tends toward the "slickness" so frowned upon by modern artists and critics. Although the roundness exists, as photographs show, this type of rendition never seems to have the vigor of a drawing or painting in which the planes are stressed. For this reason a photograph of a head can never hope to compete with a good drawing as far as vitality of execution is concerned. It seems to me that the ideal lies somewhere between the two extremes. A drawing that is too square can look as if it were chiseled out of wood or stone, with more hardness than the subject warrants. On the other hand, a drawing that is too round may have so much sweetness and smoothness that it seems to have no structure at all beneath the surface; everything is polished and shiny. Of the two, I prefer too much character to too little. Artists have found that by squaring the planes, softening them only enough to relieve their broken-stone effect, they achieve solidity and vitality without going to extremes. It also has been discovered that flattened planes tend to merge into an effect of mere roundness at a distance. When you inspect a projection on a large screen from close up, it is surprising how flat the image is. However, if you step back, this flatness disappears and the full roundness seems to take over. The truth is that the halftones which model a surface are really much more delicate than they appear to be, and this truth has been a boon to painters.

For the time being, however, let us draw the planes as we feel they would really lie on the form. Through these planes we can interpret the true solidity as in no other way. It is better to learn to turn the form in its true structure than to omit the turning entirely so it may appear flat and without form. Remember that in a drawing the planes may be stressed considerably more than they can be in a painting, since we are dealing with fewer conflicting values. Just now we are not concerned with values, or "shading," as it is often called by the layman. We simply want to know what planes will give the basic form the general shape of the face and head. In other words, we want to get out of the round into more blocky forms, for this blockiness gives much more character, especially to men's heads. Turn to Plate 9. I suggest that you study this page carefully in order to fix these planes in your memory. They are like chords from which you build music; they are basic, and almost any head can be built on them.

After you have memorized these planes, try tilting the head and incorporating the visible planes, as shown in Plate 10. From these planes you can go on to perspective, as demonstrated in Plate 11. When you have mastered the construction of the ball and planes of the face, learned to use correct spacing and construction lines, and have assembled the planes, you have come a long way toward good drawing of heads. You should now be able to spot many of the difficulties that arise, and make the corrections in your basic drawing. Many a portrait has been started, only for the artist to discover after days of work that the basic construction is at fault. Something must be moved—an eye, the nose, or the mouth—and a likeness or the desired expression simply refuses to come about. A very good way of studying construction is to draw the construction lines on a clipping of someone else's picture of a head, so that you can see the exact placement of all parts. Once you understand the construction yourself, it becomes

woefully apparent to you when the other fellow does not. Some very clever artists do not really know how to construct correctly, and they spend many hours of added difficulty as a result. No "knack" of drawing heads can compete with sound knowledge.

In Plates 12 to 16, I have planned a little fun for you. We start taking some liberties with the basic ball and planes. You will do this better without copy. We do some experimenting with types, as I promised early in the book. To produce different types we can vary the ideal or average measurements. The three divisions of the middle line of the face can be made unequal, or exaggerated as you wish. Then we can vary the shape of the cranium and bony understructure. I suggest that you play with expressions and characterizations. It is interesting and sometimes amazing what you can produce in the way of characters by variation in the spacing and basic shapes. You hardly know before finishing what type you will end up with. On the other hand, you can actually plan a given type and come very close to achieving the result you want. You will find yourself drawing heads that are most convincing, that have even a professional look. I suggest you try beards, mustaches, high or low, thin or heavy eyebrows, big noses,

little noses, jutting chins, receding chins, narrow heads, wide heads, flaring jaws, and what not. Have some real fun while you are at it. You may or may not be interested in cartooning, but it is fun to draw characters, and you will find that you can do better than you might have thought possible. Watch the perspective and construction as carefully as you would in drawing any head, but exaggerate all you can. A good way to experiment is to jot down beforehand a little description of the character you wish to draw, then try to draw the head you have described. Next, ask someone else to give you a description of a character. Try that. Such practice means that you can, at an early stage of your knowledge, begin to create, as you would if you were an illustrator. Stick fairly close to outline heads just now, but try to create the type you want.

As an example, your description might be something like this: "John is big and raw-boned. His eyes are deepset under shaggy brows. There are hollows under his cheekbones. He has a big nose, heavy jaw and chin. His hair, though thin on top, is bushy around his ears and the back of his head. His eyes are small, dark, and beady." Now try to draw John with the knowledge at your present command.

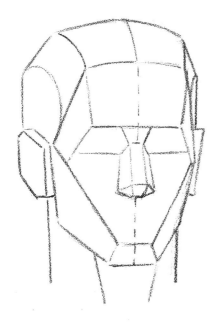
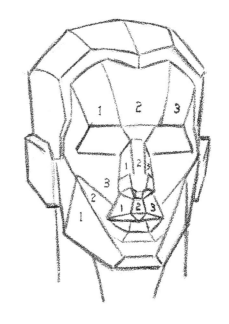
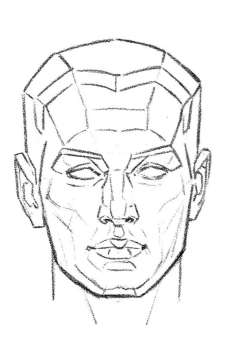
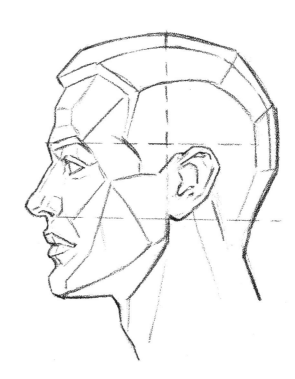

PLATE 9. Basic and secondary planes of the head

The planes of the head should be memorized, for through them we have a foundation for rendering the head in light and shadow. Begin with the basic planes (top, left), and study them until they are fixed in your mind. Then take up the secondary planes. From these sets of planes almost any head can be built. The surface varies with the individual character, but with the planes shown here you can produce a well-proportioned, manly head.

33

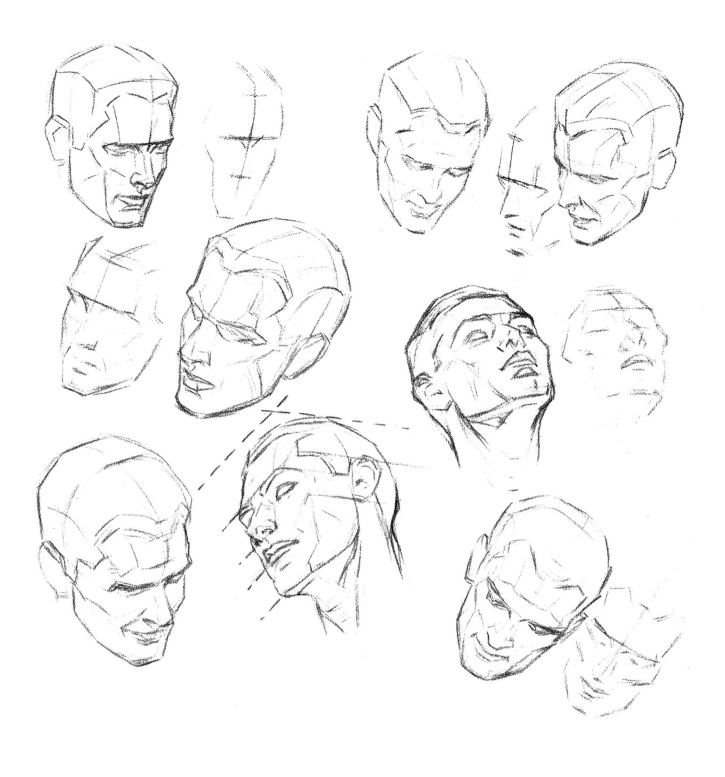

PLATE 10. Tilting the head

Planes help us to maintain construction throughout the face and head, within the construction lines or divisions of the basic ball and plane. The muzzle becomes easier to draw in all sorts of tilted positions. The slant of the cheeks and the rounded rectangle of the forehead fall into place within the three divisions of the face. By thus representing the head in block form, we determine the angles throughout the head. This is our first step toward the perspective of the head.

34

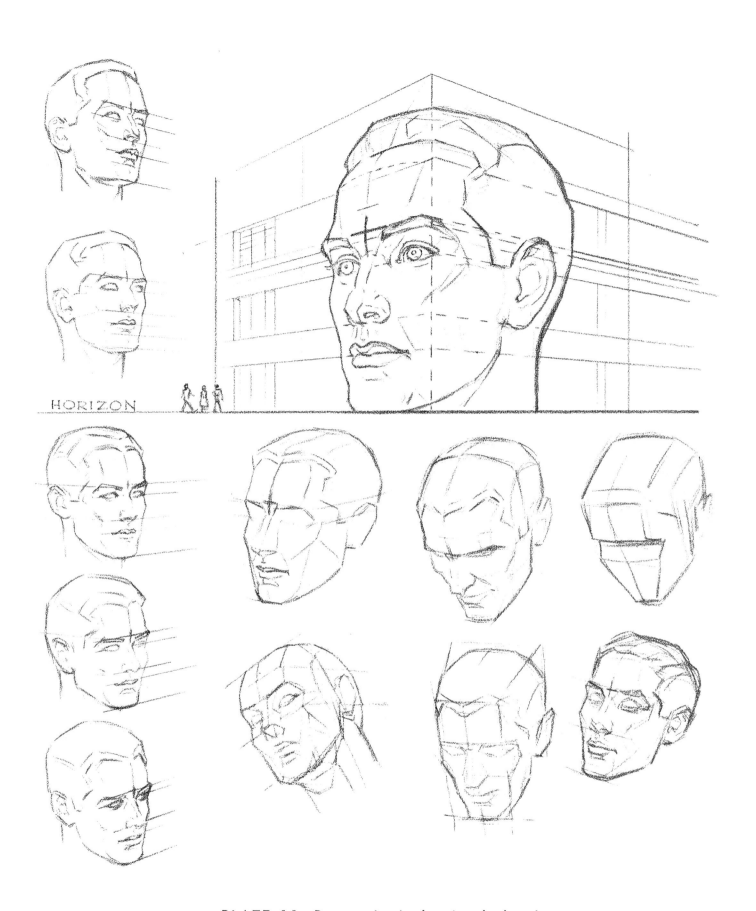

HORIZON

PLATE 11. Perspective in drawing the head

The handling of perspective marks the difference between the amateur and the professional. Every object drawn has to have an eye level or horizon, felt if not actually represented. On the left we see the planes of the head as seen from above or below the eye level. If a head were as big as a building it would be affected by perspective in the same way as a building is.

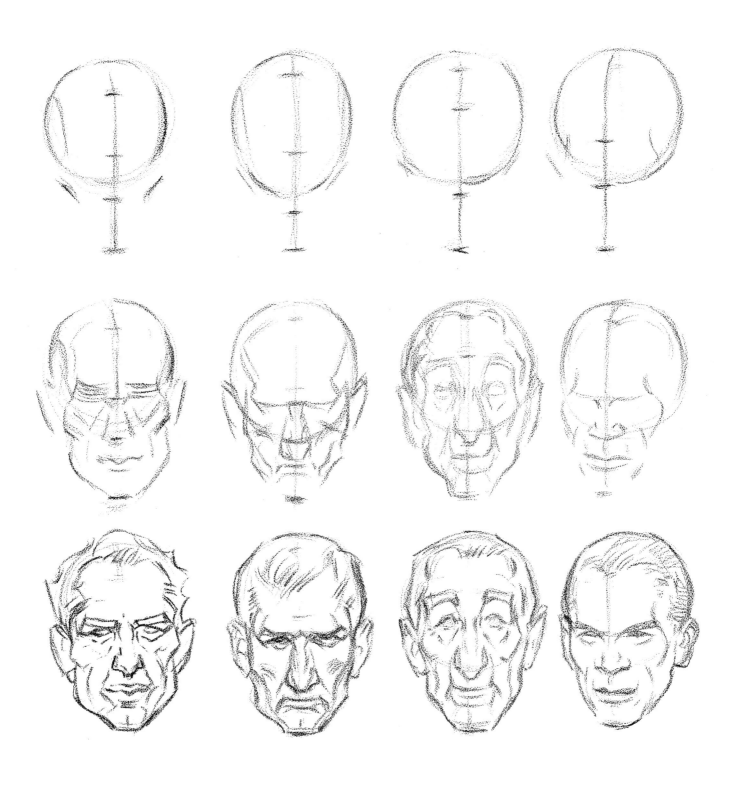

PLATE 12. Variety in spacing creates types

In order to create differences in type and character, we may decide not to follow the basic measurements or divisions too meticulously. By varying the proportions of the three divisions of the face, we come up with a good deal of variety in the results. There are thousands of possible combinations. It is fun to experiment with them.

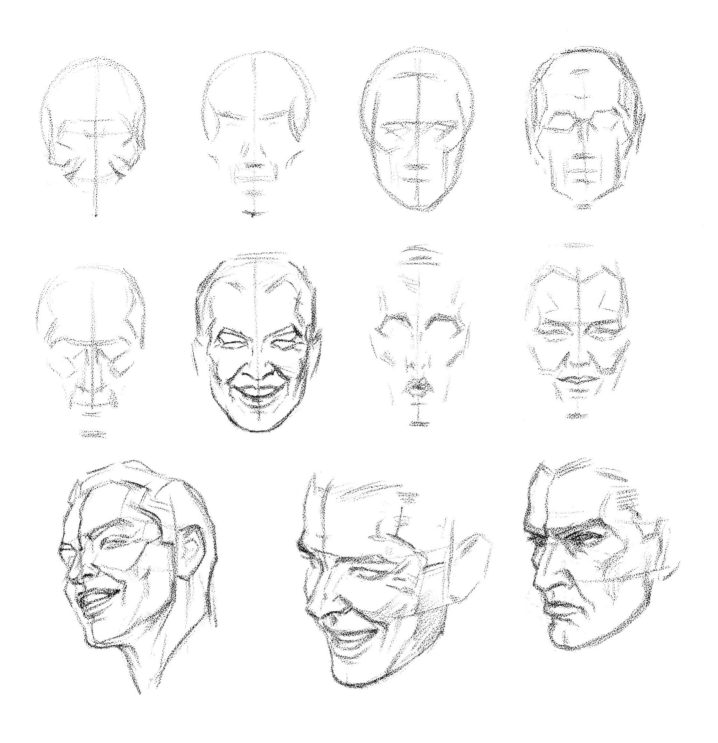

PLATE 13. Always build on the middle line

Always remember when drawing a head to balance the forms on both sides of the middle line. The bony parts stay fixed, and the expression fits in between. All the jaw can do is open and close. The expression lies in the eyes, cheeks, and mouth, with some wrinkling of the forehead and around the eyes. What we do on one side, we must do on the other.

37

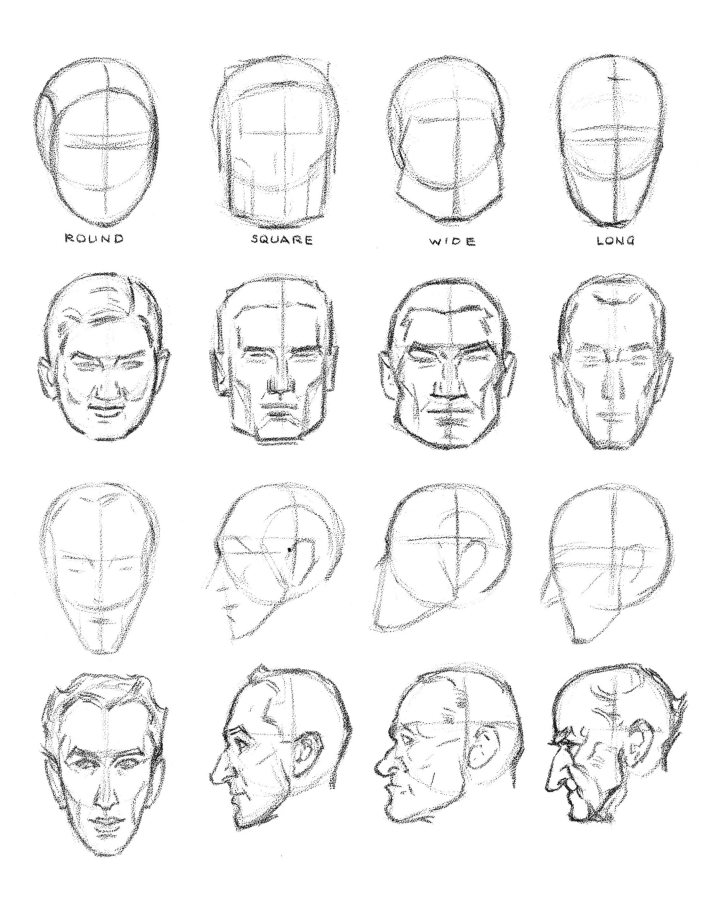

ROUND SQUARE WIDE LONG

PLATE 14. Creating any desired type

There is no reason why you can't take all the liberties you wish with the ball and plane. The variety of types mentioned in the early part of the book are drawn simply by building an understructure that is wide, square, long, narrow, or anything you wish. You have the basis of construction, so now just try some variations.

38

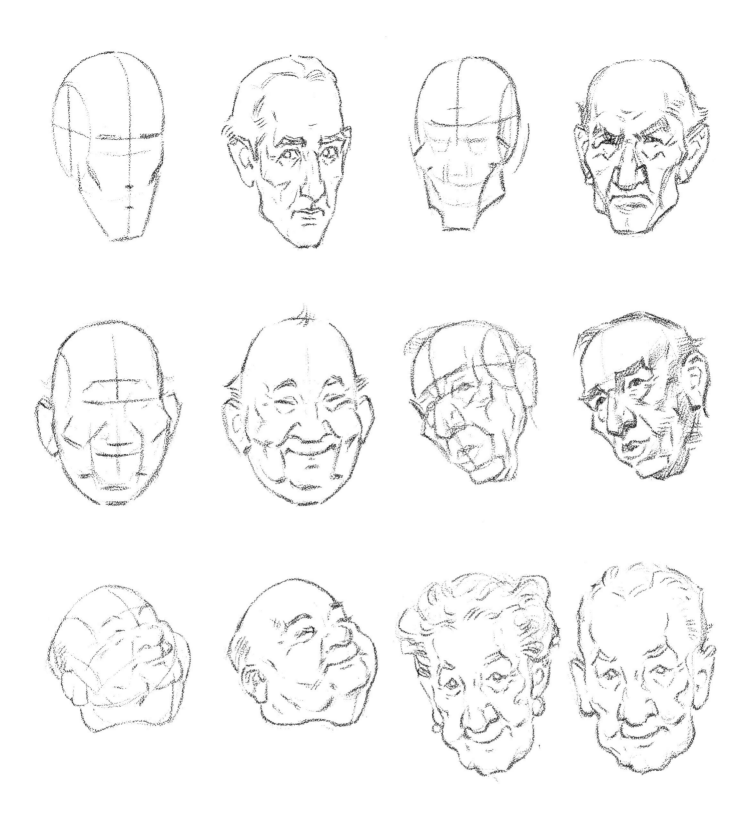

PLATE 15. Types are built by varying the ball and the plane

Look about among the people you know and those you see around you. Study them with a new understanding. See the combinations created by nature. Look from hairline to brow, then at the middle area from brow to bottom of nose, and finally to the bottom of the chin. Look down the middle line of a face; study what you see on each side.

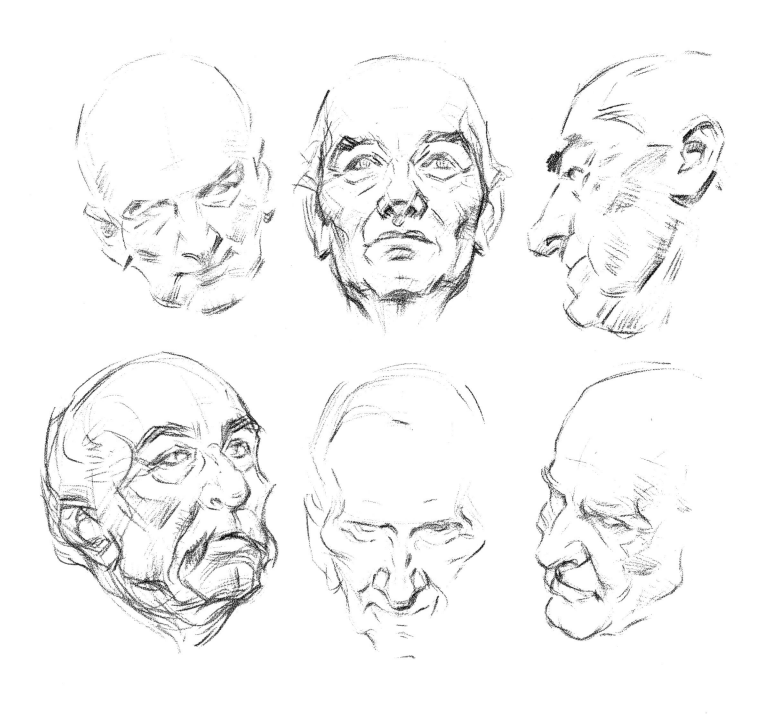

PLATE 16. Indicating character

Once you know how the lines of construction are set up in a head, you can quickly analyze faces and skulls. Always look first for the bony shapes, and the location of the features. Then look for the flesh formations in the cheeks, around the mouth, and around the eyes. Such formations can be easily indicated. See if the cheekbones are prominent and accented by shadow shapes under them. Look at the nose and the formation of the nostrils, the lips, and the creases between the lips and cheeks. Follow the shapes down into the chin and along the jaw line. These general characteristics, along with the whole shape of the head, are more important than a photographic delineation of each square inch of surface. Older people are more interesting than the young for this sort of study, since the characteristics have had a chance to develop.

RHYTHM

Rhythm in drawing is something you feel. Rhythm must be closely associated with design, and every head has design. There is a related flow of line, one line working with or opposed to another. Rhythm is freedom in drawing, freedom to express shapes, not meticulously, but in harmony. Rhythm is the hand working with the brain more than with the eye, the feel of the thing rather than the look of it. In drawing, rhythm comes with practice just as it does with a golf club. No one can tell you how to acquire it, but as you become conscious of it, you begin to recognize it when it is there.

To try to describe rhythm in drawing let us say that the artist is feeling the simplified shape of the whole thing as he draws every part of it. You see his hands swinging over the paper before the pencil goes down. He feels the stroke before he makes it. Rhythm need not always be curves. Curves may oppose blockiness. Rhythm might be an accent where it will do most good. It is more often the suggestion of the form rather than the closely scrutinized detail of the form. Here again the artist leaves the camera far behind, for the camera must record detailed fact, and only when rhythm is set up before it can it catch this elusive quality. The onlooker senses rhythm in your work even if he cannot consciously define it. You sense rhythm in some handwriting, while other specimens are cramped, jerky, and scrawly.

Some people have natural rhythm; others must strive to acquire it. Take the pencil in the palm of your hand between the thumb and first finger rather than holding it as you would to write between tight, cramped fingers. Swing it over your paper, using your wrist and arm and keeping your fingers still. That is the way to draw a rhythmic line. You can train your hand to draw, instead of using the fingers. Movement becomes associated with the whole arm rather than with the fingertips. Draw things large for a while. George Brigman, the famous anatomy teacher, used to illustrate his lectures by drawing with a crayon on the end of a four-foot stick. Some of his anatomy drawings were many times larger than life, and they were beautiful.

Rhythm is all about us, but we must train ourselves to see and recognize it. It might be described as the longest line, straight or curved, that you can make before the direction of the edge changes. A long direct line is more expressive than a myriad of little whiskery lines. An arrow in flight is a perfect example of rhythm. The movement of water or waves is another. The arc of a baseball in the air, the way a fielder drops his hands in the line of flight as he catches the ball, the movement of the forms in a woman's hair—all have rhythm. We might call it the uninterrupted flow of line which seems to reflect the movement of the artist's hand.

I cannot tell you how to acquire it, but I do believe you can. Awkwardness comes from lack of training; rhythm from trained organization, or coordination, perhaps both—knowledge and ability working together. Rhythm is one thing no camera or projector can ever give you. You feel it and strive to express it, or you don't. Swing that pencil over your paper just to draw a free line. Nobody ever does it too well the first time he tries.

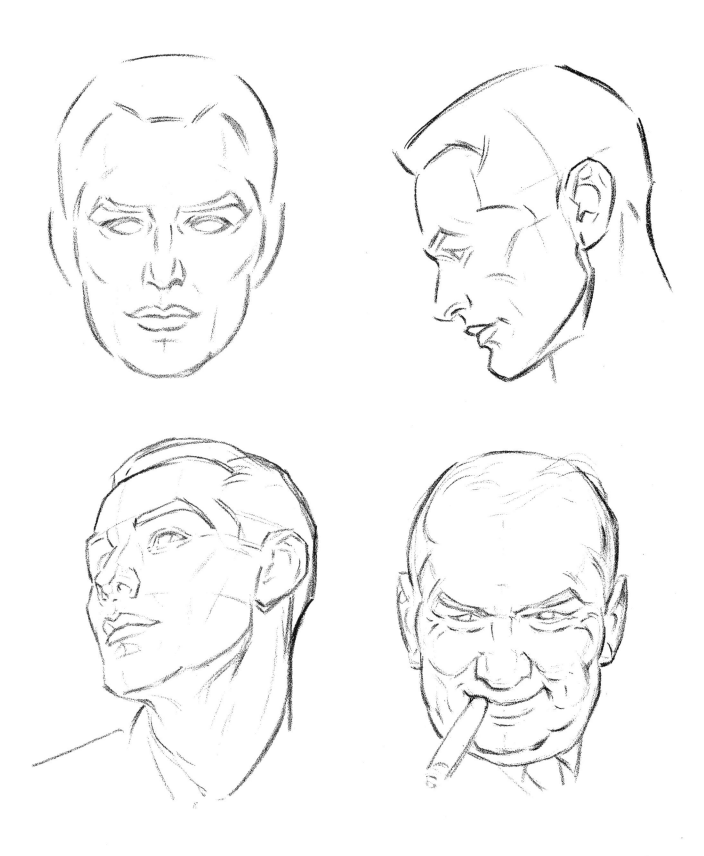

PLATE 17. Rhythmic lines in the head

It is interesting to search for the rhythmic lines in faces. You will find rounded or curved lines in opposition to angular and blocky lines. The blocky treatment helps to get away from the tight photographic approach. Then the head looks drawn, not traced. There is charm in curves but square forms have weight and solidity. You can produce happy results by combining the two instead of merely copying every waver of every edge in exact outline. In this way you set a feeling of design, and at the same time render solid form.

THE STANDARD HEAD

Heads will naturally vary in measurement and proportion. However, any artist will find it most practical to carry in his mind as basic measurements a scale of proportions, built on averages and simplified. The front view of the head fits quite well into a rectangle that is three units of measurement wide, and three and a half deep. This scale leaves a little space beyond the ears on each side. The half measurements of these units locate the eyes and nose and help in placing the mouth, and also put the line of the eyes at the halfway division of the whole head from top to bottom, as it should be and as it averages out in a large percentage of actual faces. This method of unit measurement locates the hairline and the three front divisions of the face. The side view of the head fits exactly into a square three and one-half units in each direction. You can establish your own unit; it is the proportions that are important.

These proportions, shown in Plate 18, have been worked out after a great deal of research and are offered to meet the need for a simple and practical scale that is readily usable. This scale fits perfectly with the ball-and-plane approach.

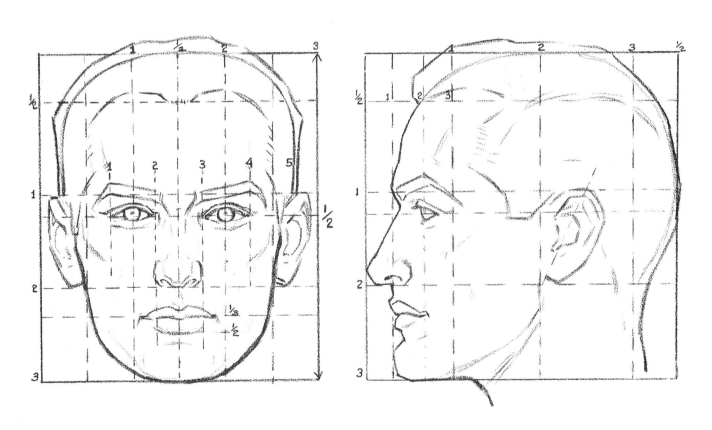

PLATE 18. Proportions of the male head

The standard proportions for a man's head are worked out here for the front view and the side view. The scale may easily be memorized. The head is three and one-half (optional) units high, nearly three units wide (to include the ears), and three and one-half units from tip of nose to the back of the head. The three units divide the face into forehead, nose, and jaw. Ears, nose to brow, lips and chin are each one unit. So you may start in this way to draw a head in any size you wish, using your own unit of measurement.

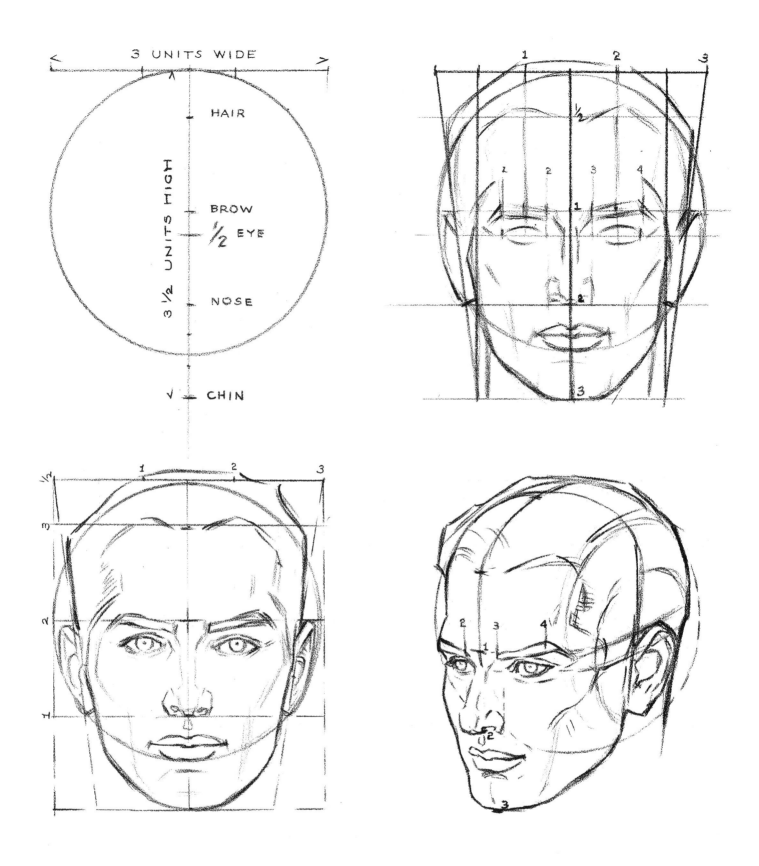

PLATE 19. Drawing the head in units

Here you see how the scale works out in practice. The circle represents the ball, and the width is the width of the head, including the ears. We find that the face is about two units wide and that the eyes fall between the middle halves or at the quarter points of the two units (see upper right). This coincides with the divisions of the ball and plane with which you are already familiar.

MUSCLES OF THE HEAD AND FACE

I do not see any material advantage to the artist in knowing the names of all the muscles and bones of the head, but it is of great importance to him to know where they are, where they attach, and what they do. It is important to know that some muscles are attached directly to bone at both ends, while others are attached to bone at one end and to other bands of muscles at the other. The former have the function of moving the bony structure. The latter move the flesh. Plate 20 shows the muscles and how they are connected.

The most important muscle of the head is the powerful muscle that closes the jaw. You feel it at the corner of the jaw, just below and in front of the ear. Circus acrobats have been known to dangle the weight of the whole body at the end of a rope by biting a bit of hard rubber attached to the rope end. The jaw is also attached to a muscle that spreads out over the side of the cranium. These two muscles give the power to crunch and grind food in the mouth.

A very marvelous mechanical principle functions in the eyes and mouth. Both are slits in a circular sheet of muscle. If you took half of a hollow rubber ball and cut a slit in it, without stress on the rubber, the slit would close itself. Under tension you could easily pull the slit open. The dropping of the weight of the jaw opens the mouth. To open the mouth wide is a conscious effort. To keep the mouth closed really requires very little effort—a piece of knowledge that can be used to great advantage at times.

Very important are the little ribbon-like muscles which open the lips laterally, pulling at the corners of the mouth. These are the "smile muscles." They are the ones that puff the cheeks by contracting within the flesh. When they pull diagonally upward and a smile flashes, great things may happen, far beyond mere mechanics. Remember these as the "happy muscles." They attach at the cheekbones and run diago-

nally down the cheeks to the muscles around the lips.

Note the muscles which run down the side of the nose past the corners of the mouth to the chin. These are the "unhappy muscles." Being attached to the bone around the nose at one end and to the jaw at the other, they can pull the lips upward in a snarl or downward in a leer. Working from both ends, they expose the teeth the way an animal shows its fangs. These muscles are operating from both ends when you brush your teeth. They seem to pull downward when you are lifting a heavy weight, or in extreme muscular effort of the body, like running. They make round corners at the mouth, where in the smile the corners are pulled out and upward. Try to associate the happy and the unhappy muscles, for they are the basis of most facial expressions. The wrinkles at the corners of the eyes are simply caused by the flesh of the cheeks' buckling by the upward pull of the "happy muscles" below the cheekbones. The bulging of the cheeks also causes the crease or fold of flesh under the eyes in a smile. It is more pronounced in some faces than others. As the "happy muscles" pull at each side in the smile, the nostrils may flare a little and become more evident, which is one of the things that help to make a face smile.

The dimple or downward line occurring in the lower part of the smiling cheek is caused by the little open space between the "unhappy muscle" and the jaw muscle. In old age this depression becomes very evident. In the young face it is a dimple.

The rest of the face muscles are simply what we may call "wrinkle muscles." There's one at the inside corner of the brows near the nose. This one lifts the corner of the eyebrow as in worry or in an expression of pleading. The "unhappy muscle" pulls down the inside corner of the brow in a frown. The two "wrinkle muscles"

above the brows also wrinkle the forehead, since they are contracting beneath the flesh, but are also attached to the flesh.

There are two small "wrinkle muscles" at the point of the chin. The depression between these muscles may account for a dimple in the middle of the chin. They also cause the chin to buckle into little bumps in some expressions.

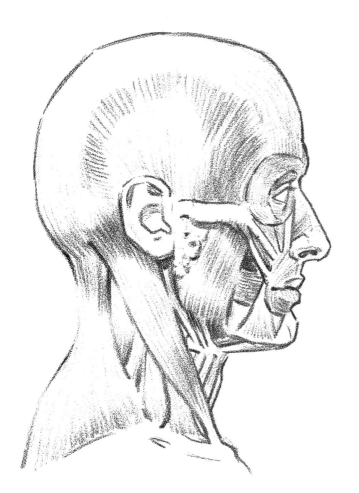
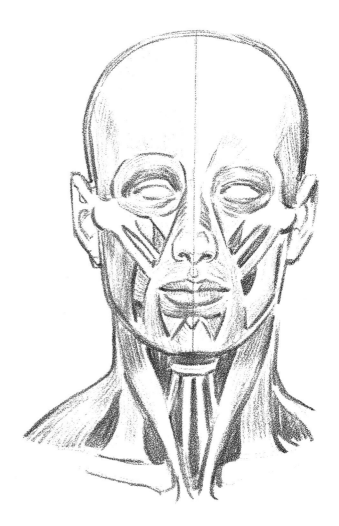

PLATE 20. Anatomy of the head

When you are studying the muscles of the face, get in front of a mirror and give them a good working over. From that and from these drawings you will learn a great deal about expression and the why of it.

Give some consideration to the muscles of the neck, for you usually have to draw a head on a neck. The two diagonally placed muscles that turn the head are attached to the skull just behind the ears at the top, and to the breastbone, which lies between the two collarbones, at the bottom. Two strong muscles attached to the back of the head underneath the back of the skull hold the head up or tip it backward. The head drops forward mostly of its own weight.

To know these muscles will help you tremendously in drawing heads.

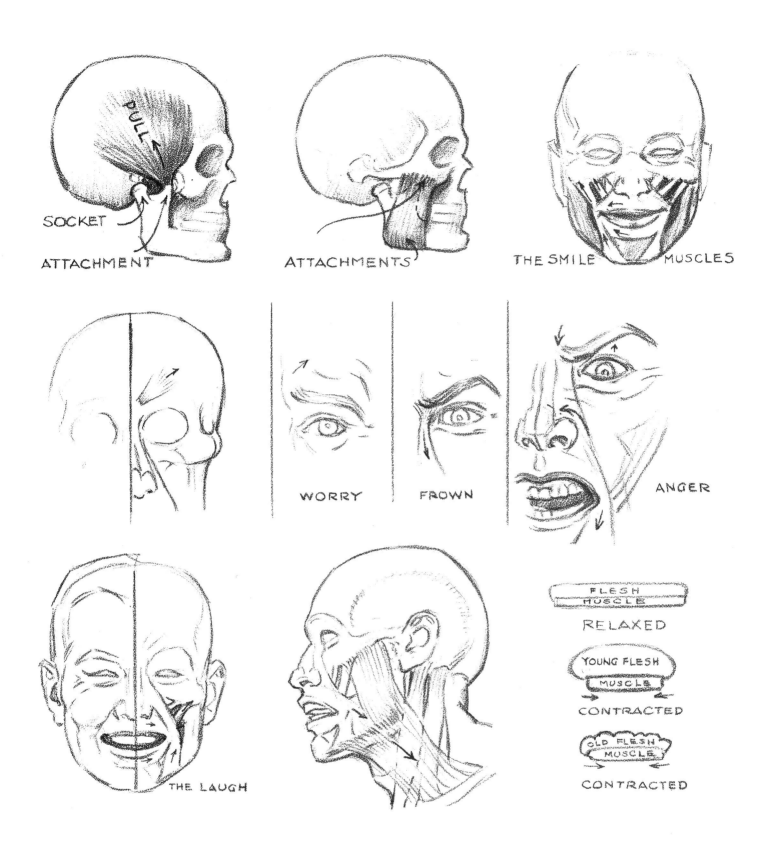

SOCKET

ATTACHMENT

ATTACHMENTS

THE SMILE MUSCLES

WORRY

FROWN

ANGER

THE LAUGH

FLESH
MUSCLE

RELAXED

YOUNG FLESH
MUSCLE

CONTRACTED

OLD FLESH
MUSCLE

CONTRACTED

PLATE 21. How the muscles function

The drawings here, though not very pleasant, are important to the artist if he intends to give his characters expression. The smile is most important in commercial art and advertising. In illustrating fiction you may have to draw an angry face occasionally but the great majority of the faces you will draw are pleasant ones. However, it is much easier to draw a "dead-pan" face than a very happy one. What we want to do is to keep the face that should reflect happiness from appearing as dead-pan or even leering. So study this page well.

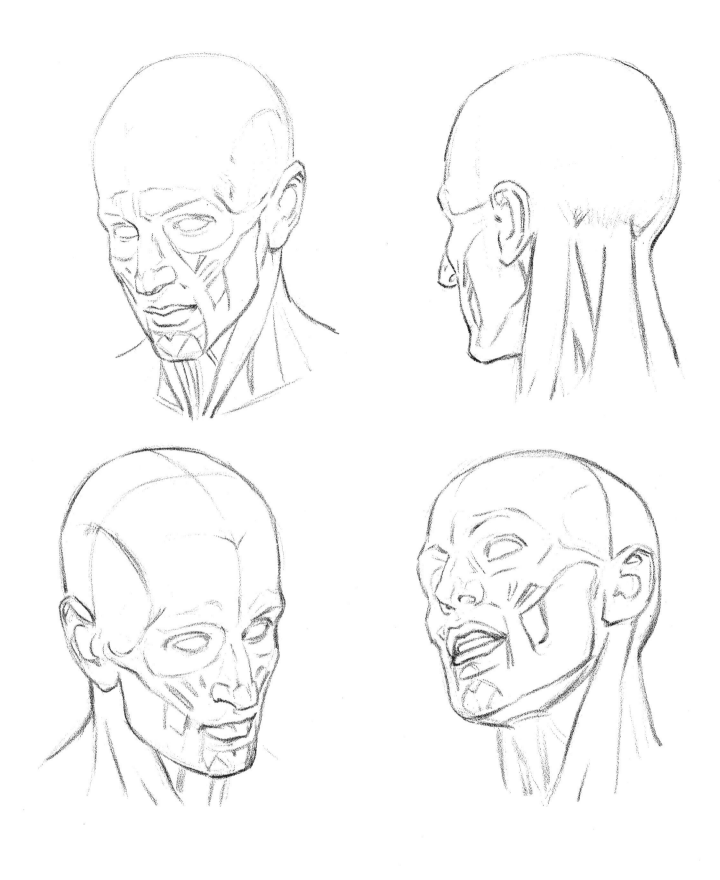

PLATE 22. The muscles from various angles

After you have learned the muscles of the head, try placing them within the head in various poses. Tip and turn the head and line up the muscles to balance on each side of the middle line of the face. You will be surprised to see how easily they will begin to fall into place within the construction plan you have already learned.

48

WHY YOU NEED ANATOMY TO DRAW HEADS

Only a few artists seem to have more than a hazy idea of the anatomy of the head, or of how the muscles function. If faces were expressionless we might manage with only a little of this knowledge. It is argued that we can depend upon photographs for expression. Frankly, many artists do just that. My contention is that one can learn the necessary principles of anatomy in two or three short periods of study, say three evenings. When so little effort is required, why not spend it to learn something that will always be valuable to you.

Every expression is entirely dependent upon a very few muscles lying under and embedded within the flesh. Knowing where the muscles lie and what they do is the difference between guesswork and knowledge. An expression must carry conviction, and it's easier to convince when you know the facts you are dealing with.

For many years I seemed to have great difficulty in drawing smiles. I had taken it for granted that the smile creases began at the nostrils and ran straight to the corners of the lips. Actually the smile creases run well outside of the corners of the mouth and around them and point for a little way toward the side of the chin. This is because the lips lie in an oval-shaped sheet of muscle and the creases form at the outer edges of this muscle. The small ribbon-like muscles which lead down from the cheekbones are attached to this sheet of muscle at the outer edge and cause the smile creases. In some smiles the pull of these little muscles actually causes the corners of the mouth to round out rather than to end in a sharp point. For some reason I had not grasped this in my early studies. The experience proved the value of going back to the source when you are in trouble.

One thing that is important in the smile is the way folds of flesh appear under the eyes. Sometimes these add a good deal of mirth to a smile; sometimes they do not. I cannot tell you why.

Some faces have this characteristic to a pronounced degree, while in other faces it is hardly evident. The difficulty is to make the folds appear natural and a part of the smile rather than to have them look like pouches under the eyes. These folds are easier to paint than to draw, because in painting they may be rendered in light values, but in a drawing we are usually using a black medium, and the folds get too black. The same is true of the wrinkles that show at the outer corners of the eyes in a smile. If these are too black, they look like crow's feet. Many smiles are spoiled because the lines around the nostrils are too heavy and black, suggesting a sneer more than a smile, or making the face look as if it were smelling something unpleasant.

Another valuable hint about the smile is that it shows more of the upper teeth than of the lower ones. That means both a greater number of teeth, and more area of the teeth themselves. The corners of the lips are pulled away from the teeth, causing a hole or dark accent within the corners of the lips. The teeth should never run right into the corners as if they were pressed against the lips all the way around. The pull of the muscles stretches and flattens the lips, but the inward curve of the teeth is still there and becomes even more evident because of the shadows cast inwardly by the lips at the corners. There should be some toning down of the teeth as they go back. The two front upper teeth are the ones to highlight. It is better not to try to model the teeth too much, or to draw lines between them. This again is because almost any line may be too black. The lines between the teeth are really very subtle and delicate. Often the teeth should be suggested rather than drawn in detail—unless you are selling toothpaste. Anders Zorn was a master at painting teeth in a smile.

Plate 23 shows the mechanics of the mouth. At the top are the bones without the flesh. We must always remember that the upper jaw is

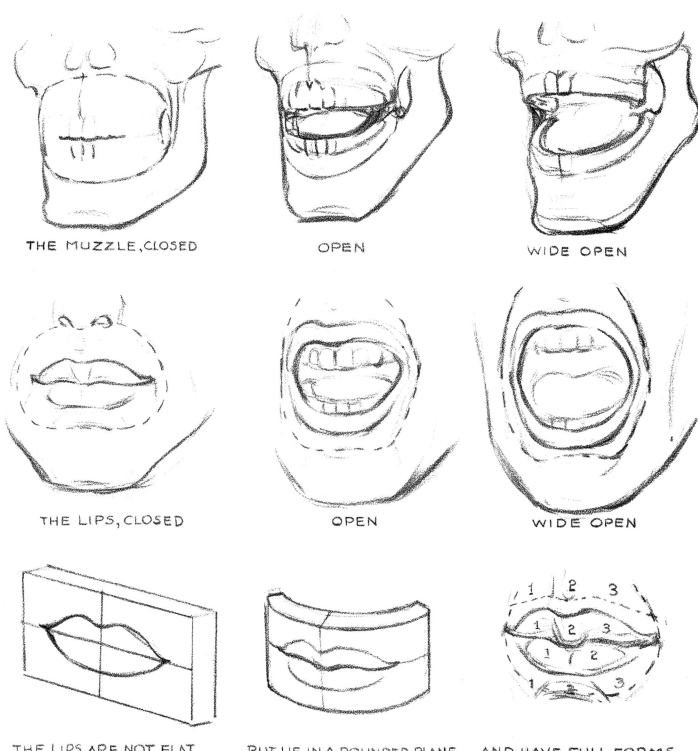

THE MUZZLE, CLOSED OPEN WIDE OPEN

THE LIPS, CLOSED OPEN WIDE OPEN

THE LIPS ARE NOT FLAT BUT LIE IN A ROUNDED PLANE AND HAVE FULL FORMS.

PLATE 23. Mechanics of the mouth

The lips and jaw can hardly be drawn convincingly without an understanding of the muzzle and how it works. Beginners draw the mouth as if it lay on a flat plane. The curve of the teeth in the rounded jaw must be considered, and the fullness of the lips themselves must be felt.

50

fixed in its relationship to the rest of the face, and all the movement takes place in the lower jaw. The curve of the upper teeth remains unchanged and is affected only by the viewpoint. The dropping of the lower jaw may add as much as two inches to the length of the face. When the upper and lower teeth are separated, be sure to compensate by dropping the chin proportionately. And, once again, always consider the roundness of the muzzle all around the lips.

Plate 24 gives you a real look at the eyes. We are too likely to think of the eye as something round (the iris) on something white (the eyeball). Until we analyze the structure we are not conscious of how much the lids are affected by the roundness of the eyeball. The reason is that we see only a little more than a quarter of the eyeball between the lids. But the curve of the eyeball is very evident from corner to corner of the lids. An eye without lids is, of course, a gruesome sight, but we must make these lids seem to lie on the rounded surface. The lids operate almost exactly like the lips. Except in the front view of the face the drawing of one eye is never an exact duplicate of the drawing of the other. When the iris of one eye is at the inner corner, that of the other is at the outer corner. There is a slight bulge of the lens of the eye which travels around under the upper lid. Think of the eyes as two balls working together on a stick. As you turn the stick you also turn the eyes. Think of the lids as the covers over the two balls, in principle like the drawing in the lower right-hand corner of Plate 24. Draw many eyes, first separately, then in pairs. Clip out some pictures of eyes and copy them.

In studying the mouths shown in Plate 25, consider the lips and teeth separately for the time being. Try drawing these mouths, and also get a mirror and draw your own mouth. Move the lips. Tilt your head at various angles. Notice that the teeth are more or less indicated, not by lines between them, but by the gums above and the accents of the dark area below. It is very easy to overemphasize the detail in teeth, so that

they do not seem to stay within the mouth. Overemphasized teeth can spoil an otherwise good head.

Noses and ears are shown in Plate 26. Noses and ears are affected by viewpoint and perspective as much as lips are. In other words, these all look the way they do because of the angle from which you see them. You can see why it is so important to establish the viewpoint of the whole head, before we can draw any of these features. When drawing from life it is most important that the pose of the head has not been changed between the drawing of separate features, since that will throw the drawing off completely. A nose must sit within the construction lines of the whole head and over the middle line, or it simply will not look right. The nose and ear should be drawn together, so that their relationship is established. The ear looks very different from the front, side view, or back. See that the nose is at right angles to the line of the eyes and brows. When the brows tip, the nose tips; in fact, everything in the face tips.

Plate 27 gives some examples of laughing and smiling faces. Though these are restricted to line alone, you can feel the muscles operating in the flesh. What I call the sharp-cornered smile is shown on the fellow in the upper right-hand corner. The faces in the middle of the top and bottom rows have a round-cornered laugh. This must come from the subject, for a round corner badly drawn can easily become a leer. Smiles require much study. You can learn a lot with your mirror.

In Plate 28 there are some examples of other expressions, which may give you some idea of how the muscles of the face operate in expressions that are not smiles. The action of the lips can vary a great deal. The basis of most expressions is usually in the mouth. For expressions in cartoons, the cartoonist keeps a mirror handy, since he can assume the expressions he wants more easily than he can explain it to a model.

In using the mirror look for the action of the muscles only; you need not even attempt a like-

ness of yourself. The mirror gives the artist one big break—he always has a head and hands available to draw from. With two mirrors set properly he can get a side view or a three-quarter view, or make the left hand appear as the right and vice versa.

With expressions, it certainly does no harm to take photographs of a lot of different ones. You can take pictures of your face in the mirror and thus stock up on various expressions for your files. I do not like to see an artist make a crutch of his camera, for I will always maintain that a man can get more into a drawing of his own than any tracing, pantograph, photostat, or projection can give. Photographs have certain distortions that always get into a drawing made from one, unless it is a freehand drawing—and sometimes even then. I think these distortions come from the fact that we see with two eyes, while the camera has only one. The distance of the camera from the subject also has a lot to do with it. Trace a photograph and you will see these things for yourself. Your artistry seems to go out the window, no matter how you try to eliminate that photographic look.

Various types and different expressions are illustrated in Plate 29. I have taken considerable liberty in creating both. It is good training to develop a type, then make several drawings of him showing different expressions. Make him smile, frown, pout, laugh, worry, or whatever else you can. It is really lots of fun, and all the time you are increasing your stock in trade.

In Plate 30 the face has been analyzed to show the structural reasons for the various lines and bumps. When you understand these, you can apply your knowledge in drawing faces of people of different ages, as Plate 31 shows.

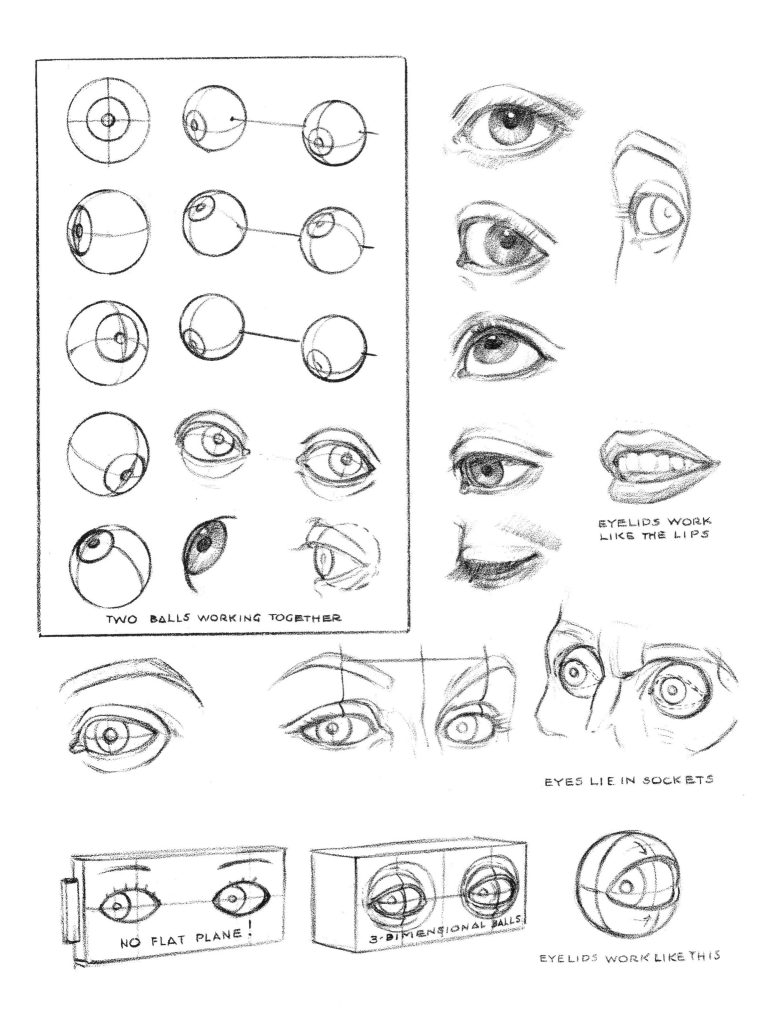

TWO BALLS WORKING TOGETHER

EYELIDS WORK LIKE THE LIPS

EYES LIE IN SOCKETS

NO FLAT PLANE!

3-DIMENSIONAL BALLS

EYELIDS WORK LIKE THIS

PLATE 24. Mechanics of the eyes

53

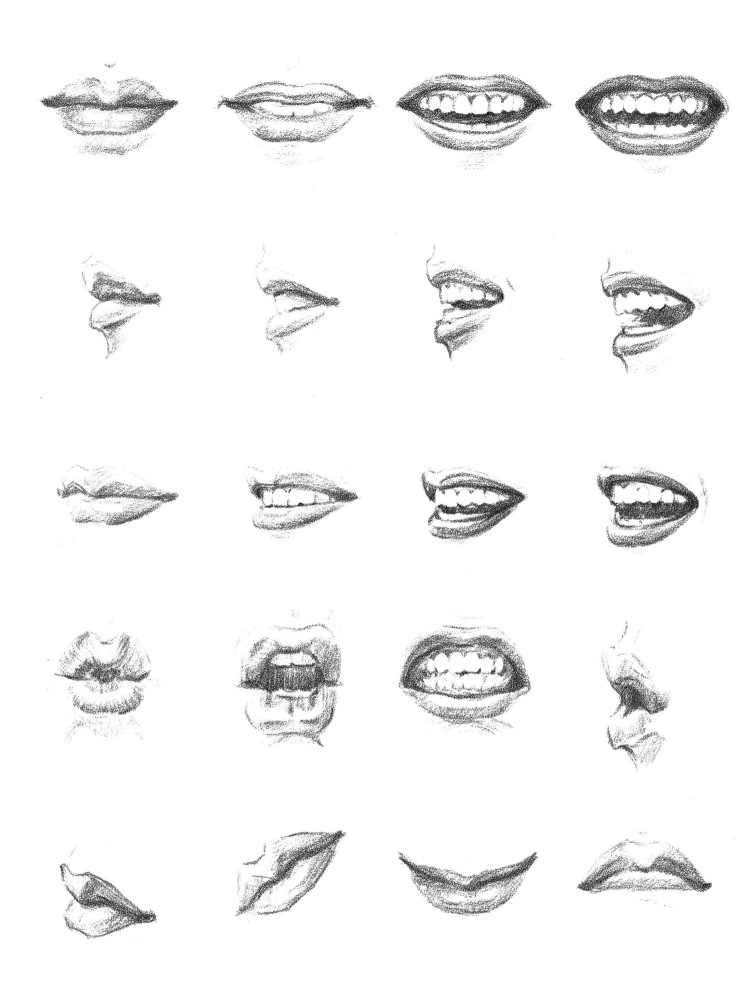

PLATE 25. Movement of the lips

54

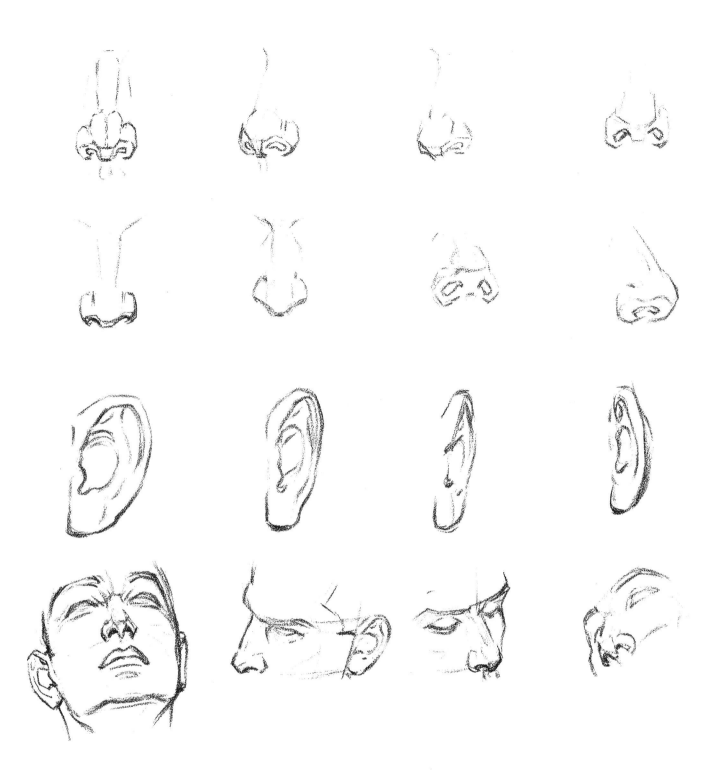

PLATE 26. Construction of the nose and the ears

The appearance of the nose and of the ears is affected by the point of view from which they are drawn. The real problem is much more one of setting them into the construction of the head in their correct positions than one of drawing the actual details themselves. Noses and ears vary widely in shape but not a great deal in basic construction. The nostrils should be set evenly on the line running from the base of the nose to the base of the ear. It is good practice to draw noses and ears from every angle until you are completely familiar with their placement in any pose of the head.

55

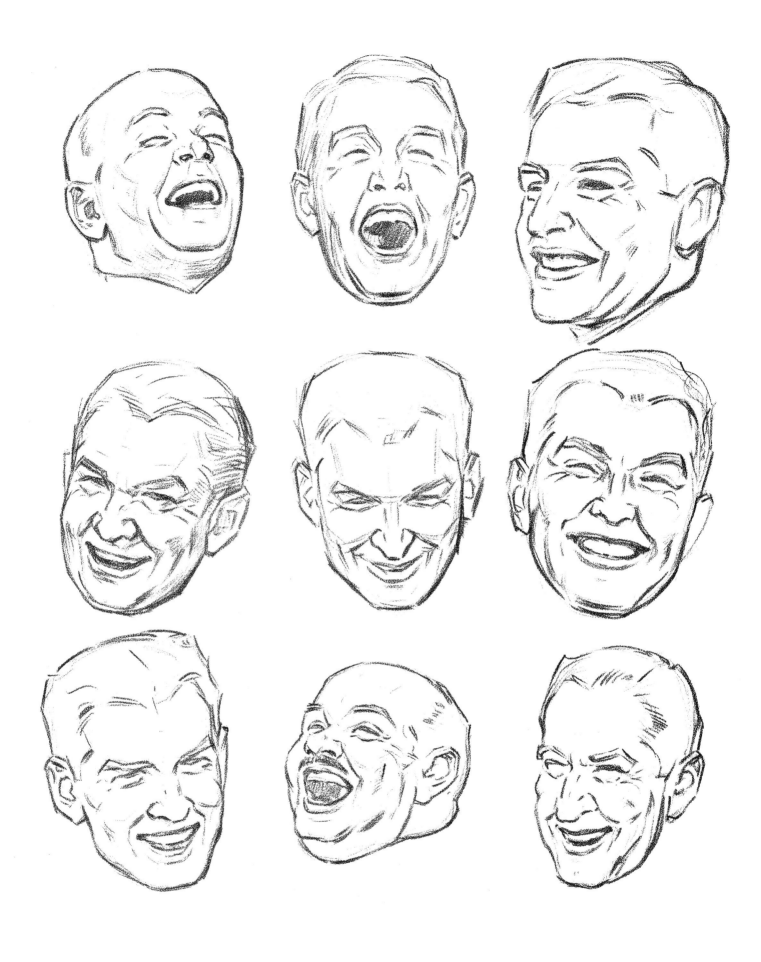

PLATE 27. Expression—the laugh

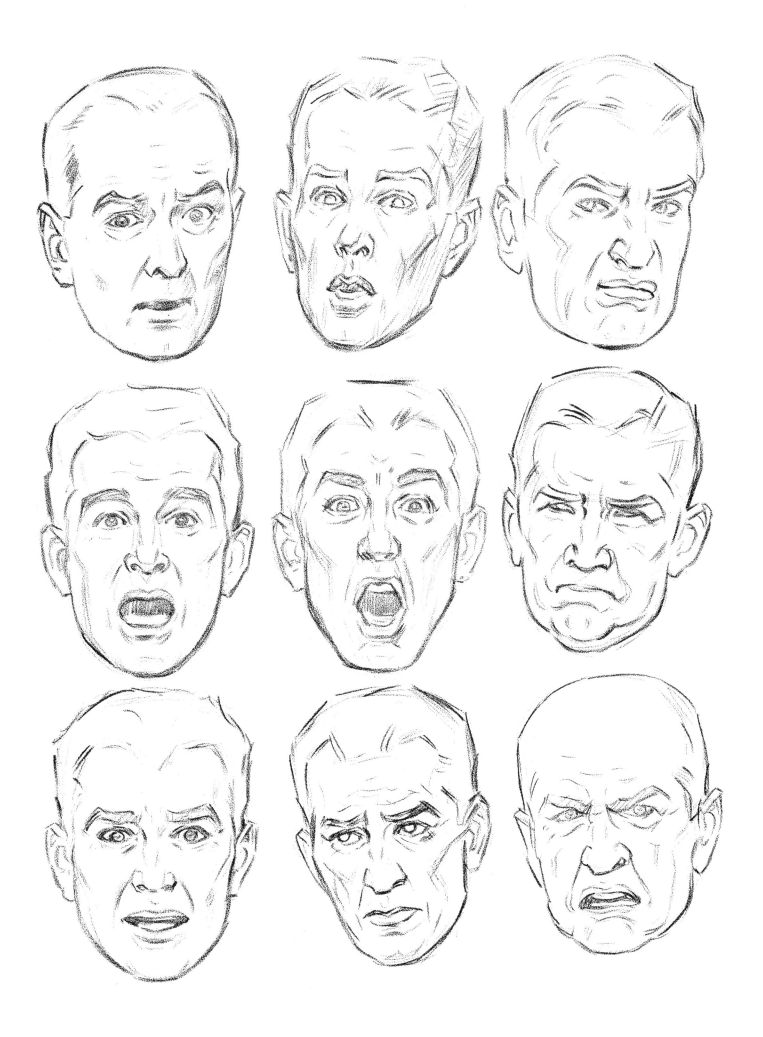

PLATE 28. Various expressions

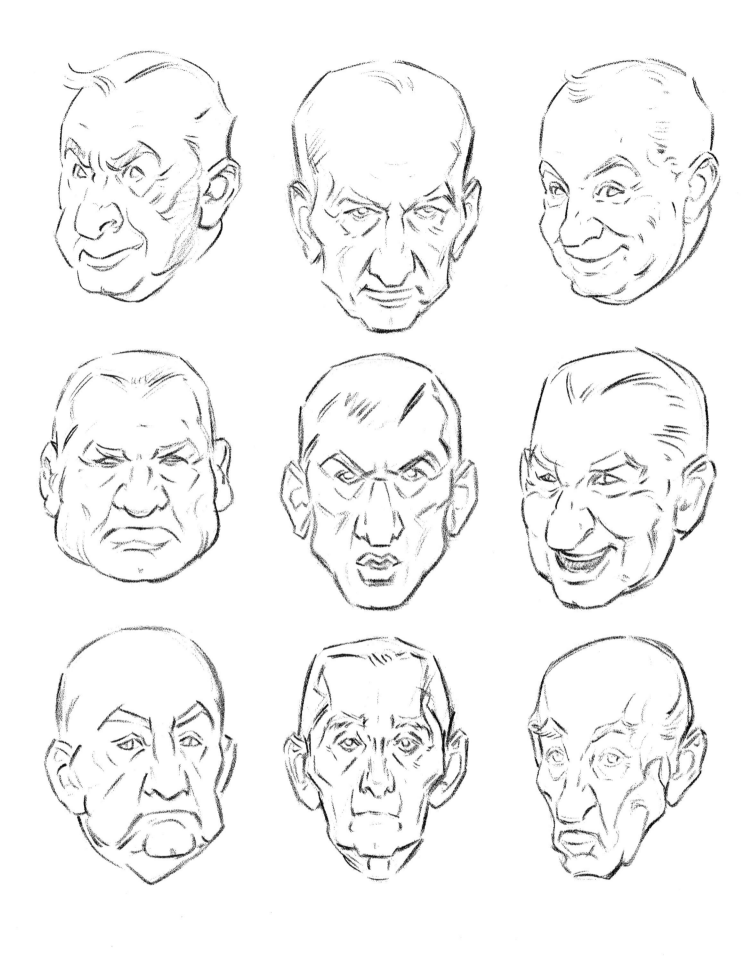

PLATE 29. Characterization through expression

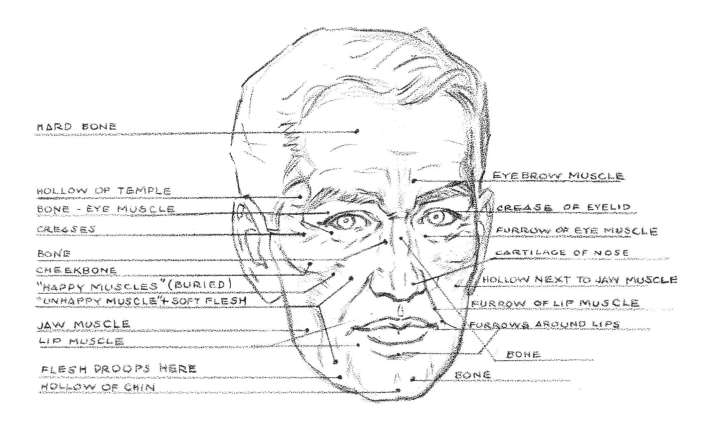

HARD BONE

HOLLOW OF TEMPLE

BONE - EYE MUSCLE

CREASES

BONE

CHEEKBONE

"HAPPY MUSCLES" (BURIED)

"UNHAPPY MUSCLE"+ SOFT FLESH

JAW MUSCLE

LIP MUSCLE

FLESH DROOPS HERE

HOLLOW OF CHIN

EYEBROW MUSCLE

CREASE OF EYELID

FURROW OF EYE MUSCLE

CARTILAGE OF NOSE

HOLLOW NEXT TO JAW MUSCLE

FURROW OF LIP MUSCLE

FURROWS AROUND LIPS

BONE

BONE

PLATE 30. Analysis of facial markings

It is not difficult to memorize the size, shape, and placement of the muscles of the face. If you do this, you will thereafter always be able to identify the lines, humps, and bumps in the face. Older people are better than young ones as sources for this information, since the older one gets the more lines and wrinkles develop. We can learn to separate the small wrinkles from the facial lines. The small wrinkles are associated with the shrinkage of the flesh between the muscles, whereas the lines are associated with the edges of the muscles themselves. The small wrinkles of the flesh are seldom drawn or painted since they eventually make a network of wrinkles over the whole face. More important are the forms, and the large creases or lines between them. These are the long creases of the cheeks, those around the mouth, and those over and under the eyes. The muscles are quite pronounced in the male head. When we speak of a strong face, we are speaking mainly of muscle and bone structure.

Only in expressions with raised eyebrows need we worry about wrinkles in the forehead. We can safely leave out most of the wrinkles most of the time and concentrate mainly on the lines, the bones, and the soft forms of the flesh beneath the surface. It is a safe bet that the more wrinkles you eliminate, the better your drawing will be liked. Remember that wrinkles are never black lines on the actual face, but very delicate lines of shadow which can be seen only a few feet away. That is why we can so easily eliminate them and still get a likeness. The deeper creases are evident for some distance, as are the shadows of the planes of the head. Never draw a face as a map or network of wrinkles.

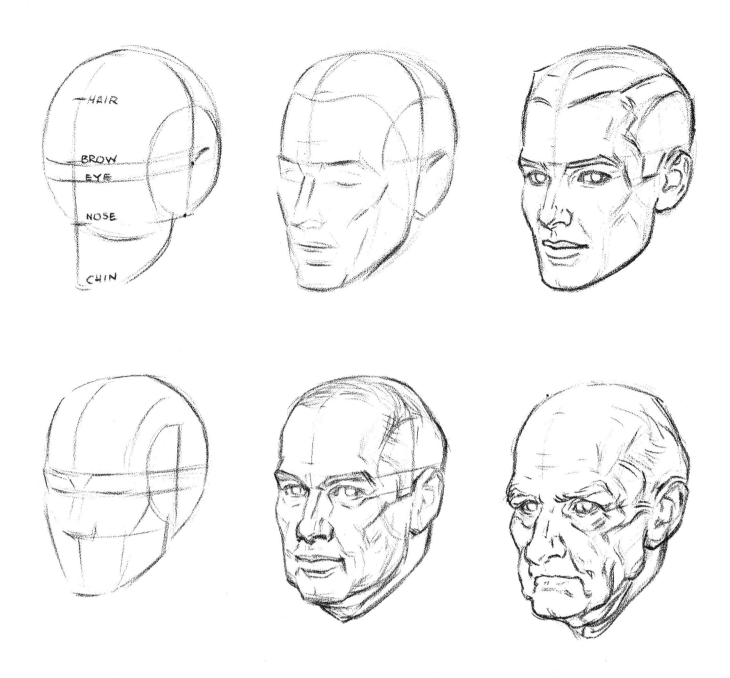

PLATE 31. Drawing faces of different ages

You can easily learn to age a face by adding the forms of the emaciating
muscles and the creases that fall between them. The cheekbones, the
corners of the jaw, and the bone of the chin become more evident in the
aging process. The cartilages of the nose and ears seem to get larger as
we get older. The chief change takes place in the cheeks and around the
eyes and mouth. The flesh sags at the sides of the chin and along the sides
of the jaw. Pouches form under the eyes, and deeper lines at the corners
of the eyes. The lips tend to get thinner and move inward, so that more
of a straight line between the lips is produced. The lines develop from
the corners of the mouth down around the sides of the chin. The flesh
above the eyelids droops and the brows seem to drop inward toward the
bridge of the nose. A few deeper lines develop across the forehead and
between the brows. These can be subordinated, to avoid overemphasizing
them. The hair, of course, thins out in varying degrees, so that the hair-
line moves up and back and there is considerable thinning of the hair at
the top of the head. However, we draw the head from the same basic
construction.

60

TONE

When we go from line into tone we take a very large step, for tone is the effect of light on form. Although drawing need not carry all the subtlety of tone that painting does, still we must consider values as more or less related. It is better at first to light your subject strongly, or choose a subject that is more or less in simple light and shadow. Shadows are really shapes to draw, shapes that occur over the surface of the form, so that we must consider both, the shape of the form itself and the shape of the shadow on it. Therefore keep the lights and shadows as simple as possible. Hold the light down to one source to begin with. Later on, you may want to introduce some back lighting, but never have both lights shining on the same area. This creates a falsity of lighting, and therefore false-looking form, for form really exists only as light, halftone, and shadow define it. If the light were not there, we would see no form.

In very diffused lighting, we see form much the way we represent it in outline only. If light is coming from all directions the form flattens out, because form turning away from the light source is what makes halftone, shadow, and cast shadow. By cast shadow we mean that the shadow has continued to another plane like the wall, or down across the neck under the chin. Cast shadows have edges of their own, which depend on the direction from which the light is coming. The difference lies in the fact that in ordinary shadow the form has simply turned so far that the light can no longer reach it. On a round form there is halftone before we reach the shadow, and the halftone merges with the shadow. On a square or angular form the shadow sharply follows the edge which cuts off the light, or around which the light cannot reach. The nose casts a shadow in a bright light; the cheeks, being rounder and more gradual as a curve, blend the shadow with the light.

This very blending of light into shadow may make the difference between a good drawing and a bad one. If the edge of the shadow is graduated or blended too much with the light, the drawing loses character; if it is not blended enough the drawing may become hard and brittle. A good way to judge is to ask yourself: Am I holding evidence of the plane or have I lost it? If you have softened the edge so much as to have lost the plane, the drawing is bound to take on a smooth, photographic look. For this reason, planes have to be established when you are drawing from a photograph, since they are not apparent in the photograph itself.

In drawing planes, we can do much to suggest the direction of the plane by the direction of line, without much change in values (see Plate 34). For this reason a drawing can be made to appear very solid, where a wash drawing or painting may lose much of the character. This is a principle which is used effectively in pen drawing, that of making the strokes follow the direction of the plane. It can be used in other mediums that are not areas of flat tone.

I hope the reader will give particular attention to Plate 33, since I consider this page one of the most important in the book. The drawings here encompass practically all the material offered up so far in this book. Here we have the plan of construction, the anatomy, the planes, and the finished rendering combined in a single pose of an individual head.

In addition to studying this page carefully, find some material of your own. See if you can render in separate drawings what you believe must be the correct proportions, anatomy, and planes of the particular head. You will learn more by doing this than by copying a hundred heads as they appear in your copy material. It will definitely point up anything lacking in your knowledge thus far. When you have, to your satisfaction, worked out the several stages, paste them on a sheet and hang them up in the place

where you work, as a constant reminder. If you have worked them out convincingly you can well take pride in the fact. They will be of interest to anyone, for through them you have stated your knowledge in no uncertain manner. They serve to help you memorize the qualities which should go into a well-drawn head, but which, of course, could not be incorporated into a single drawing with each stage in evidence. In the finished drawing, I believe you will feel this background of effort, which I hope will convince you that drawing heads is more than mere copying.

Plates 35 through 39 may help you in the matter of technical rendering, though it is my feeling that technique should be left very much to the student himself. The problems of proportion, anatomy, and planes are basically the same for all of us, but technical solutions of those problems are, to a large extent, an individual matter.

Unfortunately, the student is usually unable to see many good examples of head drawings, because so few are published. In the past decade there have been few men in the field good enough to have their drawings published regularly, aside from the fact that many artists' ability to draw the head is concealed by their use of mediums. I would like to call attention to the work of William Oberhardt, who stands almost alone in drawing the head. I hope the reader may at some time come across a few of the many drawings of his that have appeared in publications. The schools in England seem to have produced many more fine examples of head-drawing than those in America have. I think this is because the young American artist tends to turn to photographs for material before he has any real knowledge of the head. The drawings in this book are offered humbly, since there are many draftsmen whose skill exceeds mine, but because of the lack of helpful books on the subject, I submit whatever I have to offer hopefully.

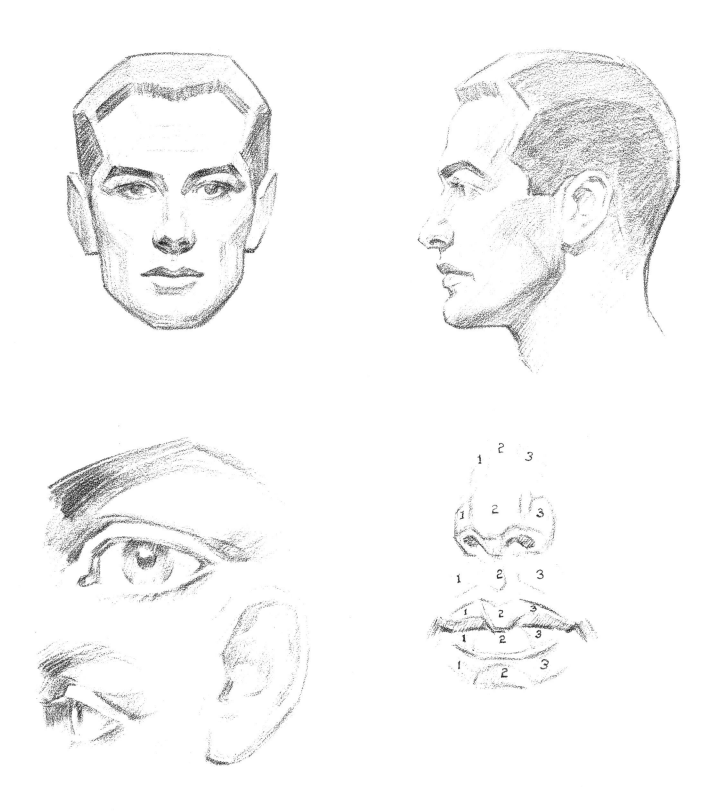

PLATE 32. Modeling the planes

As a basis for learning to show light on form, turn to Plate 9 and make a drawing of the planes of the head as shown there. It will help you a great deal with the material to follow. Let us understand that we can depict solid form only as it appears in light, halftone, and shadow. The shadows get darker as the form turns away from the light. A single light is always simple to draw, for more than one light cuts up the shadow tones, making everything more complicated. Think now in terms of flat areas in varying tones, and forget surface wrinkles entirely.

63

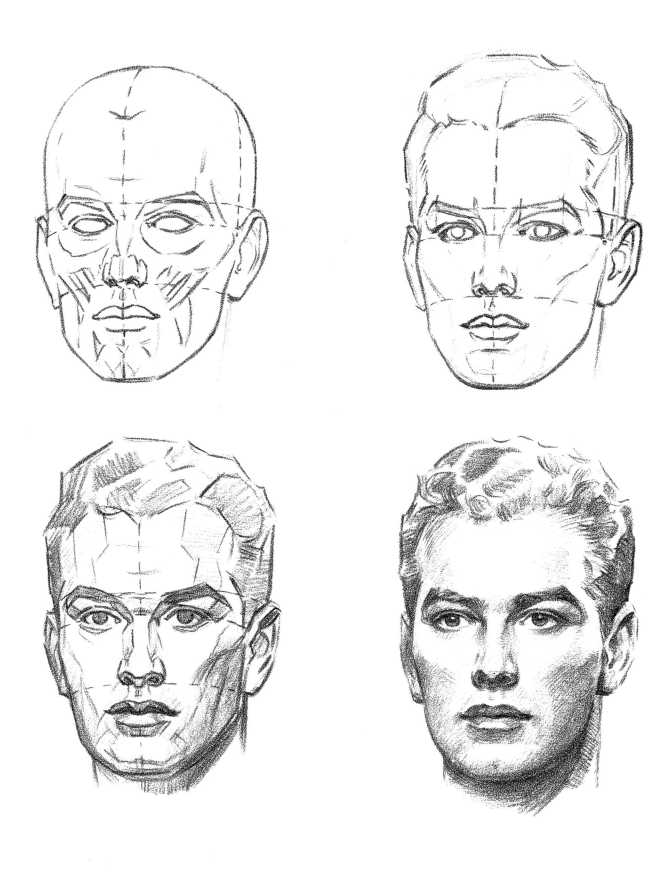

PLATE 33. Combining anatomy, construction, and planes

This page is one of the most important in the book, since it shows the stages of drawing a head from the anatomy and construction, through the outline, to the planes and the final completion of the drawing. It would be impossible to follow without considerable study of the preceding information, not in order to copy this head, but to draw one yourself. Study this page carefully; you will find it invaluable for reference.

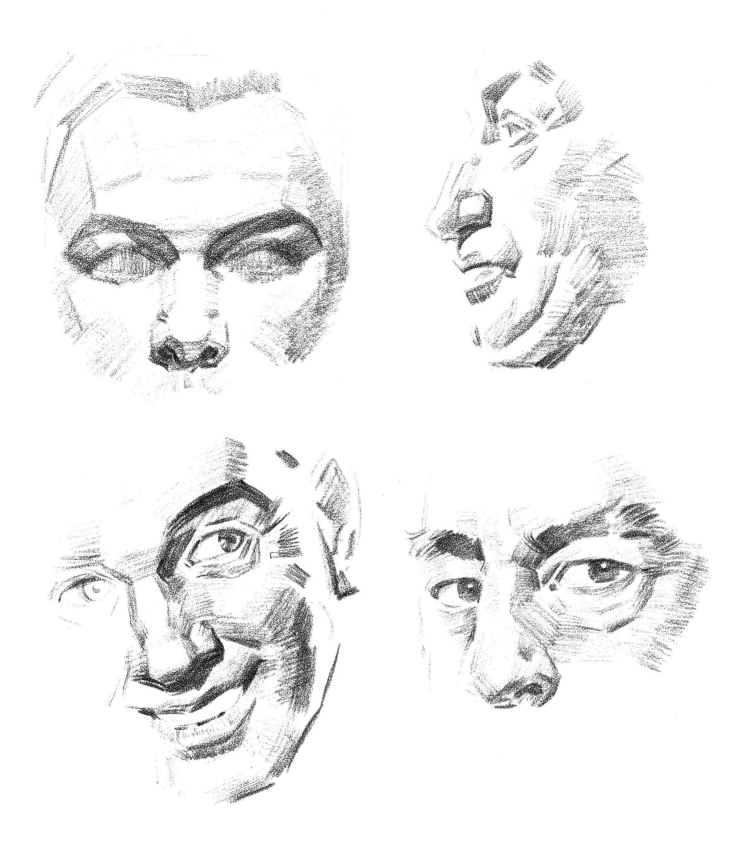

PLATE 34. Building tone with planes

This page shows how the planes may be treated as straight flat surfaces, each carrying its own value between light and dark. The very light planes should have very little tone and be treated very delicately. By directing the stroke, you can make the plane turn without changing the value more than slightly. You get more solidity if you make all the planes in the light a little lighter than they appear, and those in the shadow a little darker.

65

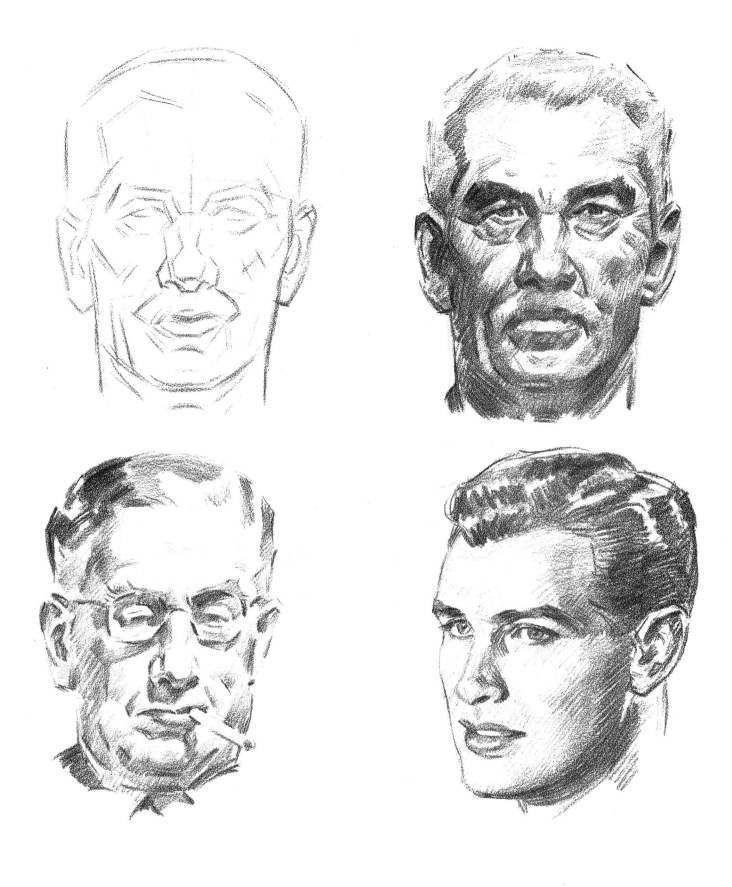

PLATE 35. Every head is a separate problem

Every head is an individual assemblage of shapes, lines, and spaces. Because of the variations of skulls and features, together with variations of spacing, millions of combinations occur. Forget every other face and concentrate on the one you are drawing. Accent the individual forms wherever you can. Start drawing real people, and collect clippings and photographs to practice from. Don't be tempted to trace; just draw.

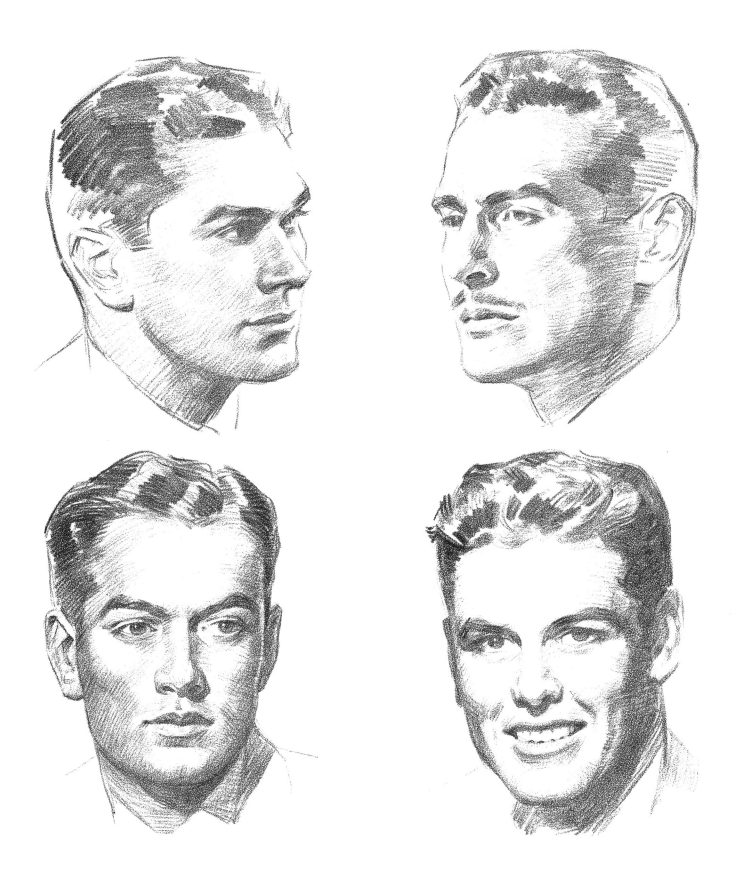

PLATE 36. Types of character

The character in a head is the result of the individual bones and muscles, as they are shown by careful construction and spacing. But the beauty of a drawing will always be in the way you use line and tone and the interpretation of light and shadow on the forms. You may experiment in your own way and develop your own approach and technique. Sometimes an unfinished study is more attractive than the completely executed drawing.

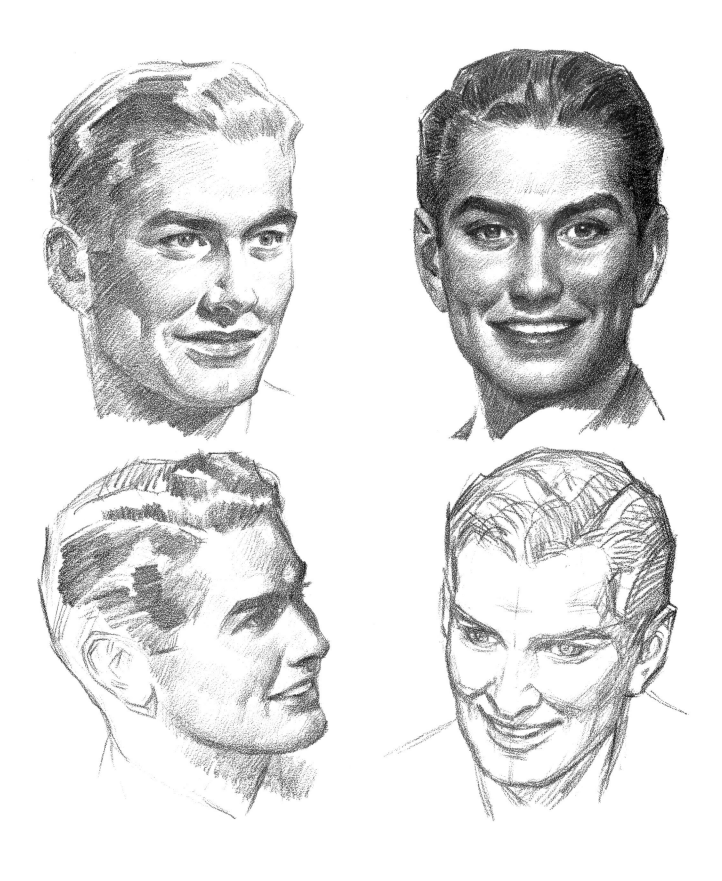

PLATE 37. Smiling men

Smiles that radiate happiness are difficult for any artist. They are much easier to render in an outline drawing than a tonal drawing. If your drawing of heads must provide an income you will do well to practice drawing smiles from clippings, since a model can rarely hold a genuine smile for very long. Study particularly the forms around the corners of the mouth, and the forms of the cheeks.

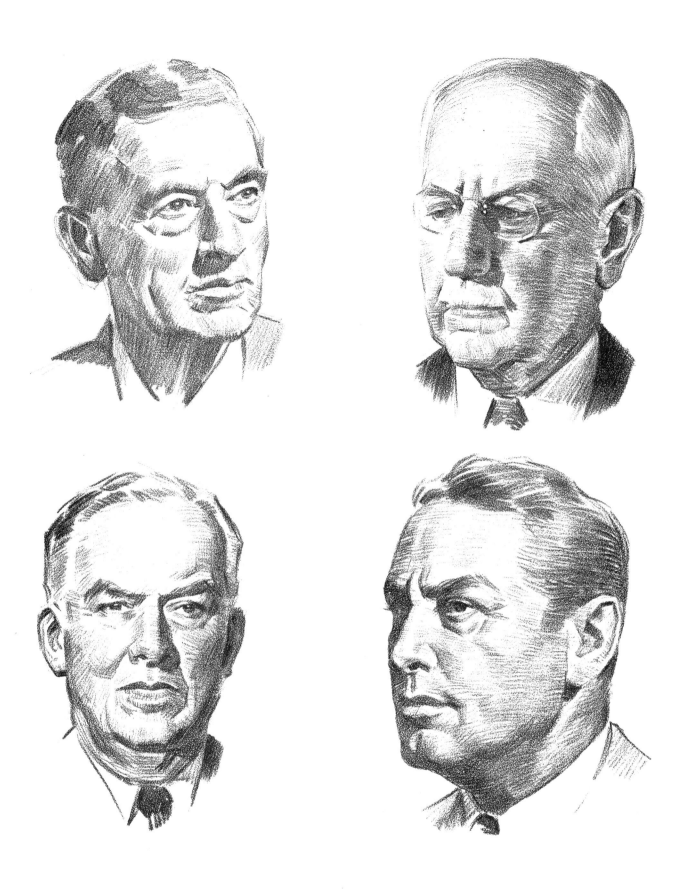

PLATE 38. Older men

The faces of older men give the artist more to "get hold of" in the way of forms and lines. Note, however, that in the faces on this page most of the surface wrinkles have been eliminated and only the main lines and forms stated. The impression of age is maintained without the incidental and insignificant wrinkles.

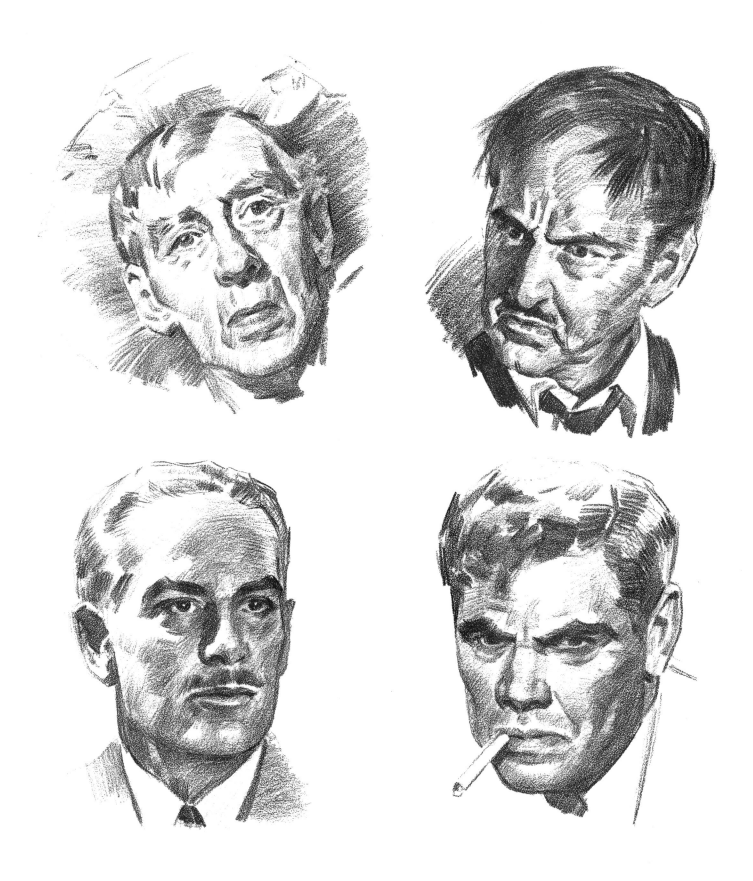

PLATE 39. Characterization

Here construction, lighting, and expression are combined. This is characterization, the way a face looks at a given moment. Expression is really no more than a distortion of the relaxed forms of the face. Such distortion causes movement in the muscles below and consequent change on the surface. Therefore it is important to know how those muscles move (see Plate 21).

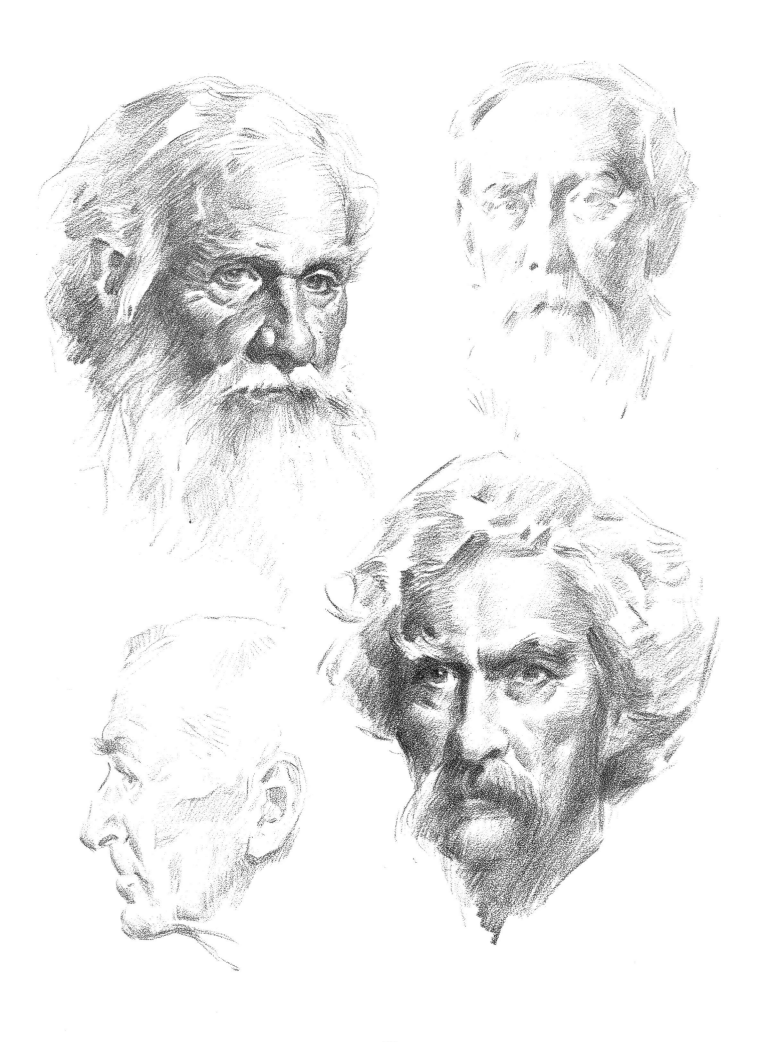

71

Part Two: Women's Heads

Part Two: Women's Heads

IN AMERICAN ADVERTISING and magazine illustration the ability to draw women's heads effectively is the greatest boon to the pocketbook. While commercial art has many departments, no other is quite so lucrative. This skill opens the door of advertising agencies, editorial offices, and calendar producers as nothing else can. Portrait drawings are much easier to sell than finished paintings, since the price is much lower. Drawings, nicely framed, can be hung anywhere in the house, while painted portraits are more or less restricted to the space over the living-room mantelpiece. A man often prefers a nicely done drawing of himself or his wife or children to an elaborate painting. Fortunately, the artist can make such drawings inexpensively, in much less time than a painting takes, and he can well afford to keep his price within the normal family budget. There are possibilities in portrait drawing which should not be overlooked. It is pleasant work. It can be part-time work, and it is remunerative. If you do studies for one family, others become interested. Such studies make attractive pictures for dens, halls, offices, and other places where furnishings are not elaborate. There is hardly a mother who would not like to have sketches of her children. There are many artists in this country already doing very well at making portrait drawings. The prices usually range from $50 to $150 and even higher, which is not too bad for a few hours' work. These sketches may even be done from camera studies with the personal ability and knowledge added to the photographic appearance.

When you are drawing women's heads, be sure to use freedom and looseness of technique in representing the hair. Usually simple planes are much more effective than the photographic representation of every strand or curl. Another important quality, which I have pointed out earlier, is a blocky effect. The camera sees everything in its roundness; the artist sees its rhythms and its angles.

For some reason a little masculinity is much more tolerable in a woman's head than roundness and femininity is in a man's. The fashion experts seem to pick the lean-faced, angular-jawed, and bony types of models oftener than the purely feminine types. It may be that to get the rest of the figure slim enough to go on a fashion page, a bony face is required. Somehow the appearance of bone in the face does seem to give more character to a woman, just as it does to a man. Perhaps most of us admire leanness more than plumpness because leanness is hard to attain and keep. At least in that we have changed since the days of the old masters.

All this means that in drawing women we still must be conscious of planes, even if we do not stress them as much as we do in drawing men. Plate 42 shows a man's head contrasted with a woman's head in the same pose. Note that the feeling of planes is evident in both, but more stressed in the man's head. Note also that the handling of the mouth and nose is more delicate in the drawing of the woman than in that of the man. If I do nothing else here I want to impress on you that smoothness and roundness are basically associated with the female, and squareness or angularity with the male. The degree to which you emphasize the one or the other in either case is determined by personal feeling about your subject. Plate 44 demonstrates how blockiness may be applied to women's heads.

Plates 45 and 46 are technical examples of women's heads which you may find of some interest. Plates 47 and 48 are sketches in which both roundness and squareness have been felt. I suggest that you make a great many sketches of this kind from life and from the wealth of material provided in magazines.

Plates 49 and 50 deal with the characteristics of aging. Drawings of elderly women are the one place where fat seems permissible. Everyone loves a plump grandma.

It is in drawing older women that your knowledge of anatomy is most evident. Younger women strive to keep the anatomy of the face pretty well covered up, and we please them most by doing the same in drawings. But sooner or later wrinkles and creases will come. We can subordinate the wrinkles, but we must take the forms very much into consideration. New forms have developed in the cheeks; indications of the way the muscles are attached in and under the flesh have begun to show through. Bone comes to the surface, for it is no longer so firmly covered by flesh. Pockets form between the mus-

cles for the same reason. Soft flesh stands out in little lumps and begins to drape somewhat toward the chin. We can be kind about it and not put too much emphasis on the aging process, but to ignore it entirely would be to lose both character and likeness. There is beauty in maturity and even in old age. By then character shines through, and there is no graciousness and charm greater than that of an elderly woman of character, who has put away most of the foibles and frivolities of youth. Be kind in your drawings, but do not fabricate. Insincere work does personal harm to your reputation, and that is more important to you than any single drawing of any face in the world. Study the aging process, be thoroughly familiar with what happens, and then treat it tenderly.

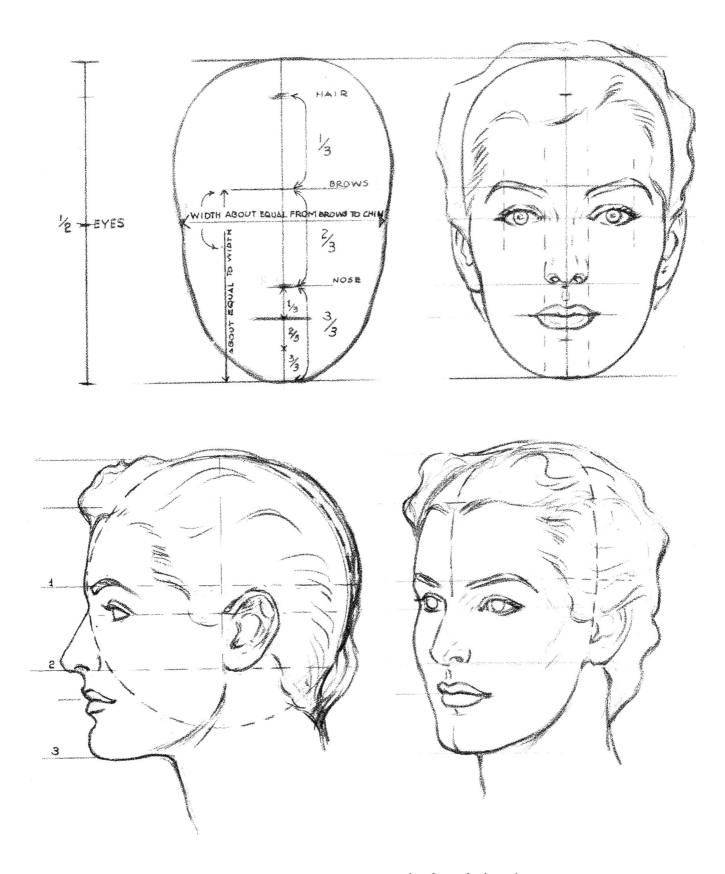

PLATE 40. Constructing the female head

The over-all proportions of the female head vary only slightly from those of the male head, but the bone and muscle structure is lighter and less prominent. In commercial art feminine types with rather firm jaws seem to have more appeal than do the very rounded. Women's eyebrows are usually a little higher above the eyes than men's are. The mouth is smaller; the lips are more full and rounded, and the eyes slightly larger. Do not stress the jaw and cheek muscles.

77

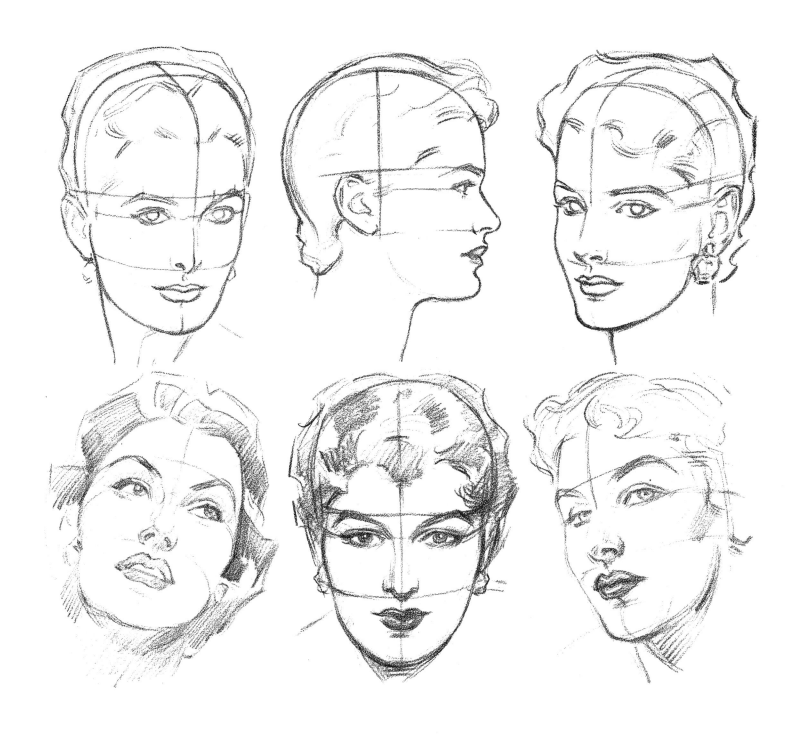

PLATE 41. Establish the construction of each head

It is almost impossible to draw a beautiful woman unless the construction and placement of features are accurate. Keep the nostrils small and watch carefully the placement of the jaw and ears. The eyes and mouth must be in perfect placement and drawing to avoid some very strange and unpleasant results. Just now the brows are left fairly thick. A few years back they were just a thin line. Personally, I like natural-looking brows, but brows and lips, since they are so often made up, follow the trends of fashion. The same is true of hair-dos. Look for the mass effect of forms in the hair rather than the detail. Beauty of face is beauty of proportion, so learn the proportions first; then study your subject individually. The fashion magazines contain quantities of material for study, and will also keep you up to date on make-up and hair styles. Be careful not to draw flat lips. Place the highlight on the lip very accurately; if it is in the wrong place it can change the mouth and the whole expression.

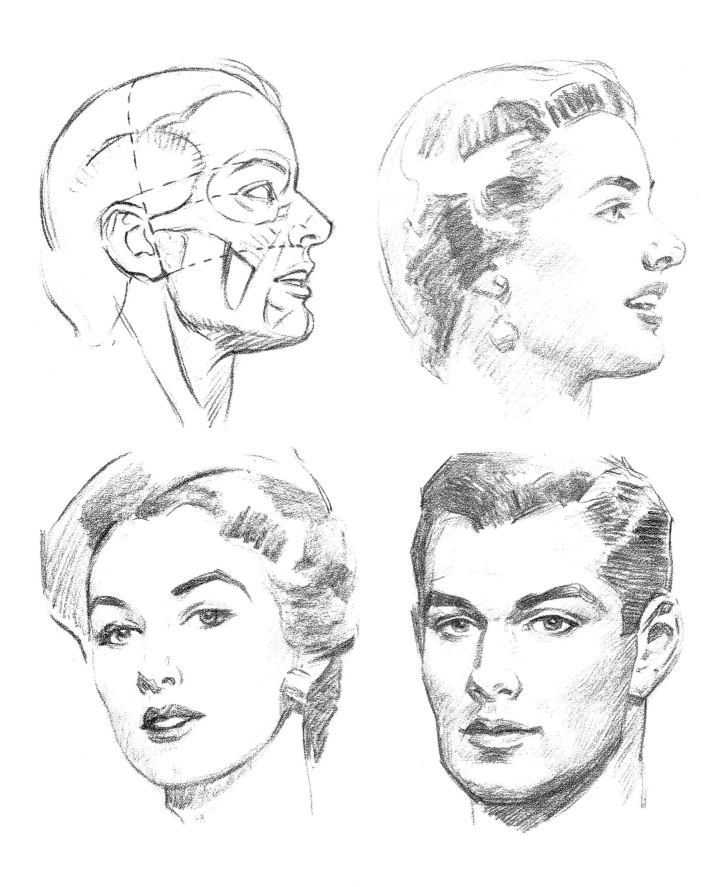

PLATE 42. Bone and muscle are less apparent in women's heads

The underlying anatomy of a girl's head is shown at the top of the page. In drawing a fairly young woman, we let very little of the anatomy show on the surface, though we must know what is underneath to make the surface convincing. At the bottom of the page a male and a female head are shown for direct comparison. Note the heavier bone and muscle construction and the more obvious planes in the male head.

PLATE 43. Charm lies in the basic drawing

80

PLATE 44. "Blockiness" also applies to women's heads

81

PLATE 45. Some girls' heads

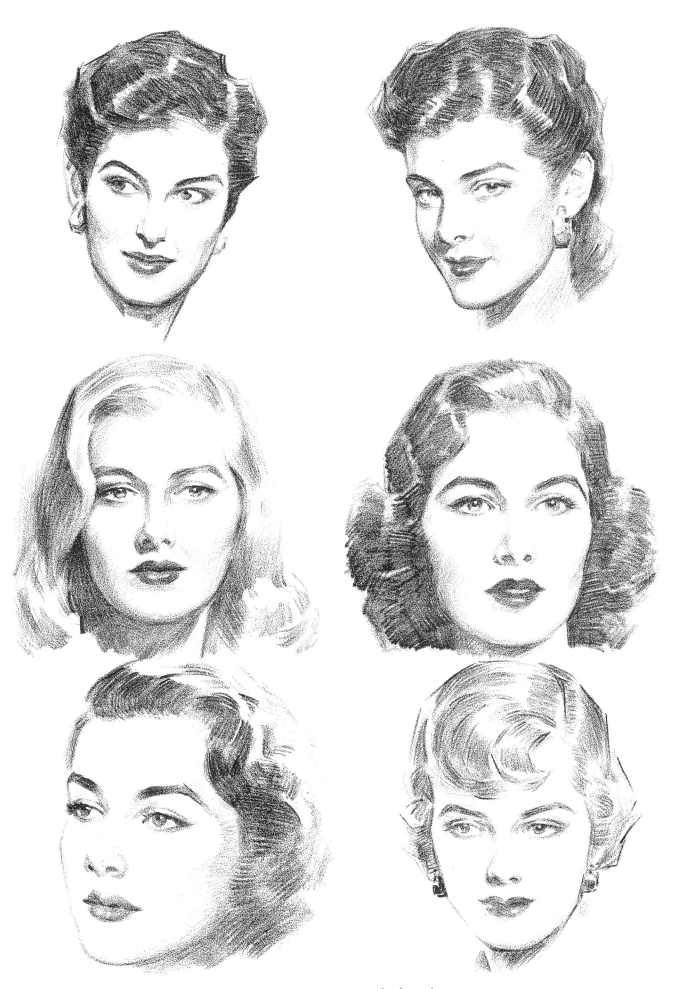

PLATE 46. More girls' heads

83

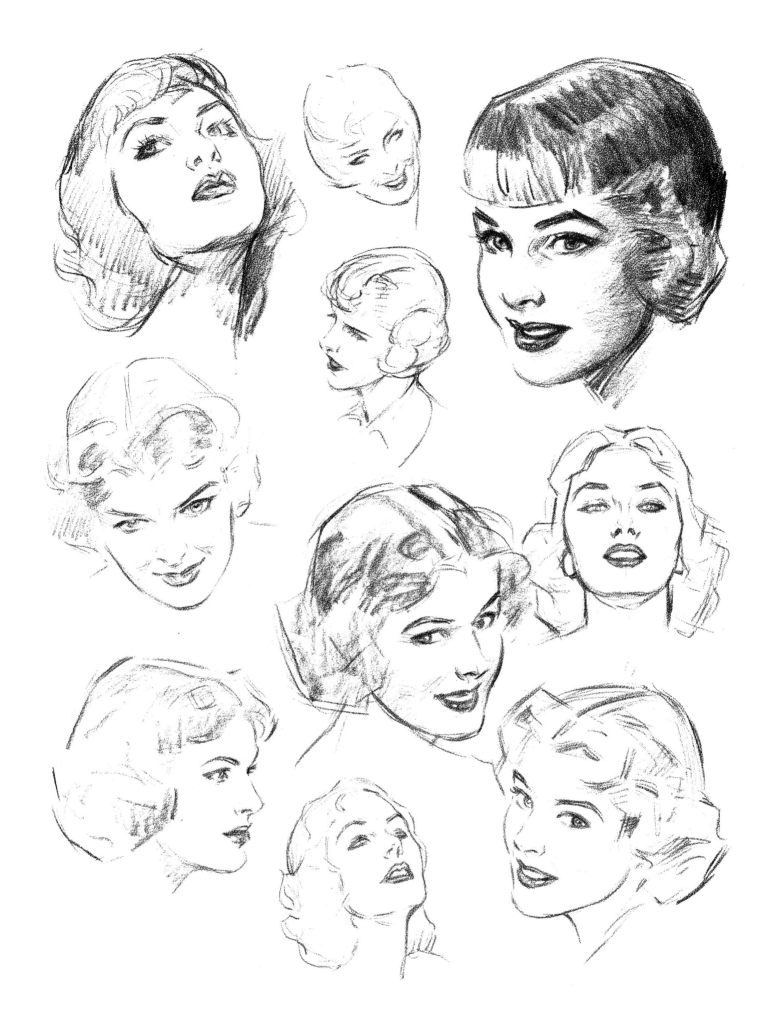

PLATE 47. Sketches

84

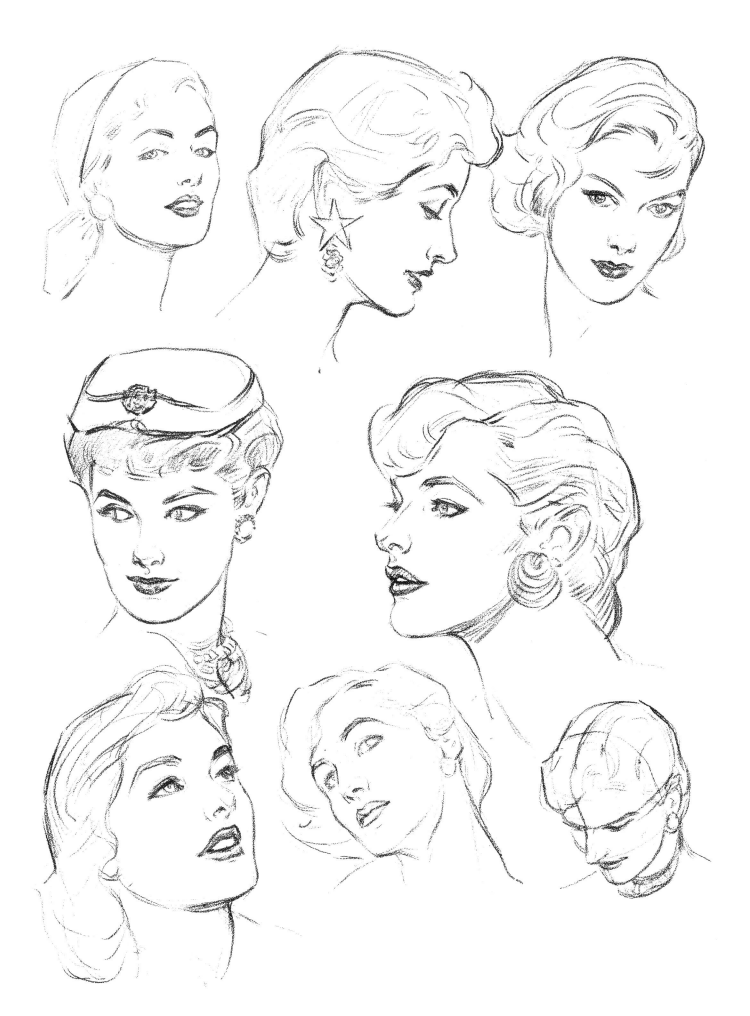

PLATE 48. Sketches

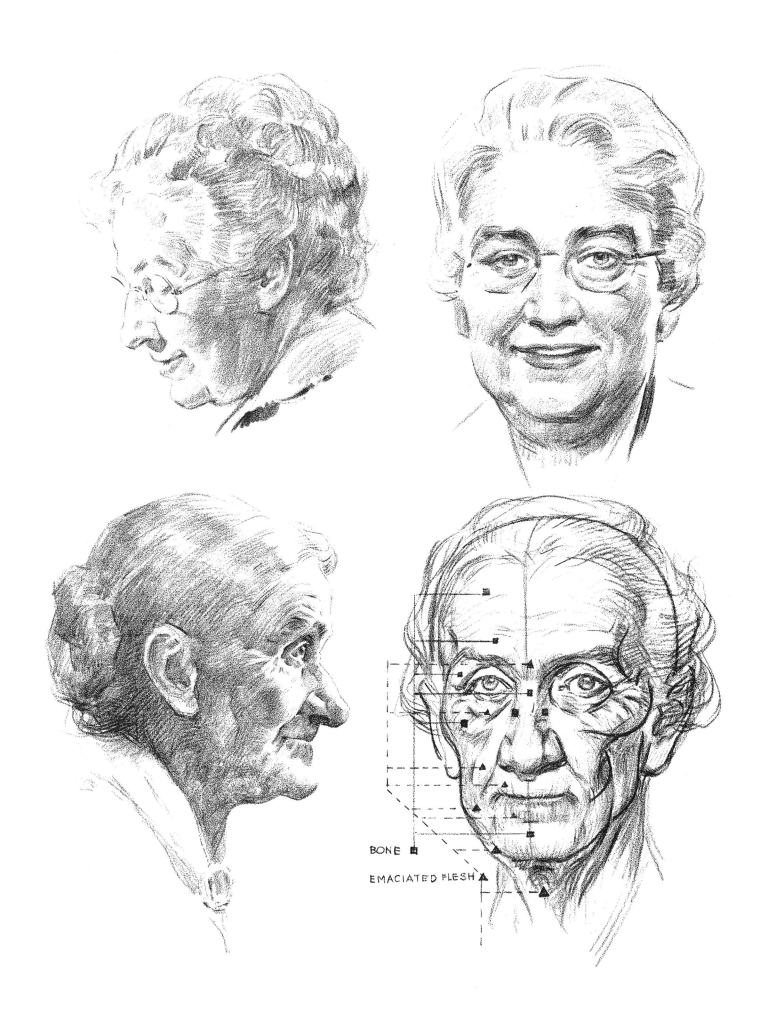

BONE ⊞

EMACIATED FLESH ▲

PLATE 49. Grandmothers

86

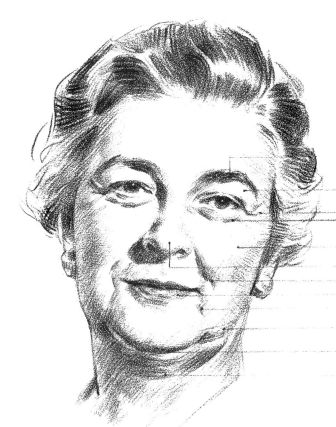

EYEBROWS LOSE SHARP DEFINITION

FLESH DROPS

PERMANENT CREASES FORM

STRUCTURE HERE STILL FIRM

NOSE LOSES SHARP DEFINITION OF CARTILAGE

PERMANENT CREASE FORMS

LIPS LOSE FULLNESS

SLIGHT CREASE FORMS

CHEEK DROPS WITH DEFINITE ACCENT

DEEP CREASE FORMS

FLESH DROOPS UNDER CHIN

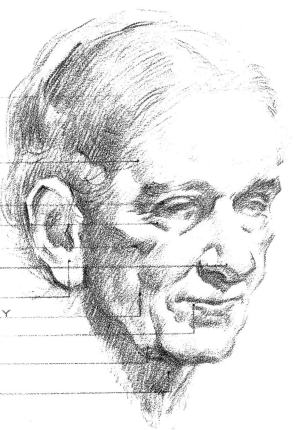

HAIR THINS OUT

TEMPLES DEEPEN

BONE OF EYESOCKET VERY EVIDENT

FORMATION OF POUCHES UNDER EYES

CHEEK BONES EVIDENT

NOSE BECOMES BULBOUS

EAR LOBES ENLARGE

CHEEK STRUCTURE LOSES VITALITY

LIPS BECOME THIN LINE

FLESH SAGS BELOW JAWBONE

NECK COMPLETELY EMACIATED

PLATE 50. The aging process

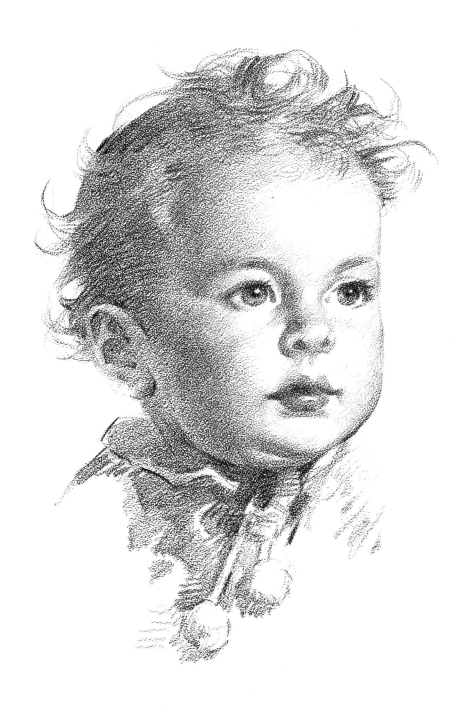

Part Three: Babies' Heads

Part Three: Babies' Heads

DRAWING BABIES is almost a branch of art in itself. Yet the illustrator and commercial artist may be called upon quite often to include them in his work. Babies also make particularly attractive pictures for framing; when they are well done, most families are delighted with them.

If the baby head is understood, it is really no harder to draw than any other head, and sometimes not as hard. The reason is that the artist is dealing much more with construction and proportion than with anatomy. The skull is important, as always, but the muscles are so deeply hidden that they hardly affect the surface. As Plates 51 and 52 show, the proportions are somewhat different from those in the adult head.

In the baby head the bone structure is not yet completely developed. The jawbone, cheekbones, and the bridge of the nose are relatively much smaller. This makes the baby face smaller in proportion to the skull, so that the face, from the brows down, only occupies about one-quarter of the whole area of the head. The cartilages of the nose are way ahead of the bone structure, so the little nose usually turns up, because the bridge above it is rounded and close to the plane of the face. The upper lip is longer, and the chin, being undeveloped, usually recedes or is well under the lips.

Only the iris of the eye is fully developed, which makes the eyes appear large and buttony. They appear to be farther apart than the average adult's eyes because they rest in a smaller head. Eyes set too close together are unpleasant in a baby face and can spoil a drawing. A baby's head can best be studied when the baby is sleeping. Otherwise we must turn to photographs or magazine illustrations. Babies are bound to wriggle and there is nothing that we can do about it. It is therefore of great importance to fix the general or average proportions in your memory.

You will find that a certain blockiness of planes and edges also helps to put vitality into a drawing of a baby. Babies' faces are so smooth and so round that if we copy that quality too meticulously the final effect may lack character.

If you are disturbed by seeing edges of planes in a drawing of a baby face it is probably because you are too close to your drawing. Step back before you change it. Maude Tousey Fangel, one of the greatest baby artists, draws quite vigorously in angles and planes. Mary Cassatt, the Impressionist painter and student of Degas, also had this quality in her work.

Plate 53 shows that the general shape of the baby's head is a bulge attached to a round ball. The distances up and down between the features are relatively short, and the face seems quite wide. The first build-up of the basic shape should have that cute baby look.

In the sketches in Plate 54, the eyes rest in the lower half of the first quarter division. The top line is the line of the brows; the nose rests on the line of the second division; the corners of the lips on the third; and the chin drops slightly below the line of the fourth division.

Plate 58 shows the four divisions for children three to four years old. Note that the brows are a little above the top line, and the nose, eyes, and mouth have been raised above the division lines. These changes make the baby look slightly older. Actually, we have allowed a little more chin and thereby lengthened the face slightly. Plates 55, 56, and 57 show a number of baby heads, all drawn with the foregoing proportions, but differing a little in character as a result of slight differences in the placement of features and the relationship of the face to the skull. Though the proportions vary only slightly, babies' skulls may differ considerably in shape. We find high, low, or elongated skulls in babies as well as in adults.

91

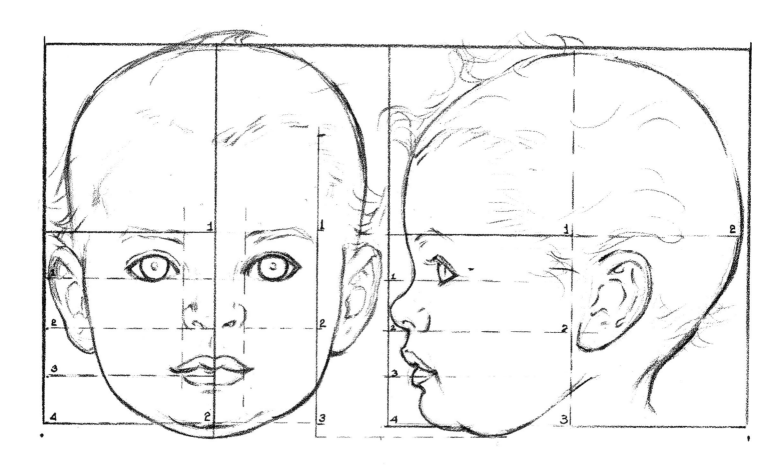

PLATE 51. Proportions of the baby head—first year

Changes in the infant skull take place very rapidly from the moment of birth through the first year or two. It is in the infant stage that the skull takes shape. The original shape may be due to prenatal pressures and the degree of hardness of the bone. After birth the bone tends to adjust to the conditions imposed upon it, the growth of the brain, the closing of the sections of the skull at the top of the cranium, which nature left open and pliable to facilitate birth. Racial skull types are inherited, but the individual type can be purely a matter of circumstance.

In the baby the cranium is much larger in proportion to the face than it is in the adult. The face to the brows occupies about one-fourth of the whole head. This sets the eyes below the halfway point. The most convenient way to set up the baby face is in quarter points. The nose, the corners of the mouth, and the chin come much closer to falling on these points.

As the baby head develops, the face gets longer in proportion to the cranium, which has the effect of moving the eyes and brows upward in the head. Actually, the development of the lower jaw brings that downward, and the nose and upper jaw also lengthen. As a result of these changes the eyes of an adult, and even of a teen-ager, are on the middle line of the head. It is most important to know this, because the setting of the eyes in relation to the middle line across the face is the direct way to establish the age of a child. The iris is fully developed in the baby, and will never get any larger; consequently the eyes look much smaller in the adult face. However, the opening between the eyelids does widen, so that we see more of the eyeball in an adult than we do in a baby.

92

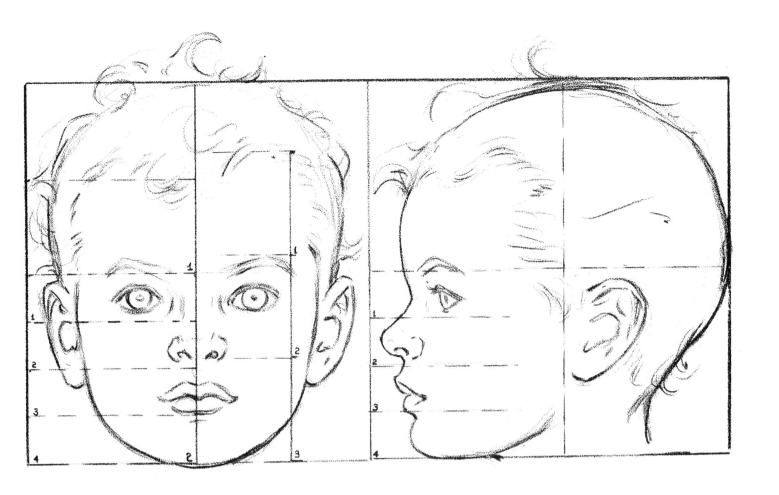

PLATE 52. Proportions of the baby head—second and third years

By the second and third year the eyes are about halfway up the top quarter space, which I have designated the number 1 space. The nose and mouth also appear to have moved up, and the brows now appear to be above the halfway line. Now the lips just touch the bottom of the third space. The ear has not reached the halfway line. However, the face has reached the proportions of three spaces: hairline to brow, brow to bottom of nose, bottom of nose to bottom of chin. Actually these three spaces are still condensed, and each will grow further. But they maintain their proportions to one another while growing. The ear is still well below the middle crossline. Note the line divided into thirds in the right half of the first drawing.

When drawing babies and children it seems easier to maintain four divisions than to use the three divisions of an adult face. While the actual head is much smaller, the spaces between the features are proportionately wider. The eyes are wider apart; the upper lip is longer; the space from eye to ear appears very wide. You have to struggle with these proportions in order to make a baby look like a baby and not like a little old bald man. The baby mouth is more pursed when relaxed. The upper lip rises sharply to its peak and usually protrudes. The chin is small and well under, with often a little fat under it. Babies' ears vary a great deal, some being quite small and others quite large. They are usually rounder and appear thicker in comparison to the face. Babies' brows are usually light and thin or even quite transparent. They are usually much more evident in dark-haired children. The nose is usually small and upturned, and quite rounded. The bridge of the nose is fairly round since it has not had time to develop. The cheeks are extended and full.

93

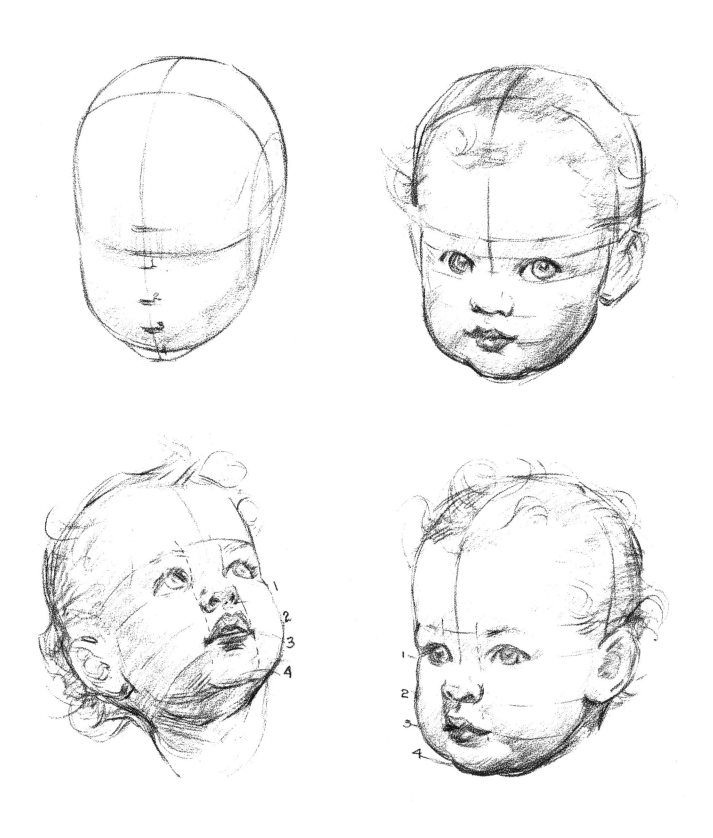

PLATE 53. Construction of the baby head

In drawing a very young baby, draw the ball and plane with the facial plane much shorter. Put the brows on the halfway line. Divide the face from the brows down into four parts. The eyes touch the bottom line of the top division. The nose touches the bottom line of the second division. The corners of the mouth fall on the bottom line of the third division, and the chin drops slightly below the fourth or bottom division. The ear is under the halfway line.

94

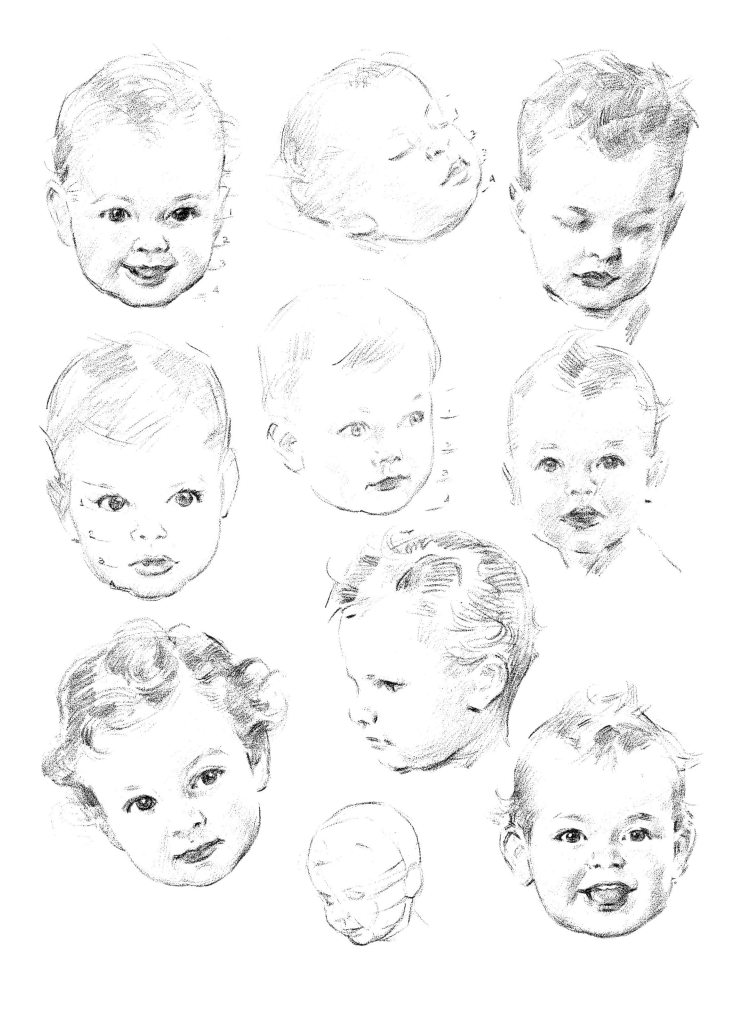

PLATE 54. Sketches of babies

95

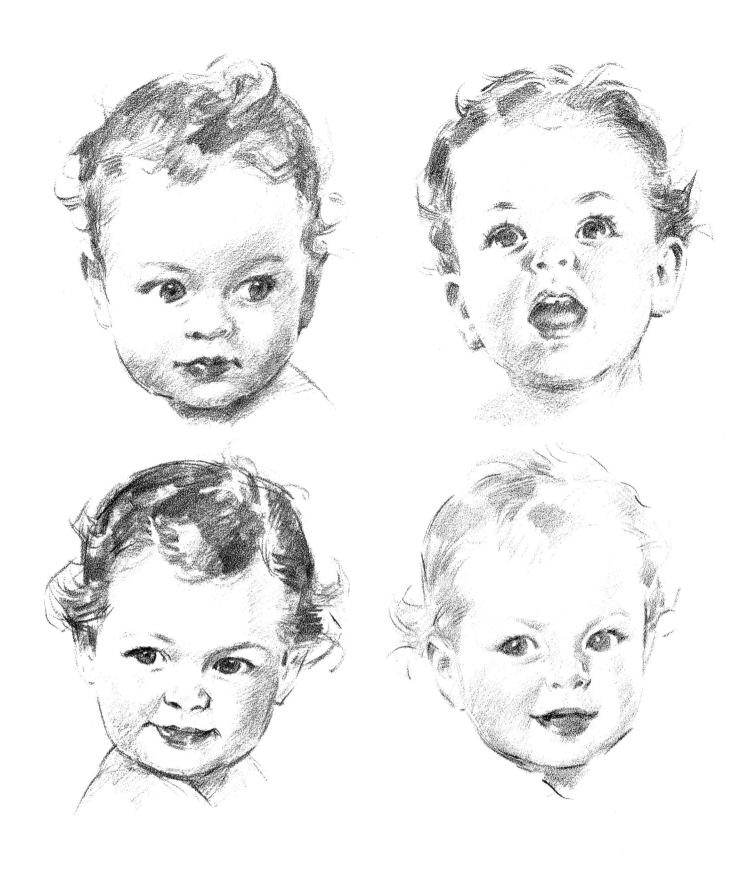

PLATE 55. Studies of babies

The magazines are full of baby pictures, and these are best to practice from, since no baby will hold still long enough for anyone who is not thoroughly familiar with baby proportions to draw from life. The best one can do is to make fast sketches. For this reason finished pictures of babies are usually drawn from photographs, as are the ones on this page.

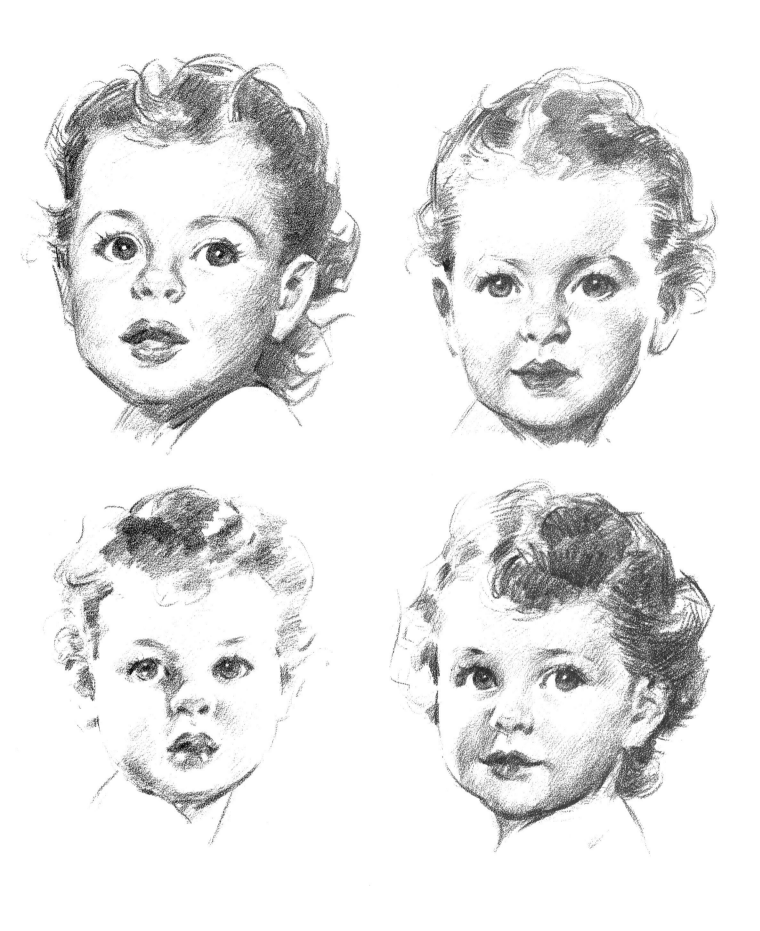

PLATE 56. More studies of babies

As babies grow more hair, they look older, although the proportions have changed only slightly. Some babies develop long eyelashes, which, with their already large and widely spaced eyes, give a great deal of appeal. Go easy on the eyebrows; keep them delicate.

97

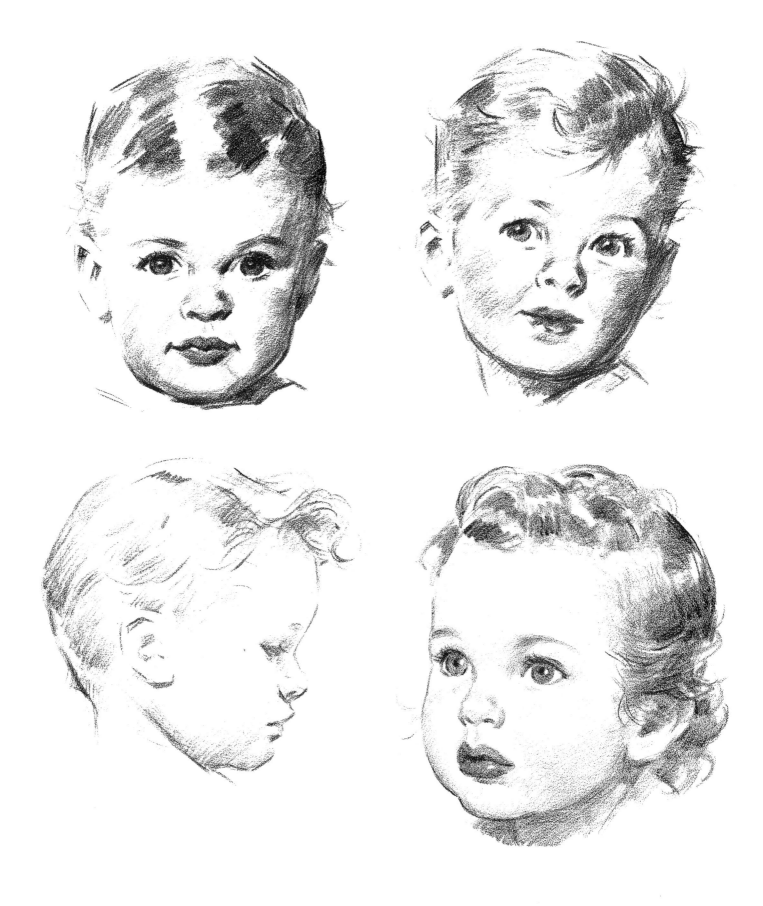

PLATE 57. Some more studies of babies

Remember to keep the bridge of the nose low and concave and the two little round nostrils rather widely spaced. Let the upper lip protrude when the baby is not smiling. Set the ears fairly low, and the chin round and well under. Keep the cheeks high and full. You will usually want to add light tone with a highlight.

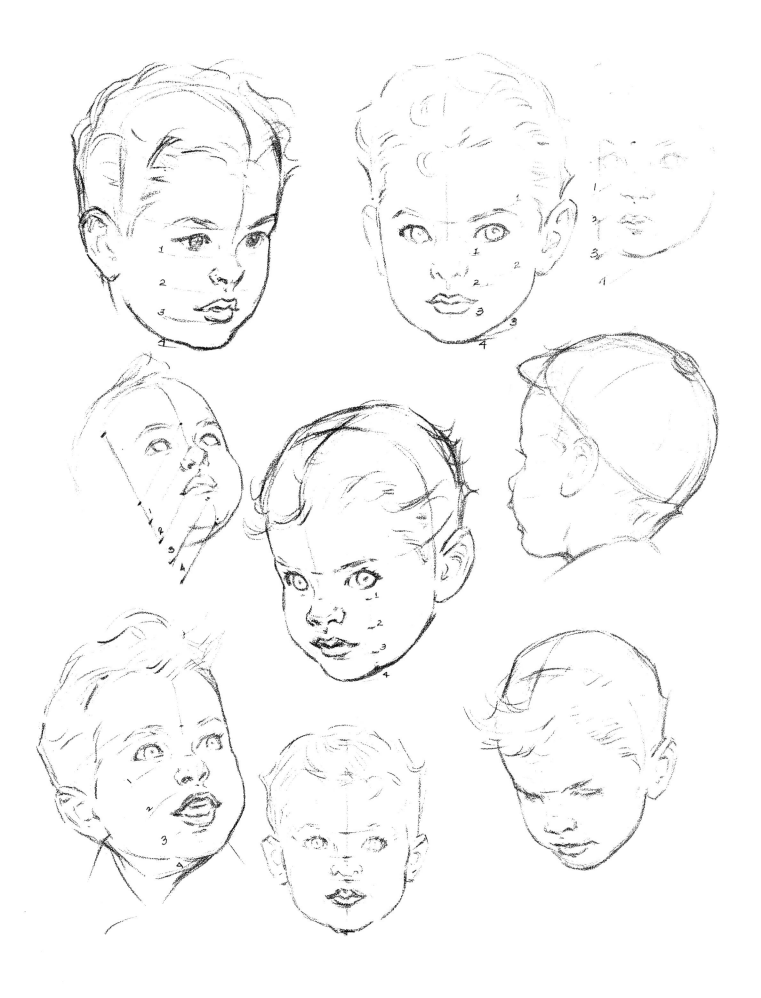

PLATE 58. The four divisions of the face—third and fourth years

99

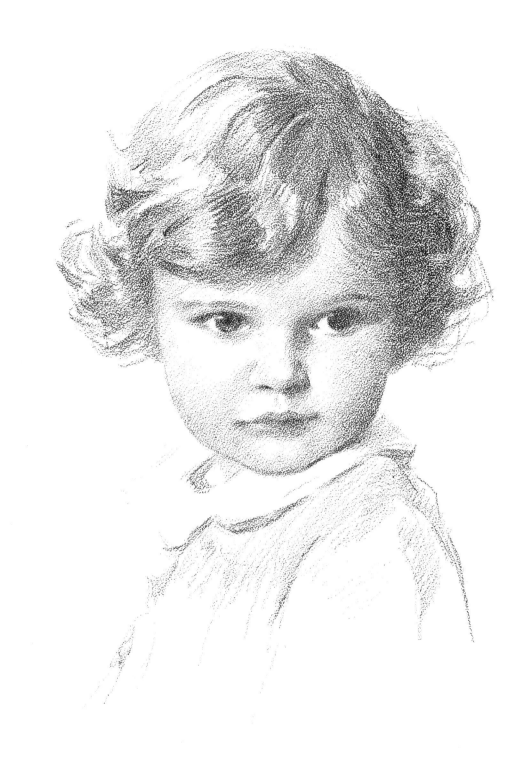

Part Four: Heads of Boys and Girls

I. SMALL CHILDREN

Part Four: Heads of Boys and Girls

I. SMALL CHILDREN

LET US UNDERSTAND that no branch of art can be reduced completely to a formula without endangering the very art that must go into it. We do, of course, seek ways and means to an end, and that end is correctness. Art, however, is not the justification of correctness. Art is not always perfection. Let us say that art is truly a form of expression, and full expression cannot be limited by formula, but only guided toward greater meaning and truth. African sculpture has expression and because of that it is art. It is certainly not truth as we know it, but it may be truth with a greater meaning as they know it. We may reach greater truth by simplification and even by subordinating minor truth. Detail may be minor truth but without real significance. Each hair in an eyebrow is detail and minor truth, but carries little significance. Each blade of grass is detail, but we may be more interested in the whole hillside and the effect of sunlight on it.

In drawing children, let us be guided as much by our feeling toward them as by rules of construction and anatomy. The light on a child's hair may be just as beautiful and intriguing as the light on the hillside. The glint of mischief in the eye of a young boy may really be what we are drawing, more than the perfect anatomical construction of that eye.

It is easy to become so absorbed in technicalities that we miss the purpose. The technical must be united to the spiritual, because technique without spirit is meaningless. But feeling cannot be conveyed without technique and the knowledge behind technique.

Every area of every drawing, painting, or any other expression of form should be a part of a whole design. The lights and shadows, the edges, the textures and materials may all be considered as much from the standpoint of design and arrangement as for any other quality. In drawing heads, the pattern of the hair, the shadows cast from the head, and the bit of clothing all offer opportunity for design. The lights and shadows on the face itself create design, good or bad, whether we are conscious of it or not. The whole head is a design of forms fitted together, and it is a masterpiece of design, functionally as well as artistically.

I speak of all this so that we may approach our subject with humility and appreciation of its wonders. To me there is nothing more beautiful or wonderful in the world than the head of a small child. Life has left no scars, no lines of anxiety and frustration; it is the new flower emanating from the bud, fresh and as yet almost untouched.

If children do not move you, it is perhaps a mistake to try to draw them. You cannot draw them effectively from too great an emotional distance. When joy goes out of your work, it is apt to bog down in pure technicality.

It happens that much of my own work has been concerned with drawing children, and the more I do it, the more I find to enjoy in it. I feel that there is a mountain of fascinating truth of which I have barely scratched the surface, and this comes after drawing and painting perhaps thousands of heads of adults. Drawing children has a vast and relatively unexploited commercial market. We need more drawings of children and fewer photographs, both in advertising and on our walls. The fact that children cannot sit still need not discourage you. You can trace from photographs and still raise the quality of your rendering beyond the purely photographic detail to a more artistic expression.

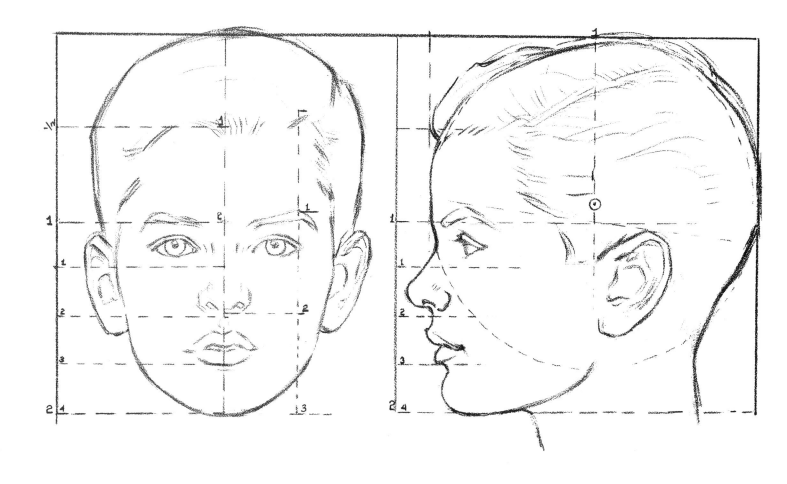

PLATE 59. Proportions of the little boy's head

In the small boy the up-and-down proportions are about the same as those in the older baby. But now the face is relatively narrower, coming well inside the square in the front view. The eyes appear smaller, because they do not grow and the face does. We can only use the large "button" eyes for very young children. The jaw and chin of the boy pictured above have started to grow, making the chin more prominent. The bridge of the nose is higher, and the nose is a little longer, almost touching the bottom of the second quarter. The lips touch the bottom line of the third quarter. At a fairly early age a full shock of hair grows. This accentuates the large cranium but keeps the face looking small and adds to the cuteness of the child. If a child has curly hair, mothers sometimes let the hair grow until it begins to look grotesque. So it is well to know where the cranium really is.

It is hard for little boys to sit still; in drawing them, as in drawing babies, practice from photographs and clippings. Note that the ear is coming up to the halfway line. Little boys' heads seem to extend far back because the neck is small and the muscles which attach to the base of the skull are not yet developed.

Notice particularly that the nostrils have grown and the upper lip appears to be somewhat shorter. The ear grows considerably during this period and the one which follows. I believe the ear is fully developed by the time the child is ten or twelve. The space from the nose to the ear still appears quite wide. Lashes are quite long. The hair grows quite well over the temples.

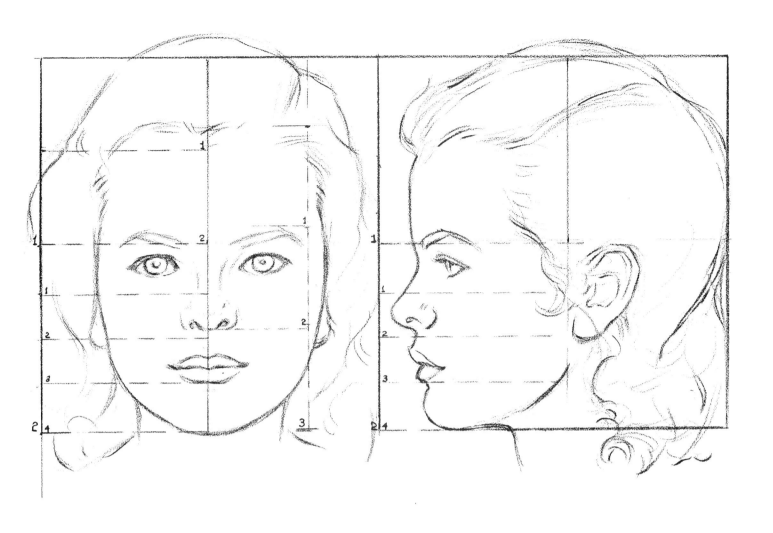

PLATE 60. Proportions of the little girl's head

The proportions of the head are practically the same in little girls as in little boys. Little girls are characteristically wider at the eyes and the jaw and chin are rounder. Very often the crease of the upper lid hardly shows over the eye. All the lines of contour are usually rounder in girls. Knowing this helps you make a little face more feminine; blocky or squarish forms give a little boy a more rugged look. In little girls the forehead tends to be higher at an earlier age than in boys. Some authorities claim that certain qualities of mentality develop faster in girls than in boys. This may account for the higher, wider forehead, I cannot say. I do know that a closer hairline makes a boy look more boyish, while a larger forehead makes a little girl look more girlish. The treatment of the hair helps greatly in drawing little girls.

Care should be taken not to draw the mouth too large on a little girl's face, or too black. This can easily give an adult look, or a theatrical effect not pleasant in children. The little girl's neck is round and small in proportion to the head. The crease between the neck and jaw seldom runs up to the ear but points below it. It is seldom sharply defined. The forehead may easily protrude a little at the top. The planes of the face are all well rounded, but to keep your drawing from looking too smooth and photographic, you can introduce a good deal of blockiness into the hair. The ear is more delicate in structure and it comes up to the half-way line. The brows should also be kept delicate.

105

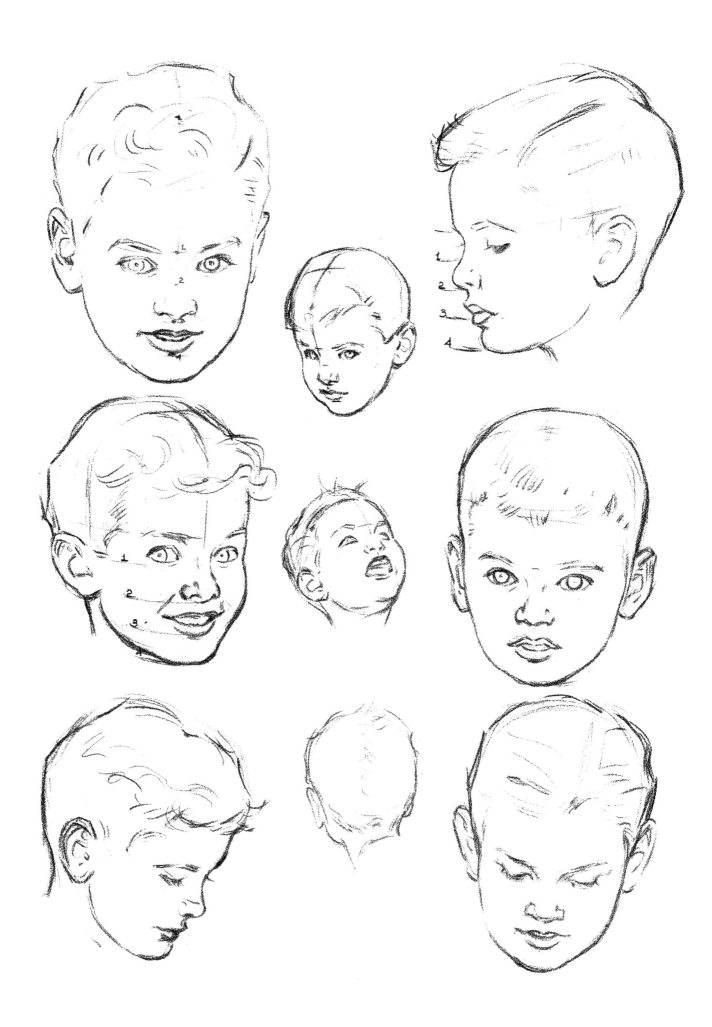

PLATE 61. Construction of the little boy's head

106

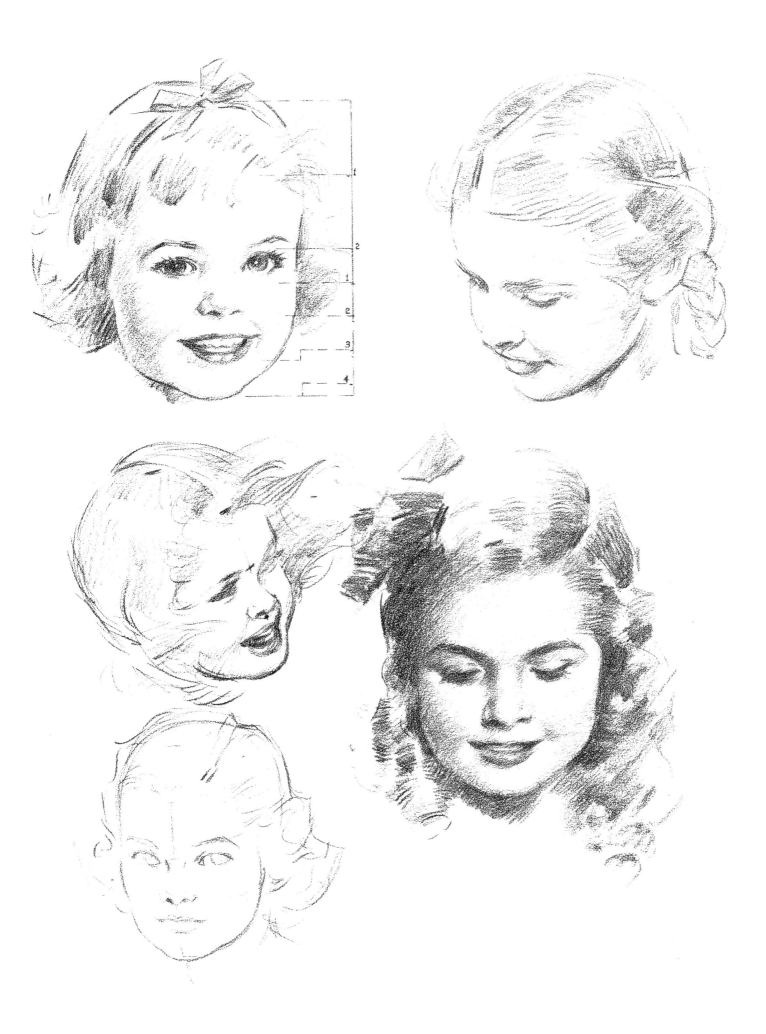

PLATE 62. Construction of the little girl's head

107

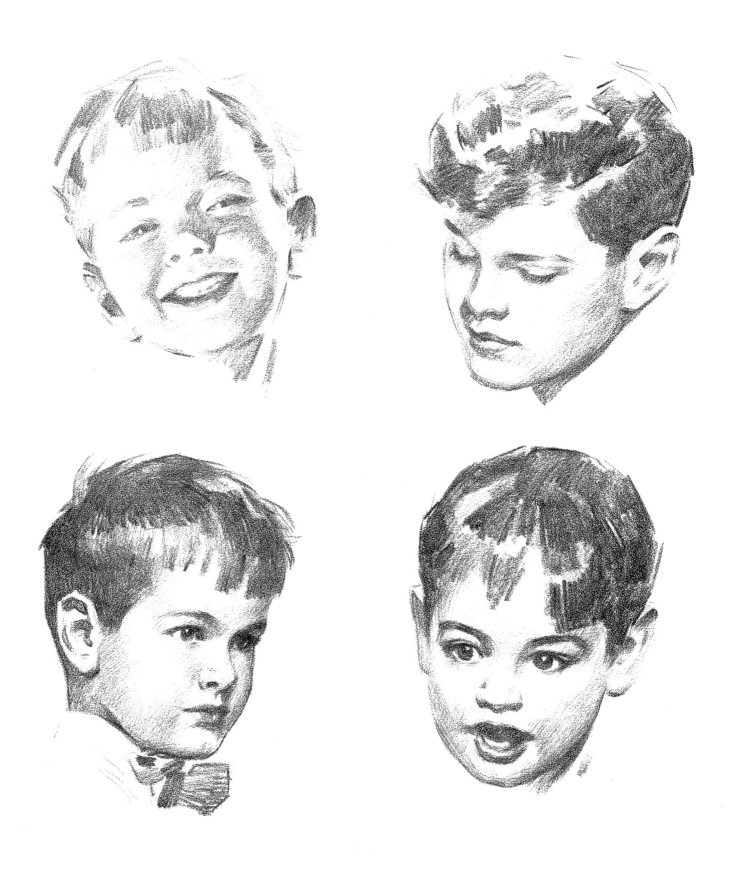

PLATE 63. Studies of little boys

Sometimes back lighting or rear top lighting is effective in combination with front lighting in drawing heads. The important thing is not to allow two lights to fall on the same surface, because this type of lighting cuts the area into crisscross shadows. Build up the hair in blocky forms.

108

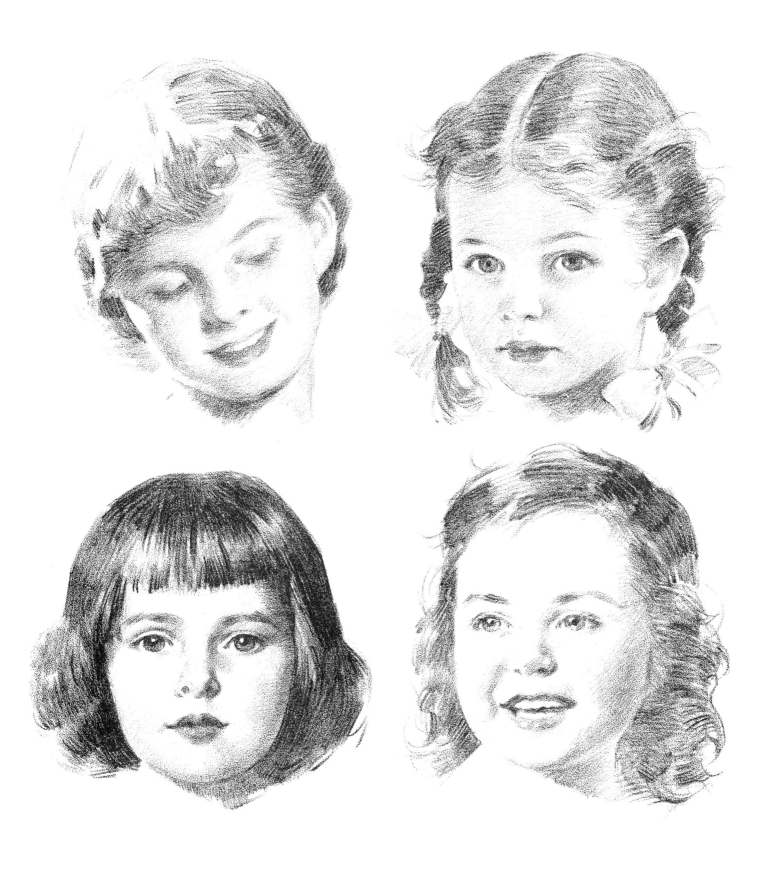

PLATE 64. Studies of little girls

The treatment of the hair has a lot to do with the appeal of a little girl's head. Little pigtails will probably never go out of style. Bangs also seem to be ever popular, and hair hanging loose or in curls is always in evidence. In color drawings or paintings, a bit of color in a hair ribbon is always effective.

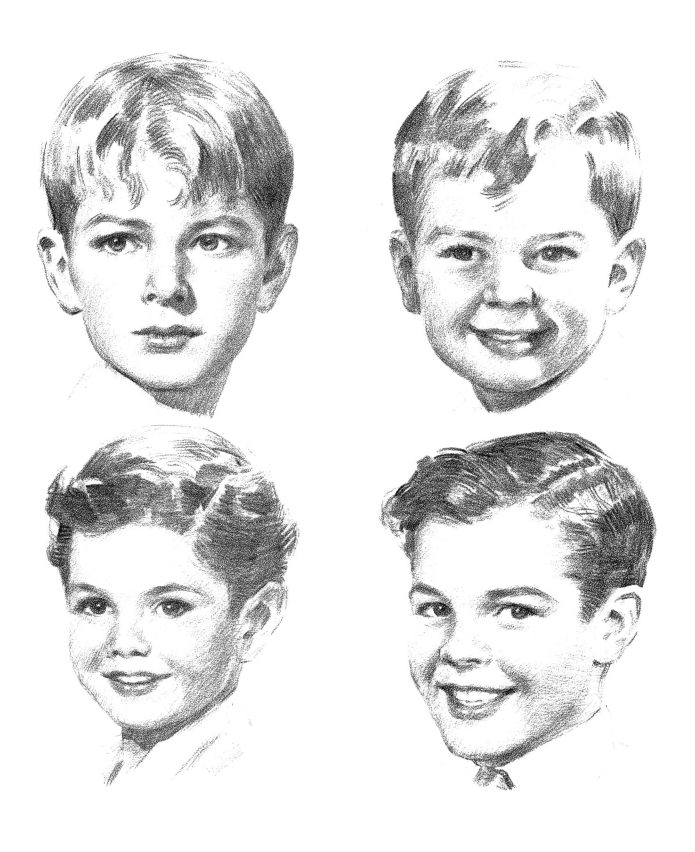

PLATE 65. More little boys

As one progresses in the drawing of children, he becomes impressed with the distinctive character and personalities he finds. Children register as many feelings and emotions as adults, and much more freely and obviously. As we grow older we learn to hide our real emotions, sometimes too deeply. Most children are much more truly themselves than adults are.

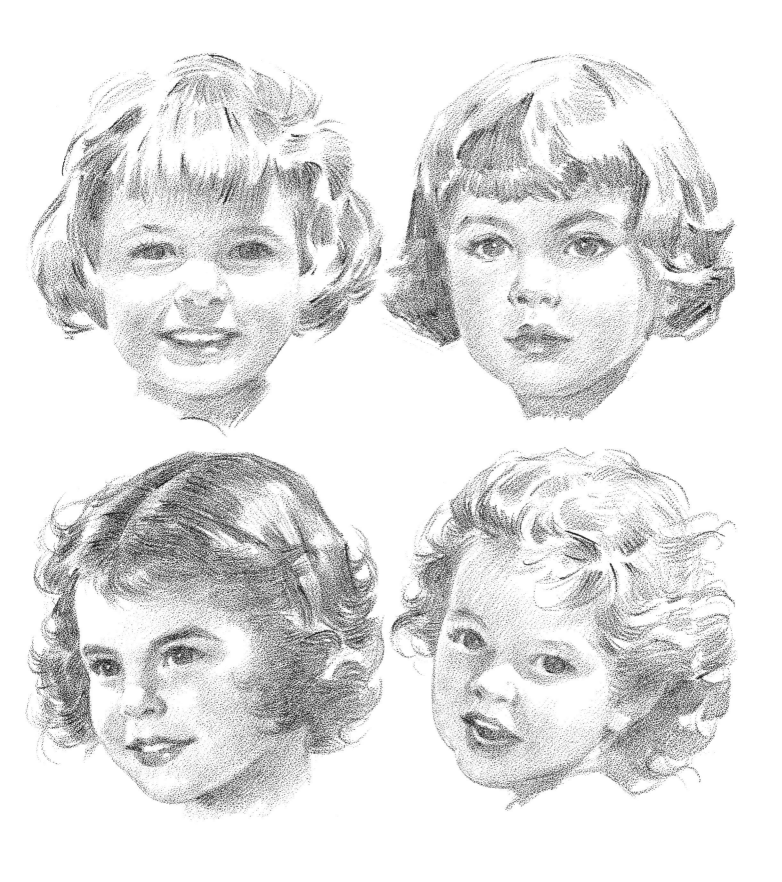

PLATE 66. More little girls

It is much easier to show a child's expression in a drawing if we catch it first with a camera. Their changes of expression are lightning fast, and no child should be asked to hold an expression.

111

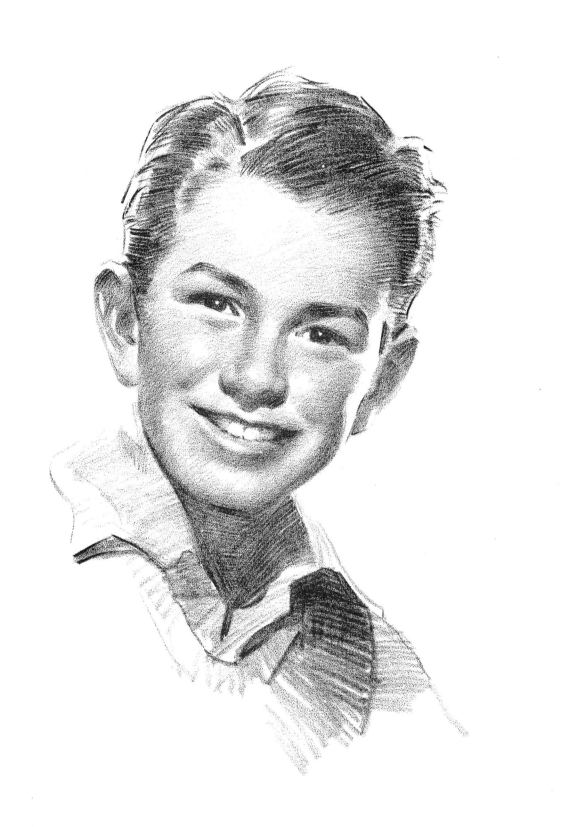

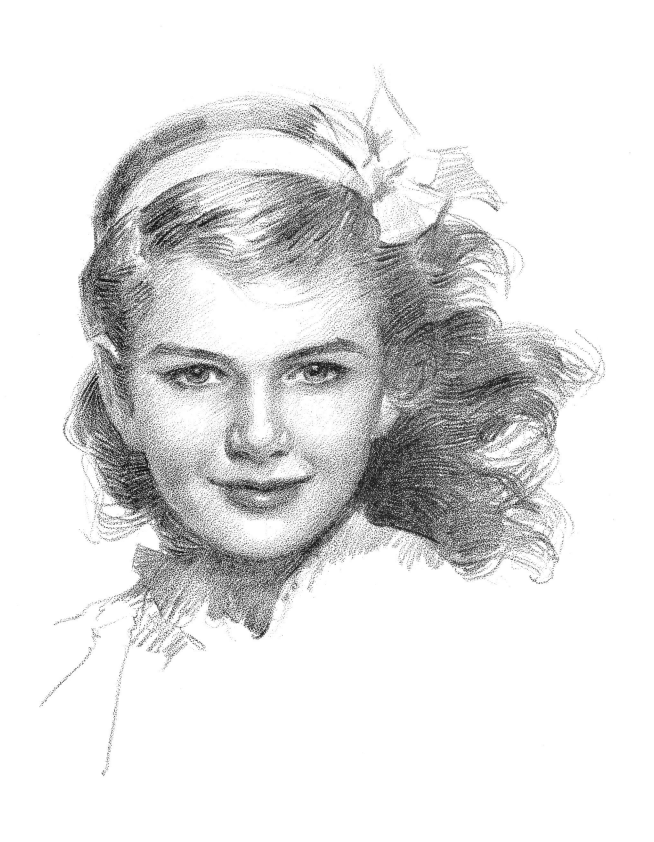

II. SCHOOL CHILDREN

II. SCHOOL CHILDREN

This section deals with children of the grammar-school age, or up to adolescence. That is the age of activity and rather gradual growth, before the spurt of growth that comes at the time of adolescence. It is also the age in which habit and character begin to be formed and to show in the face. We might also call it the age of mischief, because the energy cannot be confined to growth and overflows into physical activity.

It is most important to learn to draw children of this age with a smile—not only on the face you are drawing, but on your own face. Almost one hundred per cent of children in advertising must appear as both active and happy. On the other hand, a youngster's face can be particularly beautiful in repose. Sometimes you will wish that the editors and art directors appreciated this more often. At least when a story is touching, the child may be drawn without a grin. But in advertising, especially of foods, children have to be shown going into ecstasies over the product.

Children at this age live in a world of their own. Most of the time a little revolution seems to be going on inside them, against all the authority which is heaped upon them by parents and teachers and which they are not quite old enough to understand. Try to remember your own schooldays. When asked why you did this or that, you could hardly have answered, "Because I'm getting tired of so much authority." Sometimes adults find it hard to understand why

the effect of our authority slips off so easily, and the answer can only be that there is so much of it.

While we consider this the age of learning, we are likely to forget that much learning is gained by experiment, and not all by direction. All the wonders of invention are holding themselves out for inspection by the young. If your boy takes your alarm clock apart, or strews your pet tools out by the back fence, this comes under the head of experiment without direction, and you would have a dull boy if he didn't do a few of these things.

When drawing children, or even when photographing them, forget that you are grown up. Try hard to meet them in their own world, and draw them out. A child who is afraid of you or who shuts you out is not going to be himself, and so will not be a good model, if you are interested in conveying the spirit of childhood. That spirit lies in their faces only when they are free of authority. Watch their faces change when authority descends on them. I am not speaking against authority itself; I just mean that it does not photograph well, and resentment or sulkiness certainly does not make an attractive picture.

Since proportions have already been thoroughly discussed, you can learn from Plates 67 and 68 to apply them to the faces of school children. It is helpful to understand them, but merely to get them right is not the ultimate objective.

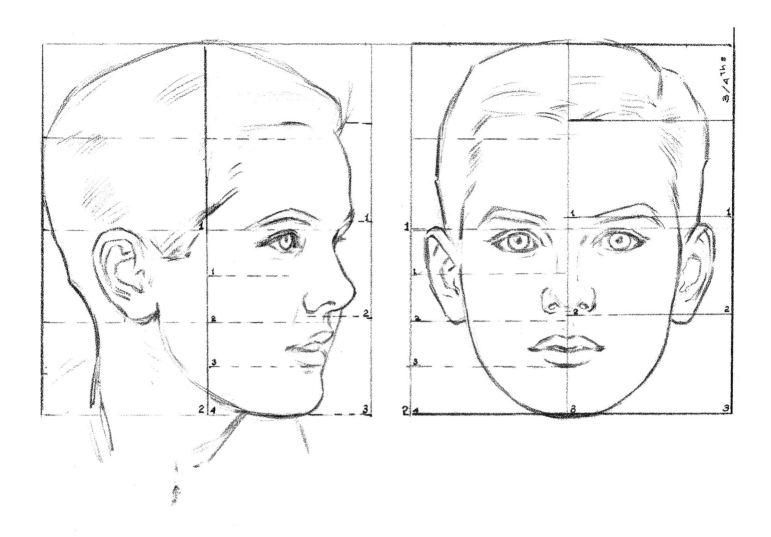

PLATE 67. Proportions of the schoolboy's head

Children between eight and twelve are more difficult to draw than either very young children or adults. The character of the head is pretty well established by this time, and some children have even taken on quite an adult look. But there is a trick to indicating this age group which is quite dependable. The eyes have moved up to touch the halfway line, and the space from the hairline to the top of the head is three-fourths of a unit instead of one-half unit as it is in the adult. In the adult the halfway line cuts through the middle of the eyes and out through the outer corners, while in the child approaching teen age the whole eye is below this line. The nose is still slightly above the second quarter division in the lower half of the face. The lower lip touches the line of the third quarter division.

In boys there is notable development in the ears. The mouth loses much of the baby look. The second teeth have replaced the baby teeth and the jaw has developed to accommodate them. The nostrils develop and the cartilages of the nose spread. The bone at the bridge of the nose develops a little more slowly, so many boys retain a turned-up nose until they are well into their teens.

This is the age of freckles. It is also the age of mischief and carefree happiness, as the expressions show. The hair is unruly; the front teeth look large. While the front of the jaw develops, the rear of the jaw at the corner below the ear does not develop until later. A large square jaw does more than any other feature to give a look of maturity. If you want to keep the face young, keep the corners of the jaw rounded.

116

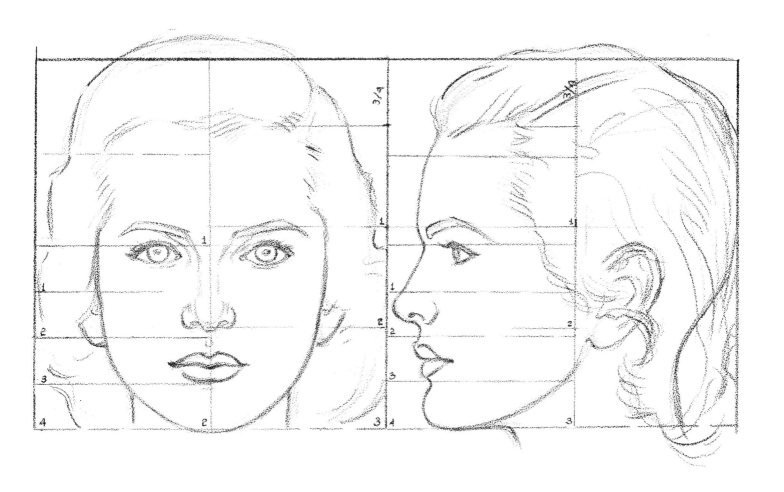

PLATE 68. Proportions of the schoolgirl's head

Young girls seem to mature faster than boys as far as facial character-
istics are concerned. Most girls acquire a fairly mature look quite early in
their teens. As I mentioned earlier, they usually have higher foreheads,
and the hairline is well up. The cheeks are rounder and there is often more
space in the front view between the corners of the eyes and the edges of
the face where the ears attach.

It must be remembered that here we are dealing with averages. There
are always variations and exceptions. Photographs of girls ten to twelve
years old often look more mature than the children actually look. Some-
times this is because we are seeing only the head and shoulders, and not
the head in association with the rest of the body. In a girl of thirteen or
fourteen the head is almost full grown, while the body is not.

Full lips are always appealing in the face of a young girl, and round-
ness rather than boniness. Girls as well as boys often have freckles at this
age, but do not overdo the freckles in drawing girls.

To draw heads of children of this age group well, you will have to
practice on a great many.

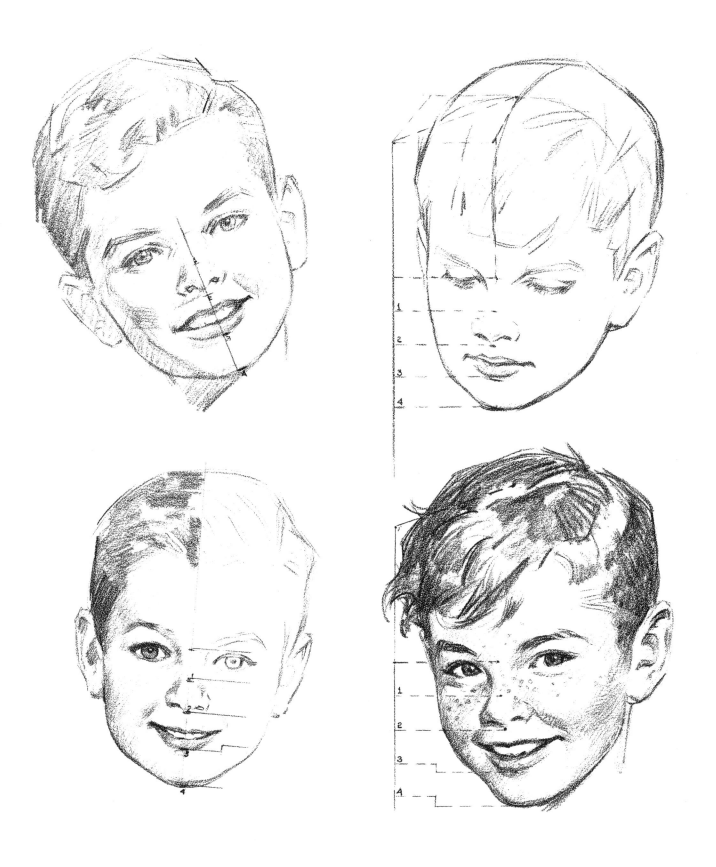

PLATE 69. The four divisions—schoolboys

If you plan to do advertising illustration, or are already in that field, you will find drawing growing boys and girls very remunerative. Practically all foods are advertised to mothers with growing children and the children appear in profusion in such advertising. You can practice from the heads here, or find others in the women's magazines that offer excellent practice.

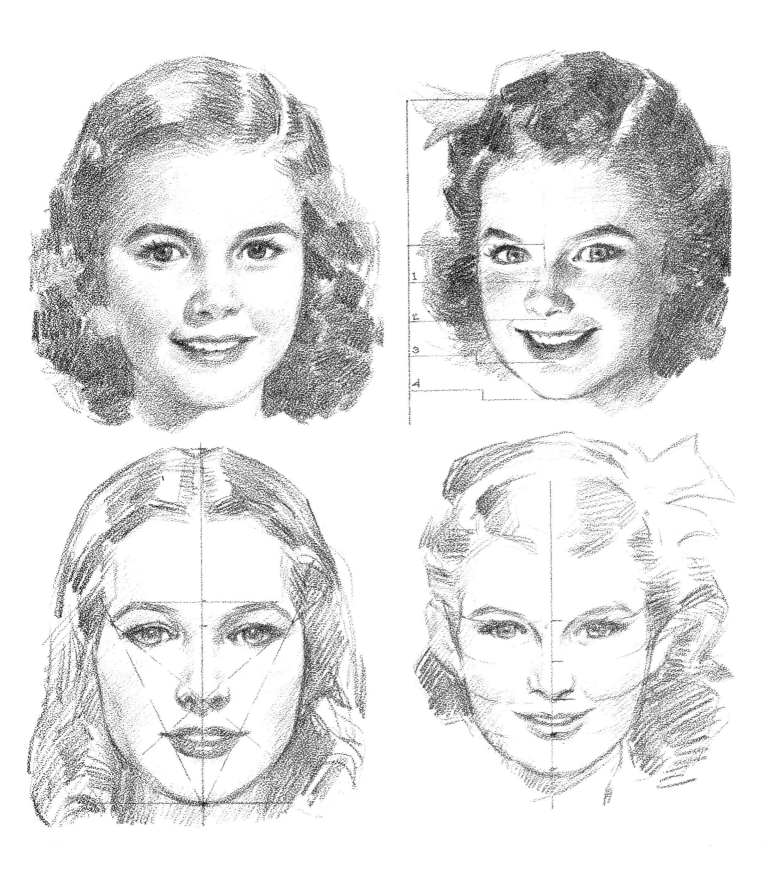

PLATE 70. The four divisions—schoolgirls

At the right, above, we have the usual quarter spacing. It is interesting and helpful to note how the diagonals cross in a young girl's head. The diagonals from the corners of the eyes through a point at the middle of the base of the nose also cut through the corners of the mouth; those from the outer ends of the brows cut through the corners of the mouth to a point at the base of the middle of the chin.

119

PLATE 71. Sketches of schoolboys

These heads have been left in outline since the outlines will probably be more helpful than the finished heads. There is a wideness to young faces that is more felt than measured. In drawing young people it is particularly important to trust your feelings. Once in a while a face will look older or younger than you intended no matter what you do. In that case the best thing to do is to try another subject.

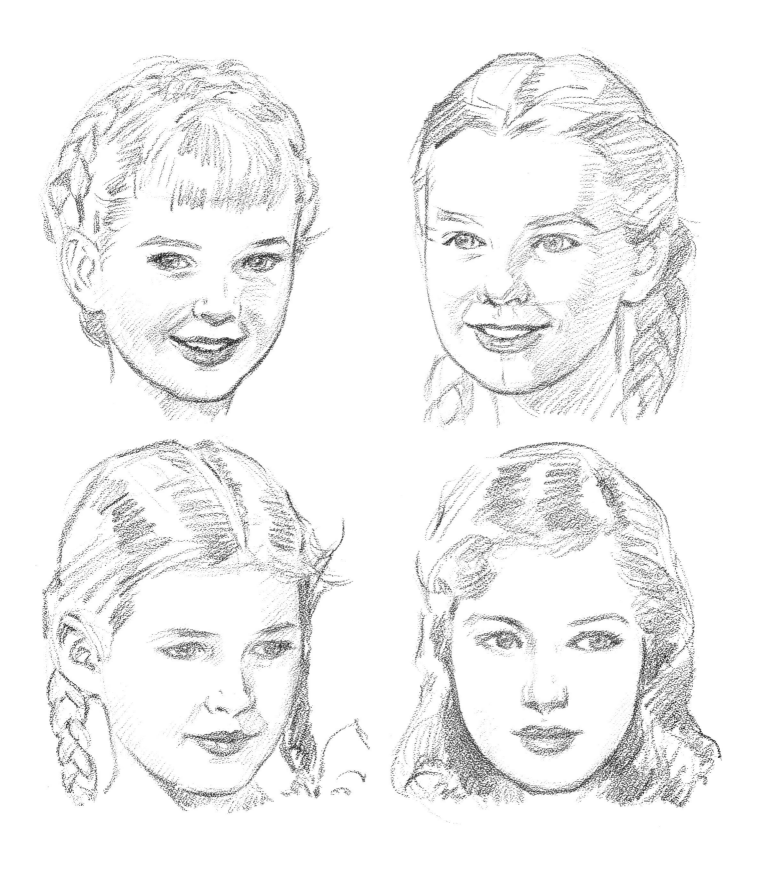

PLATE 72. Sketches of schoolgirls

Draw heads in outline until you are satisfied that the age and expression look right. There is no point in adding tone to a head that does not appeal to you. The tone can only build up the forms already established. If they are wrong, tone does little to help. Sometimes a head in outline may look better than one completely finished.

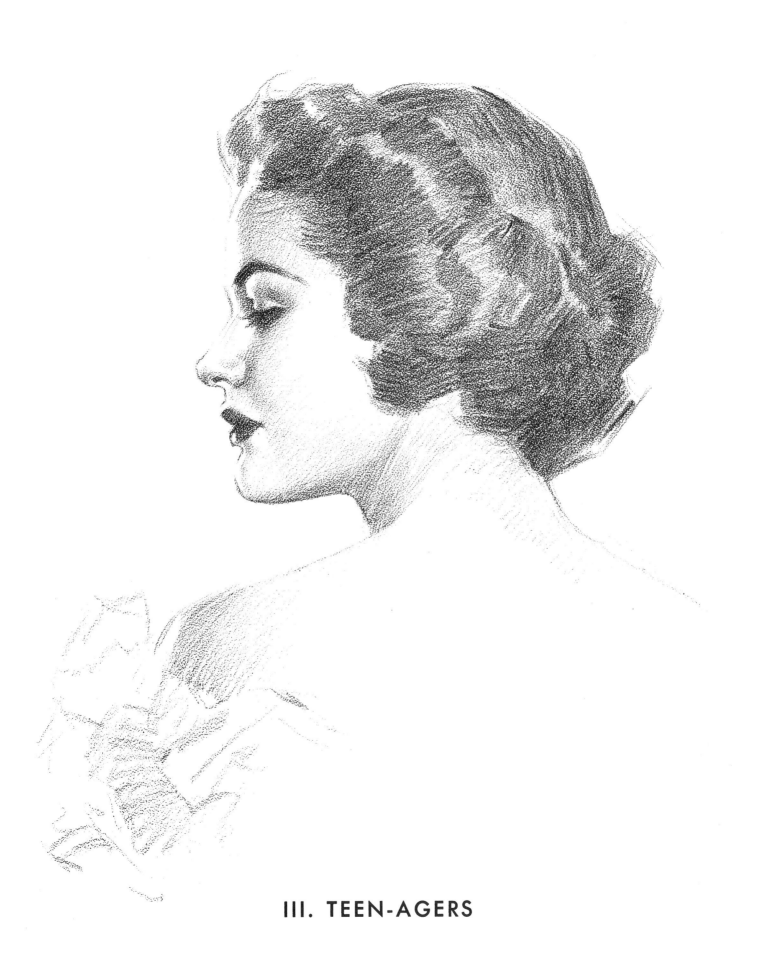

III. TEEN-AGERS

III. TEEN-AGERS

Teen-agers are popular subjects in fiction, advertising, and portraits. Since the proportions of the head are so nearly those of the adult head, we are almost back to where we started, but I hope with much more understanding.

In drawing teen-age boys and girls we must take into consideration the great variety of types. In boys, bony faces with well-marked muscles are associated with athletic types. The muscular activities contribute to a certain leanness. Some boys grow so fast they are robbed of some vitality; others simply do not lean toward athletics. Another type of teen-age boy has a round face, long legs and arms and large hands and feet, tends to drape himself over anything suitable to rest upon, and hates effort—especially home chores. As a rule, these boys develop more energy later when they attain full growth.

Since most teen-agers—girls as well as boys— are big eaters, if they do not exercise, they have a tendency toward fatness. Fortunately, they lose most of this excess weight in the spurt of energy that follows full growth.

Treat teen-agers with as much understanding as possible. Remember that this is the age of the first big heart throb, the age when the urge to be different from their elders comes out in every conceivable fad, in dress, hair-do, and personality. Study teen-agers closely to catch the spirit, for youth is elusive in more ways than one.

Now that we are completing our study of heads, you will find it rewarding to review parts of this book which might have given you trouble earlier. The new drawings should show great improvement over your first ones. You will find everything much easier, and will also have gained confidence from your practice work.

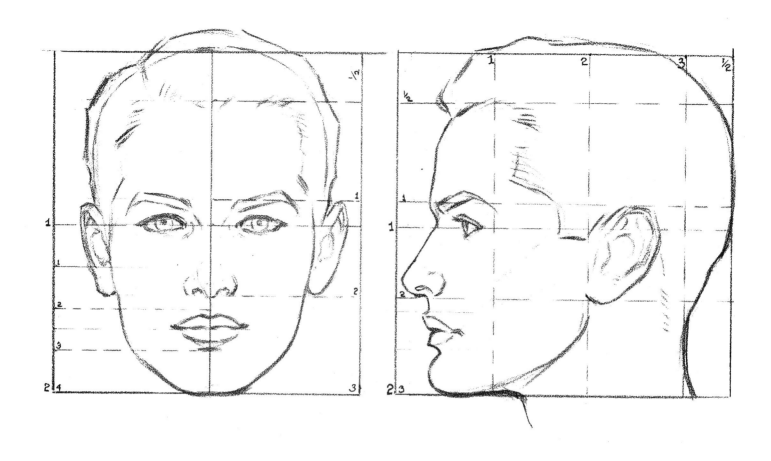

PLATE 73. Proportions of the teen-age boy's head

The proportions of the head in teen-agers are almost identical with adults; the difference is largely a matter of feeling. In boys the bone structure has become quite evident, though it should not be stressed as much as in men's heads. There are no noticeable lines. The flesh is firm and still inclined to smoothness. The cheeks are smooth without much definition of the muscles. The jaw has developed considerably in a short time. The bridge of the nose has taken permanent shape. As the jaw and cranium have grown, the ears appear smaller in relation to the whole head than they do in a little boy. The cartilage of the ear is now well defined; the ears have lost much of their roundness and taken on more angular lines.

The hair has moved back somewhat from the temples. The brows have definitely thickened. The lips are fully developed in size. The chin has come forward in permanent shape.

The only bone not fully developed is the corner of the jaw. This continues to develop, research shows, until the age of twenty or more. I suspect the cranium itself does not reach its maximum growth until full maturity, though further growth does not perceptibly affect the proportions of the head.

126

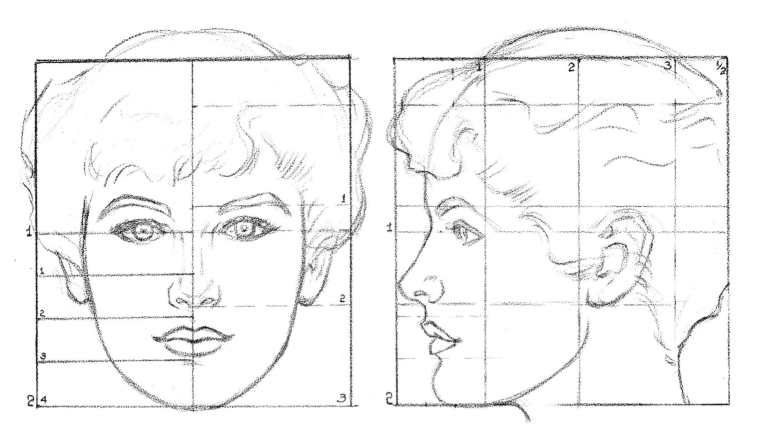

PLATE 74. Proportions of the teen-age girl's head

Sixteen is traditionally the perfect age for girls. By that time they have lost the gangliness of fast growth, and all is smooth, round, and fair. Now that girls also engage in athletics, their faces tend to show more muscle than did those of their mothers at the same age. But the predominating quality is youth—the faces are unlined, full of freshness and vigor.

These things are important in portraying young people, because the actual proportions of the face change very little from sixteen to sixty. The jaw in the girl may develop a little, but hardly enough to affect the drawing of the proportions much. That is why the artist must more or less "feel" the age he wishes to draw.

It is quite important to obtain good material to work from. Faking a drawing of a beautiful young American girl is a very difficult thing to do, until you have drawn a great many heads, and know the basic construction inside and out. I do not believe any of the outstanding artists proceed without adequate material to work from. Beauty, remember, is largely a matter of perfect proportions and perfect placement of features. The commercial illustrator will need to draw many pretty girls.

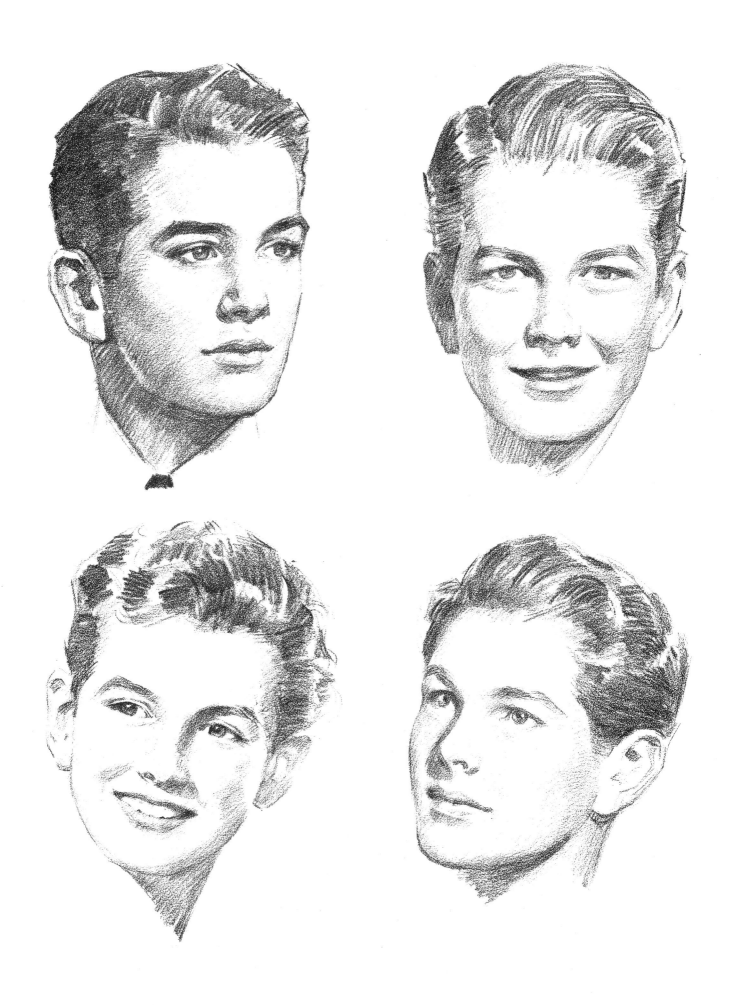

PLATE 75. Teen-age boys

128

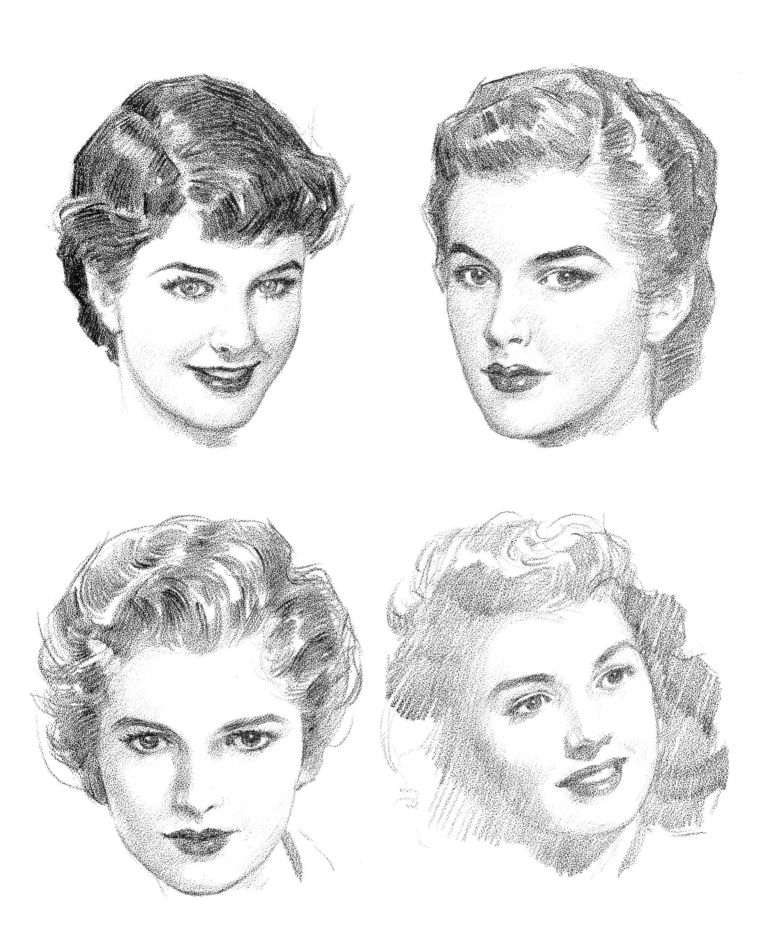

PLATE 76. Teen-age girls

129

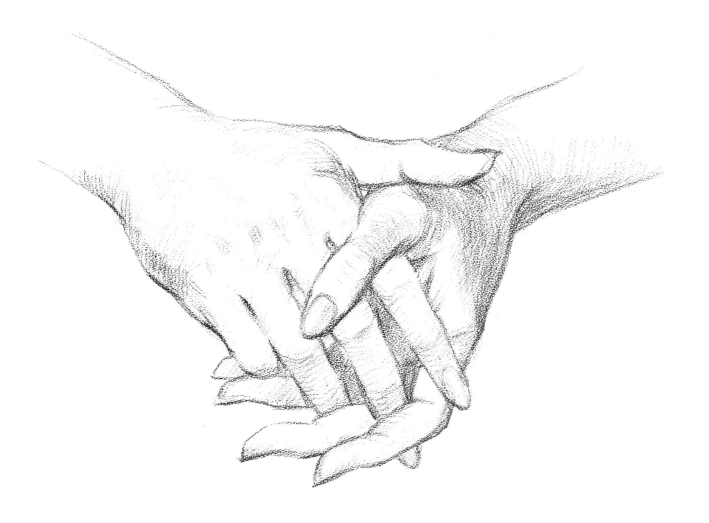

Part Five: Hands

Part Five: Hands

PERHAPS NO ASPECT of drawing is accompanied by more confusion and provided with less adequate material for study than is the drawing of hands. Much of the trouble is caused by searching for material instead of using the material you have available, because in your own two hands you have the best source of information available. Perhaps you have never thought about them in that light. Drawing of hands must be largely self-taught. All any instructor can do is point out the facts that lie right in your own hands.

The study of hands, aside from learning their anatomical construction, consists mainly of breaking down the measurements of various parts into comparisons. Fingers have a certain length in relation to the palm; spaces between the joints of the fingers are in definite proportion to the whole finger. The palm is so wide in comparison to the length. The distances between the knuckles on the back of the fingers are longer than those between the creases on the undersides. The length of the longest finger from its tip to the third knuckle in back is practically half the length of the back of the hand from fingertip to wrist. The thumb reaches nearly to the second joint of the first finger. The length of the hand is about equal to the length of the face from chin to hairline. You can make these comparative measurements as well as anyone else.

The hand is the most pliable and adjustable part of the whole anatomy; it can be made to fit around or grasp almost any shape within reasonable size or weight. This pliability is what causes difficulty for the artist, because the whole hand can assume countless different positions. Yet the mechanical principle by which the hands work remains constant. The palm, as a hollow, opens and closes, and the fingers fold inward toward the middle of the palm. The

nails are really a stiff backing for the tips of the fingers, as well as an extra edge for precise grasping. You pick up a pin with the fingertips; you pick up a hammer with the palm and fingers. The back of the hand is more or less rigid to the backward pressure of the fingers, as used in pushing. For adjustment to almost unlimited purposes, the hand is the most wonderful mechanism we know. In addition to its perfection as an instrument, it is perhaps more closely coordinated with the brain than any other part of the body is. Many of its movements are controlled by subconscious reflexes; examples are typing and playing the piano.

Man started to educate his hands long before he educated his brain in the cultural sense. The infant can use his hands effectively long before he can think. He will grasp a lighted match before he has learned that it will burn. The story of man's progress from prehistoric times must be closely associated with the adaptability of the human hand.

The fact that the hands and their movements require so little conscious thought may be one reason why so little thought is given to drawing them. Look now at your own hands; you will see them in a new light. Note how the hand automatically assumes a shape compatible with an object *before grasping the object*. To draw a hand in the act of picking up an object you must first study the contour of the object, then observe the automatic adjustment of the hand to fit that contour. Start to pick up a ball, a peach, or an apple and watch your fingers adjust themselves, just ahead of the grasp. The mechanical principle involved is very important in the drawing of the hand. Only by knowing how it actually works can the hand be drawn convincingly.

The back of the hand can usually be drawn in three planes—one for the thumb section as

133

far as the bottom knuckle of the first finger, and the other two across the back of the hand, tapering to the wrist. In most actions the back of the hand is curved and the curve is reduced to these three planes. The palm is usually the three blocks surrounding the hollow of the palm—the heel of the hand, the thick base of the thumb, and the padded portion just under the fingers. The knuckles of the fingers and thumb must be aligned to work inward toward the hollow of the palm, or when outstretched to be at right angles to the direction of the column of the finger. We must also be careful to align the nails so that they lie on top of the column with the middle line of the nail extended from the middle line of the column of the finger. Otherwise the nail may slip around the finger without our realizing what is wrong.

Keep studying your own hands to learn about hands in general. The inner muscles are so deeply embedded that they are not as important as the outer shapes. The only indication of bone we see is across the back, the knuckles, and the wrists. If you get the shape of the palm in almost any action, the fingers can quite easily be attached to it and aligned with it. Study the comparative lengths of the fingers; remember

that the thumb works mostly at a right angle to the fingers. Get rid of the idea that hands are hard to draw. They are simply confusing to draw unless you know how they operate. Once understood, hands become fascinating.

The most important fact to remember about the hand is that it is hollow on the palm side and convex on top. The pads are so arranged around the palm that even liquid can be held in the hand. The hand served primitive man as a cup, and by cupping the two hands together he could eat food which he could not hold with his fingers alone. The big muscle of the thumb is by far the most important one in the hand. That muscle, combined with or in opposition to the pull of the fingers, gave man a grasp powerful enough to hold even his own weight in suspension. This powerful muscle held his club, his bow, his spear. Animals depend upon the jaw muscles for existence, but we might say that man depended upon his hands.

When you have mastered the construction and proportions of the hand (Plates 77 to 85), you will find it easy to use your knowledge to show the special characteristics of women's hands and those of babies, children, and older people.

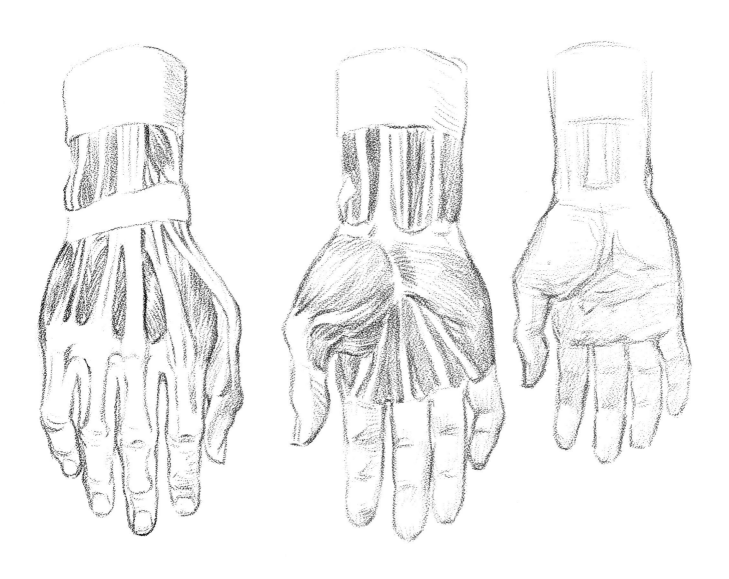

PLATE 77. Anatomy of the hand

Note the strong tendon which attaches to the heel of the hand, and how, on the back of the hand, the tendons are grouped to pull the fingers out. The operation of these tendons is marvelous, for they can operate all the fingers together from inside or outside the palm, yet can control each finger separately. The muscles which pull these tendons are located in the forearm. Fortunately for the artist, most of the tendons of the palm are buried deeply and do not show. In babies and young people, the tendons on the back of the hand are hidden, but they are much in evidence in the hands of adults and the aged.

135

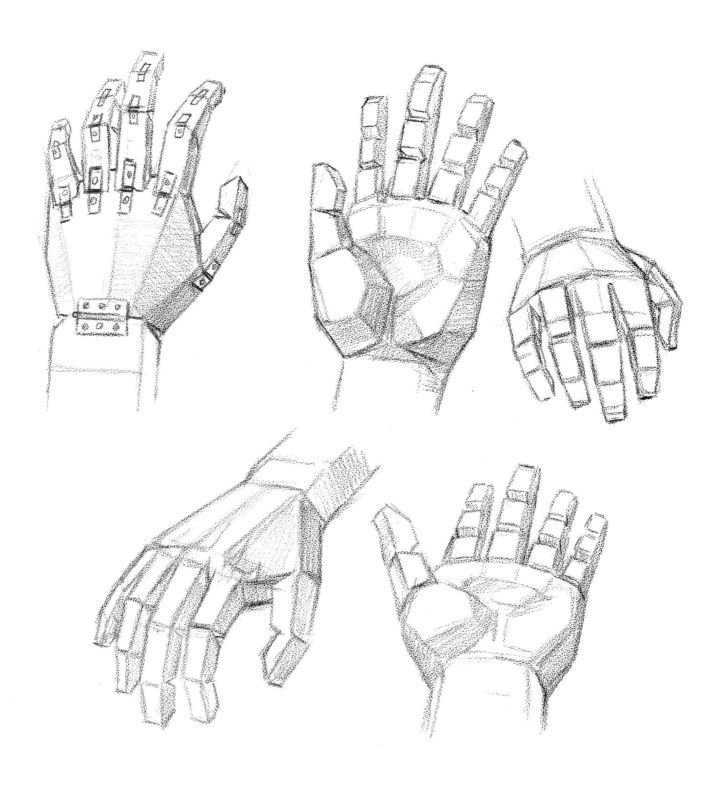

PLATE 78. Block forms of the hand

The bones and tendons across the back of the hand are close to the surface; those around the palm and inside of the fingers are thoroughly padded. I have blocked out these pads so you can familiarize yourself with them. Note the extra thickness of the pads of the thumb muscle and the heel of the palm. At the base of each finger there is a pad. These combine to make a pad across the top of the palm. The pads of the fingers protect the bones inside. Since these pads are all pliable, they provide an even firmer grip on objects much as the pliable treads on an automobile tire grip the surface of a road. There are no pads on the top of the hand, though the pad at the outer edge on the little-finger side can take a tremendous blow, especially with the fist closed, without injury to the hand.

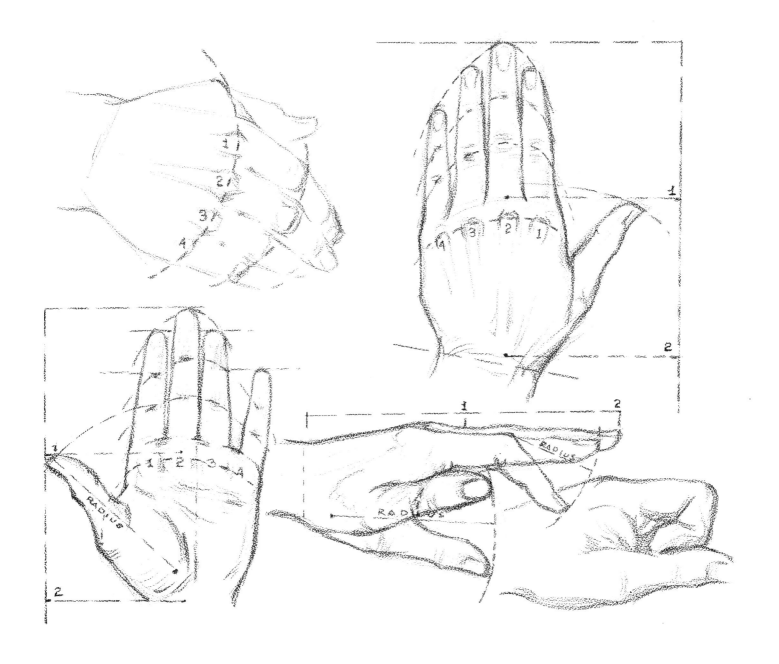

PLATE 79. Proportions of the hand

The next thing of importance is the curved arrangement of the fingertips and knuckles. Two fingers lie on each side of a line drawn through the middle of the palm. The tendon of the middle finger just about divides the back of the hand in half. Important also is the fact that the thumb is turned at right angles to the other fingers. The thumb operates mostly in and out from the palm, while the fingers open and close toward the palm. The knuckles of the fingers are slightly above their creases on the inside of the fingers. Note the flat curve of the knuckles across the back of the hand, with the curves getting deeper as they cross the knuckles toward the fingertips.

The middle finger is the key finger from which we determine the length of the hand. The length of this finger to its knuckle in back is slightly over half the length of the hand. The width of the palm is slightly more than that of half the hand on the inside. The first or index finger just about reaches the fingernail of the middle finger. The third finger is about equal to the index finger in length. The little finger just reaches the top knuckle of the third finger.

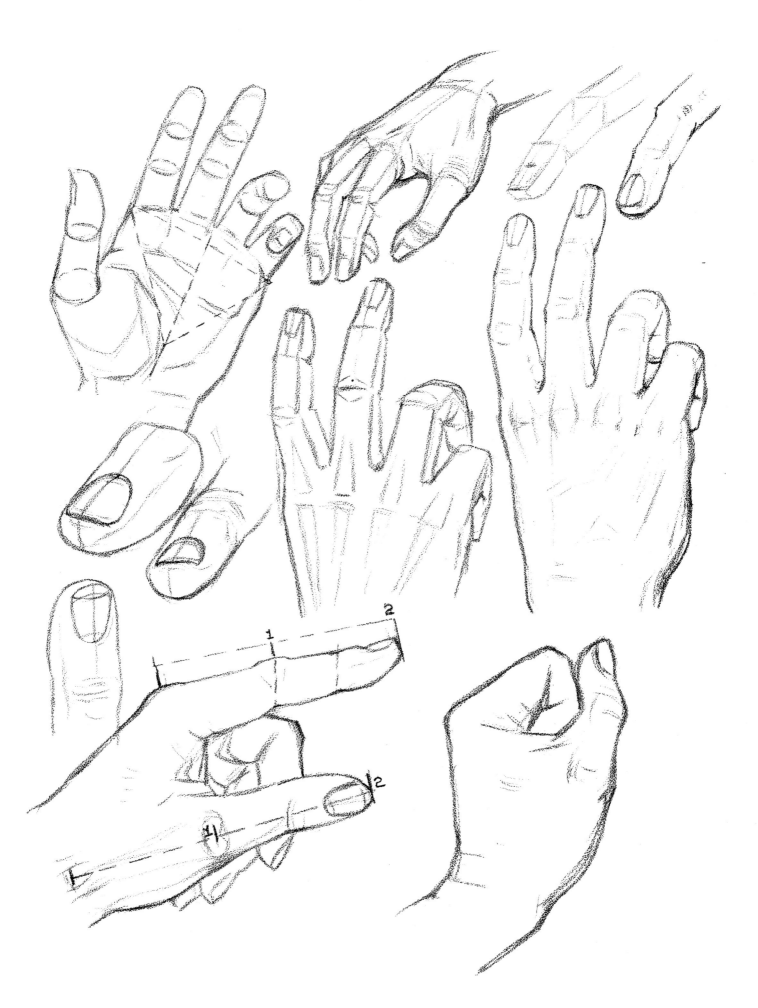

PLATE 80. Construction of the hand

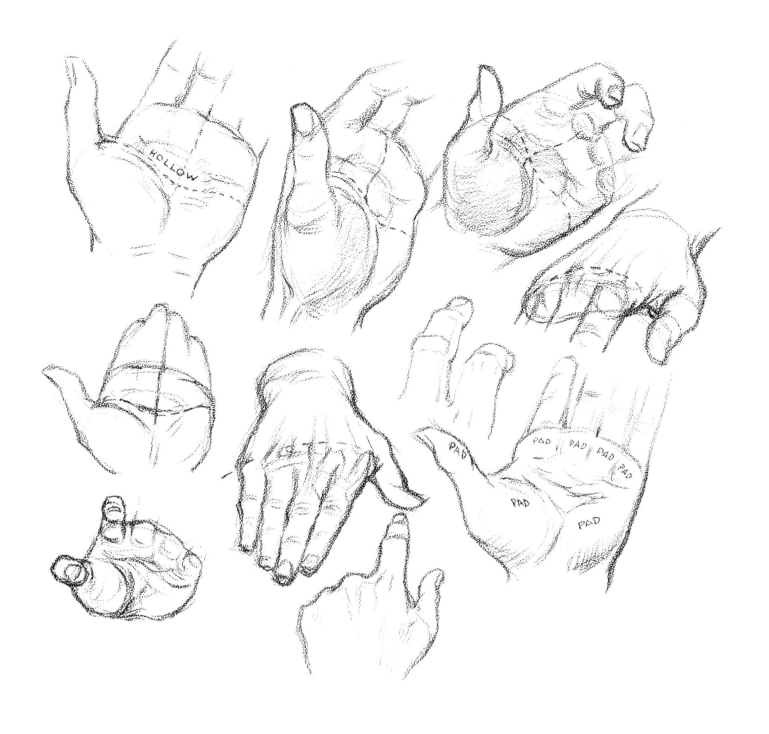

PLATE 81. The hollow of the palm

In the drawings above, note how the hollow of the hand has been carefully defined. Also note the resulting curve of the back of the hand. Hands never look natural or capable of grasping until the artist understands this feature of the hand. All these hands look as if they could take hold of an object. The loud sound of clapping comes from the sudden compression of air between these two cups or pockets of the palms. A hand that does not look capable of clasping is badly drawn. Study your own hands.

139

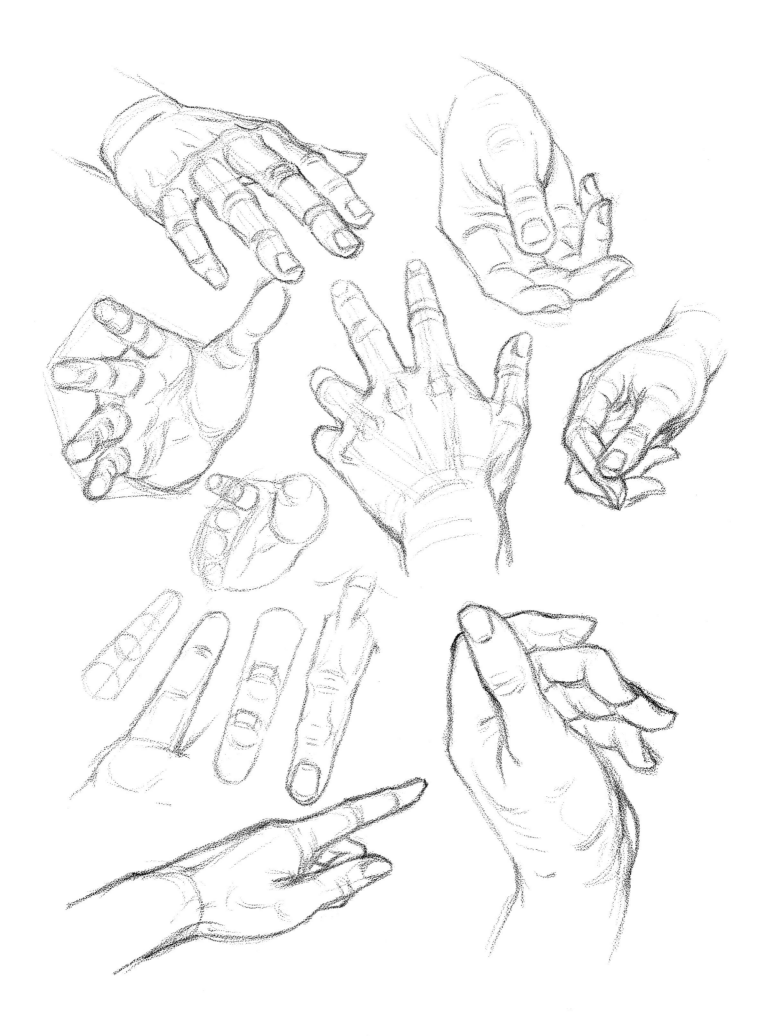

PLATE 82. Foreshortening in drawing hands

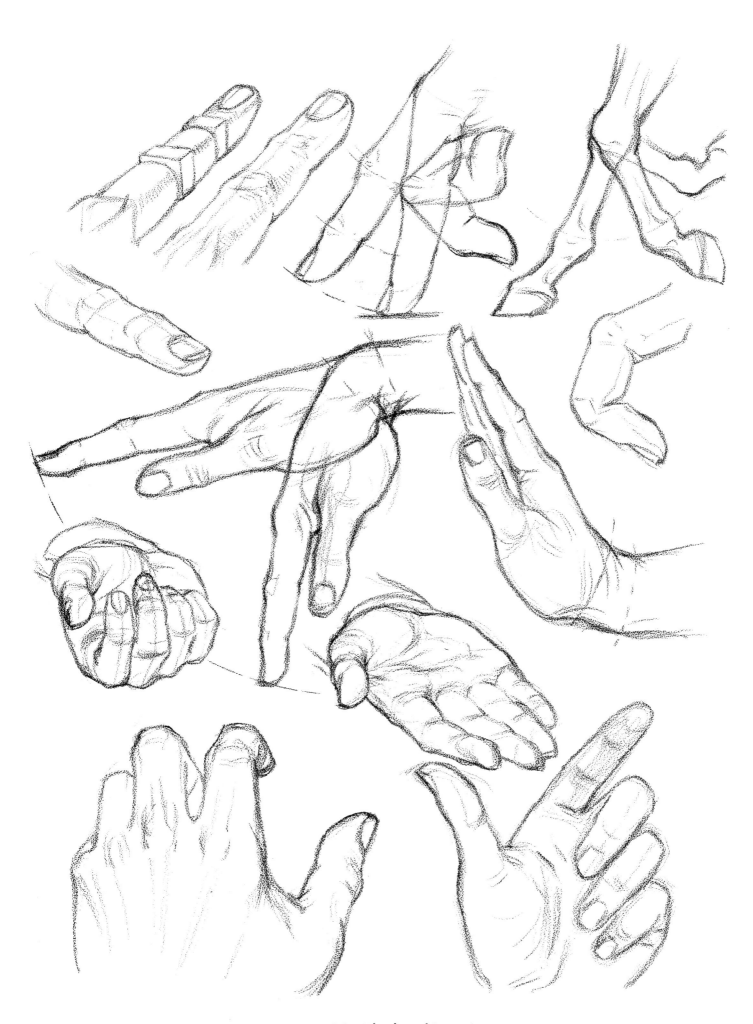

PLATE 83. The hand in action

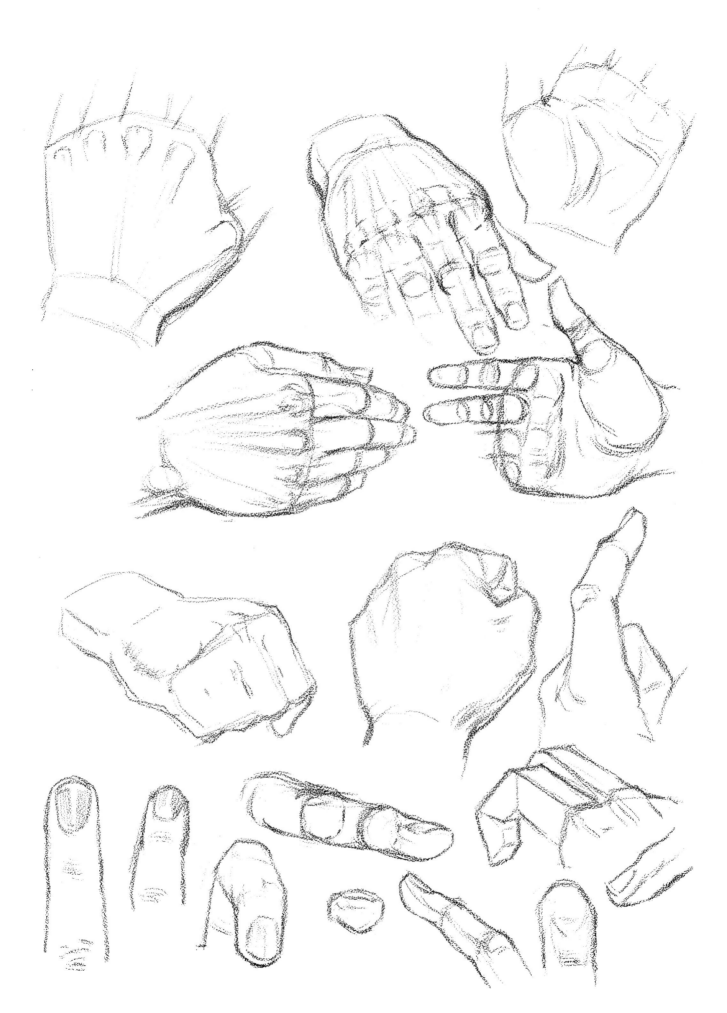

PLATE 84. Knuckles

142

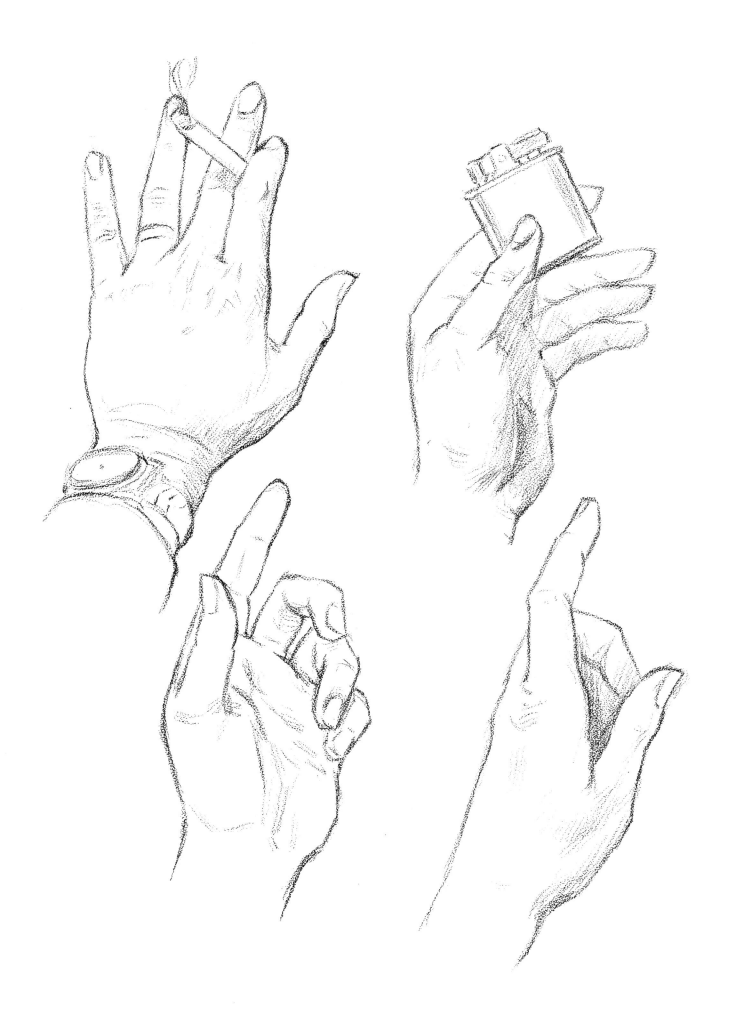

PLATE 85. Drawing your own hand

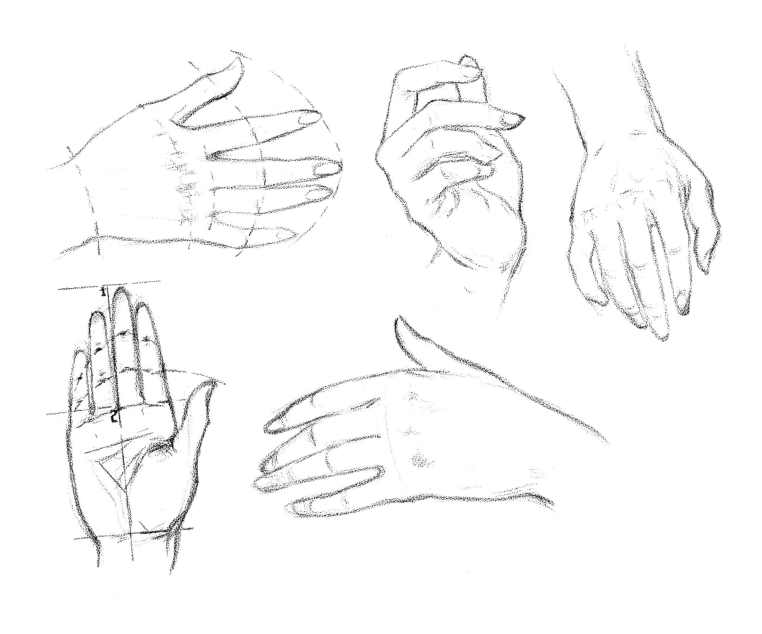

PLATE 86. The female hand

Women's hands, like their faces, differ from those of men chiefly in having smaller bones, more delicate muscles, and generally more roundness of planes. If the middle finger is made at least half the length of the hand on the palm side it will be more graceful and will characterize the hand as feminine. Even though feminine hands are slim, they still have amazing tenacity of grip. The long fingernails, oval in shape, add charm.

144

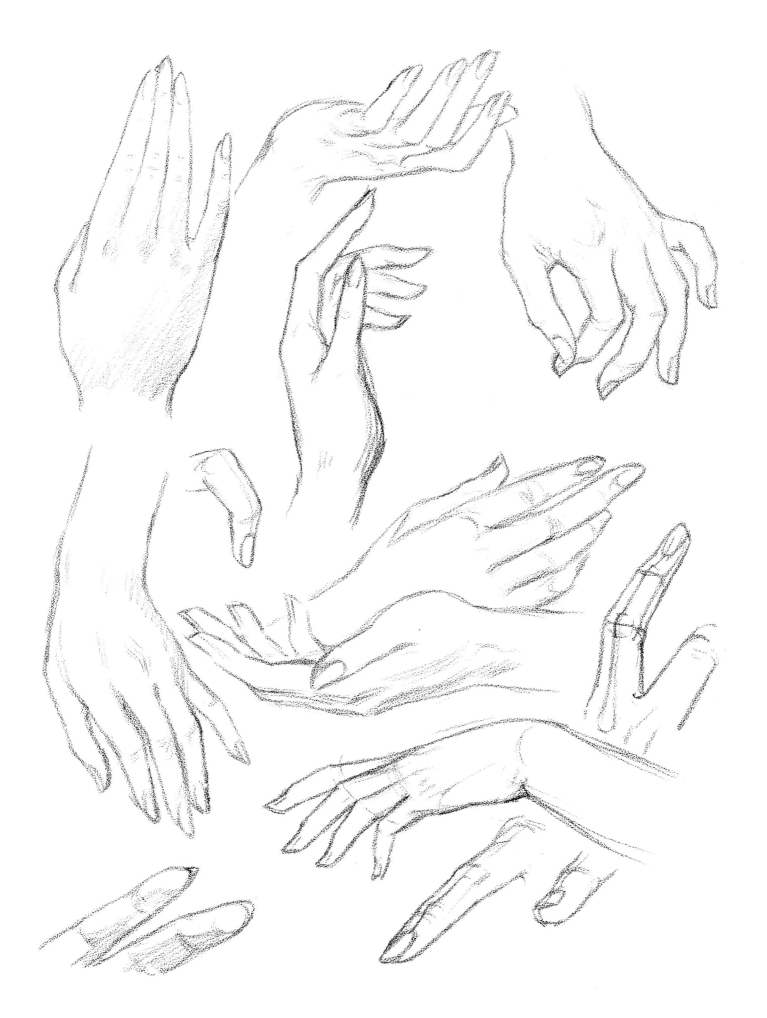

PLATE 87. Tapered fingers

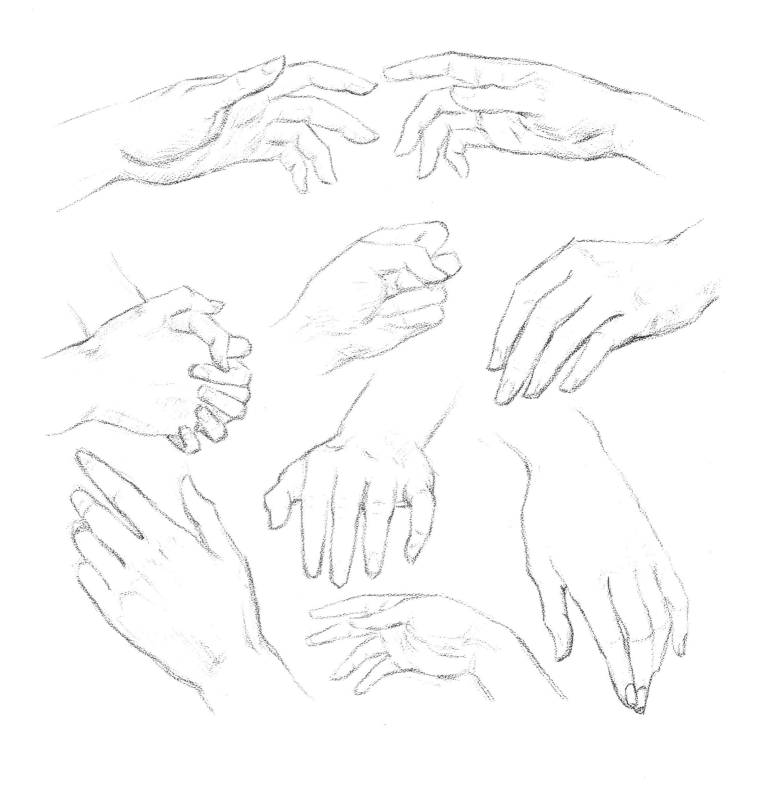

PLATE 88. Make many studies of hands

There is only one sure way to learn to draw hands, and that is to draw many, many studies. With hands, more than with anything else, proper spacing is essential. You must fit the fingers onto the palm in the particular view you see before you. Hands are almost never straight and flat. Judge the spaces between the knuckles carefully. Much of the time the view will require foreshortening, as shown in Plates 82 through 85.

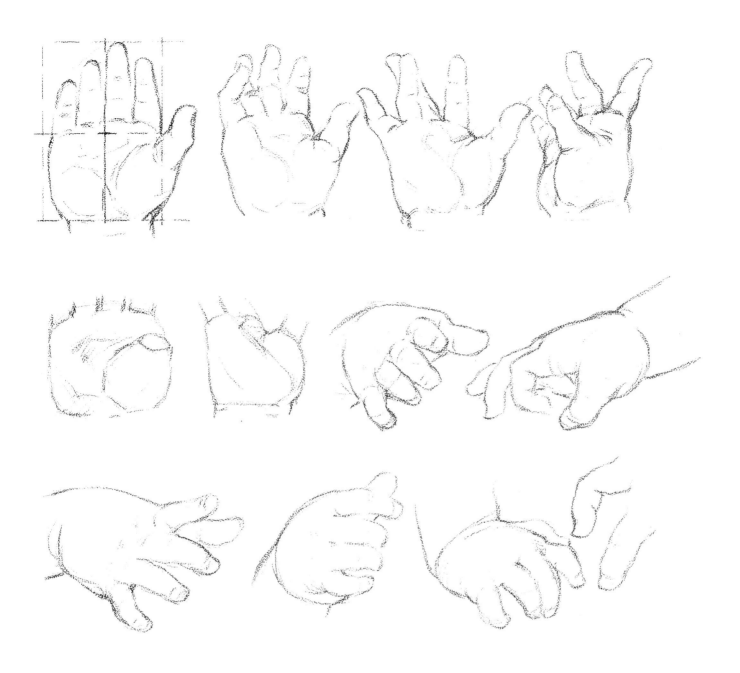

PLATE 89. The baby hand

Babies' hands are a study in themselves. The basic difference from adults' hands is that the palm is relatively thicker in relation to the small fingers. The thumb muscle and heel of the baby hand are proportionately very powerful. Quite young babies have a grasp equal to their own weight. The knuckles across the back of the hand are buried in flesh and are indicated by dimples. The base of the hand may be entirely surrounded with creases. The heel of the hand is much thicker than the pads across the top of the palm.

147

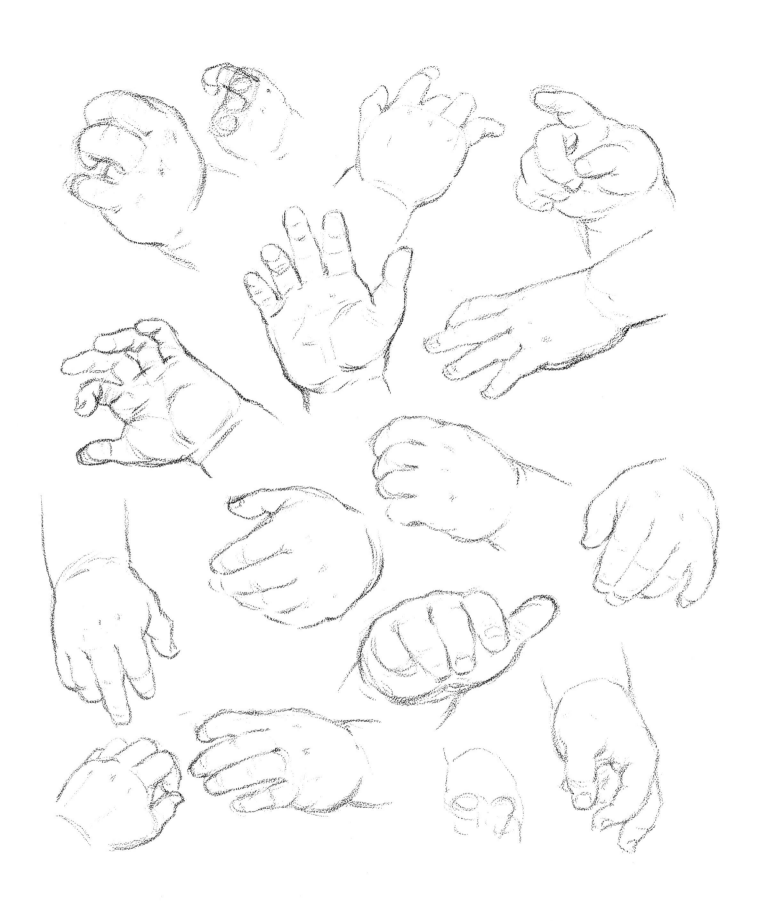

PLATE 90. Studies of baby hands

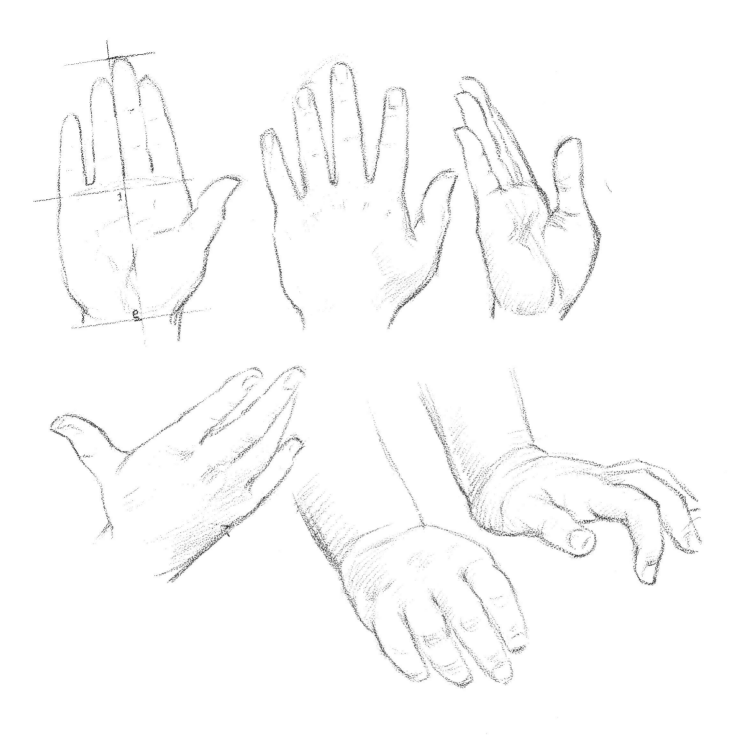

PLATE 91. Children's hands

The child's hand is halfway between that of the baby and that of the teen-ager. This means that the thumb muscle and the heel of the hand are thicker proportionately than they are in the adult hand, but not as thick in relation to the fingers as they are in the baby hand. The fingers in relation to the palm are about the same as in the adult. The whole hand is smaller, a little fatter, and more dimpled, and the knuckles are of course smoother.

149

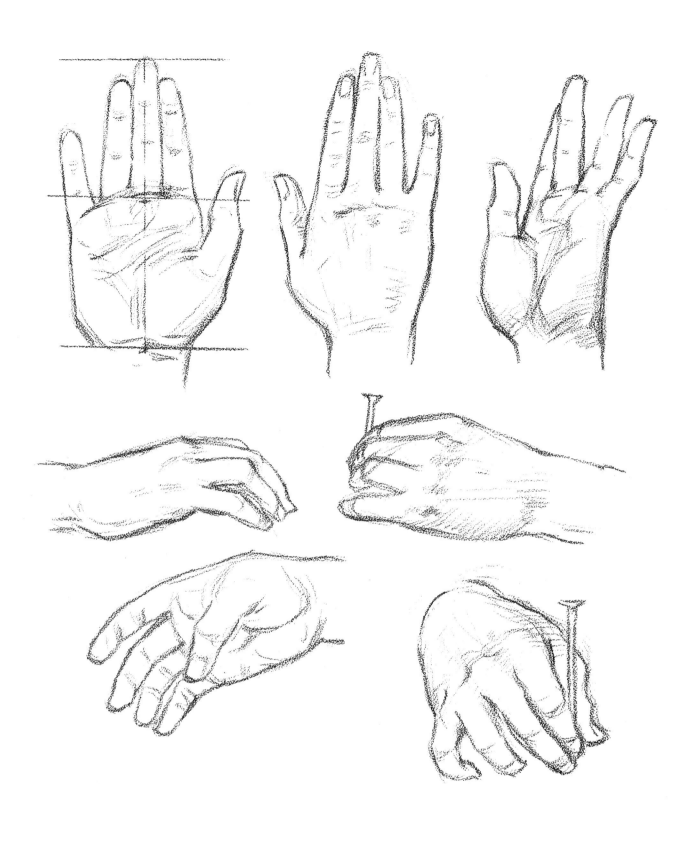

PLATE 92. The proportions remain fairly constant

At grammar-school age there is very little difference between the hand of a boy and that of a girl but at adolescence there is a big change. The boy's hand is much larger and sturdier, showing development of bone and muscle. The girl's hand never develops the big knuckles of the boy's, since the bones stay smaller. The heel of the hand develops in the boy, but stays much softer and slimmer in the girl. In the boy's hand the fingernails as well as the fingers are slightly broader.

150

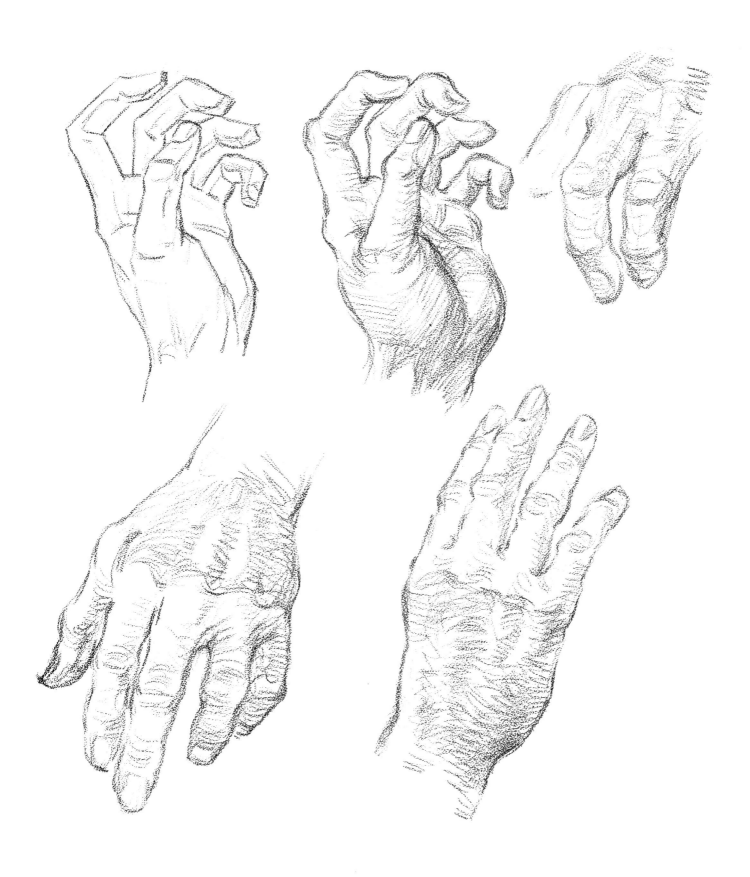

PLATE 93. The hand ages

Once you have mastered the construction of hands, old people's hands are a delight to draw. Actually they are easier than young people's, since the anatomy and construction are more obvious and show clearly on the surface. While the basic construction is the same, the fingers get thicker, the joints larger, and the knuckles protrude. The skin becomes wrinkled, but this need not be emphasized except in a close-up view.

151

A Farewell to the Reader

IN CONCLUDING this book, I want to thank the readers of my previous books for their very kind letters. Because of the large number of these, and because of the pressure on my own time, I have never been able to answer as many as I wished to. If my books have helped you, I am happy.

It is only within the past decade that so many books on drawing and painting have been available. Perhaps another seems superfluous, but in investigating before starting this one, I found very few which concentrated on heads or hands. Both are so important to commercial and portrait artists that I have undertaken to fill the gap. It is my conviction that such a book should come from a person whose livelihood has depended upon the very material he is writing about. In this capacity I have felt that I could substitute actual practice for theory, because my own work based on the principles given here has proved itself by actual sales to leading publications over a long period of time.

There are many fine men in the field of commercial art, and many fine teachers in the schools, who would be capable of handling the same subject. It is largely a matter of finding the time and energy for such an effort in an already full schedule. I have found, however, that time can be apportioned for almost any endeavor that is interesting and pleasant to undertake, simply by curtailing competing pleasures. Much of this book has been done in the evenings or at times between the pressure of other work. My hope is that if I could find time to do the book, others could also in the same way set aside time to study it. My end of the effort is completed, but I am still concerned that it will go out and do the job for young people that I want it to do.

The men in the field who are now the greatest contributors are men who had to come up the hard way, without much knowledge available in books, grasping here and there for information together with much personal practice and experiment. Books will not do the work for anyone, but they can make individual effort more practical and profitable, speeding the acquiring of much-needed knowledge, so that the artist can have more years of successful practice.

It is not my intention to have my readers stop their study of the head and hands with the closing of this book. My aim has been to help them to a well-grounded start that will give their own ability the best of chances. We know that a head cannot be well drawn by any approach that does not, in the final effort, produce solidity and good construction. The portrayal of character must come from specific analysis and from understanding the general anatomy of the head. If I have shown you how that analysis can be made and the reasons for the things that happen in drawing a head, your own progress will be greatly accelerated.

Aside from technical knowledge, I feel that the artist must have a certain reverence for the beauty of the construction of the head, the qualities of its forms that give it individuality, plus a desire for beauty of craftsmanship in the rendering. He should strive never to let his technique become a routine formula, by which all heads are done in the same manner. Let him experiment constantly with the expression of his basic knowledge. Some heads can be done best by suggestion, others by complete detail and fidelity to life. Some will be more interesting if rendered in line, others by tonal suggestion. The result should never look as if it came off an assembly line. To vary your technical style is not easy; neither is keeping your thinking varied. A great deal of practice and experiment is required.

A very fine idea is for a group of young artists

to organize a sketch class, meeting once a week, sharing the cost of a model and other expenses. Such a class offers each man the possibility of learning from the others, and it also establishes friendships which last a lifetime. We did this in my early days in Chicago. Many of the men in that group have forged ahead in their fields, and some are doing the outstanding work of the country. While each must be credited with a great deal of individual effort, there is no doubt that all gained from the collective experience. Of course, any person intending to make a living at art should attend a good art school if possible. But training need not stop there. In the group

I mention, all the fellows had finished their academic work and already were active in the field, but they were all interested in learning more and so organized this informal clinic.

I have enjoyed the preparation of this volume, even if it turned into a mountain of work. I wish every reader the best of luck, and I hope that each will find something in these pages that will be of lasting value. For those to whom drawing is a hobby rather than a profession, I hope the simplification of their problems will bring them still greater happiness in their chosen pastime.

FIGURE DRAWING
FOR ALL IT'S WORTH

ALSO BY ANDREW LOOMIS:

FUN WITH A PENCIL

CREATIVE ILLUSTRATION

SUCCESSFUL DRAWING

FIGURE DRAWING
FOR ALL IT'S WORTH

ANDREW LOOMIS

Figure Drawing For All It's Worth
ISBN: 9780857680983

Published by
Titan Books
A division of Titan Publishing Group Ltd.
144 Southwark St.
London
SE1 0UP

This edition: May 2011
20

To receive advance information, news, competitions, and exclusive offers online, please sign up for the Titan newsletter on our website: **www.titanbooks.com**

Did you enjoy this book? We love to hear from our readers. Please e-mail us at: **readerfeedback@titanemail.com** or write to Reader Feedback at the above address.

A CIP catalogue record for this title is available from the British Library.

Printed and bound in China.

DEDICATION

TO THE YOUNG MEN AND WOMEN

OF THE UNITED STATES

WHO HAVE TURNED

TO THE DRAWING OF THE HUMAN FIGURE

AS A MEANS OF LIVELIHOOD,

THIS VOLUME IS

RESPECTFULLY DEDICATED

CONTENTS, INCLUDING ILLUSTRATIONS

CONTENTS, INCLUDING ILLUSTRATIONS

CONTENTS, INCLUDING ILLUSTRATIONS

CONTENTS, INCLUDING ILLUSTRATIONS

CONTENTS, INCLUDING ILLUSTRATIONS

CONTENTS, INCLUDING ILLUSTRATIONS

FIGURE DRAWING
FOR ALL IT'S WORTH

AN OPENING CHAT

Dear Reader:

For many years the need of a further book on the subject of figure drawing has been apparent to me. I have waited for such a book to appear which could be recommended to the many young artists with whom I have come in contact. Finally, I have come to the realization that such a book, regardless of one's ability as an author, could be written only by a man actually in the field of commercial art, who in his experience had met and countered with the actual problems that must be clarified. I recall how frantically, in the earlier days of my own experience, I searched for practical information that might lend a helping hand in making my work marketable. Being in the not unusual position of having to support myself, it was the predicament of having to make good at art or being forced to turn to something else.

Across this wide country there are many of you in that predicament. You, also possessed of that unaccountable urge which seemingly comes from nowhere, want to speak the language of art. You love to draw. You wish to draw well. If there is any chance, you greatly wish to make a living at it. Perhaps I can help you. I sincerely hope so, for I think I have lived through every minute you are now living. Perhaps I can compile some of the information that experience tells me you want and need. I do not pretend to undervalue the fine work that has been done; the difficulty has always been in finding it and sorting out what is of practical value and putting it into practice. I believe that the greater chances of success lie in the mental approach to the work, rather than in sheer technical knowledge, and since the mental approach has not often been stressed, here lies the opportunity to serve you.

I not only assume that my reader is interested in drawing but that he wishes from his toes up to become an efficient and self-supporting craftsman. I assume that the desire to express yourself with pen and pencil is not only urgent but almost undeniable, and that you feel you *must do something about it*. I feel that talent means little unless coupled with an insatiable desire to give an excellent personal demonstration of ability. I feel also that talent must be in company with a capacity for unlimited effort, which provides the power that eventually hurdles the difficulties that would frustrate lukewarm enthusiasm.

Let us try to define that quality which makes an artist "tick." Every bit of work he does starts out with the premise that it has a message, a purpose, a job to do. What is the most direct answer, the simplest interpretation of that message he can make? Stripping a subject to its barest and most efficient essentials is a mental procedure. Every inch of the surface of his work should be considered as to whether it bears important relationship to a whole purpose. He sees, and his picture tells us the importance of what he sees and how he feels about it. Then within his picture he stresses what is of greatest importance, and subordinates what must be there but is of lesser importance. He will place his area of greatest contrast about the head of the most important character. He will search diligently for means to make that character express the emotion in facial expression and pose that is to be the all important theme. He will first draw attention to that character, by every means available. In other words, he plans and thinks, and does not passively accept simply because it exists. Not far back in the annals of art the ability to achieve just a lifelike appearance might have caused some wonder in a spectator, enough to

capture his interest. Today with color photography and the excellence of the camera going perhaps even further in that respect, we are surfeited with realism par excellence, until mere lifelike representation is not enough. There is no other course than somehow to go beyond obvious fact to pertinent fact, to characterization, to the emotional and dramatic, to selection and taste, to simplification, subordination, and accentuation. It is ten per cent how you draw, and ninety per cent *what you draw*. Equally defining everything within your picture area, in value, edge and detail, will add no more than can be achieved in photography. Subordination may be achieved by diffusion, by closeness of color and value to surrounding areas, by simplification of insistent detail, or by omission. Accentuation is achieved by the opposite in each case, by sharpness, contrast, detail, or any added device.

I take this opportunity to impress upon you, my reader, how important you really are in the whole of art procedure. You, your personality, your individuality come first. Your pictures are your by-product. Everything about your pictures is, and should be, a little of you. They will be a reflection of your knowledge, your experience, your observation, your likes and dislikes, your good taste, and your thinking. So the real concentration is centered on you, and your work follows along in the wake of what mental self-improvement you are making. It has taken me a lifetime to realize that. So before we talk at all about drawing, it is important to sell you strongly on yourself, to plant that urge so definitely in your consciousness that you must know at once that most of it comes from the other end of your pencil rather than the business end.

As a student I thought there was a formula of some kind that I would get hold of somewhere, and thereby become an artist. There is a formula, but it has not been in books. It is really plain old courage, standing on one's own feet,

and forever seeking enlightenment; courage to develop your way, but learning from the other fellow; experimentation with your own ideas, observing for yourself, a rigid discipline of doing over that which you can improve. I have never found a book that stressed the importance of myself as the caretaker of my ability, of staying healthy mentally and physically, or that gave me an inkling that my courage might be strained to the utmost. Perhaps that is not the way to write books, but I can see no harm in the author realizing that he is dealing with personalities, and that there is something more important than technique. In art we are dealing with something far removed from a cold science, where the human element is everything. At least I am determined to established a fellowship with my reader, welcoming him to the craft at which I have spent so many years. If I have any blue chips I can pass on to him, I lay them before him so that he may join in the game. I cannot profess to know more than the experience of one individual. However, one individual experience if wide enough might well cover many of the problems that will doubtless come to others. Solutions of those problems may provide like solutions. I can lay out an assortment of facts and fundamentals that were helpful to me. I can speak of the idealizations, the practical hints and devices that will undoubtedly make drawings more salable. Since the requirements are almost universal, and since my own experience does not vary greatly from the average experience of my contemporaries, I offer my material without setting up myself and my work as a criterion. In fact, I would prefer, if it were possible, to subordinate my own viewpoint, or technical approach, and leave the reader as free as possible for individual decision and self-expression. I use my experience merely to clarify the general requirements.

It should be obvious that, first of all, salable

figure drawing must be good drawing, and "good drawing" means a great deal more to the professional than to the beginner. It means that a figure must be convincing and appealing at the same time. It must be of idealistic rather than literal or normal proportion. It must be related in perspective to a constant eye level or viewpoint. The anatomy must be correct, whether exposed to the eye or concealed beneath drapery or costume. The light and shadow must be so handled as to impart a living quality. Its action or gesture, its dramatic quality, expression, and emotion must be convincing. Good drawing is neither an accident nor the result of an inspired moment when the Muses lend a guiding hand. Good drawing is a co-ordination of many factors, all understood and handled expertly, as in a delicate surgical operation. Let us say that each factor becomes an instrument or part of a *means of expression*. It is when the means of expression is developed as a whole that inspiration and individual feeling come into play. It is possible for anybody to be "off" at any time in any one or more of the factors. Every artist will do "good ones" and "bad ones." The bad will have to be thrown out and done over. The artist should, of course, make a critical analysis to determine why a drawing is bad; usually he will be forced to go back to fundamentals, for bad drawing springs from basic faults as surely as good drawing springs from basic merits.

Therefore a useful book of figure drawing cannot treat one phase alone, as the study of anatomy; it must also seek out and co-ordinate all the basic factors upon which good drawing depends. It must consider both aesthetics and sales possibilities, technical rendering and typical problems to be solved. Otherwise the reader is only partially informed; he is taught but one angle, and then left to flounder.

May I assume that you as a young artist are facing a bread-and-butter problem? Whenever you achieve sufficient technical ability, there will be an income waiting for you. From that point on your earnings will increase in ratio to your improvement. In the fields of practical art the ranks thin out at the top, just as they do everywhere else. There is not an advertising agency, a magazine publisher, a lithograph house, or an art dealer's that will not gladly open its doors to real ability that is new and different. It is mediocrity to which the door is closed. Unfortunately most of us are mediocre when we start out; by and large, most commercial artists of outstanding ability had no more than average talent at the start.

May I confess that two weeks after entering art school, I was advised to go back home? That experience has made me much more tolerant of an inauspicious beginning than I might otherwise have been, and it has given me additional incentive in teaching.

Individuality of expression is, without question, an artist's most valuable asset. You could make no more fatal error than to attempt to duplicate, for the sake of duplication alone, either my work or that of any other individual. Use another's style as a crutch only—until you can walk alone. Trends of popularity are as changeable as the weather. Anatomy, perspective, values remain constant; but you must diligently search for new ways to apply them. The greatest problem here is to provide you with a solid basis that will nurture individuality and not produce imitation. I grant that a certain amount of imitation in the earliest phase of learning may be necessary in order that self-expression may have an essential background. But there can be no progress in any art or craft without an accumulation of individual experience. The experience comes best through your own effort or observation, through self-instruction, the reading of a book, or the study of an old master. These experiences are bundled together to form your

working knowledge, and the process should never stop. New, creative ideas are usually variants of the old.

In this volume I shall try to treat the figure as a living thing, its power of movement related to its structure and its movement separated into several kinds. We shall draw the nude for the purpose of better understanding the draped figure. We shall think of the figure as possessed of bulk and weight, as being exposed to light and therefore shadow, and hence set into space as we know it. Then we shall try to understand light for what it is; and how form, with its planes of various direction, is affected by it. We shall consider the head and its structure separately. In other words, we shall provide a foundation that will enable you to make your figures original and convincing. The interpretation, the type, the pose, the drama, the costume, and the accessories will all be yours. Whether your figures are drawn for an advertisement, to illustrate a story, or for a poster or a calendar will not change appreciably the fundamental demands upon your knowledge. Technique is not so important as the young artist is inclined to believe; the living and emotional qualities—the idealization you put into your work—are far more important. So are your selection and taste in costume and setting—provided you have mastered fundamentals. The smartest dress in the world will not be effective on a badly drawn figure. Expression or emotion cannot possibly be drawn into a face that is poorly constructed. You cannot paint in color successfully without some conception of light and color values, or even hope to build a composition of figures until you know how to draw them in absolute perspective. Your job is to glorify and idealize the everyday material about you.

It is my purpose from start to finish of this book to lend you a hand to the top of the hill, but upon reaching the crest to push you over and leave you to your own momentum. I have hired and paid the best models I could find, knowing that the limited funds of the average young artist, would not permit that. If you study my drawings in the light of a model posing for you, rather than thinking of them as something to be duplicated line for line and tone for tone, I think you will in the end derive greater benefit. With every page I suggest you place your pad at the side of the book. Try to get the meaning behind the drawing much more than the drawing itself. Keep your pencil as busy as possible. Try figures varying as much as possible from those in my pages. Set up figures roughly, from the imagination, make them do all sorts of actions. If it is possible to draw from the live model in school or elsewhere, do so by all means, utilizing as best you can the fundamentals we have here. If you can take photos or have access to them, try your skill in drawing from them, adding what idealization you think should be there.

It might be a good plan to read the entire book at the start so that you will better understand the general plan of procedure. Other kinds of drawing such as still life should be supplemented, for all form presents the general problem of contour, planes, light and shadow.

Get used to using a soft pencil, one that will give considerable range from light to dark. A thin, weak and gray drawing has practically no commercial value. The switching to a pen and black drawing ink is not only interesting but has real value commercially. Use one that is fairly flexible. Pull the pen to make your line, never push it at the paper, for it will only catch and splutter. Charcoal is a fine medium for study. A large tissue or layout pad is excellent to work on.

Perhaps the best way is to suggest that you use the book in whatever manner suits you best.

THE APPROACH TO FIGURE DRAWING

The first chapter of this book will be treated a little differently from the others, as a prelude to the actual figure, and to lay the groundwork of the structure we are later to build. This part of the book will be of especial value to the layout man and to the artist for the preparation of preliminary sketches, roughs, the setting down of ideas, suggestions of actions and pose, where the figure must be drawn without the use of models or copy. This is the sort of work the artist does in advance of the finished work. This, in other words, is the work with which he sells himself to the prospective client. In that respect it is most important since it really creates opportunity. He will be able to prepare this work intelligently so that when he gets to the final work he will not be confused with new problems of perspective, spacing, and other difficulties.

The reader is urged to give this chapter his utmost attention since it is unquestionably the most important chapter in the book, and one to pay good dividends for the concentrated effort involved.

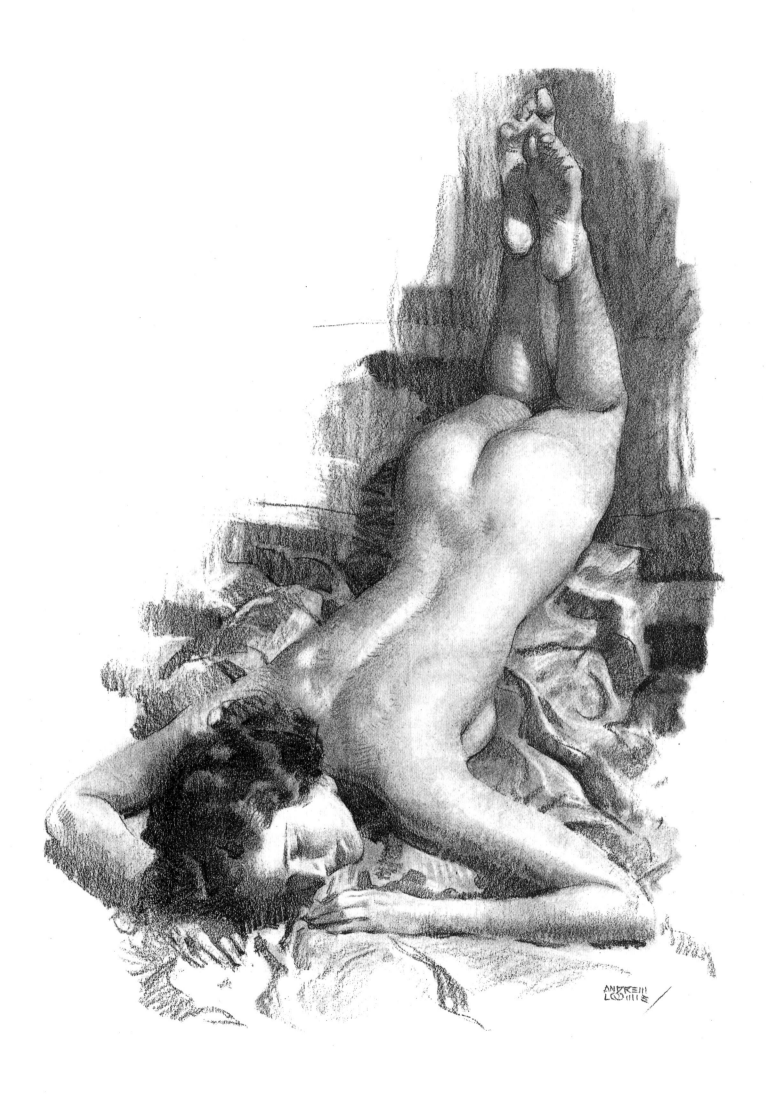

I. THE APPROACH TO FIGURE DRAWING

As we begin the book, let us take note of the broad field of opportunity afforded the figure draftsman. Starting with the comic or simple line drawings of the newspaper, it extends all the way up through every kind of poster, display, and magazine advertising, through covers and story illustration to the realms of fine art, portraiture, sculpture, and mural decoration. Figure drawing presents the broadest opportunity from the standpoint of earning of any artistic endeavor. Coupled with this fact is the great advantage that all these uses are so interrelated that success in one almost assures success in another.

The interrelation of all these uses springs from the fact that all figure drawing is based on the same fundamentals which can be applied no matter what use the work is put to. This brings a further great advantage to the figure man in that he has a constant market if he is capable of good work. The market is constant because his work fits into so many notches in the cycle of buying and selling which must always be present barring financial collapse. To sell one must advertise, to advertise one must have advertising space, to have advertising space there must be attractively illustrated magazines, billboards, and other mediums. So starts the chain of uses of which the artist is an integral part.

To top it all, it becomes the most fascinating of any art effort because it offers such endless variety, encompassing so much that it ever remains new and stimulating. Dealing with the human aspects of life it runs the gamut of expression, emotion, gesture, environment, and the interpretation of character. What other fields of effort offer so great a variety for interest and genuine relief from monotony? I speak of this to build within you that confidence that all is well

once you arrive at your destination; your real concern is making the journey.

Art in its broadest sense is a language, a message that can be expressed better in no other way. It tells us what a product looks like and how we can use it. It describes the clothes and even the manners of other times. In a war poster it incites us to action; in a magazine it makes characters alive and vivid. It projects an idea visually, so that before a brick is laid we may see, before our eyes, the finished building.

There was a time when the artist withdrew to a bare attic to live in seclusion for an ideal. For subject, a plate of apples sufficed. Today, however, art has become an integral part of our lives, and the successful artist cannot set himself apart. He must do a certain job, in a definite manner, to a definite purpose, and with a specified date of delivery.

Start at once to take a new interest in people. Look for typical characters everywhere. Familiarize yourself with the characteristics and details that distinguish them. What is arrogance in terms of light and shadow, form and color? What lines give frustration and forlorn hope to people? What is the gesture in relation to the emotion? Why is a certain childish face adorable, a certain adult face suspicious and untrustworthy? You must search for the answers to these questions and be able to make them clear to your public. This knowledge will in time become a part of you, but it can come only from observation and understanding.

Try to develop the habit of observing your surroundings carefully. Some day you may want to place a figure in a similar atmosphere. You cannot succeed completely with the figure unless you can draw the details of the setting. So

begin now to collect a file of the details that give a setting its "atmosphere."

Learn to observe significant details. You must be concerned with more than Martha's hairdress. Precisely why does Martha in a formal gown look so different in shorts or slacks? How do the folds of her dress break at the floor when she sits down?

Watch emotional gestures and expressions. What does a girl do with her hands when she says, "Oh, that's wonderful!"? Or with her feet when she drops into a chair and says, "Gosh, I'm tired!"? What does a mother's face register when she appeals to the doctor, "Is there no hope?" Or a child's when he says, "Gee, that's good!"? You must have more than mere technical ability to produce a good drawing.

Nearly every successful artist has a particular interest or drive or passion that gives direction to his technical skill. Often it is an absorption in some one phase of life. Harold von Schmidt, for example, loves the outdoors, rural life, horses, the pioneer, drama, and action. His work breathes the fire that is in him. Harry Anderson loves plain American people — the old family doctor, the little white cottage. Norman Rockwell, a great portrayer of character, loves a gnarled old hand that has done a lifetime of work, a shoe that has seen better days. His tender and sympathetic attitude toward humanity, implemented by his marvelous technical ability, has won him his place in the world of art. Jon Whitcomb and Al Parker are at the top because they can set down a poignant, up-to-the-minute portrayal of young America. The Clark brothers have a fondness for drawing the Old West and frontier days, and have been most successful at it. Maude Fangel loved babies and drew them beautifully. None of these people could have reached the pinnacle without their inner drives. Yet none could have arrived there without being able to draw well.

I do not strongly recommend becoming "helper" to a successful artist in order to gain background. More often than not, it is a discouraging experience. The reason is that you are continually matching your humble efforts against the stellar performance of your employer. You are not thinking and observing for yourself. You are usually dreaming, developing an inferiority complex, becoming an imitator. Remember: artists have no jealously guarded professional secrets. How often have I heard students say, "If I could just watch that man work, I'm sure I could get ahead!" Getting ahead does not happen that way. The only mystery, if such it may be called, is the personal interpretation of the individual artist. He himself probably does not know his own "secret." Fundamentals you must master, but you can never do so by watching another man paint. You have to reason them out for yourself.

Before you decide what type of drawing you want to concentrate on, it would be wise to consider your particular background of experience. If you have been brought up on a farm, for instance, you are much more likely to succeed in interpreting life on a farm than in depicting Long Island society life. Don't ignore the intimate knowledge you have gained from long, everyday acquaintance. All of us tend to discount our own experience and knowledge—to consider *our* background dull and commonplace. But that is a serious mistake. No background is barren of artistic material. The artist who grew up in poverty can create just as much beauty in drawing tumble-down sheds as another artist might in drawing ornate and luxurious settings. As a matter of fact, he is apt to know much more about life, and his art is likely to have a broader appeal. Today great interest has developed in the "American Scene." Simple homeliness is its general keynote. Our advertising and much of our illustration, however, de-

mand the sophisticated and the smart, but it is wise to bear in mind this newer trend, for which a humble background is no handicap.

It is true that most artists must be prepared to handle any sort of subject on demand. But gradually each one will be chosen for the thing he does best. If you do not want to be typed or "catalogued," you will have to work hard to widen your scope. It means learning broad drawing principles (everything has proportion, three dimensions, texture, color, light, and shadow) so that you will not be floored by commissions that may call for a bit of still life, a landscape, an animal, a particular texture such as satin or knitted wool. If you learn to observe, the demands should not tax your technical capacity, because the rendering of all form is based upon the way light falls upon it and the way light affects its value and color. Furthermore, you can always do research on any unfamiliar subject. Most artists spend as much time in obtaining suitable data as in actual drawing or painting.

The fundamentals of painting and drawing are the same. Perhaps it might be said that drawing in general does not attempt to render the subtleties of values, edges, and planes or modeling that may be obtained in paint. In any medium, however, the artist is confronted with the same problems: he will have to consider the horizon and viewpoint; he will have to set down properly length, breadth, and thickness (in so far as he is able on the flat surface); he will have to consider, in short, the elements that I am talking about in this book.

The nude human figure must serve as the basis for all figure study. It is impossible to draw the clothed or draped figure without a knowledge of the structure and form of the figure underneath. The artist who cannot put the figure together properly does not have one chance in a thousand of success—either as a figure draftsman or as a painter. It would be as reasonable to expect to become a surgeon without studying anatomy. If you are offended by the sight of the body the Almighty gave us to live in, then put this book aside at once and likewise give up all thought of a career in art. Since all of us are either male or female, and since the figures of the two sexes differ so radically in construction and appearance (a woman in slacks is *not* a man in pants, even when she has a short haircut), it is fantastic to conceive of a study of figure drawing that did not analyze the many differences. I have been engaged in almost every type of commercial art, and my experience confirms the fact that the study of the nude is indispensable to any art career that requires figure drawing. A vocational course without such study is a deplorable waste of time. Life classes generally work from the living model; hence I have tried to supply drawings that will serve as a substitute.

Broadly speaking, there are two kinds of drawing: linear and solid. Linear drawing—for example, a floor plan—embraces design or scale. Solid drawing attempts to render bulk or three-dimensional quality on a flat plane of paper or canvas. The first involves no consideration of light and shadow. The latter gives it every consideration. It is possible, however, without light and shadow, to make a flat or outline drawing of a figure and still suggest its bulk. Therefore it is logical to begin with the figure in flat dimension—start out with proportion, carry it from the flat to the round, and then proceed to render the bulk in space or in terms of light and shadow.

The eye perceives form much more readily by contour or edge than by the modeling. Yet there is really no outline on form; rather, there is a silhouette of contour, encompassing as much of the form as we can see from a single viewpoint. We must of necessity limit that form some way. So we draw a line—an outline. An outline truly belongs within the category of flat rendering, though it can be accompanied by the use of light

and shadow. The painter dispenses with outline because he can define contours against other masses or build out the form in relief by the use of values.

You must understand the difference between contour and line. A piece of wire presents a line. A contour is an edge. That edge may be a sharp limitation to the form (the edges of a cube) or a rounded and disappearing limitation (the contour of a sphere). Many contours pass in front of one another, like the contours of an undulating landscape. Line figure drawing, even as landscape drawing, demands foreshortening in order to produce the effect of solid form. You cannot outline a figure with a bent wire and hope to render its solid aspect. Look for two kinds of lines: the flowing or rhythmic line, weaving it about the form; and, for the sake of stability and structure, the contrasting straight or angular line.

Line can have infinite variety, or it can be intensely monotonous. Even if you start with a bent wire, you need not make it entirely monotonous. You can vary the weight of line. When you are drawing a contour that is near a very light area, you can use a light line or even omit it entirely. When the line represents a contour that is dark and strong, you can give it more weight and vitality. The slightest outline drawing can be inventive and expressive.

Take up your pencil and begin to swing it over your paper; then let it down. That is a "free" line, a "rhythmic" line. Now, grasping your pencil lightly between thumb and index finger, draw lightly or delicately. Then bear down as though you really meant it. That is a "variable" line. See if you can draw a straight line and then set down another parallel to it. That is a "studied" line.

If you have considered a line as merely a mark, it may be a revelation to you that line alone possesses so much variation that you can worry over it for the rest of your days. Remember that line is something to turn to when your drawings are dull. You can start expressing your individuality with the kinds of line you draw.

Now to the figure. What is the height-to-width relationship of an ideal figure? An ideal figure standing straight must fit within a certain rectangle. What is that rectangle? See drawing, page 26. The simplest and most convenient unit for measuring the figure is the head. A normal person will fall short of our ideal by half a head—he will measure only seven and a half heads instead of eight. You need not take eight heads as an absolute measure. Your ideal man may have any proportions you wish, but he is usually made tall. On pages 26 to 29 you will find various proportions in head units. Note that at any time you can vary your proportions to suit the particular problem. Study these carefully and draw them, two or three times, for you will use them, consciously or not, every time you set up a figure. Some artists prefer the legs even a little longer than shown. But, if the foot is shown tipped down in perspective, it will add considerable length and be about right.

It is remarkable that most beginners' work looks alike. Analyzing it, I have found certain characteristics that should be mentioned here. I suggest that you compare this list with your own work to see if you can locate some of the characteristics for improvement.

1. *Consistently gray throughout.*
 What to do: First get a soft pencil that will make a good black.
 Pick out the blacks in your subject and state them strongly.
 By contrast, leave areas of white where subject is white or very light.
 Avoid putting overstated grays in light areas.
 Do not surround things that are light with heavy lines.

2. *An overabundance of small fuzzy line.*

Do not "pet" in your line, draw it cleanly with long sweep.

Do not shade with a multitude of little "pecky" strokes.

Use the side of the lead with the pencil laid almost flat for your modeling and shadows.

3. *Features misplaced in a head.*

Learn what the construction lines of the head are and how spaced. (See Head Drawing.)

Build the features into the correct spaces.

4. *Rubbed and dirty, usually in a roll.*

Spray with fixative. If on thin paper, mount on heavier stock.

Try never to break the surface of your paper. This is very bad. If you have done so, start over. Keep your drawings flat. Keep untouched areas scrupulously clean with a kneaded eraser.

5. *Too many mediums in same picture.*

Make your subject in one medium. Do not combine wax crayons with pencil, or pastel with something else. Make it all pencil, all crayon, all pastel, all water color, or all pen and ink. It gives a certain consistency. Later on you may combine different mediums effectively but do not start that way.

6. *The tendency to use tinted papers.*

A black and white drawing looks better on white paper than anything else.

If you have to use tinted paper, then work in a color that is harmonious. For instance a brown or red conte crayon on a tan or cream paper.

It is better to put your color on white for clarity.

7. *Copies of movie stars.*

This gets intensely monotonous to anyone inspecting a beginner's work. The heads are usually badly lighted from a drawing standpoint. Take a head that is not well known.

8. *Bad arrangement.*

If you are doing a vignetted head, plan interesting and attractive shapes. Don't run over to the edge of the paper unless whole space is to be squared off.

9. *Highlights in chalk.*

It takes a very skillful artist to do this successfully.

10. *Uninteresting subjects.*

Just a costume does not make a picture. Every picture should have some interest if possible other than a technical demonstration. Heads should portray character, or expression. Other subjects should have mood or action or sentiment to make it interesting.

Water color is perhaps the most tricky medium of all. Yet most beginners take to it. Water color to be effective should be broad in treatment, with large loose washes, and not too finicky. If you find yourself stippling and pecking you can be pretty sure it will not be liked.

Water color should have a feeling of the "accidental" or color that has done something of its own and dried that way. Lovely effects are obtained by dampening an area first and then flowing the color into the wet area. Use a real water color paper or board, for it can get very messy on a soft and very absorbent paper. The less you have to go over what you have once put down, the better. Generally water-colorists prefer not to leave a lot of pencil, especially dark or shaded pencil showing through. Some water-colorists work by washing in a general tone, scrubbing out the lights with a soft sponge or brush, and washing in the halftones and darks over the original tone. If you are unable to handle water color in any other way than by pecking in little strokes, I would suggest you try pastel which can be spread and rubbed at will. Oil paint has the advantage that it stays wet long enough to maneuver the color as you wish.

IDEAL PROPORTION, MALE

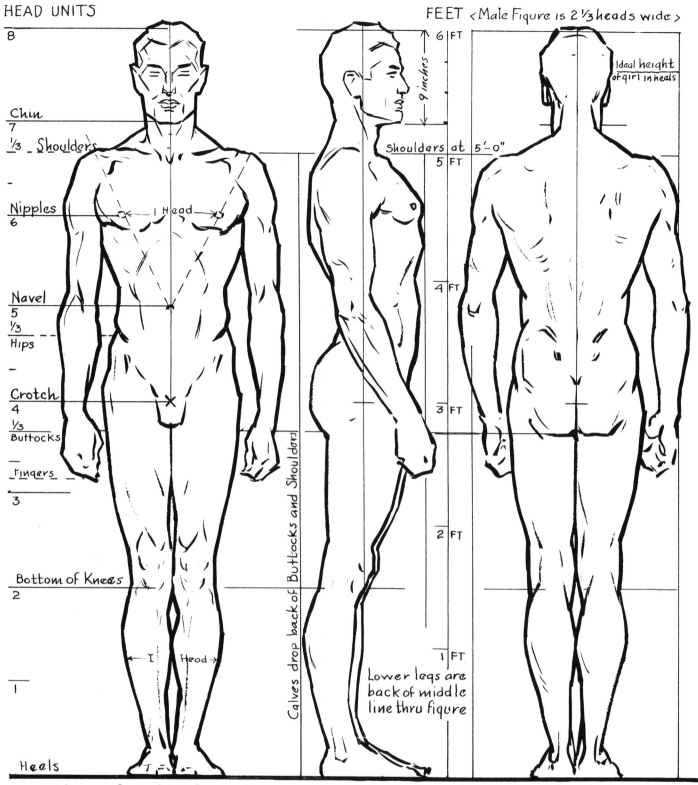

HEAD UNITS

8

Chin
7

⅓ Shoulders

Nipples
6

Navel
5

⅓

Hips

Crotch
4

⅓
Buttocks

Fingers
3

Bottom of Knees
2

1

Heels

1 Head

1 Head

Calves drop back of Buttocks and Shoulders

FEET ‹Male Figure is 2⅓ heads wide›

6 FT
9 inches

Shoulders at 5'-0"
5 FT

4 FT

3 FT

2 FT

1 FT

Lower legs are
back of middle
line thru figure

Ideal height
of girl in heads

Take any desired height, or place points for top of head and heels. Divide into eighths. Two and one third of these units will be the relative width for the male figure. It is not necessary at this stage to attempt to render the anatomy correctly. But fix in your mind the divisions.

Draw the figure in the three positions: front, side, and back. Note the comparative widths at shoulders, hips, and calves. Note that the space between nipples is one head unit. The waist is a little wider than one head unit. The wrist drops just below the crotch. The elbows are about on a line with the navel. The knees are just above the lower quarter of the figure. The shoulders are one-sixth of the way down. The proportions are also given in feet so that you may accurately relate your figure to furniture and interiors.

26

IDEAL PROPORTION, FEMALE

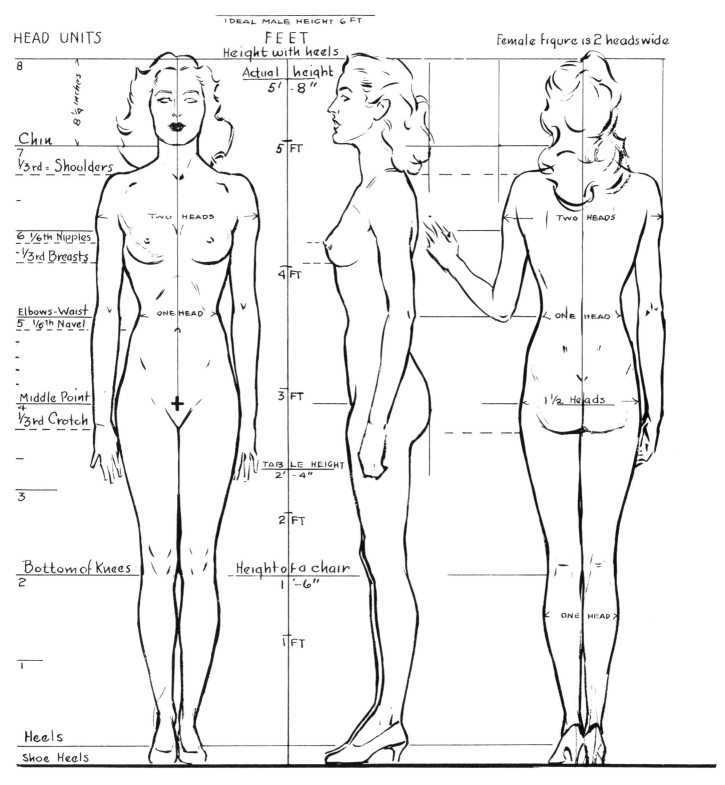

HEAD UNITS

IDEAL MALE HEIGHT 6 FT

FEET
Height with heels
Actual height
5' - 8"

Female figure is 2 heads wide

8

8½ inches

Chin
7
⅓rd = Shoulders

5 FT

TWO HEADS

6 ⅙th Nipples
⅓rd Breasts

4 FT

Elbows-Waist
5 ⅙th Navel

ONE HEAD

TWO HEADS

ONE HEAD

Middle Point
4
⅓rd Crotch

3 FT

1½ Heads

TABLE HEIGHT
2' - 4"

2 FT

3

Bottom of Knees
2

Height of a chair
1' - 6"

ONE HEAD

1 FT

1

Heels
Shoe Heels

The female figure is relatively narrower—two heads at the widest point. The nipples are slightly lower than in the male. The waistline measures one head unit across. In front the thighs are slightly wider than the armpits, narrower in back. It is optional whether or not you draw the legs even a little longer from the knees down. Wrists are even with crotch. Five feet eight inches (in heels) is considered an ideal height for a girl. Actually, of course, the average girl has shorter legs and somewhat heavier thighs. Note carefully that the female navel is below the waistline; the male, above or even with it. The nipples and navel are one head apart, but both are dropped below the head divisions. The elbow is above the navel. It is important that you learn the variations between the male and female figure.

VARIOUS STANDARDS OF PROPORTION

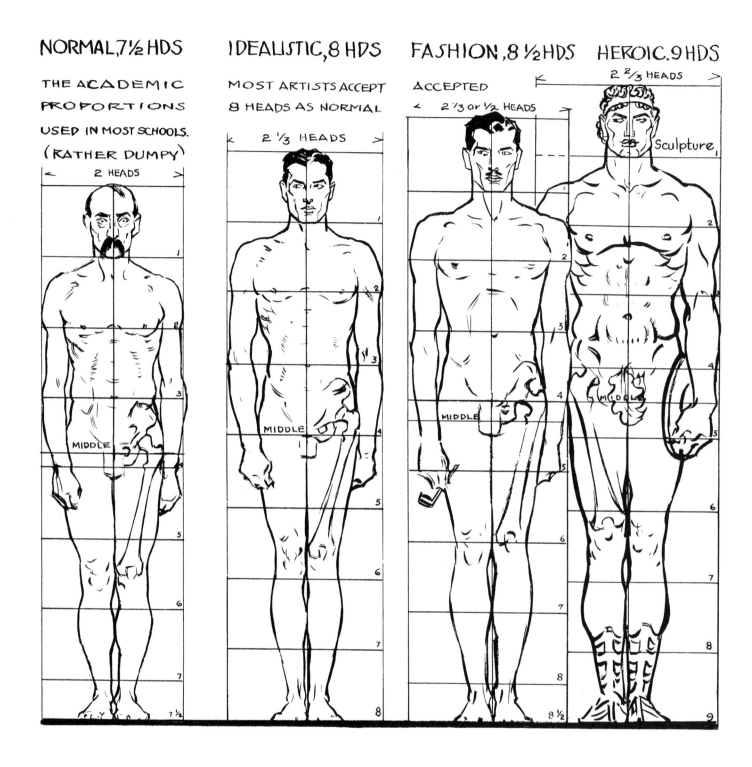

NORMAL, 7½ HDS

THE ACADEMIC PROPORTIONS USED IN MOST SCHOOLS. (RATHER DUMPY)

2 HEADS

MIDDLE

IDEALISTIC, 8 HDS

MOST ARTISTS ACCEPT 8 HEADS AS NORMAL

2⅓ HEADS

MIDDLE

FASHION, 8½ HDS

ACCEPTED

2⅓ or ½ HEADS

MIDDLE

HEROIC, 9 HDS

2⅔ HEADS

Sculpture

MIDDLE

You can see at a glance why the actual or normal proportions are not very satisfactory. All academic drawings based on normal proportions have this dumpy, old-fashioned look. Most fashion artists stretch the figure even beyond eight heads, and in allegorical or heroic figures the "superhuman" type — nine heads — may be used effectively. Note at what point, or head unit, the middle of the figure falls in each. It would be well to draw the side and back in these various proportions, using the previous page for a general guide but changing the proportion. You can control the appearance of height or shortness in any figure by the relative size of the head you use.

28

IDEAL PROPORTIONS AT VARIOUS AGES

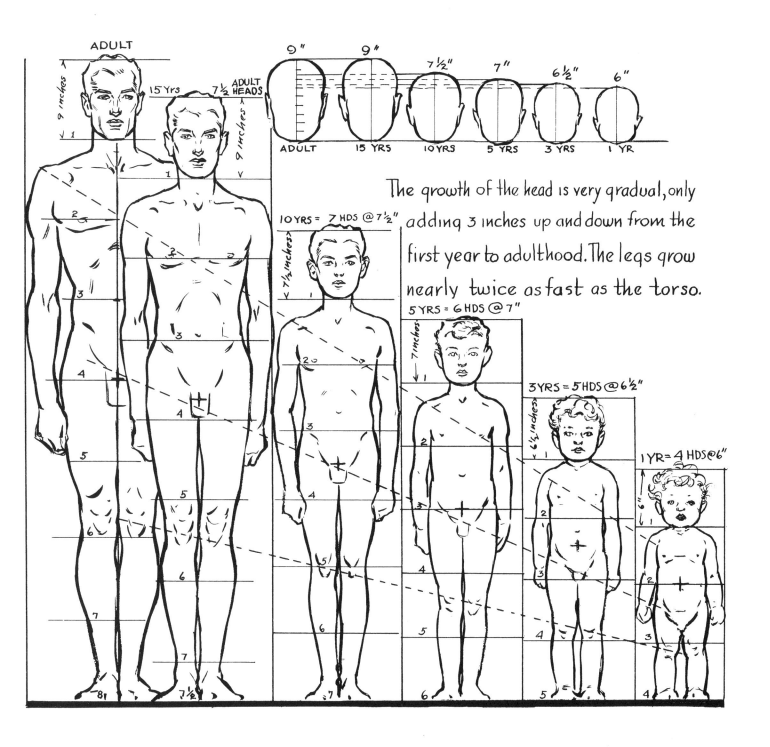

The growth of the head is very gradual, only adding 3 inches up and down from the first year to adulthood. The legs grow nearly twice as fast as the torso.

These proportions have been worked out with a great deal of effort and, as far as I know, have never before been put down for the artist. The scale assumes that the child will grow to be an ideal adult of eight head units. If, for instance, you want to draw a man or a woman (about half a head shorter than you would draw the man) with a five-year-old boy, you have here his relative height. Children under ten are made a little shorter and chubbier than normal, since this effect is considered more desirable; those over ten, a little taller than normal — for the same reason.

29

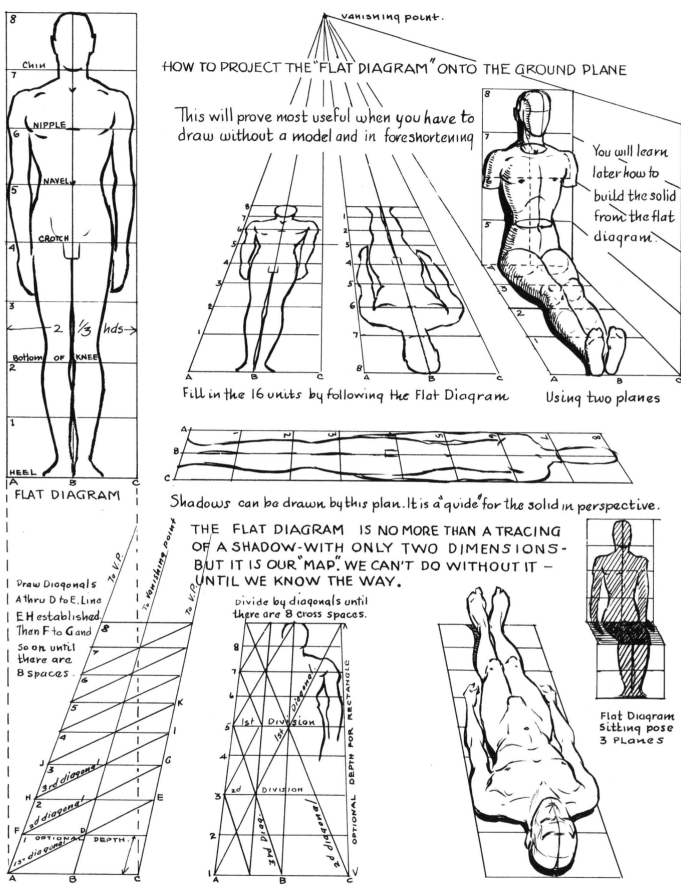

vanishing point.

HOW TO PROJECT THE "FLAT DIAGRAM" ONTO THE GROUND PLANE

This will prove most useful when you have to draw without a model and in foreshortening

You will learn later how to build the solid from the flat diagram.

8 Chin 7 NIPPLE 6 NAVEL 5 CROTCH 4 3 — 2 ⅓ hds → Bottom OF KNEE 2 1 HEEL

A B C

FLAT DIAGRAM

Fill in the 16 units by following the Flat Diagram

Using two planes

Shadows can be drawn by this plan. It is a "guide" for the solid in perspective.

THE FLAT DIAGRAM IS NO MORE THAN A TRACING OF A SHADOW-WITH ONLY TWO DIMENSIONS- BUT IT IS OUR "MAP". WE CAN'T DO WITHOUT IT — UNTIL WE KNOW THE WAY.

Draw Diagonals A thru D to E. Line E H established. Then F to G and So on until there are 8 spaces.

To V.P. To Vanishing point To V.P.

3rd diagonal
2d diagonal
1 OPTIONAL DEPTH.
1st diagonal

A B C

Divide by diagonals until there are 8 cross spaces.

1st Division
2d DIVISION

OPTIONAL DEPTH FOR RECTANGLE

A B C V

Flat Diagram Sitting pose 3 PLANES

Two ways of rendering the "Box" of the Flat Diagram in perspective. You are urged to learn this now. It will help you out of many difficulties later on.

Showing how the principle applies to difficult foreshortening to be explained.

THE FLAT DIAGRAM
OTHER IMPORTANT USES OF THE "MAP" OR FLAT DIAGRAM.

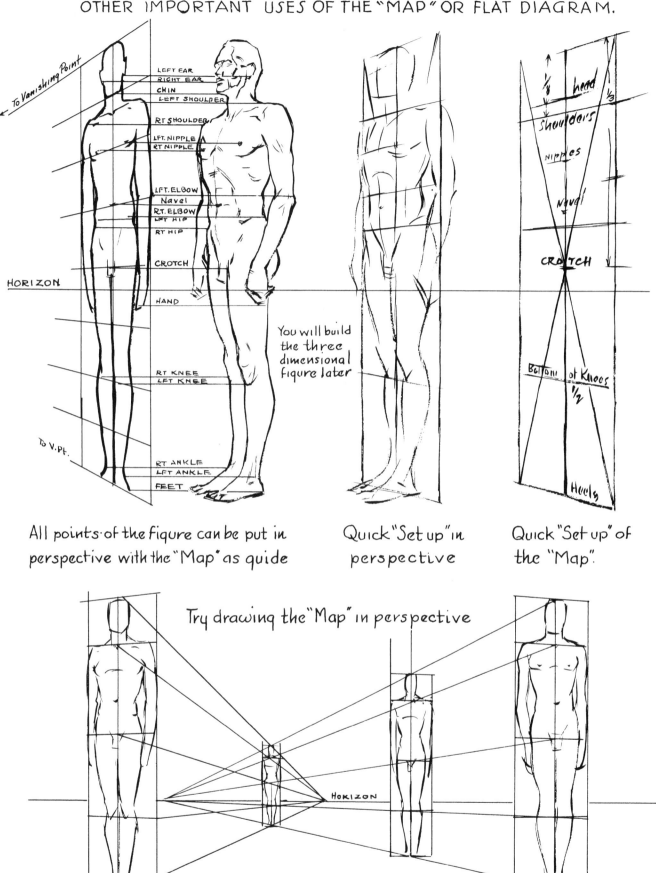

All points of the figure can be put in perspective with the "Map" as guide

Quick "Set up" in perspective

Quick "Set up" of the "Map".

Try drawing the "Map" in perspective

The proportions of one figure can easily be projected by perspective to others.

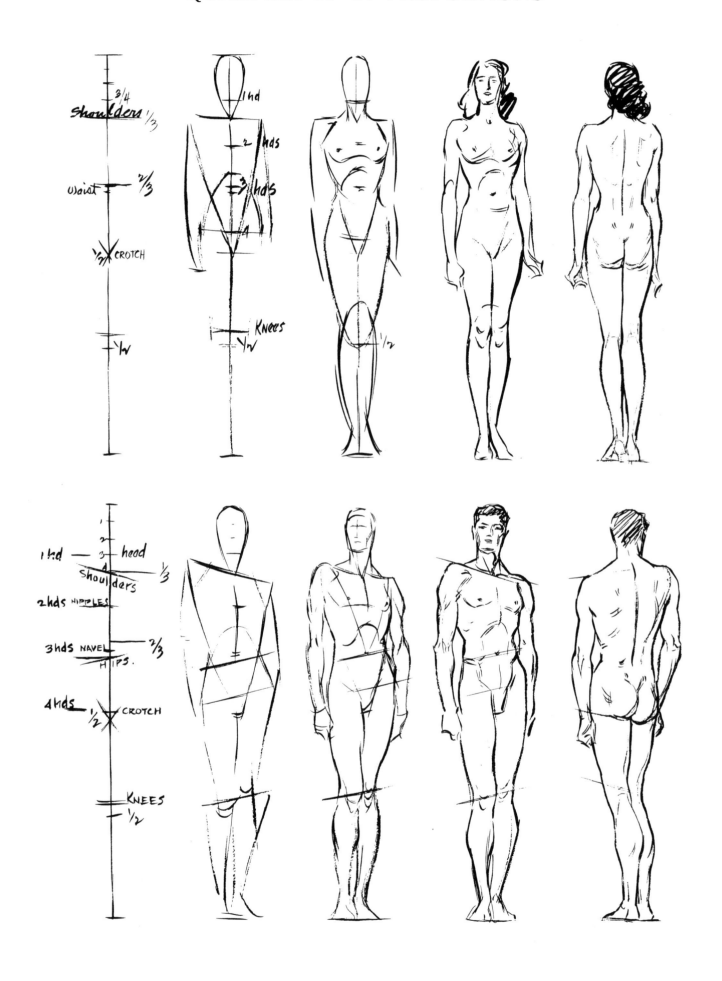

PROPORTIONS BY ARCS AND HEAD UNITS

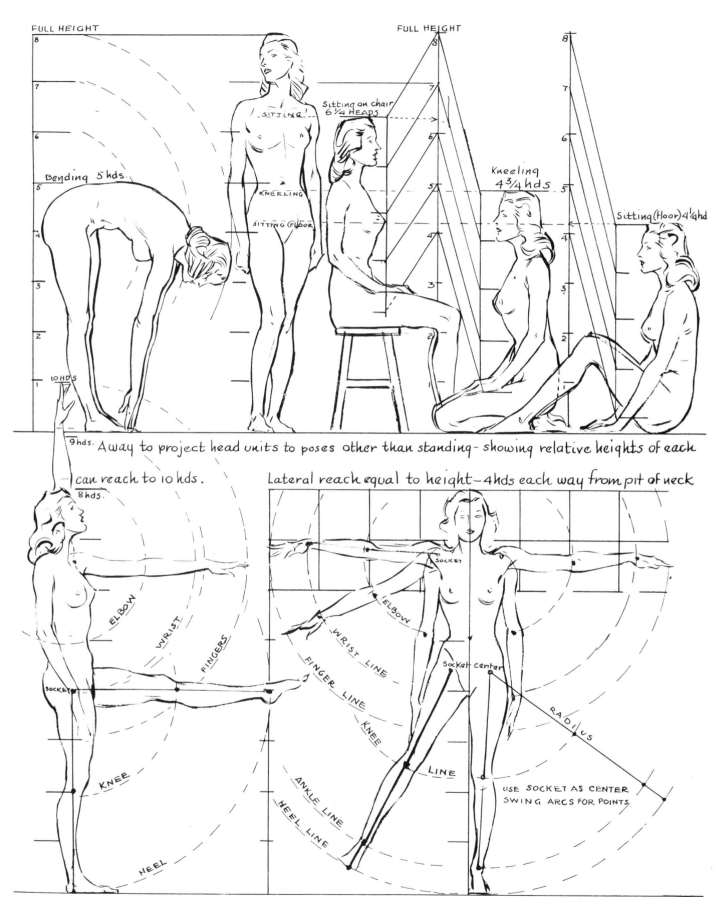

FULL HEIGHT

FULL HEIGHT

8
7
6
5
4
3
2
1

Bending 5 hds.

SITTING

Sitting on chair
6¼ HEADS

KNEELING

SITTING (FLOOR)

Kneeling
4¾ hds

Sitting (floor) 4¼ hd

10 HDS

9 hds. A way to project head units to poses other than standing - showing relative heights of each

can reach to 10 hds.

8 hds.

Lateral reach equal to height - 4 hds each way from pit of neck

ELBOW

WRIST

FINGERS

SOCKET

KNEE

HEEL

SOCKET

ELBOW

WRIST LINE

FINGER LINE

KNEE

LINE

ANKLE LINE

HEEL LINE

SOCKET

Socket center

RADIUS

USE SOCKET AS CENTER
SWING ARCS FOR POINTS

A simple method of finding lengths of extended limbs. Later you will do this in perspective.

PROPORTION IN RELATION TO THE HORIZON

How to build your picture and figures from any eye level (or Horizon, which means the same)

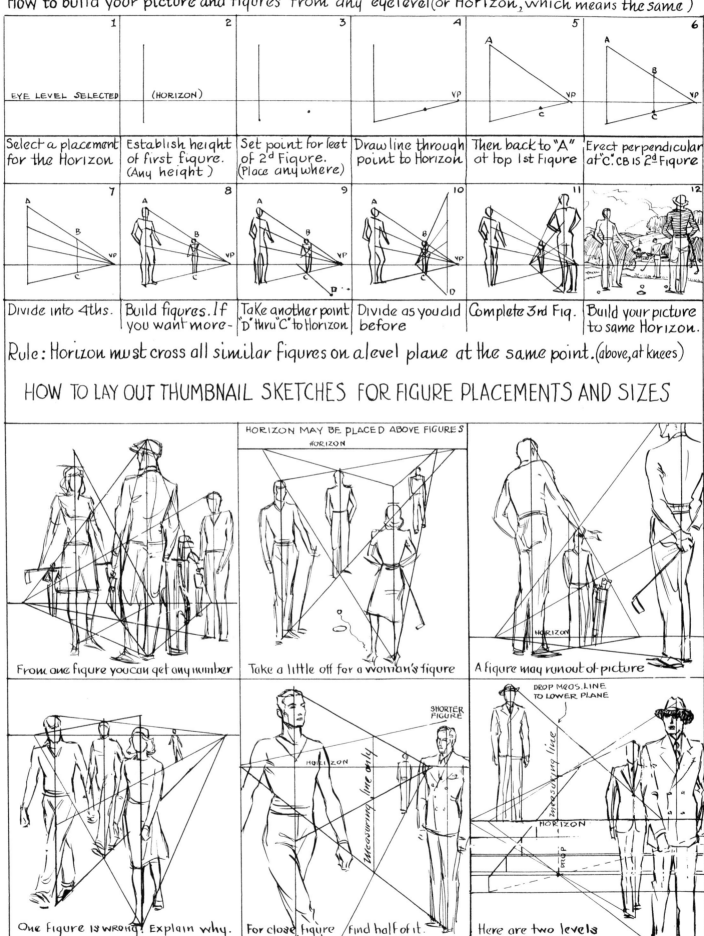

1	2	3	4	5	6
EYE LEVEL SELECTED	(HORIZON)		VP	VP	VP
Select a placement for the Horizon	Establish height of first figure. (Any height)	Set point for feet of 2ᵈ Figure. (Place anywhere)	Draw line through point to Horizon	Then back to "A" at top 1st Figure	Erect perpendicular at "C". CB is 2ᵈ Figure

7	8	9	10	11	12
Divide into 4ths.	Build figures. If you want more—	Take another point "D" thru "C" to Horizon	Divide as you did before	Complete 3rd Fig.	Build your picture to same Horizon.

Rule: Horizon must cross all similar figures on a level plane at the same point. (above, at knees)

HOW TO LAY OUT THUMBNAIL SKETCHES FOR FIGURE PLACEMENTS AND SIZES

From one figure you can get any number

HORIZON MAY BE PLACED ABOVE FIGURES
HORIZON

Take a little off for a woman's figure

HORIZON
A figure may run out of picture

One figure is wrong! Explain why.

HORIZON
Measuring line only
SHORTER FIGURE
For close figure / find half of it.

DROP MEOS. LINE TO LOWER PLANE
measuring line
HORIZON
DROP
Here are two levels

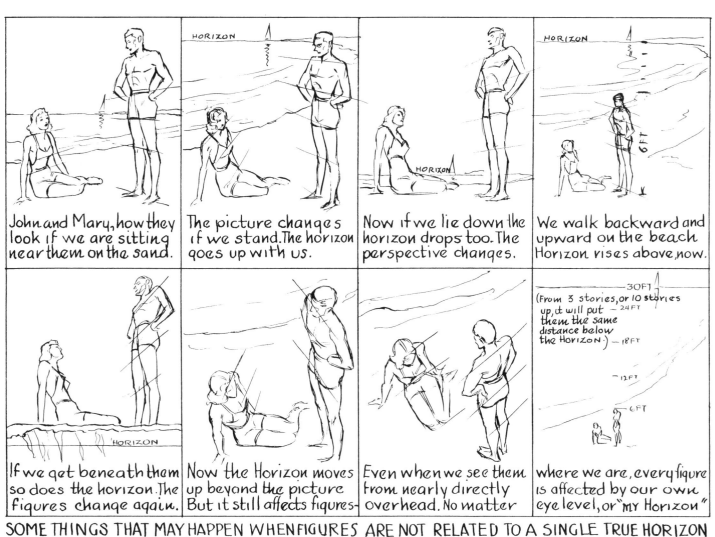

John and Mary, how they look if we are sitting near them on the sand.

The picture changes if we stand. The horizon goes up with us.

Now if we lie down the horizon drops too. The perspective changes.

We walk backward and upward on the beach Horizon rises above, now.

If we get beneath them so does the horizon. The figures change again.

Now the Horizon moves up beyond the picture But it still affects figures-

Even when we see them from nearly directly overhead. No matter

(From 3 stories, or 10 stories up, it will put them the same distance below the Horizon.) where we are, every figure is affected by our own eye level, or "MY Horizon"

SOME THINGS THAT MAY HAPPEN WHEN FIGURES ARE NOT RELATED TO A SINGLE TRUE HORIZON

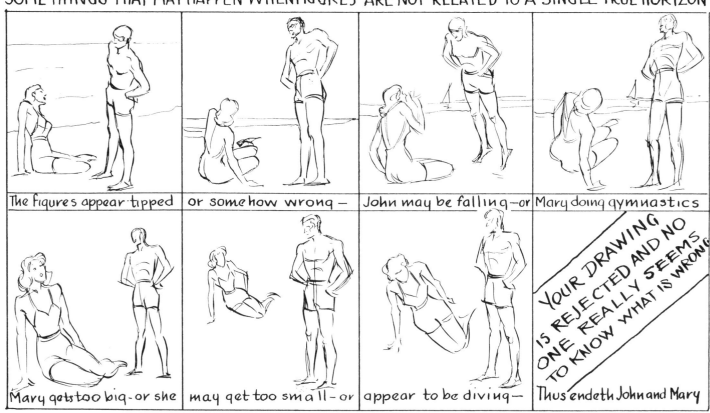

The figures appear tipped

or somehow wrong —

John may be falling — or

Mary doing gymnastics

Mary gets too big - or she

may get too small - or

appear to be diving —

YOUR DRAWING IS REJECTED AND NO ONE REALLY SEEMS TO KNOW WHAT IS WRONG

Thus endeth John and Mary

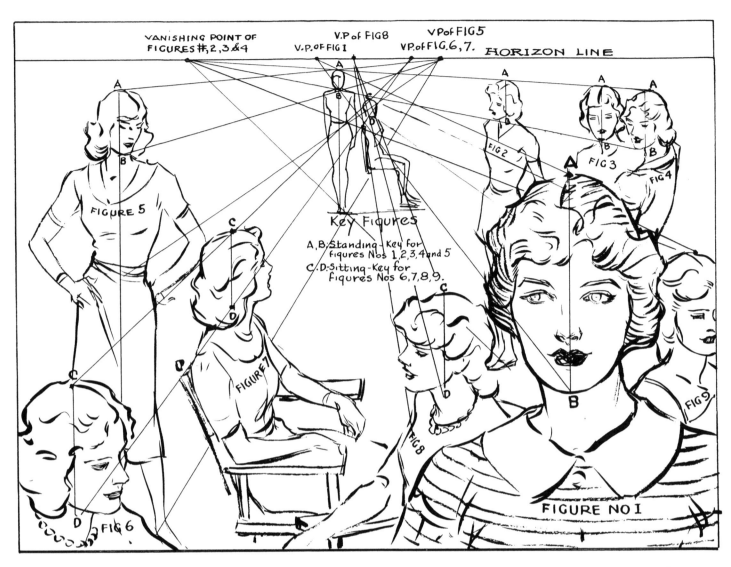

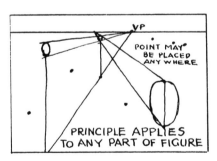

Many artists have difficulty in placing figures in their picture and properly relating them to each other, especially if the complete figure is not shown. The solution is to draw a key figure for standing or sitting poses. Either the whole figure or any part of it can then be scaled with the horizon. *AB* is taken as the head measurement and applied to all standing figures; *CD* to the sitting figures. This applies *when all figures are on the same ground plane.* (On page 37 there is an explanation of how to proceed when the figures are at different levels.) You can place a point anywhere within your space and find the relative size of the figure or portion of the figure at precisely that spot. Obviously everything else should be drawn to the same horizon and scaled so that the figures are relative. For instance, draw a key horse or cow or chair or boat. The important thing is that all figures retain their size relationships, no matter how close or distant. A picture can have only one horizon, and only one station point. The horizon moves up or down with the observer. It is not possible to look over the horizon, for it is constituted by the eye level or lens level of the subject. The horizon on an open, flat plane of land or water is visible. Among hills or indoors it may not be actually visible, but your eye level determines it. If you do not understand perspective, there is a good book on the subject, *Perspective Made Easy,* available at most booksellers.

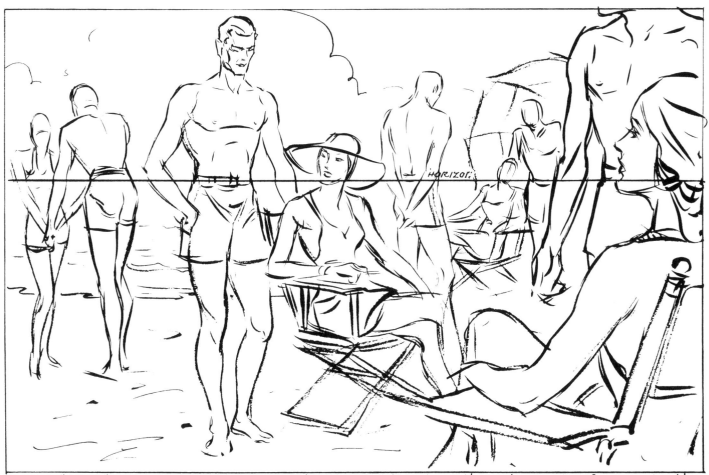

You can "hang" your figures on the Horizon line by making it cut through similar figures in the same place. This keeps them on the same ground plane. Note Horizon cuts men at waist and the seated women at chin. The one standing woman at left is drawn relative to the men. Simple?

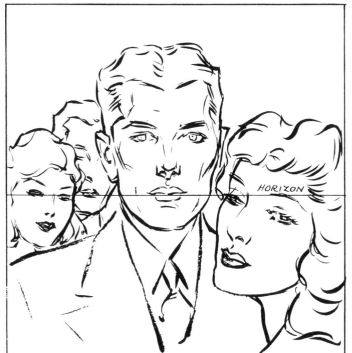

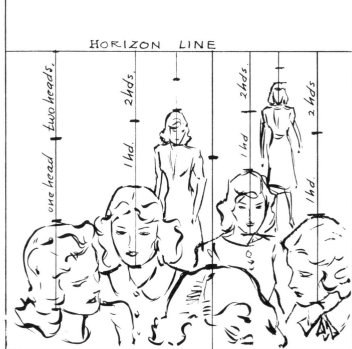

You can also "hang" heads on the Horizon line. In this case it cuts men's heads at the mouth, the womens at the eyes.

Here we have measured a proportionate distance down from the Horizon. I have taken two heads as an optional space.

WE BEGIN TO DRAW: FIRST THE MANNIKIN FRAME

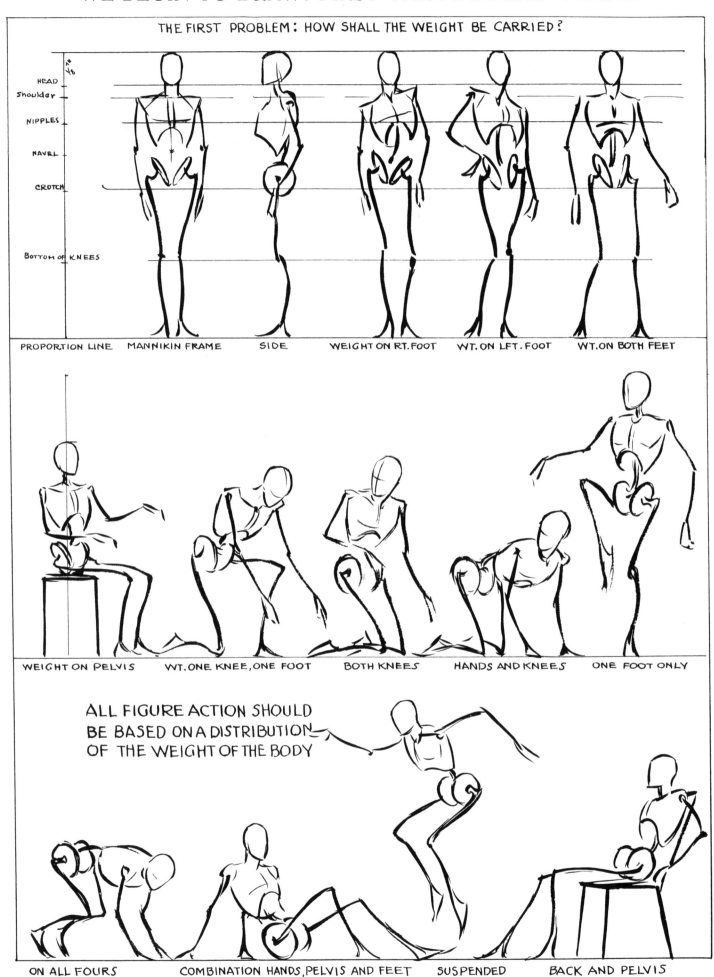

THE FIRST PROBLEM: HOW SHALL THE WEIGHT BE CARRIED?

HEAD
Shoulder
NIPPLES
NAVEL
CROTCH
Bottom of KNEES

PROPORTION LINE MANNIKIN FRAME SIDE WEIGHT ON RT. FOOT WT. ON LFT. FOOT WT. ON BOTH FEET

WEIGHT ON PELVIS WT. ONE KNEE, ONE FOOT BOTH KNEES HANDS AND KNEES ONE FOOT ONLY

ALL FIGURE ACTION SHOULD
BE BASED ON A DISTRIBUTION
OF THE WEIGHT OF THE BODY

ON ALL FOURS COMBINATION HANDS, PELVIS AND FEET SUSPENDED BACK AND PELVIS

38

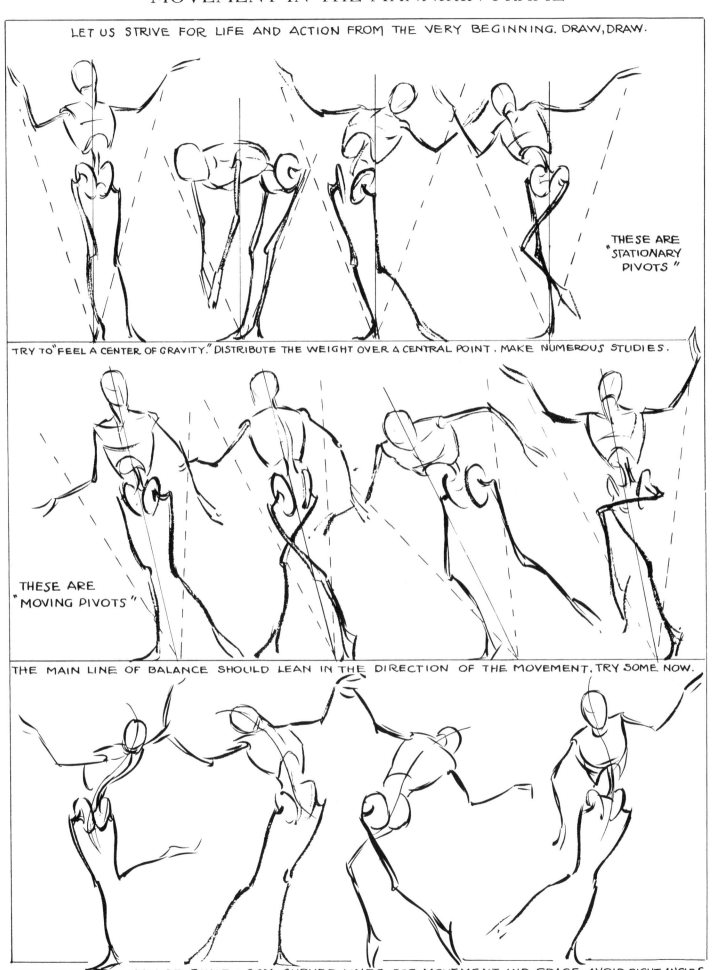

LET US STRIVE FOR LIFE AND ACTION FROM THE VERY BEGINNING. DRAW, DRAW.

THESE ARE "STATIONARY PIVOTS"

TRY TO "FEEL A CENTER OF GRAVITY." DISTRIBUTE THE WEIGHT OVER A CENTRAL POINT. MAKE NUMEROUS STUDIES.

THESE ARE "MOVING PIVOTS"

THE MAIN LINE OF BALANCE SHOULD LEAN IN THE DIRECTION OF THE MOVEMENT. TRY SOME NOW.

YOUR FIGURES MAY BE BUILT UPON CURVED LINES FOR MOVEMENT AND GRACE. AVOID RIGHT ANGLES

DETAILS OF THE MANNIKIN FRAME

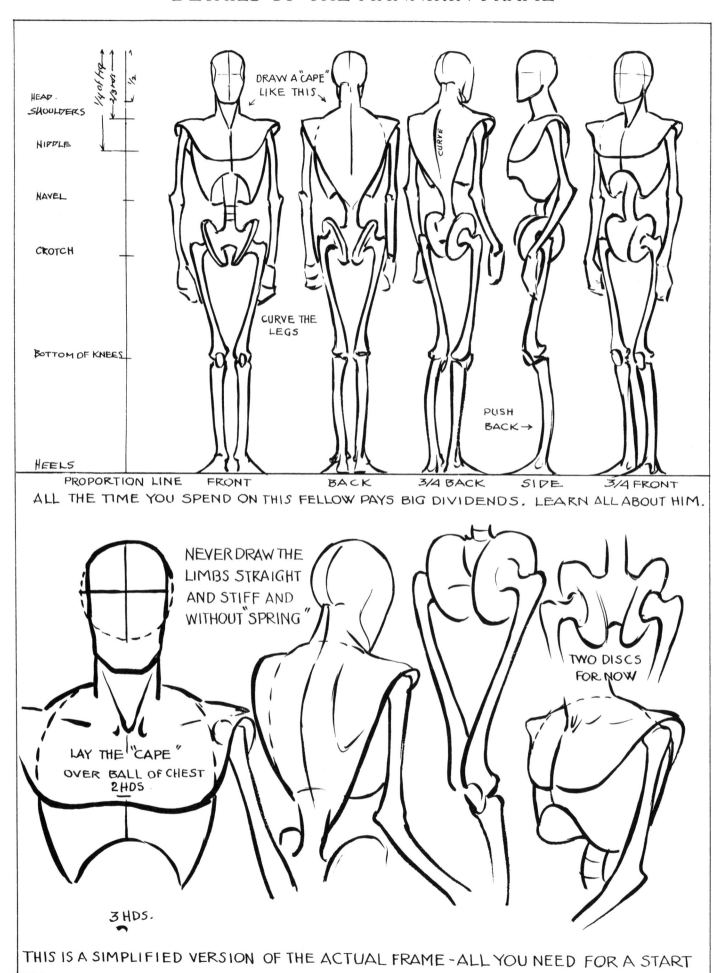

HEAD.
SHOULDERS

NIPPLE

NAVEL

CROTCH

BOTTOM OF KNEES

HEELS

DRAW A "CAPE" LIKE THIS

CURVE

CURVE THE LEGS

PUSH BACK →

PROPORTION LINE FRONT BACK 3/4 BACK SIDE 3/4 FRONT

ALL THE TIME YOU SPEND ON THIS FELLOW PAYS BIG DIVIDENDS. LEARN ALL ABOUT HIM.

NEVER DRAW THE LIMBS STRAIGHT AND STIFF AND WITHOUT "SPRING"

TWO DISCS FOR NOW

LAY THE "CAPE" OVER BALL OF CHEST 2 HDS.

3 HDS.

THIS IS A SIMPLIFIED VERSION OF THE ACTUAL FRAME - ALL YOU NEED FOR A START

40

EXPERIMENTING WITH THE MANNIKIN FRAME

DO A LOT OF EXPERIMENTING. REMEMBER THAT MOST OF THE ACTION IN YOUR FIGURES MUST COME FROM YOU "AS YOU FEEL IT" RATHER THAN FROM A MODEL.

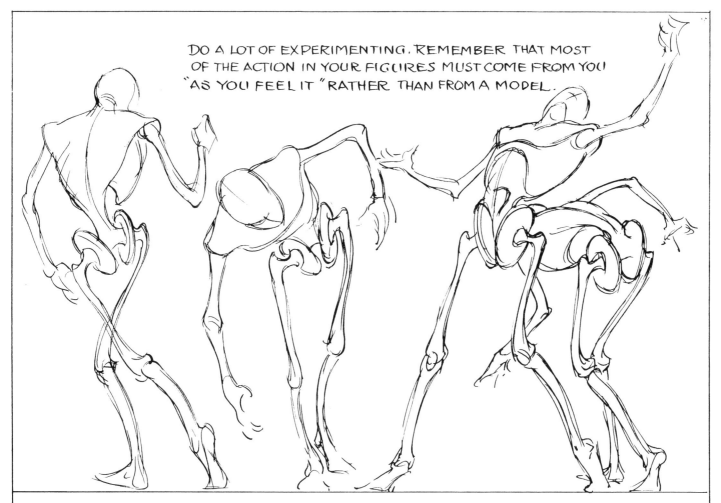

YOU WILL SOON LEARN TO EXPRESS YOURSELF. A VITAL EXPRESSION IS MORE IMPORTANT HERE THAN ACCURACY.

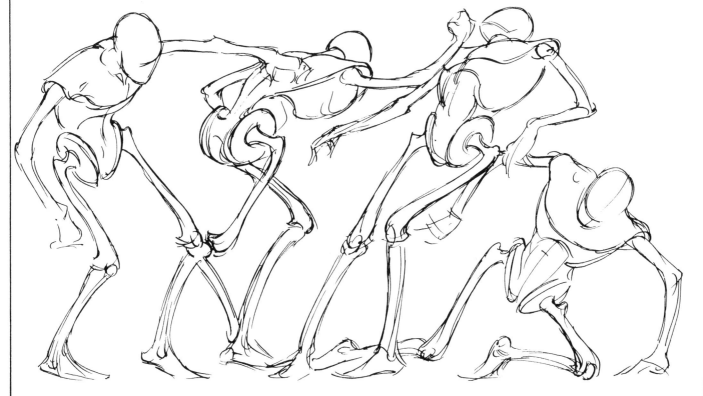

YOU CAN USE THIS TYPE OF SKELETON WHEN PLANNING ROUGHS, LAYOUTS, COMPOSITIONS.

OUTLINES IN RELATION TO SOLID FORM

A. LET US ASSUME WE HAVE OUTLINES OF THREE CIRCLES SET ON 3 ADJACENT PLANES.

ALL SOLIDS MUST HAVE THESE THREE DIMENSIONS.

1 LENGTH

2 BREADTH

3 THICKNESS

B. BY MOVING CIRCLES FORWARD TO A COMMON CENTER, WE PRODUCE A "SOLID" BALL.

NOW TAKE A COMMON OBJECT.

THE "OUTLINES" OF EACH PLANE MAY BE VERY DIFFERENT, BUT PUT TOGETHER, FORM THE SOLID.

FLAT

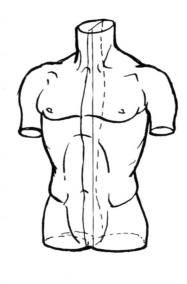

SOLID

SO, IN DRAWING WE MUST ALWAYS TRY TO "FEEL" THE MIDDLE CONTOURS AS WELL AS THE EDGES. THE OUTLINES ALONE CAN SUGGEST SOLIDITY. WATCH HOW EDGES PASS ONE ANOTHER.

THIS WILL NOT BE EASY UNTIL YOU BECOME ABLE TO "THINK ALL AROUND" THE THING YOU HAPPEN TO BE DRAWING, TRULY KNOWING ALL OF THE FORM.

THE MANNIKIN FIGURE

The foregoing has given us a general framework to which we can now add a simplification of the bulk or solid aspect of the figure. It would be both tedious and superfluous if, every time we drew a figure, we went through the whole procedure of figure drawing. The artist will want to make roughs and sketches that can serve as an understructure for pose or action—perhaps to cover with clothing, perhaps to work out a pose that he will finish with a model. We must have some direct and quick way of indicating or setting up an experimental figure — one with which we can tell a story. The figure set up as suggested in the following pages will usually suffice. Properly done, it can always be developed into the more finished drawing. When you are drawing a mannikin figure, you need not be greatly concerned with the actual muscles or how they affect the surface. The mannikin in drawing is used much as is a "lay" figure, to indicate joints and the general proportion of framework and masses.

The mannikin serves a double purpose here. I believe that the student will do much better to set up the figure this way and get the "feel" of its parts in action than to begin at once with the live model. It will not only serve for rough sketches but will also become an ideal approach to the actual drawing of the figure from life or copy. If you have the frame and masses to begin with, you can later break them down into actual bone and muscle. Then you can more easily grasp the placing and functions of the muscles and what they do to the surface. I am of the opinion that to teach anatomy before proportion—before bulk and mass and action—is to put the cart before the horse. You cannot draw a muscle correctly without a fair estimate of the area it occupies within the figure, without an understanding of why it is there and of how it works.

Think of the figure in a plastic sense, or as something with three dimensions. It has weight that must be held up by a framework which is extremely mobile. The fleshy masses or bulk follows the frame. Some of these masses are knit together quite closely and adhere to the bony structure, whereas other masses are full and thick and will be affected in appearance by action.

If you have never studied anatomy, you may not know that the muscles fall naturally into groups or chunks attached in certain ways to the frame. We will not treat their physiological detail here, but consider them merely as parts interlocked or wedged together. Hence the human figure looks very much like our mannikin. The thorax, or chest, is egg-shaped and, as far as we are concerned, hollow. Over it is draped a cape of muscle extending across the chest and down the back to the base of the spine. Over the cape, in front, lie the shoulder muscles. The buttocks start halfway around in back, from the hips, and slant downward, ending in rather square creases. A V is formed by the slant above the middle crease. There is actually a V-shaped bone here, wedged between the two pelvic bones that support the spine. The chest is joined to the hips by two masses on either side. In back the calf wedges into the thigh, and in front there is the bulge of the knee.

Learn to draw this mannikin as well as you can. You will use it much more often than a careful anatomical rendering. Since it is in proportion in bulk and frame, it may also be treated in perspective. No artist could possibly afford a model for all his rough preliminary work—for layouts and ideas. Yet he cannot intelligently approach his final work without a preliminary draft. If only art directors would base their layouts on such mannikin figures, the finished figures would all stand on the same floor, and heads would not run off the page when drawn correctly.

THE GROUPS OF MUSCLES SIMPLIFIED.

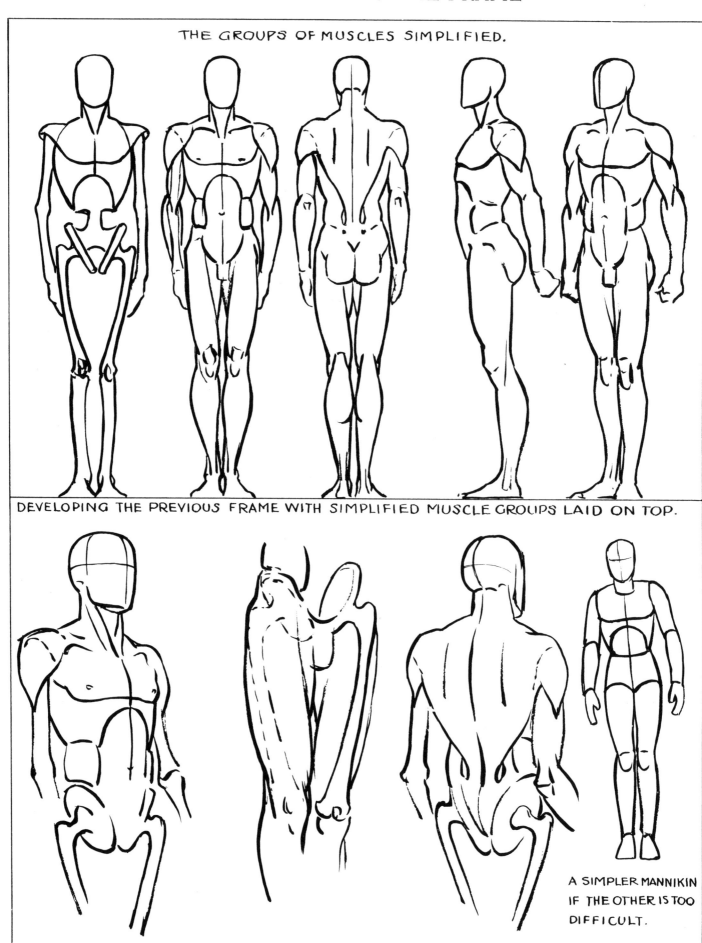

DEVELOPING THE PREVIOUS FRAME WITH SIMPLIFIED MUSCLE GROUPS LAID ON TOP.

A SIMPLER MANNIKIN IF THE OTHER IS TOO DIFFICULT.

WE WILL STUDY THE "ACTUAL" BONE AND MUSCLE CONSTRUCTION LATER. GET THIS.

ADDING PERSPECTIVE TO THE SOLID MANNIKIN

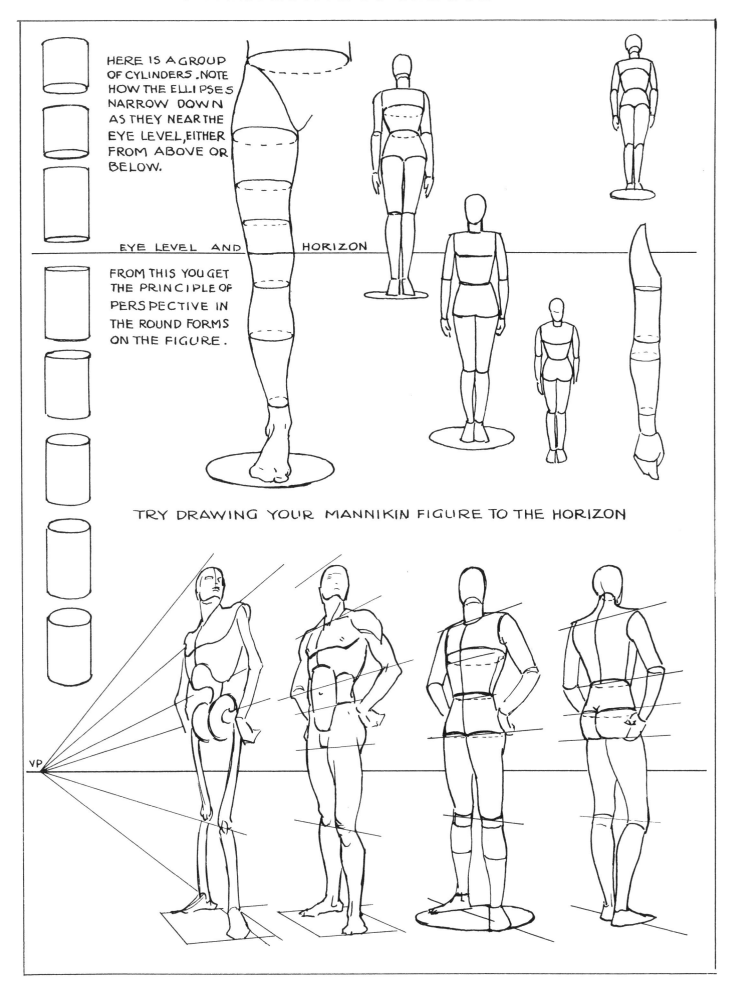

HERE IS A GROUP OF CYLINDERS. NOTE HOW THE ELLIPSES NARROW DOWN AS THEY NEAR THE EYE LEVEL, EITHER FROM ABOVE OR BELOW.

EYE LEVEL AND HORIZON

FROM THIS YOU GET THE PRINCIPLE OF PERSPECTIVE IN THE ROUND FORMS ON THE FIGURE.

TRY DRAWING YOUR MANNIKIN FIGURE TO THE HORIZON

VP

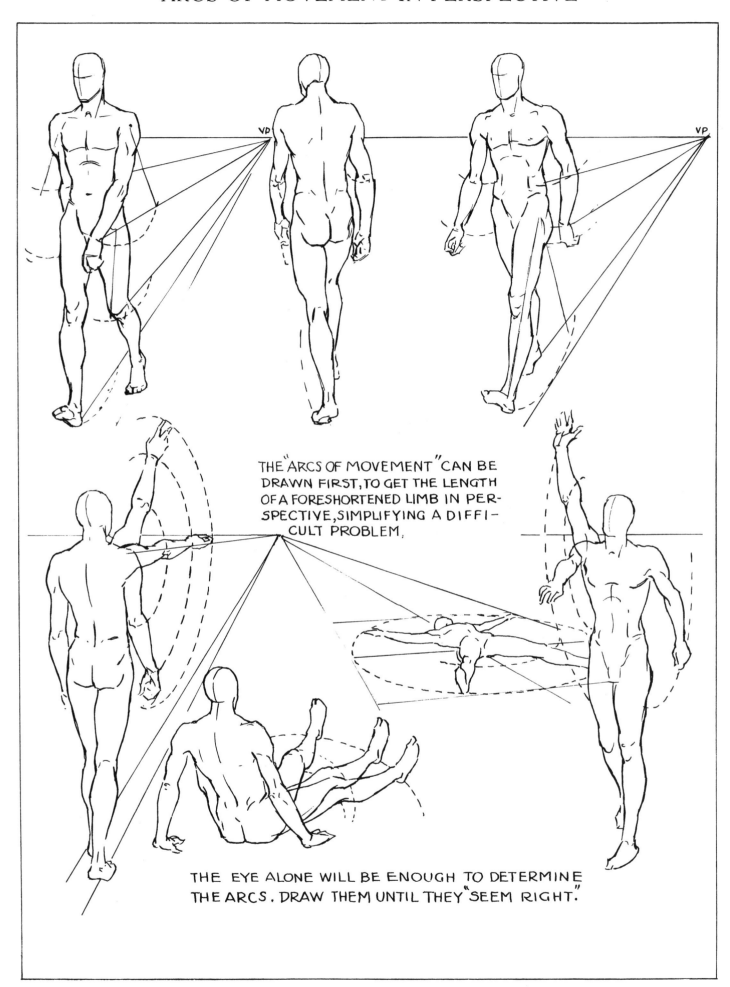

THE "ARCS OF MOVEMENT" CAN BE DRAWN FIRST, TO GET THE LENGTH OF A FORESHORTENED LIMB IN PERSPECTIVE, SIMPLIFYING A DIFFICULT PROBLEM.

THE EYE ALONE WILL BE ENOUGH TO DETERMINE THE ARCS. DRAW THEM UNTIL THEY "SEEM RIGHT."

PLACING THE MANNIKIN AT ANY SPOT OR LEVEL

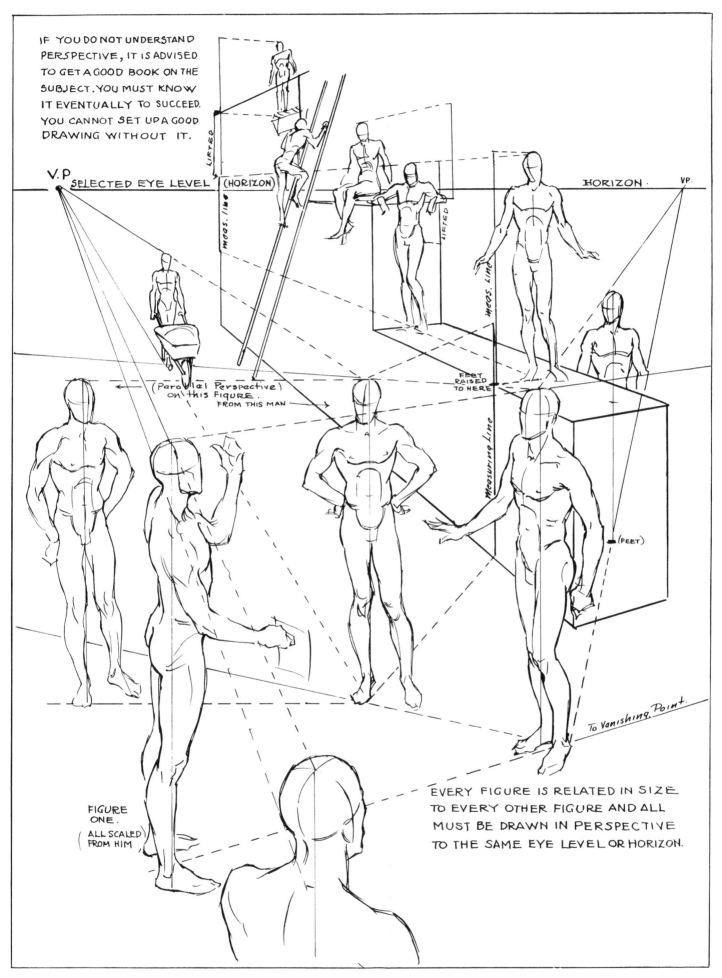

IF YOU DO NOT UNDERSTAND PERSPECTIVE, IT IS ADVISED TO GET A GOOD BOOK ON THE SUBJECT. YOU MUST KNOW IT EVENTUALLY TO SUCCEED. YOU CANNOT SET UP A GOOD DRAWING WITHOUT IT.

V.P SELECTED EYE LEVEL (HORIZON)

HORIZON.

VP.

(Parallel Perspective) on this Figure. FROM THIS MAN

FEET RAISED TO HERE

Measuring Line

(FEET)

To Vanishing Point.

FIGURE ONE. (ALL SCALED FROM HIM)

EVERY FIGURE IS RELATED IN SIZE TO EVERY OTHER FIGURE AND ALL MUST BE DRAWN IN PERSPECTIVE TO THE SAME EYE LEVEL OR HORIZON.

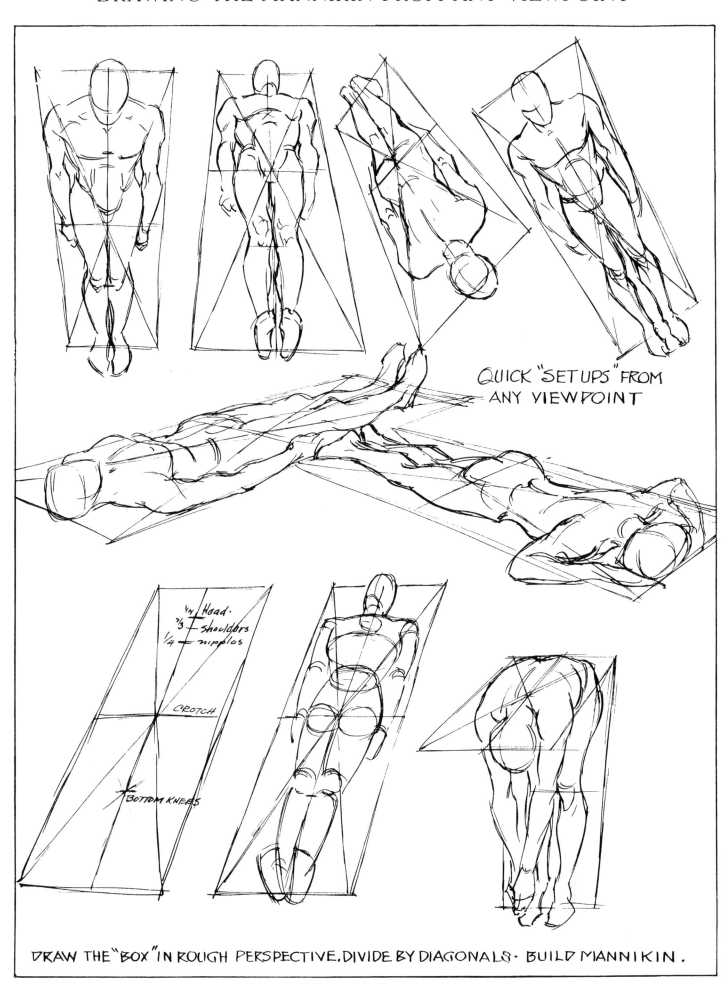

QUICK "SET UPS" FROM ANY VIEWPOINT

¹/₁₄ Head.
²/₃ shoulders
¹/₄ nipples

CROTCH

BOTTOM KNEES

DRAW THE "BOX" IN ROUGH PERSPECTIVE. DIVIDE BY DIAGONALS · BUILD MANNIKIN.

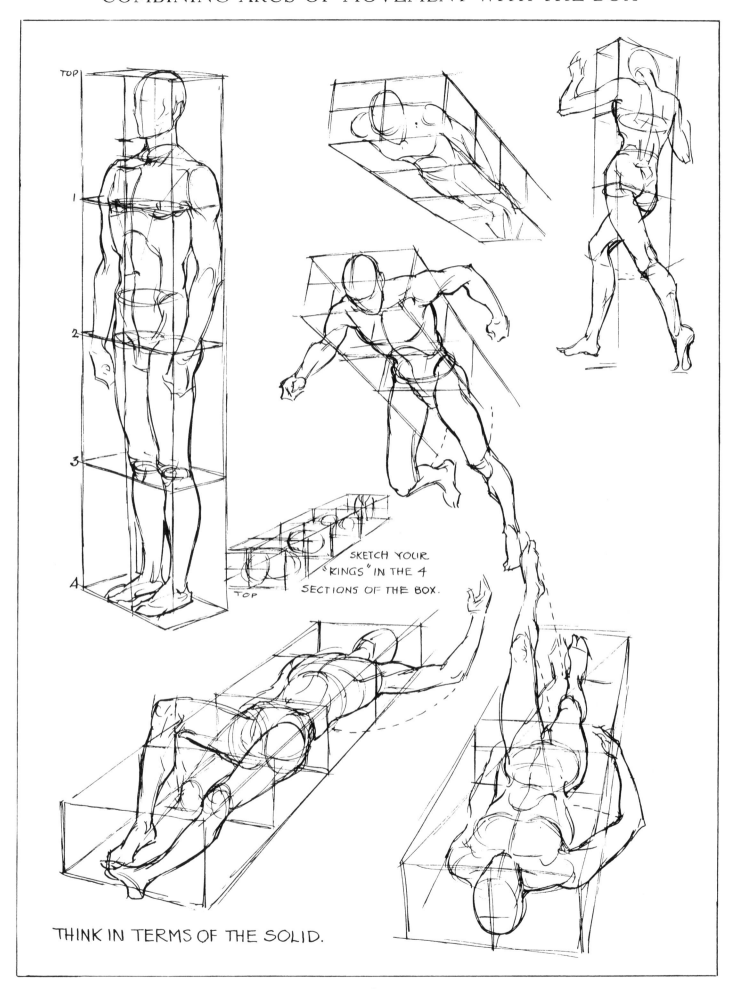

TOP

1

2

3

4

SKETCH YOUR
"RINGS" IN THE 4
SECTIONS OF THE BOX.

TOP

THINK IN TERMS OF THE SOLID.

LANDMARKS YOU SHOULD KNOW

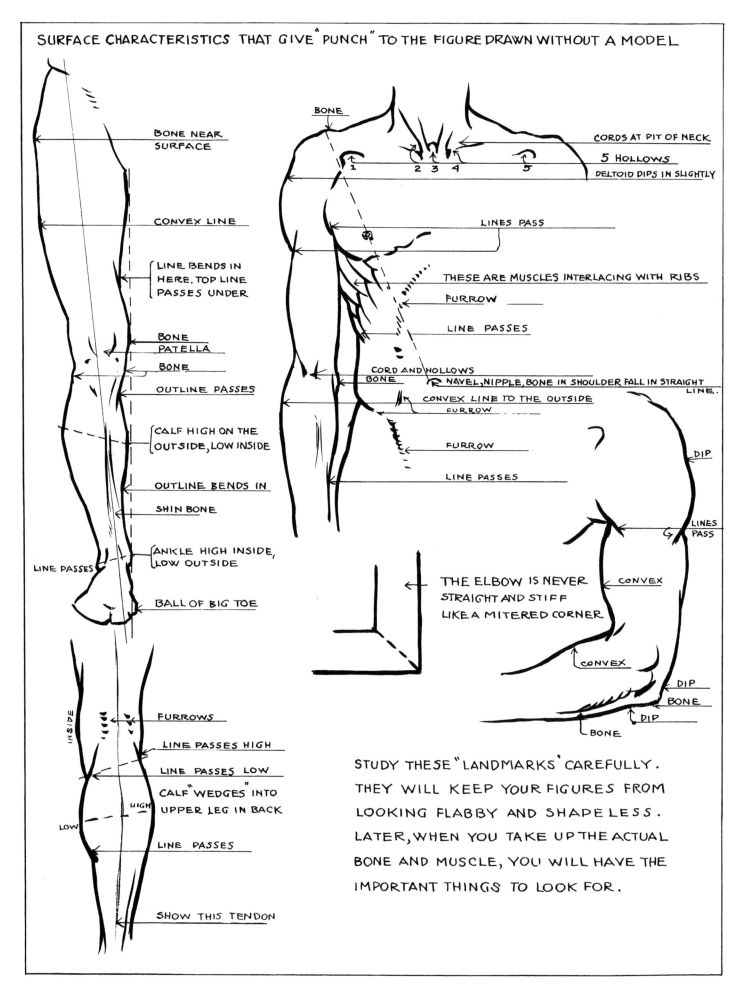

SURFACE CHARACTERISTICS THAT GIVE "PUNCH" TO THE FIGURE DRAWN WITHOUT A MODEL

BONE NEAR SURFACE

CONVEX LINE

LINE BENDS IN HERE, TOP LINE PASSES UNDER

BONE PATELLA

BONE

OUTLINE PASSES

CALF HIGH ON THE OUTSIDE, LOW INSIDE

OUTLINE BENDS IN

SHIN BONE

ANKLE HIGH INSIDE, LOW OUTSIDE

LINE PASSES

BALL OF BIG TOE

INSIDE

FURROWS

LINE PASSES HIGH

LINE PASSES LOW

CALF "WEDGES" INTO UPPER LEG IN BACK

HIGH

LOW

LINE PASSES

SHOW THIS TENDON

BONE

CORDS AT PIT OF NECK

5 HOLLOWS

DELTOID DIPS IN SLIGHTLY

1 2 3 4 5

LINES PASS

THESE ARE MUSCLES INTERLACING WITH RIBS

FURROW

LINE PASSES

CORD AND HOLLOWS

BONE

NAVEL, NIPPLE, BONE IN SHOULDER FALL IN STRAIGHT LINE.

CONVEX LINE TO THE OUTSIDE

FURROW

FURROW

LINE PASSES

DIP

LINES PASS

CONVEX

THE ELBOW IS NEVER STRAIGHT AND STIFF LIKE A MITERED CORNER.

CONVEX

DIP

BONE

DIP

BONE

STUDY THESE "LANDMARKS" CAREFULLY. THEY WILL KEEP YOUR FIGURES FROM LOOKING FLABBY AND SHAPELESS. LATER, WHEN YOU TAKE UP THE ACTUAL BONE AND MUSCLE, YOU WILL HAVE THE IMPORTANT THINGS TO LOOK FOR.

50

LANDMARKS YOU SHOULD KNOW

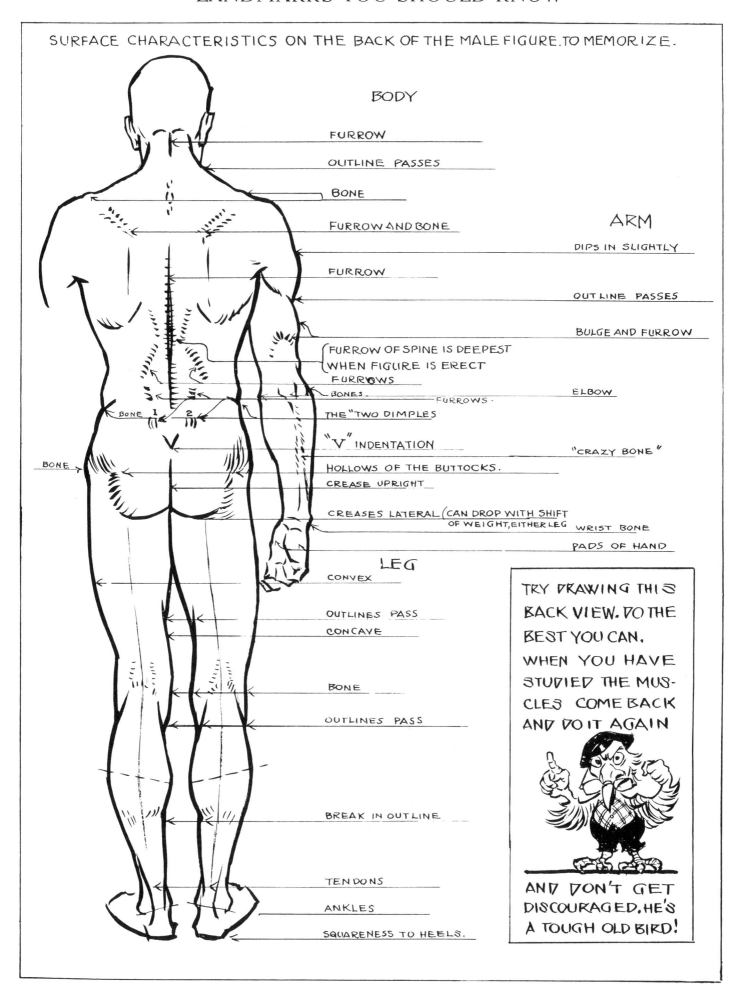

SURFACE CHARACTERISTICS ON THE BACK OF THE MALE FIGURE. TO MEMORIZE.

BODY

FURROW

OUTLINE PASSES

BONE

FURROW AND BONE

ARM

DIPS IN SLIGHTLY

FURROW

OUTLINE PASSES

BULGE AND FURROW

FURROW OF SPINE IS DEEPEST
WHEN FIGURE IS ERECT
FURROWS

BONES.

FURROWS.

ELBOW

BONE 1 2

THE "TWO DIMPLES

"V" INDENTATION

"CRAZY BONE"

BONE

HOLLOWS OF THE BUTTOCKS.

CREASE UPRIGHT

CREASES LATERAL (CAN DROP WITH SHIFT
OF WEIGHT, EITHER LEG WRIST BONE

PADS OF HAND

LEG

CONVEX

OUTLINES PASS

CONCAVE

BONE

OUTLINES PASS

BREAK IN OUTLINE

TENDONS

ANKLES

SQUARENESS TO HEELS.

TRY DRAWING THIS
BACK VIEW. DO THE
BEST YOU CAN.
WHEN YOU HAVE
STUDIED THE MUS-
CLES COME BACK
AND DO IT AGAIN

AND DON'T GET
DISCOURAGED, HE'S
A TOUGH OLD BIRD!

51

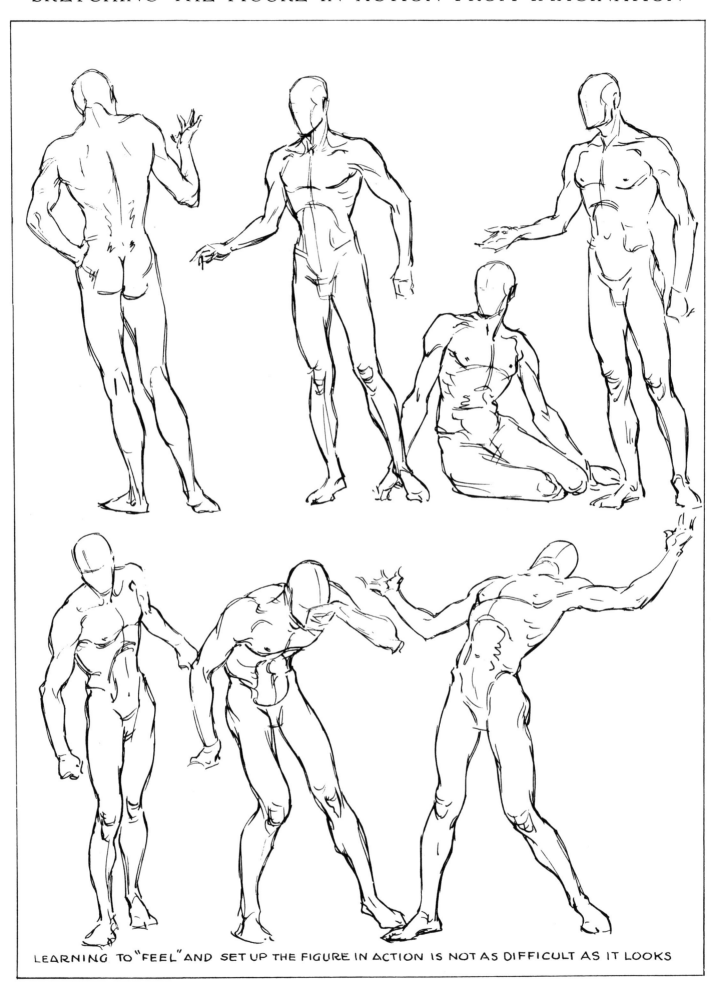

LEARNING TO "FEEL" AND SET UP THE FIGURE IN ACTION IS NOT AS DIFFICULT AS IT LOOKS

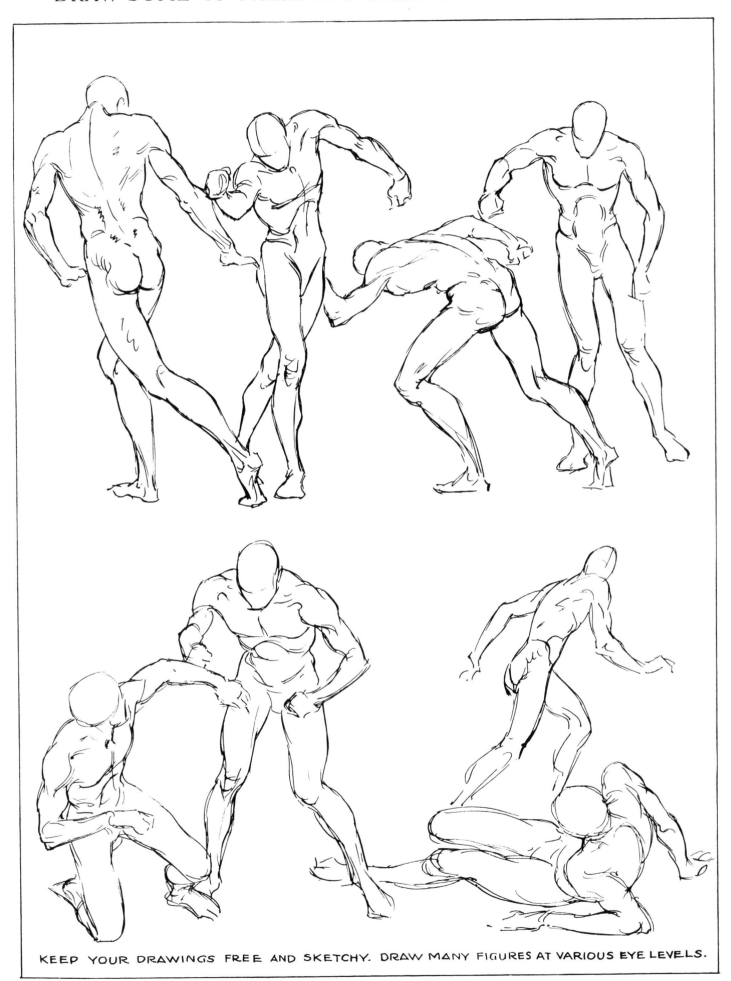

KEEP YOUR DRAWINGS FREE AND SKETCHY. DRAW MANY FIGURES AT VARIOUS EYE LEVELS.

THE FEMALE MANNIKIN

THE MAIN DIFFERENCE BETWEEN THE MALE AND FEMALE MANNIKIN IS IN THE PELVIS (DISCS). THE HIP BONES COME UP TO THE LINE OF THE NAVEL (MALE, THEY ARE TWO OR THREE INCHES BELOW). THE FEMALE WAISTLINE IS ABOVE THE NAVEL, THE MALE AT OR JUST BELOW. FEMALE RIB CASE IS SMALLER, PELVIS WIDER AND DEEPER, SHOULDERS NARROWER. "CAPE" DROPS IN FRONT TO INCLUDE BREASTS.

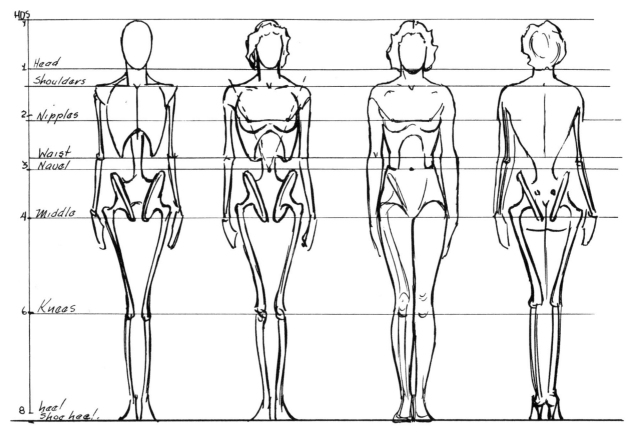

A SIMPLE WAY OF GETTING FEMALE PROPORTIONS-TAKE ⅓ TO KNEES- ⅔ TO WAIST, ³⁄₃ TO TOP OF HEAD.

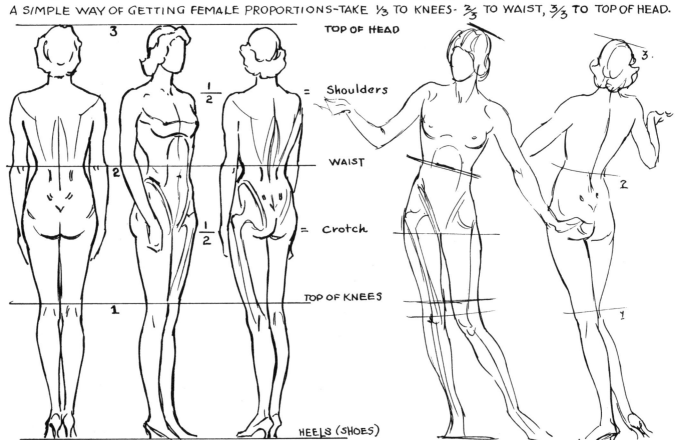

54

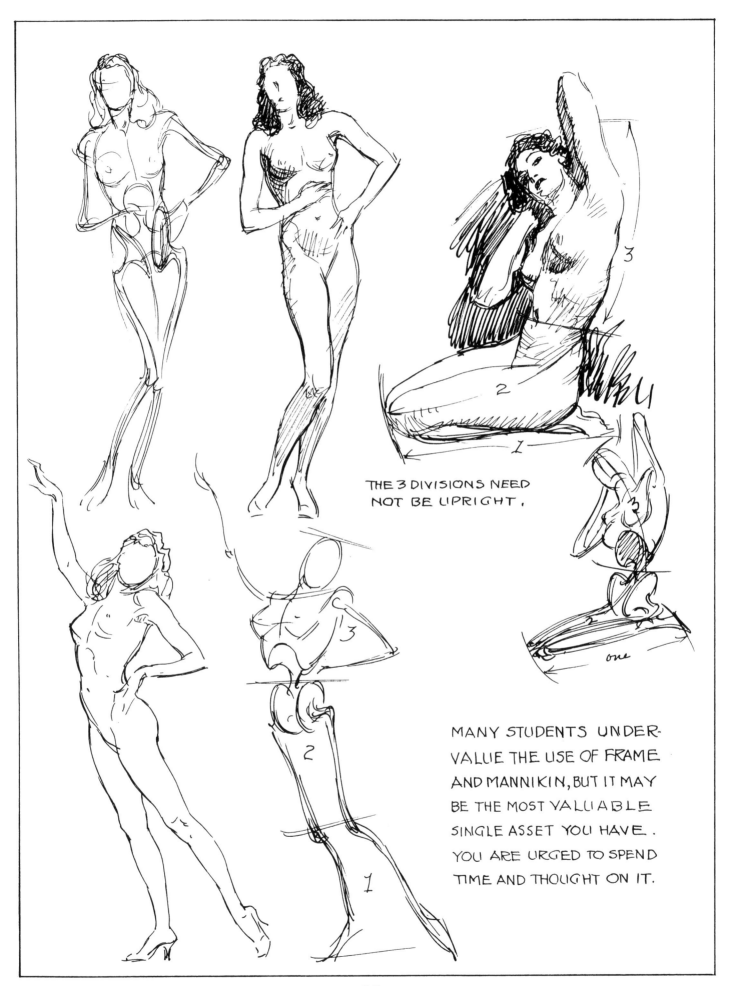

THE 3 DIVISIONS NEED
NOT BE UPRIGHT.

one

MANY STUDENTS UNDER-
VALUE THE USE OF FRAME
AND MANNIKIN, BUT IT MAY
BE THE MOST VALUABLE
SINGLE ASSET YOU HAVE.
YOU ARE URGED TO SPEND
TIME AND THOUGHT ON IT.

THE MALE AND FEMALE SKELETONS

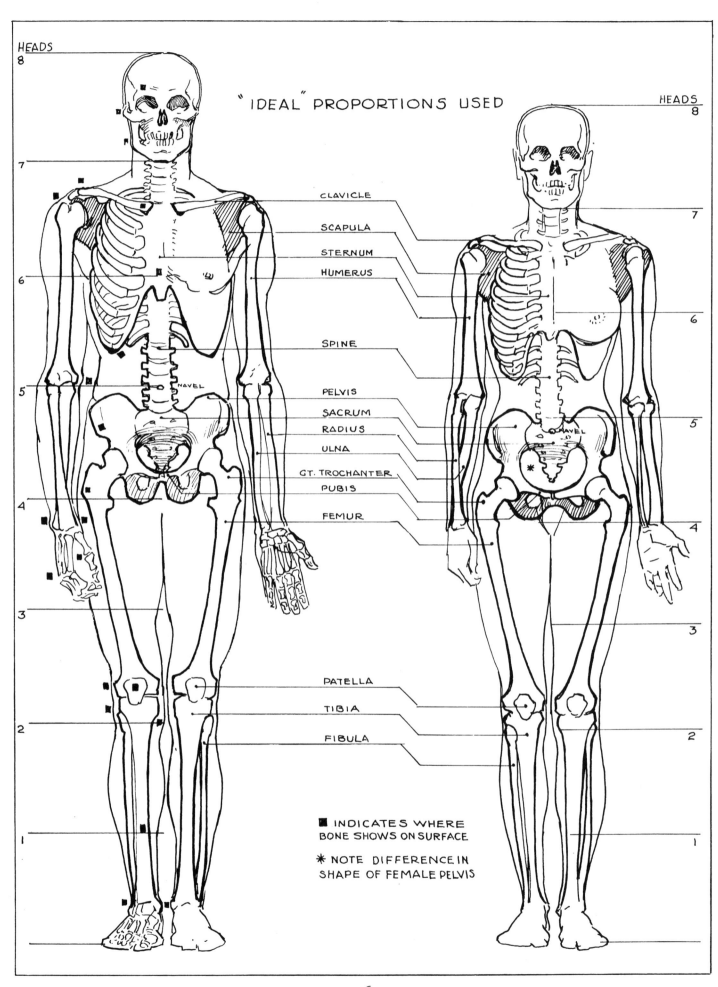

"IDEAL" PROPORTIONS USED

CLAVICLE

SCAPULA

STERNUM

HUMERUS

SPINE

PELVIS

SACRUM

RADIUS

ULNA

GT. TROCHANTER

PUBIS

FEMUR

PATELLA

TIBIA

FIBULA

HEADS
8

HEADS
8

■ INDICATES WHERE
BONE SHOWS ON SURFACE

✳ NOTE DIFFERENCE IN
SHAPE OF FEMALE PELVIS

II. THE BONES AND MUSCLES

The further you go in the study of anatomy, the more interesting it becomes. Made of soft and pliable material, elastic yet strong, capable of unlimited movement and of performing countless tasks, operating on self-generated power, and repairing or renewing itself over a period of time in which the strongest of steel parts would wear out—the human body is indeed an engineering miracle.

On the opposite page the male and female skeletons have been set up. I have kept the head units alongside so that you may relate the bones to the figure in correct proportion.

The skeleton, though strong, is really not so rigid as it appears. Though the spine has a rigid base in the pelvis, it possesses great flexibility; and the ribs, too, though they are fastened firmly into the spine, are flexible. All the bones are held together and upright by cartilage and muscle, and the joints operate on a ball-and-socket plan with a "stop" for stability. The whole structure collapses with a loss of consciousness.

Strain upon the muscles can usually be transferred to the bony structure. The weight of a heavy load, for example, is largely taken over by the bones, leaving the muscles free to propel the limbs. Bones also form a protection to delicate organs and parts. The skull protects the eyes, the brain, and the delicate inner parts of the throat. The ribs and pelvis protect the heart, lungs, and other organs. Where protection is most needed, the bone comes closest to the surface.

It is very important for the artist to know that no bone is perfectly straight. An arm or a leg drawn with a perfectly straight bone will be rigid and stiff-looking. Curvature in the bones has much to do with the rhythm and action of a figure. It helps make it appear alive.

The chief differences between the male and female skeletons are the proportionately larger pelvis in the female and the proportionately larger thorax, or rib case, in the male. These differences account for the wider shoulders and narrower hips of the male; the longer waistline, lower buttocks, and wider hips of the female. They also cause the female arms to flare out wider when they are swinging back and forth and the femur, or thigh bone, to be a little more oblique. The hair and breasts, of course, distinguish the female figure, but they are merely its most obvious characteristics. The female is different from head to toe. The jaw is less developed. The neck is more slender. The hands are smaller and much more delicate. The muscles of the arms are smaller and much less in evidence. The waistline is higher. The great trochanter of the femur extends out farther; the buttocks are fuller, rounder, and lower. The thighs are flatter and wider. The calf is much less developed. The ankles and wrists are smaller. The feet are smaller and more arched. The muscles, in general, are less prominent, more straplike—all but those of the thighs and buttocks, which are proportionately larger and stronger in the female. This extra strength is, like the larger pelvis, designed to carry the extra burden of the unborn child. Concentrate upon these fundamental differences until you can set up an unmistakable male or female figure at will.

Note the black squares on the male skeleton. These are bony prominences where the bones are so near the surface that they affect the contour. When the body becomes fat, these spots become dimples or recessions in the surface. In thin or aged figures, these bones protrude.

Working from life or photographs will not eliminate the necessity of knowing anatomy and proportion. You should recognize what the

REQUIREMENTS OF SUCCESSFUL FIGURE DRAWING

humps and bumps are—and why they are there. Otherwise your drawing will have the look of inflated rubber, or a wax department-store dummy. The final work on any commission of importance should be drawn from a model or good copy of some kind, since it must compete with the work of men who use models and good copy. Most artists own and operate a camera as a help. But it will not do the whole job. Outlines traced from a photograph, because of the exaggerated foreshortening by the lenses, have a wide and dumpy look. Limbs look short and heavy. Hands and feet appear too large. If these distortions are not corrected, your drawing will simply look photographic.

It might be well to mention here some of the requirements of successful figure drawing. The "smart" female figure has some mannish contours. The shoulders are drawn a little wider than normal, without much slope, the hips a little narrower. The thighs and legs are made longer and more slender, with tapering calves. When the legs are together, they should touch at the thigh, knee, and ankle. The knees should be small. The leg is elongated from the knee down with small ankles. It is merely a waste of time to show an art director a figure that looks large-headed, narrow-shouldered, short-armed or -legged, wide-hipped, short, fat, dumpy, or pudgy. But a figure may be actually bony and unusually tall and still please a fashion editor.

Slimness in figure drawing has become almost a cult. What the artists of the Middle Ages considered voluptuous appeal would be plain fat today. Nothing will kill a sale so quickly as fatness or shortness. (It is a curious fact that short people are apt to draw short figures. A man with a short wife will tend to draw short women.) If my figures seem absurdly tall, remember that I am giving you the conception accepted as a standard. They will not look too tall to the art buyer. In fact, some of my figures here are even shorter than I would instinctively draw them.

The essence of successful male figure drawing is that it be kept masculine—plenty of bone and muscle. The face should be lean, the cheeks slightly hollowed, the eyebrows fairly thick (never in a thin line), the mouth full, the chin prominent and well defined. The figure is, of course, wide shouldered and at least six feet (eight or more heads) tall. Unfortunately, it is not easy to find these lean-faced, hard-muscled male models. They are usually at harder work.

Children should be drawn fairly close to the scale of proportions given in this book. Babies obviously should be plump, dimpled, and healthy. Special study should be given to the folds and creases at the neck, wrists, and ankles. The cheeks are full and round, the chin is well under. The upper lip protrudes somewhat. The nose is round and small and concave at the bridge. The ears are small, thick, and round. The eyes practically fill the openings. The hands are fat and dimpled and there is considerable taper to the short fingers. Until the structure of babies is well understood it is almost fatal to try to draw them without good working material.

Keep all children up to six or eight years quite chubby. From eight to twelve they can be drawn very much as they appear, though the relative size of the head should be a little larger than normal.

If you get into character drawing, you may do a fat fellow—but don't make him too young. Do not draw ears too large or protruding in any male drawing. The male hands should be exaggerated a little in size and in the ideal type must look bony and muscular. Soft, round hands on a man simply won't go.

The art director seldom points out your faults. He simply says he does not like your drawing. Any one of the above mistakes may account for his dislike. Ignorance of the demands upon you is as great a handicap as ignorance of anatomy.

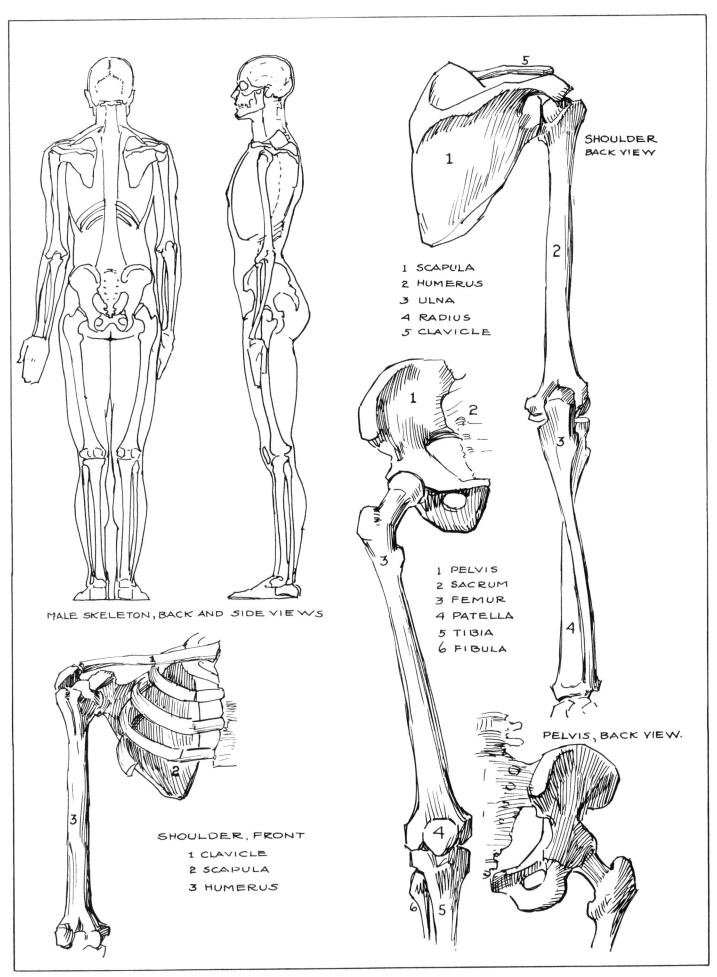

SHOULDER
BACK VIEW

1 SCAPULA
2 HUMERUS
3 ULNA
4 RADIUS
5 CLAVICLE

1 PELVIS
2 SACRUM
3 FEMUR
4 PATELLA
5 TIBIA
6 FIBULA

MALE SKELETON, BACK AND SIDE VIEWS

PELVIS, BACK VIEW.

SHOULDER, FRONT
1 CLAVICLE
2 SCAPULA
3 HUMERUS

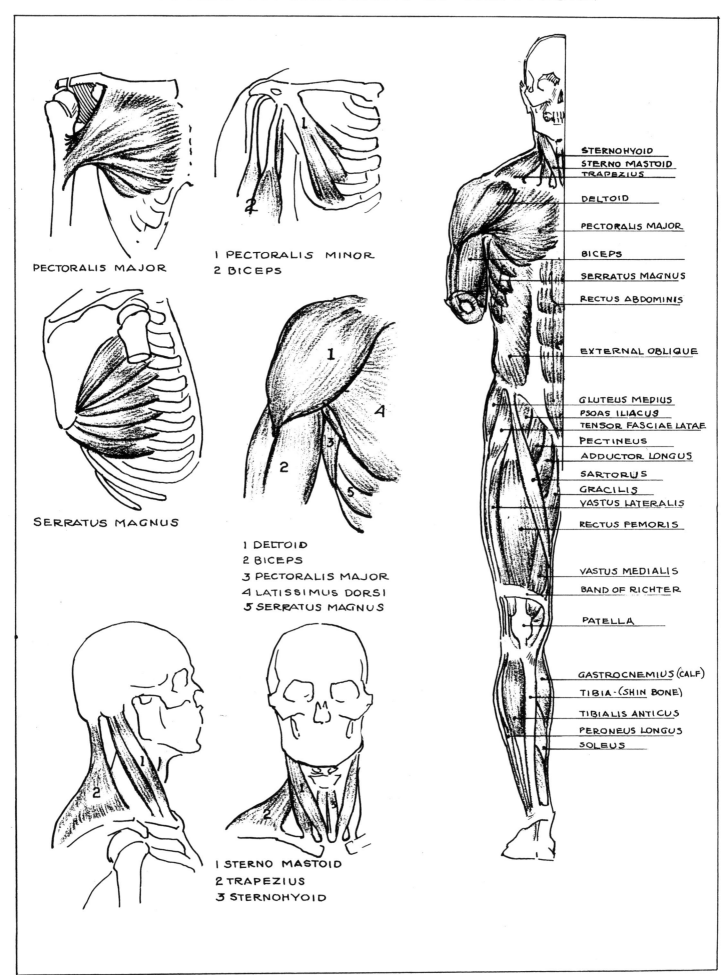

PECTORALIS MAJOR

1 PECTORALIS MINOR
2 BICEPS

SERRATUS MAGNUS

1 DELTOID
2 BICEPS
3 PECTORALIS MAJOR
4 LATISSIMUS DORSI
5 SERRATUS MAGNUS

1 STERNO MASTOID
2 TRAPEZIUS
3 STERNOHYOID

STERNOHYOID
STERNO MASTOID
TRAPEZIUS
DELTOID
PECTORALIS MAJOR
BICEPS
SERRATUS MAGNUS
RECTUS ABDOMINIS
EXTERNAL OBLIQUE
GLUTEUS MEDIUS
PSOAS ILIACUS
TENSOR FASCIAE LATAE
PECTINEUS
ADDUCTOR LONGUS
SARTORIUS
GRACILIS
VASTUS LATERALIS
RECTUS FEMORIS
VASTUS MEDIALIS
BAND OF RICHTER
PATELLA
GASTROCNEMIUS (CALF)
TIBIA - (SHIN BONE)
TIBIALIS ANTICUS
PERONEUS LONGUS
SOLEUS

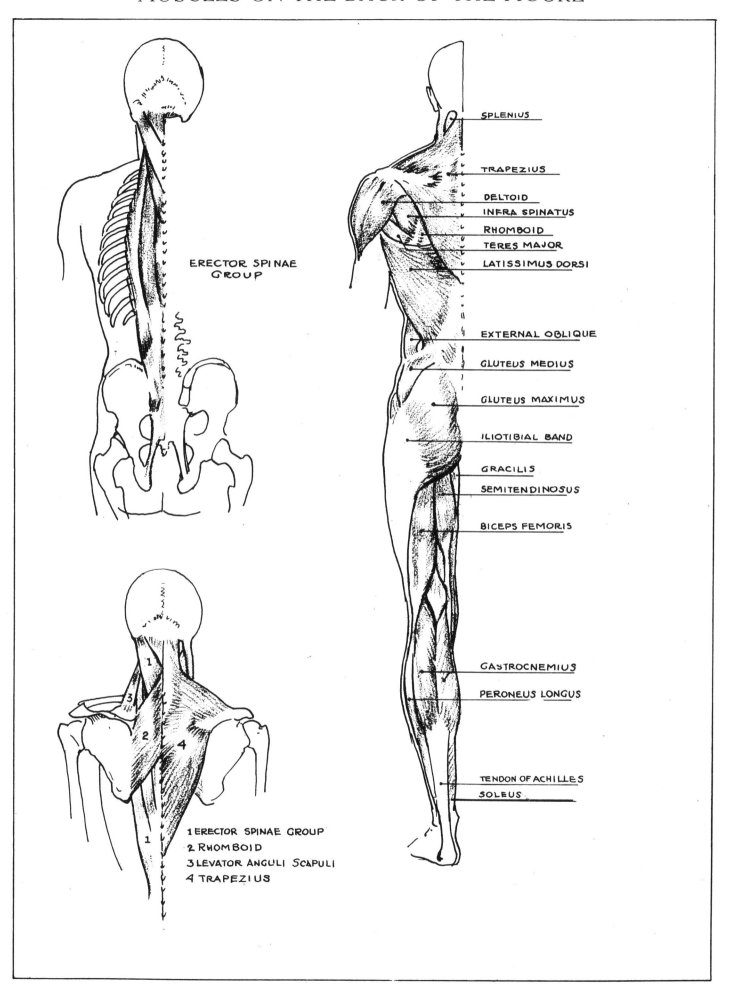

ERECTOR SPINAE
GROUP

SPLENIUS

TRAPEZIUS

DELTOID

INFRA SPINATUS

RHOMBOID

TERES MAJOR

LATISSIMUS DORSI

EXTERNAL OBLIQUE

GLUTEUS MEDIUS

GLUTEUS MAXIMUS

ILIOTIBIAL BAND

GRACILIS

SEMITENDINOSUS

BICEPS FEMORIS

GASTROCNEMIUS

PERONEUS LONGUS

TENDON OF ACHILLES

SOLEUS

1 ERECTOR SPINAE GROUP
2 RHOMBOID
3 LEVATOR ANGULI SCAPULI
4 TRAPEZIUS

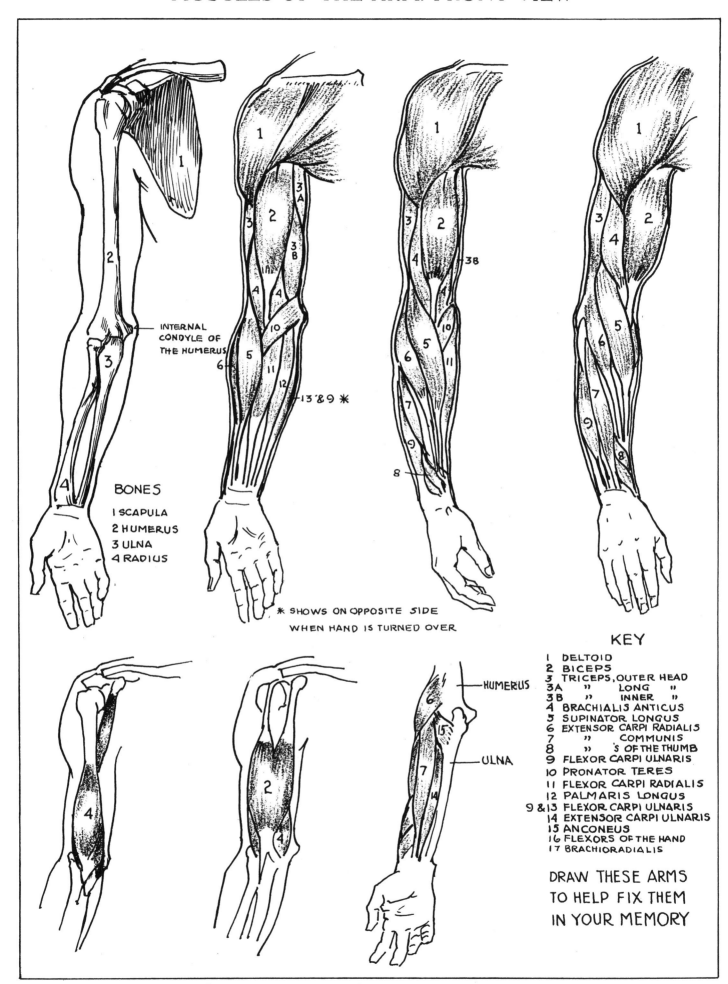

INTERNAL
CONDYLE OF
THE HUMERUS

BONES

1 SCAPULA
2 HUMERUS
3 ULNA
4 RADIUS

* SHOWS ON OPPOSITE SIDE
WHEN HAND IS TURNED OVER

HUMERUS

ULNA

KEY

1 DELTOID
2 BICEPS
3 TRICEPS, OUTER HEAD
3A ” LONG ”
3B ” INNER ”
4 BRACHIALIS ANTICUS
5 SUPINATOR LONGUS
6 EXTENSOR CARPI RADIALIS
7 ” COMMUNIS
8 ” ’S OF THE THUMB
9 FLEXOR CARPI ULNARIS
10 PRONATOR TERES
11 FLEXOR CARPI RADIALIS
12 PALMARIS LONGUS
9 &13 FLEXOR CARPI ULNARIS
14 EXTENSOR CARPI ULNARIS
15 ANCONEUS
16 FLEXORS OF THE HAND
17 BRACHIORADIALIS

DRAW THESE ARMS
TO HELP FIX THEM
IN YOUR MEMORY

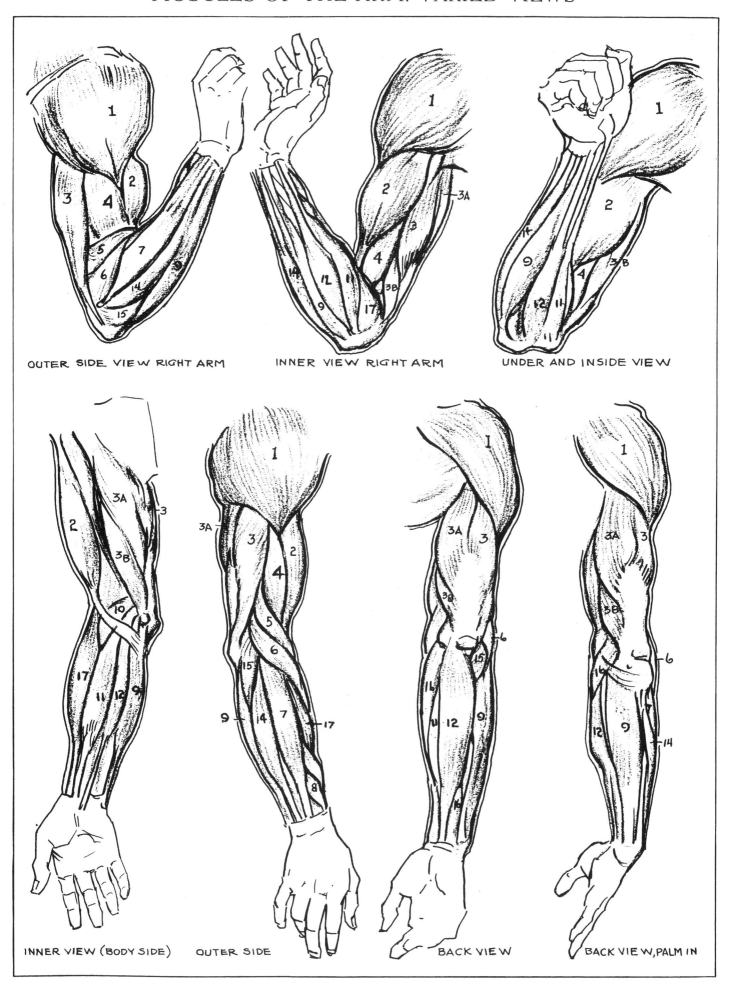

OUTER SIDE VIEW RIGHT ARM INNER VIEW RIGHT ARM UNDER AND INSIDE VIEW

INNER VIEW (BODY SIDE) OUTER SIDE BACK VIEW BACK VIEW, PALM IN

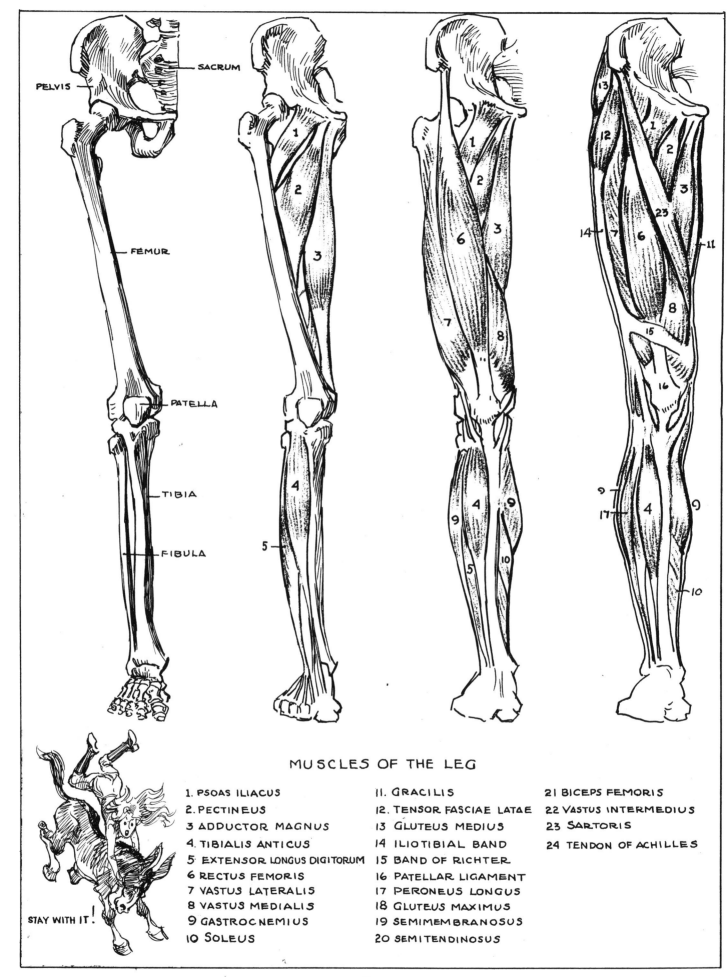

PELVIS
SACRUM
FEMUR
PATELLA
TIBIA
FIBULA

MUSCLES OF THE LEG

1. PSOAS ILIACUS
2. PECTINEUS
3. ADDUCTOR MAGNUS
4. TIBIALIS ANTICUS
5. EXTENSOR LONGUS DIGITORUM
6. RECTUS FEMORIS
7. VASTUS LATERALIS
8. VASTUS MEDIALIS
9. GASTROCNEMIUS
10. SOLEUS

11. GRACILIS
12. TENSOR FASCIAE LATAE
13. GLUTEUS MEDIUS
14. ILIOTIBIAL BAND
15. BAND OF RICHTER
16. PATELLAR LIGAMENT
17. PERONEUS LONGUS
18. GLUTEUS MAXIMUS
19. SEMIMEMBRANOSUS
20. SEMITENDINOSUS

21. BICEPS FEMORIS
22. VASTUS INTERMEDIUS
23. SARTORIS
24. TENDON OF ACHILLES

STAY WITH IT!

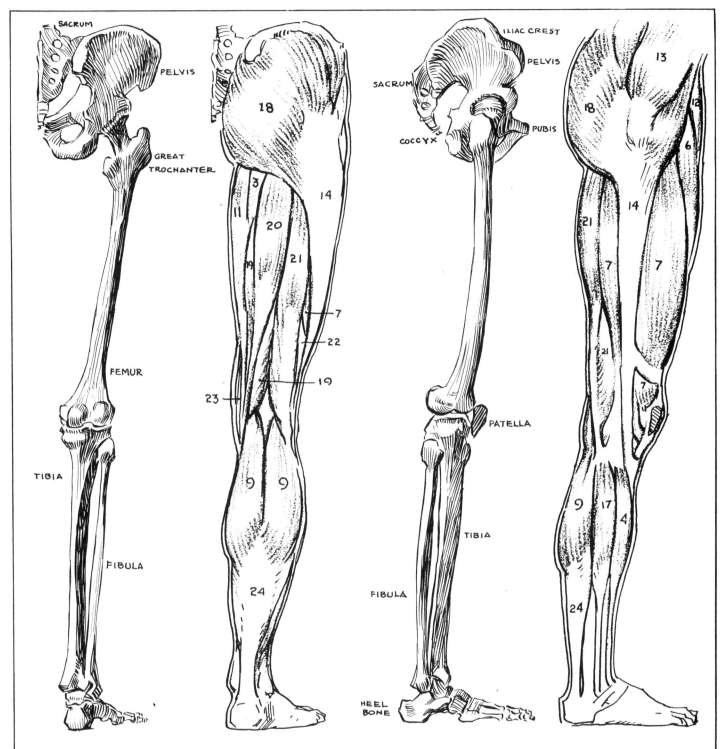

BACK VIEW OUTER SIDE VIEW

THERE IS NO OTHER WAY TO ACQUIRE A KNOWLEDGE OF ANATOMY THAN TO "DIG IT OUT". STAY WITH IT UNTIL YOU CAN DRAW THE MUSCLES FROM MEMORY. GET FURTHER BOOKS ON THE SUBJECT. THE AUTHOR RECOMMENDS THE BOOKS BY GEORGE BRIDGMAN AS EXCELLENT. THERE IS ALSO A VERY FINE BOOK OF DIAGRAMS, "ARTISTIC ANATOMY" BY WALTER F. MOSES. IN THESE BOOKS, THE SUBJECT IS MORE EXPERTLY COVERED, AND MUCH MORE COMPLETE. "IT PAYS TO KNOW", SO STAY WITH IT !

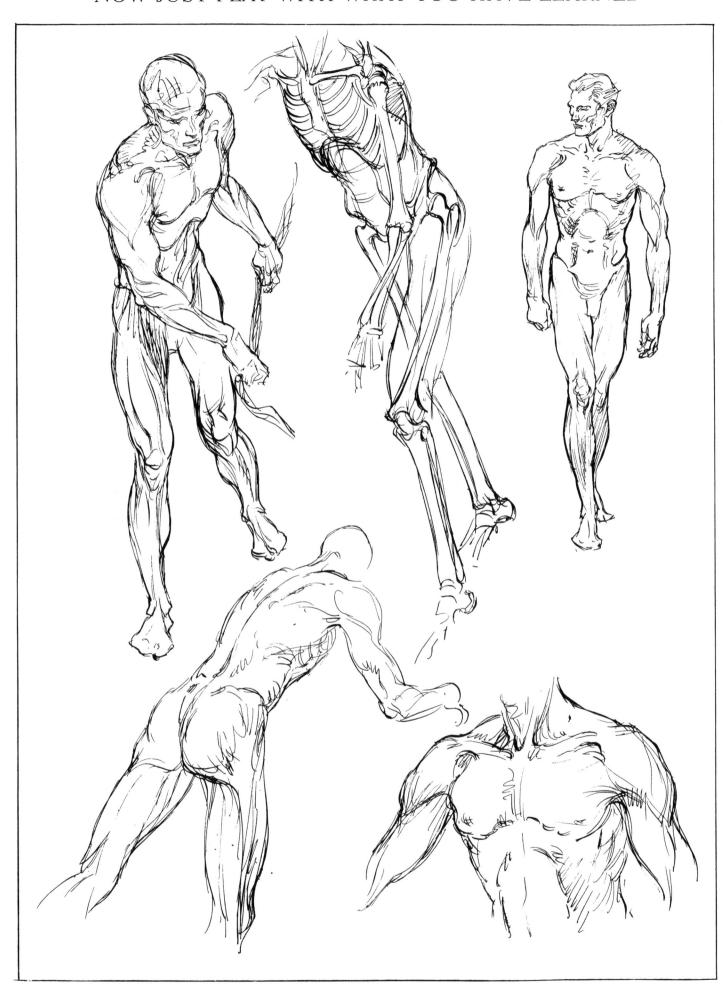

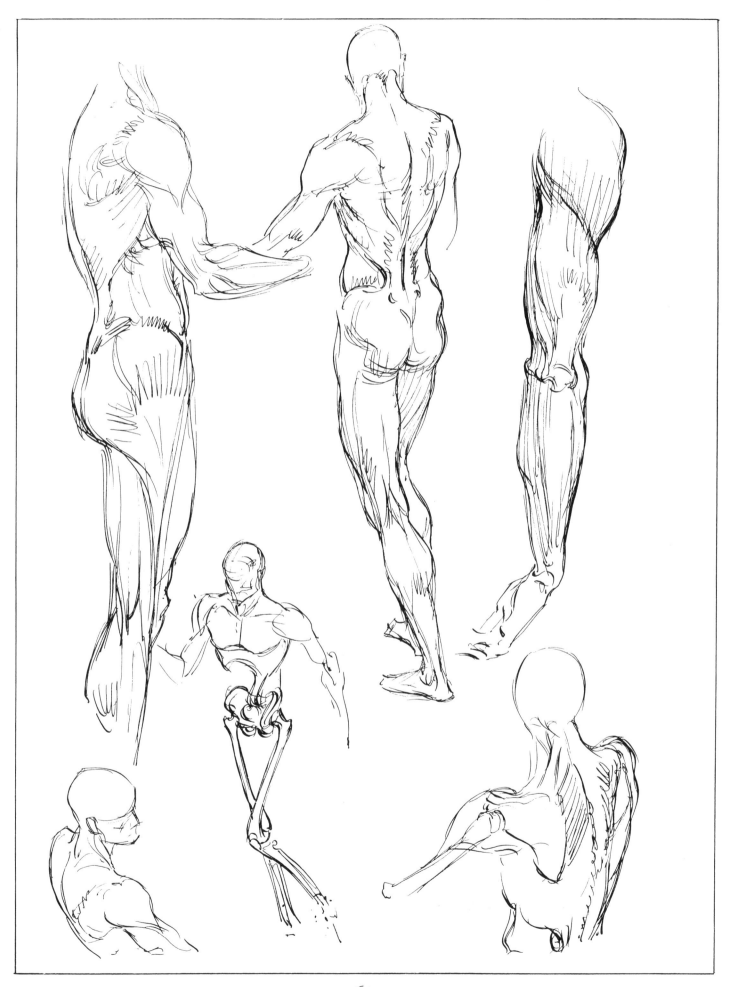

III. BLOCK FORMS, PLANES, FORESHORTENING, AND LIGHTING

The transition from outline and specific construction to the figure rendered in light and shadow is quite a hurdle. Often the student is unable to make this jump. The difficulty arises from a lack of conception of the solid. Yet there are intermediate steps that can make the rendering of the third dimension (thickness) fairly simple.

How can a solid form be set into space? How do we conceive of it so that we know it has bulk and weight—that we can pick it up or bump into it? The answer is that our eye instinctively recognizes the solid by the way light falls upon it. As far as the artist is concerned, when there is no light there is no form. The only reason an outline drawing can suggest the solid is that theoretically a drawing represents the form in a light that comes from directly behind the artist; hence the form casts no shadow visible to us. As the contours and edges turn away from us and the light, they tend to darken until they begin to look like lines, sharp at the edges and softening as they approach the middle or closer part of the form. We call this "flat lighting." It is the only way that form can be rendered without shadow, but it does include "halftone," which is the next step between the full light and the shadow. The shadow is really there also, but we cannot see it from our viewpoint.

When white paper is used for the drawing, the paper theoretically represents the greatest light—that is, the *plane which is at right angles to the source of light*. In all cases other than flat-front lighting, the form is rendered by the correct interpretation of the direction of the planes away from the right-angle planes, or the turning away of the form from the source of light.

The first and brightest planes are called the "light planes." The next planes are the "halftone planes," and the third planes, which are unable to receive direct lighting because of their angle, are called "shadow planes." Within the shadow planes may be those that are still receiving subdued, reflected light; these are called "planes of reflection." Form cannot be rendered without a clear grasp of this principle. The planes are worked out in the simple order of: (1) light, (2) halftone, (3) shadow—which is the darkest and is at the point where the plane parallels the direction of light, and (4) reflected light. This is called "simple lighting." It is unquestionably the best for our purpose. When there are several sources of light, the whole composition becomes a hodgepodge, inconsistent with natural light and highly confusing to the student. Sunlight naturally gives us the most perfect rendition of form. Daylight is softer and more diffused, but the principle still holds. Artificial light, unless controlled and based upon the sun principle, is the fly in the ointment. The camera may be able to get away with four or five sources of light; the chances are that the artist cannot.

Before you plunge into the intricacies of light and shadow, it would be well to know what is going to happen to form when light strikes it. Since the light can be made to come from any direction, the organization of the light-to-dark may start with any plane as the light plane. In other words, in a top lighting slightly to the front, the plane across the breast would be the light plane. Move the light to the side, and that plane would become a halftone plane. Set the light below, and the same plane is in shadow. Hence *all planes are relative to the light source.*

68

FORESHORTENING AND LIGHTING

Let us start, then, with the form in the simplest possible terms. By drawing block forms we cut out the extreme subtleties of halftone. Continuing a plane as a single tone on a surface as long as we can before turning it in another direction is simplification, or massing. Actually the figure is very rounded. But rounded surfaces produce such a delicate gradation of light and shadow that it is difficult to approach without a simplification and massing of these tones. Strangely enough, the simplification is a good deal better in the end than the exact photographic and literal interpretation. It is somewhat like trying to paint a tree by painting every leaf instead of massing the foliage into its big forms and working for bulk rather than intricate detail.

After we have mastered the larger plane, we can soften it at its edges to mold it into the more rounded form, while retaining all we can of the bigness of conception. Or, we can start with a big block, as the sculptor would start with a block of stone or marble. We hew away the excess and block in the general mass that we want. We then subdivide the big, straight planes into smaller ones until the rounded effect has been produced. It is like going around a circle with a series of short, straight lines. You may question why we do not at once proceed to the finished, smooth, and round form. The answer is that in a drawing or painting, something of the individual procedure and structural quality should remain. When it is too much smoothed down and polished, it becomes entirely factual. The camera can do *that*. In a drawing, however, "finish" is not necessarily art. It is the interpretation and process of individual conception that is art and that has value. If you include all the literal facts and actualities, the result will be boring. It is your selection of relevant facts that will create interest. A sweeping conception carries with it vitality, purpose, and conviction. The more detailed and involved we get, the less

forceful and powerful is our message. We can take a compass and draw a circle perfectly, but we have left no trace of ourselves in what we have set down. It is the big form that does the job—not the little and the exact.

On pages 70 and 71 I have tried to give an inkling of what I mean. Here the surface is conceived of as having mass and bulk. The effect is sculptural. It is looking at our mannikin a little differently. If we are to compose the mannikin of simplified blocks, how shall we shape those blocks? Your way is as good as mine. Shape them any way you will to arrive at a massed or bulk effect. This is the real approach to "solidity" in your work: actually thinking of the mass, bulk, and weight of it.

With this approach, we take the art-store wooden mannikin and use it as a basis for setting up a figure (page 72). We go a step further with the mannikin on page 73 and attempt to eliminate the stiffness of the jointed parts, still thinking though in terms of masses.

Retaining these terms we take solids (page 74) and tip them, remembering at all times what each *section* of the mass would be and where it belongs in relation to the whole. We must depend chiefly upon line to render the form, or that part of it which goes back into space, as seen by the eye of the observer. This is foreshortening. Actual measurement of length cannot be made, since viewing the form from one point is like looking at a gun barrel aimed directly at you. We must think of the contours and form as sections lined up one behind the other. An outline is rarely sufficient, however, to represent the receding sections; most often halftone and shadow are needed as well, as shown on page 75. Pages 76 and 77 are an interpretation of the rounded figure flattened into planes that go a step further than our simplest block forms. On pages 78 and 79 we place the simplified form of the head under various kinds of lighting.

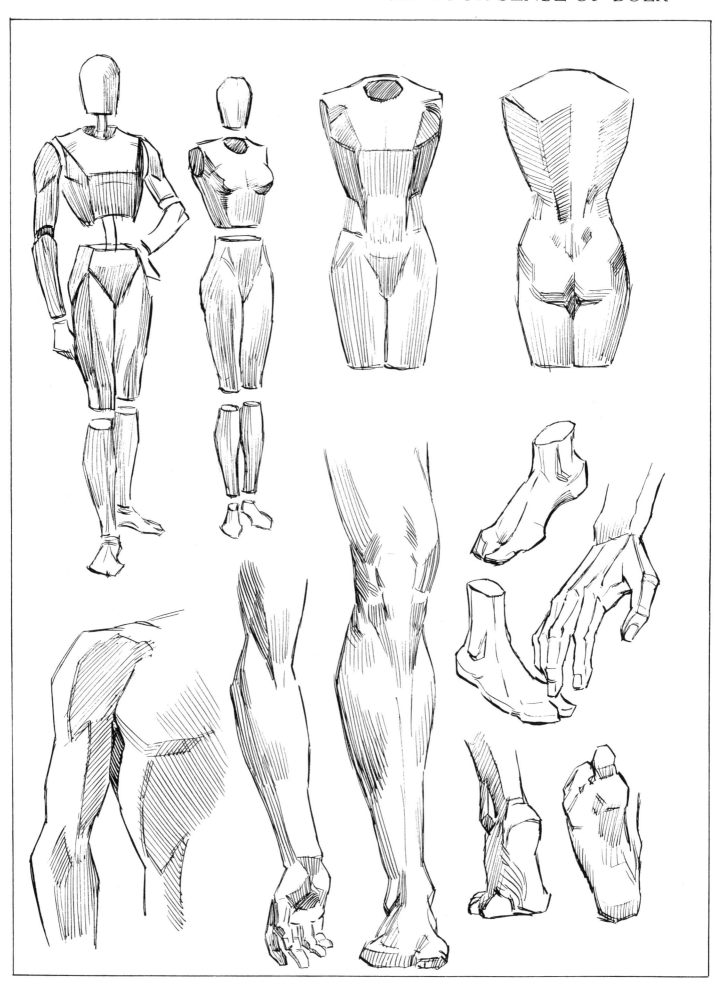

FEEL FREE TO INVENT YOUR OWN BLOCKS.

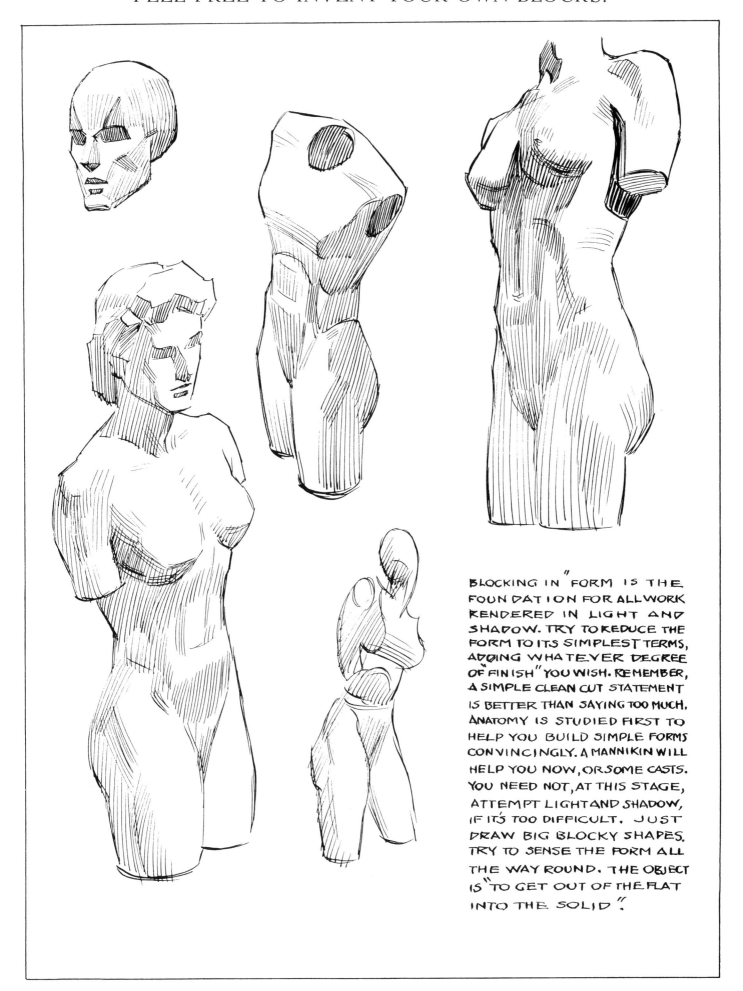

BLOCKING IN "FORM" IS THE FOUNDATION FOR ALL WORK RENDERED IN LIGHT AND SHADOW. TRY TO REDUCE THE FORM TO ITS SIMPLEST TERMS, ADDING WHATEVER DEGREE OF "FINISH" YOU WISH. REMEMBER, A SIMPLE CLEAN CUT STATEMENT IS BETTER THAN SAYING TOO MUCH. ANATOMY IS STUDIED FIRST TO HELP YOU BUILD SIMPLE FORMS CONVINCINGLY. A MANNIKIN WILL HELP YOU NOW, OR SOME CASTS. YOU NEED NOT, AT THIS STAGE, ATTEMPT LIGHT AND SHADOW, IF IT'S TOO DIFFICULT. JUST DRAW BIG BLOCKY SHAPES. TRY TO SENSE THE FORM ALL THE WAY ROUND. THE OBJECT IS "TO GET OUT OF THE FLAT INTO THE SOLID".

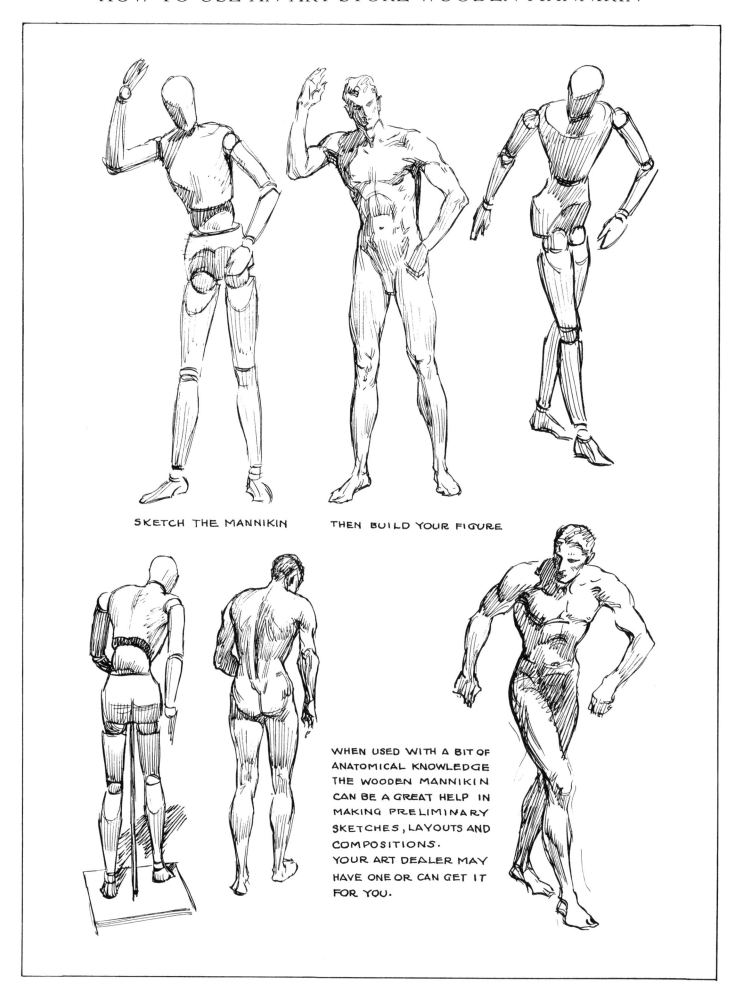

SKETCH THE MANNIKIN

THEN BUILD YOUR FIGURE

WHEN USED WITH A BIT OF
ANATOMICAL KNOWLEDGE
THE WOODEN MANNIKIN
CAN BE A GREAT HELP IN
MAKING PRELIMINARY
SKETCHES, LAYOUTS AND
COMPOSITIONS.
YOUR ART DEALER MAY
HAVE ONE OR CAN GET IT
FOR YOU.

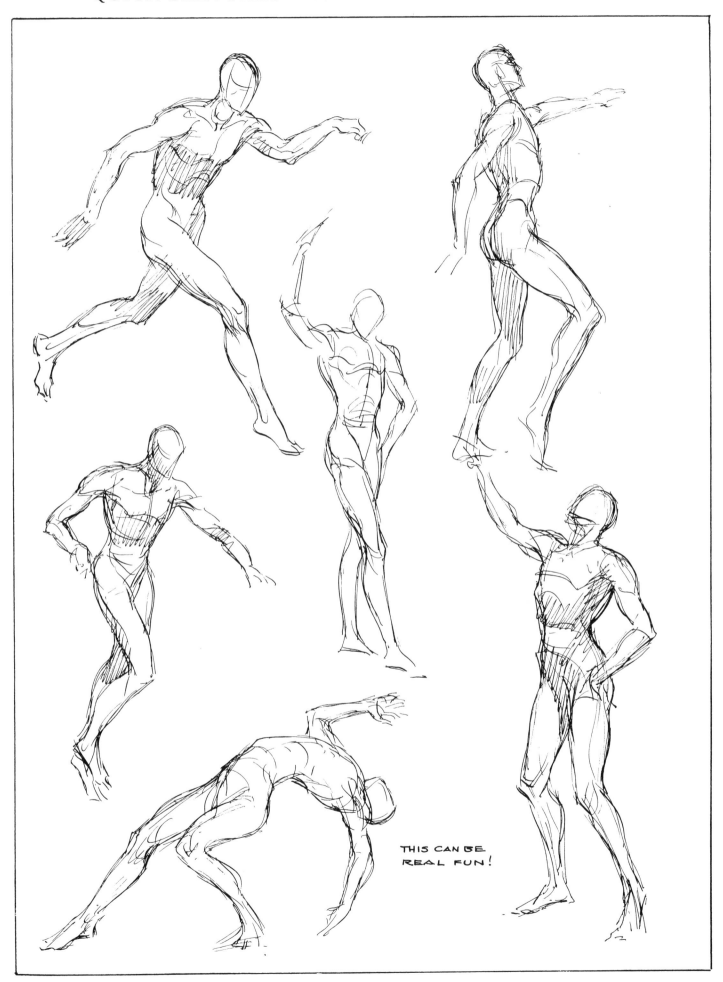

THIS CAN BE
REAL FUN!

FORESHORTENING

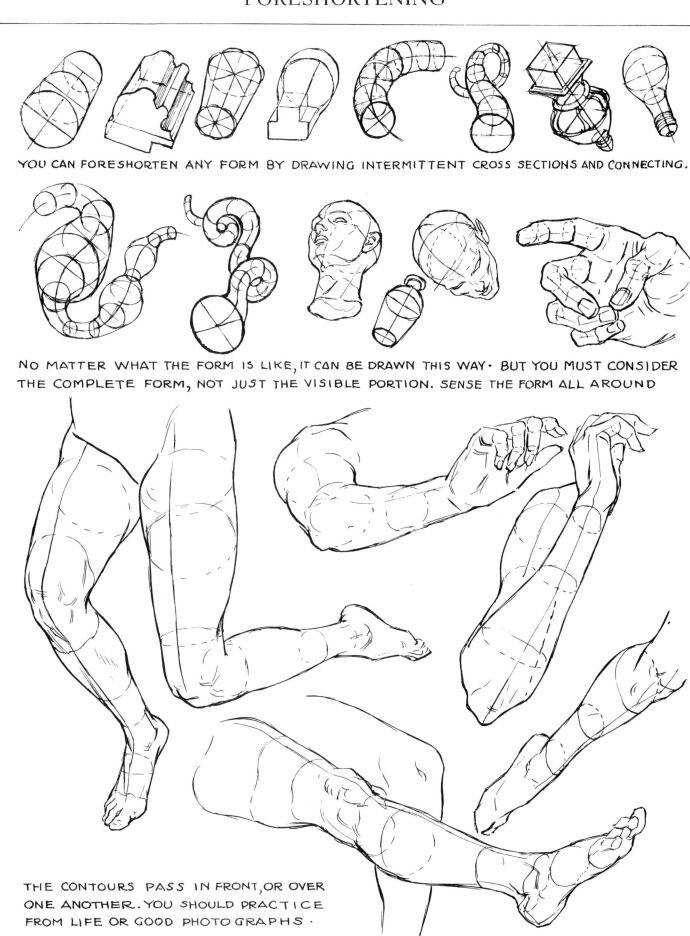

YOU CAN FORESHORTEN ANY FORM BY DRAWING INTERMITTENT CROSS SECTIONS AND CONNECTING.

NO MATTER WHAT THE FORM IS LIKE, IT CAN BE DRAWN THIS WAY. BUT YOU MUST CONSIDER THE COMPLETE FORM, NOT JUST THE VISIBLE PORTION. SENSE THE FORM ALL AROUND

THE CONTOURS PASS IN FRONT, OR OVER ONE ANOTHER. YOU SHOULD PRACTICE FROM LIFE OR GOOD PHOTOGRAPHS.

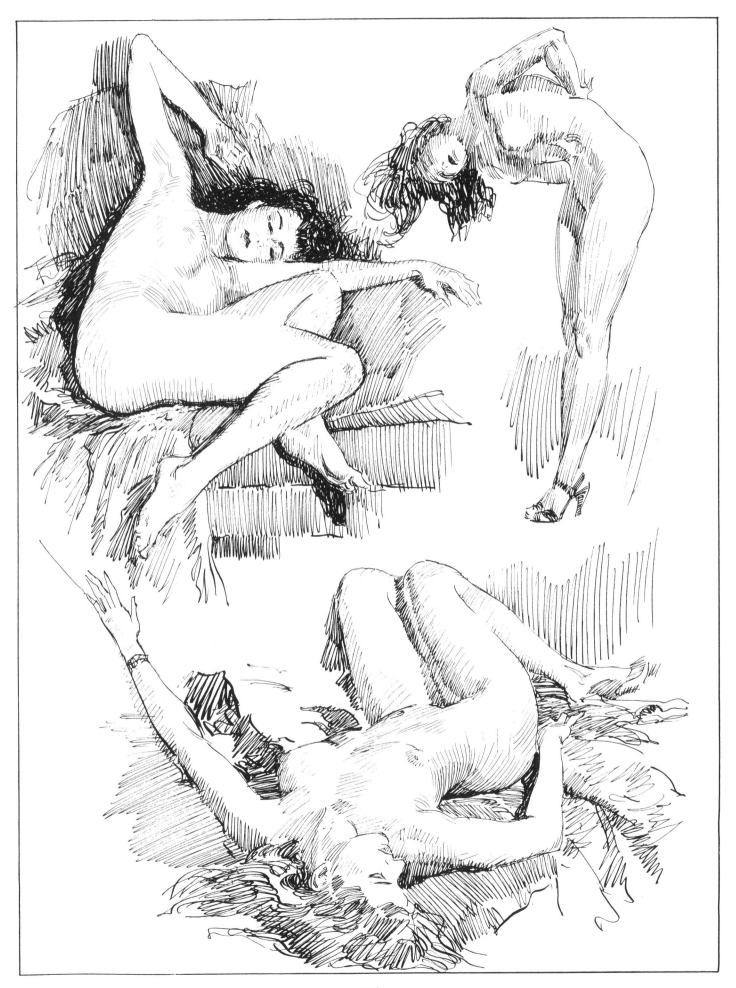

PLANES

PLANES ARE THEORETICAL FLATTENING OF ROUNDED FORMS AS WELL AS ACTUAL FLAT AREAS. IN ART AN EXTREME SMOOTHNESS AND ROUNDNESS OF FORM TENDS TOWARD THE "SLICK" AND "PHOTOGRAPHIC." IT SHOULD BE AVOIDED "LIKE THE MEASLES."

THE USE OF PLANES GIVES MORE OF AN INDIVIDUAL QUALITY. NO TWO ARTISTS WILL SEE PLANES ALIKE. "SQUARENESS" OF ROUNDED FORM IMPARTS A CERTAIN RUGGEDNESS AND VITALITY. A GOOD AXIOM IS, "SEE HOW SQUARE YOU CAN MAKE THE ROUND."

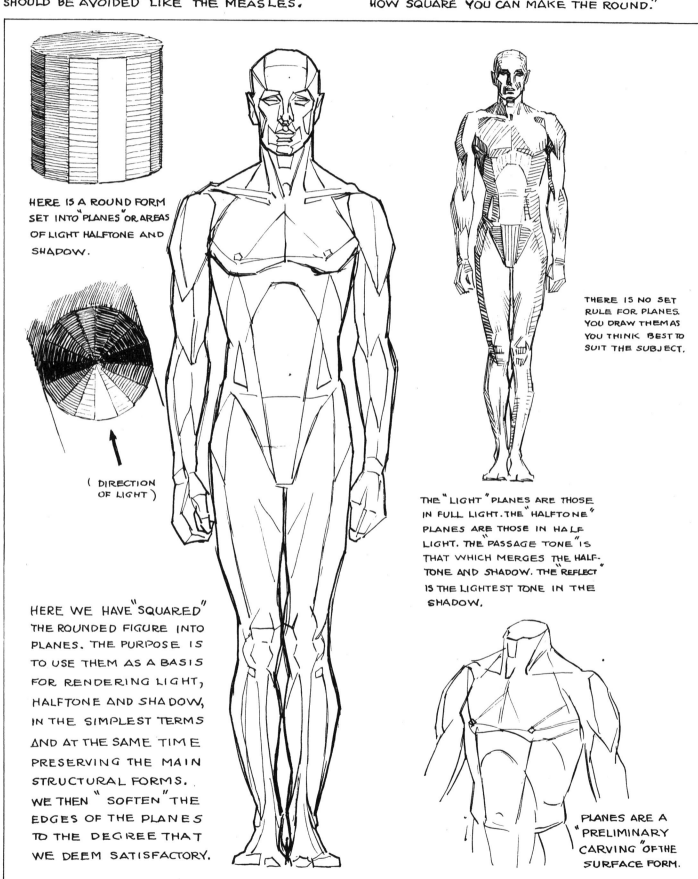

HERE IS A ROUND FORM SET INTO "PLANES" OR AREAS OF LIGHT HALFTONE AND SHADOW.

(DIRECTION OF LIGHT)

HERE WE HAVE "SQUARED" THE ROUNDED FIGURE INTO PLANES. THE PURPOSE IS TO USE THEM AS A BASIS FOR RENDERING LIGHT, HALFTONE AND SHADOW, IN THE SIMPLEST TERMS AND AT THE SAME TIME PRESERVING THE MAIN STRUCTURAL FORMS. WE THEN "SOFTEN" THE EDGES OF THE PLANES TO THE DEGREE THAT WE DEEM SATISFACTORY.

THERE IS NO SET RULE FOR PLANES. YOU DRAW THEM AS YOU THINK BEST TO SUIT THE SUBJECT.

THE "LIGHT" PLANES ARE THOSE IN FULL LIGHT. THE "HALFTONE" PLANES ARE THOSE IN HALF LIGHT. THE "PASSAGE TONE" IS THAT WHICH MERGES THE HALF-TONE AND SHADOW. THE "REFLECT" IS THE LIGHTEST TONE IN THE SHADOW.

PLANES ARE A "PRELIMINARY CARVING" OF THE SURFACE FORM.

PLANES

THERE IS NO SET OF PLANES WHICH WILL FIT THE FIGURE AT ALL TIMES, SINCE THE SURFACE FORM CHANGES WITH MOVEMENT SUCH AS BENDING AT THE WAIST, MOVEMENT OF THE SHOULDERS, ETC. THE PLANES ARE GIVEN MAINLY TO SHOW HOW THE FORMS CAN BE SIMPLIFIED. EVEN WHEN YOU HAVE THE LIVE MODEL OR COPY, YOU STILL WORK FOR THE MAIN PLANES OF LIGHT, HALFTONE AND SHADOW. OTHERWISE YOU MAY HAVE AN OVERPOWERING CONFUSION OF TONES.

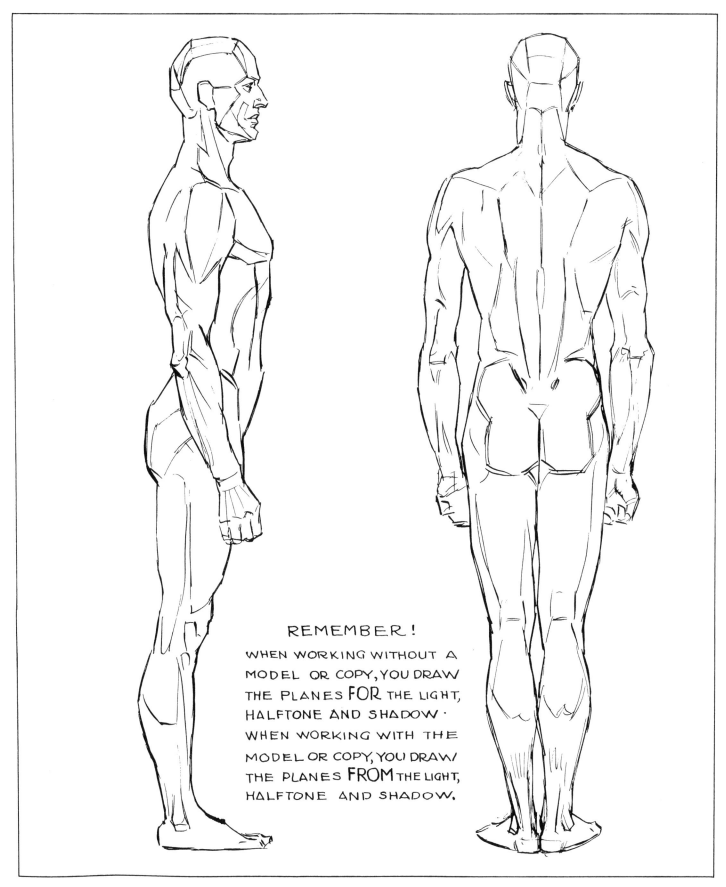

REMEMBER!

WHEN WORKING WITHOUT A MODEL OR COPY, YOU DRAW THE PLANES FOR THE LIGHT, HALFTONE AND SHADOW. WHEN WORKING WITH THE MODEL OR COPY, YOU DRAW THE PLANES FROM THE LIGHT, HALFTONE AND SHADOW.

1. "FLAT LIGHTING"-(FROM DIRECTLY IN FRONT)
GOOD FOR POSTER, DECORATIVE, SIMPLICITY.

2. "STAGE."- DRAMATIC, WEIRD, GHOSTLY, LIKE
THE LIGHT FROM A CRATER. (LOW-FRONT)

3. "3/4 SIDE": A GOOD LIGHTING. PLACE THE
LIGHT 45° FRONT. USE ONE LIGHT ONLY.

4. "3/4 TOP SIDE"- ONE OF THE BEST. IT GIVES
MAXIMUM LIGHT, HALFTONE, SHADOW & REFLECT.

5. "TOP"- A VERY BEAUTIFUL LIGHTING. THIS
GIVES GREAT LUMINOSITY TO SHADOWS.

6. "TOP BACK": WITH REFLECTOR, VERY GOOD.
GIVES GREAT SOLIDITY TO THE FORM.

7. "CRISSCROSS". USUALLY BAD. NEVER HAVE
LIGHT EQUAL ON BOTH SIDES. CUTS UP FORM.

8. "ALL FLAT"- PROVING HOW EXCESS LIGHTS
MAY ACTUALLY ELIMINATE SOLID FORM.

9. "1/2 and 1/2" BAD. AREAS OF LIGHT & SHADOW
SHOULD NEVER BE EQUAL. GIVE ONE THE EDGE.

Here the camera lends us a helping hand by showing the "actual" light as it falls on a simplified form. The form has been rounded to give you the gradation from light through halftone to shadow. Number 1 is a front lighting, corresponding to the treatment of a flat and unshaded outline drawing. The only shadow, under the chin, occurs because the light was raised a little to allow the camera to be placed under it. Camera and light, of course, could not have been placed in the identical spot. Had this been possible, there would have been no shadow. An all-flat or formless lighting may be obtained by piling in equal lighting from every direction (Number 8).

When there is a single source of light on the object, the shadowed side reflects some of the light in a luminous manner. The reflected-light areas within the shadow, however, never become competitive with the areas in light, and the unity of the mass of light as opposed to the mass of shadow is maintained. In drawing nothing within a shadow area should ever be as light as that within a light area, because reflected light is never so strong as its source. One exception might be the use of a mirror. That, however, would be a duplication of the light source rather than reflection (refraction). The dazzling light upon water is another example of refraction.

Simple lighting, which means lighting from a single source, and the reflected light of that source, is the most perfect lighting there is. It renders form in its actual contours and bulk. True modeling of form cannot be approached any other way, since to change the normal or true value of the plane is to change and upset the form; if the value is "off," the form is incorrect. Since the photographer may not have reasoned this out, it is better to make your own photographs, or at least supervise the lighting of any photographic copy. The photographer hates shadows; the artist loves them.

10. "SILHOUETTE"- THE REVERSE OF NO.1. GOOD FOR POSTER, DESIGN & FLAT EFFECTS.

LIGHT BACKGROUND

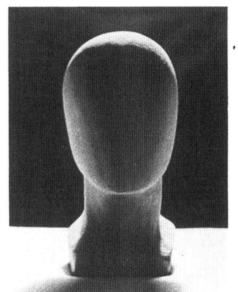

11. "FRINGE"- LIGHTED DIRECTLY FROM BACK SLIGHTLY TOP. VERY EFFECTIVE.

DARK BACKGROUND

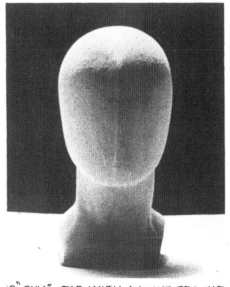

12. "SKY". TOP WITH A LIGHT GROUND FOR REFLECTION. NATURAL, VERY GOOD.

DARK BACKGROUND.

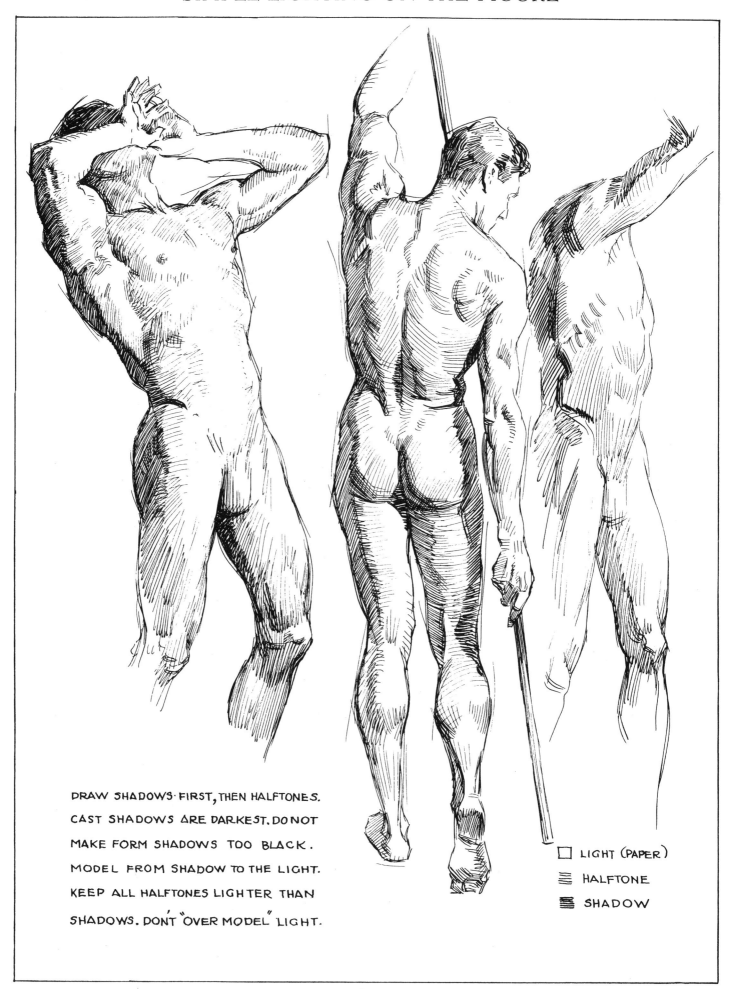

DRAW SHADOWS·FIRST, THEN HALFTONES.
CAST SHADOWS ARE DARKEST. DO NOT
MAKE FORM SHADOWS TOO BLACK.
MODEL FROM SHADOW TO THE LIGHT.
KEEP ALL HALFTONES LIGHTER THAN
SHADOWS. DON'T "OVER MODEL" LIGHT.

☐ LIGHT (PAPER)
≡ HALFTONE
▤ SHADOW

The simplest way to explain the fundamental principle of rendering light and shadow is to think of a ball with light focused upon it just as the sun lights the earth. The area on the ball closest to the light is the high light (A), comparable to noon. If we move on the surface of the sphere away from the high light in any direction, we find that the light begins imperceptibly to fade into the halftone area (B), which may be compared to twilight, and then to last light (B+), and on to night (C). If there is nothing to reflect the light, there is true darkness; however, if the moon, a reflector of the sun's light, comes up, it will reflect light into the shadow (D). When light is intercepted by a body, its silhouette falls upon the adjacent light plane. This, the darkest of the shadows, is called "cast shadow." It is still possible, however, for a cast shadow to pick up some reflected light.

The artist should be able to look at any given place on his subject and determine to which area it belongs — the light, the halftone, the shadow, or the reflected light. Correct values must be given in order to obtain unity and organization of these four fundamental areas. Otherwise a drawing will not hold together. Treatment of light gives a drawing cohesion no less than structural form.

There are many things you can learn from photographs if you use them intelligently. Remember, however, that the range of light to dark is much greater in the eye than in pigment. You cannot possibly put down the full range; you have to simplify.

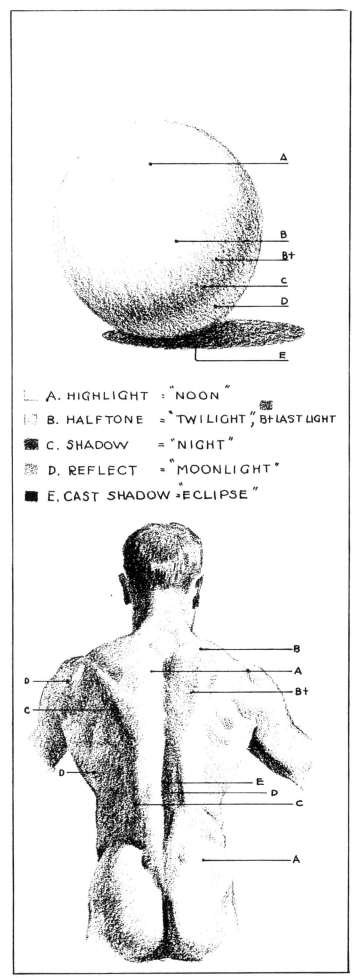

A. HIGHLIGHT = "NOON"
B. HALFTONE = "TWILIGHT", B+ LAST LIGHT
C. SHADOW = "NIGHT"
D. REFLECT = "MOONLIGHT"
E. CAST SHADOW = "ECLIPSE"

IV. DRAWING THE LIVE FIGURE:
METHODS OF PROCEDURE

Before you undertake to draw from the living model, be sure you have absorbed all the preliminaries so far discussed. These are:

The proportions of the idealized figure
The general framework
The relationship of perspective to the figure
Movement and action
The mannikin and simplified building of the form
The anatomic construction
The planes by which we build light and shadow
Foreshortening
The fundamentals of light and shadow
The true modeling of form

Now when you have to draw something set up in front of you, you must possess still another fundamental skill—intelligent measurement. I say "intelligent" because your aim is not mere duplication.

Suppose you begin to draw a husky young man, arms uplifted, whom you want to interpret in terms of light, halftone, and shadow. You have set your light source low and to the right, so that there will be a varied play of light across the form. First, look for the area of greatest light. It is found on the chest under the left arm of the model. Now look for the whole mass of light as opposed to the whole mass of shadow. Sketch in the contours of the figure and block in these masses. (On page 83 you will find the halftones added and the shadows relatively darkened.) I suggest that you use the point of your pencil for the contours and the side of the lead for the massing of the halftone and shadow. When you are drawing with a pen, shadows and halftones

can be achieved only by combinations of lines. But a brush or pencil adapts itself to mass. Observe, too, that the grain of your paper will add to or detract from the attractiveness of the texture of the drawing. Because of the method of reproduction, a coated, smooth paper could not be used for the drawings in this book. Beautiful grays and darks are possible, however, on the smooth papers if the side of a soft lead pencil is used. The halftones and darks may be produced in either pencil or charcoal by rubbing with the finger or a stump of paper. The whole figure drawing may be rubbed with a rag and the lights picked out with a kneaded eraser.

On pages 86 and 87, look over my shoulder as I proceed with my own method for drawing a figure. On page 88 see a plan of approach that I call the "visual survey." It is less complicated than it looks, for I have included visual measurement lines that, ordinarily, are not set down. It is a plan of finding level points and plumb points and the angles established by sighting a continuation of the line to see where it emerges. This is the only plan I know that can be depended upon to offer any degree of accuracy in freehand drawing.

It is easiest to sight in vertical and horizontal lines, so that important points directly across or under each other are quickly "checked." When a point falls outside the figure, such as a hand, angles of points within the figure will help to find it. When you have correctly placed one point, proceed to others, and finally your drawing will check with the model. This principle, also illustrated on page 89, applies to any subject before you and provides a valuable means of corroborating the accuracy of your drawing.

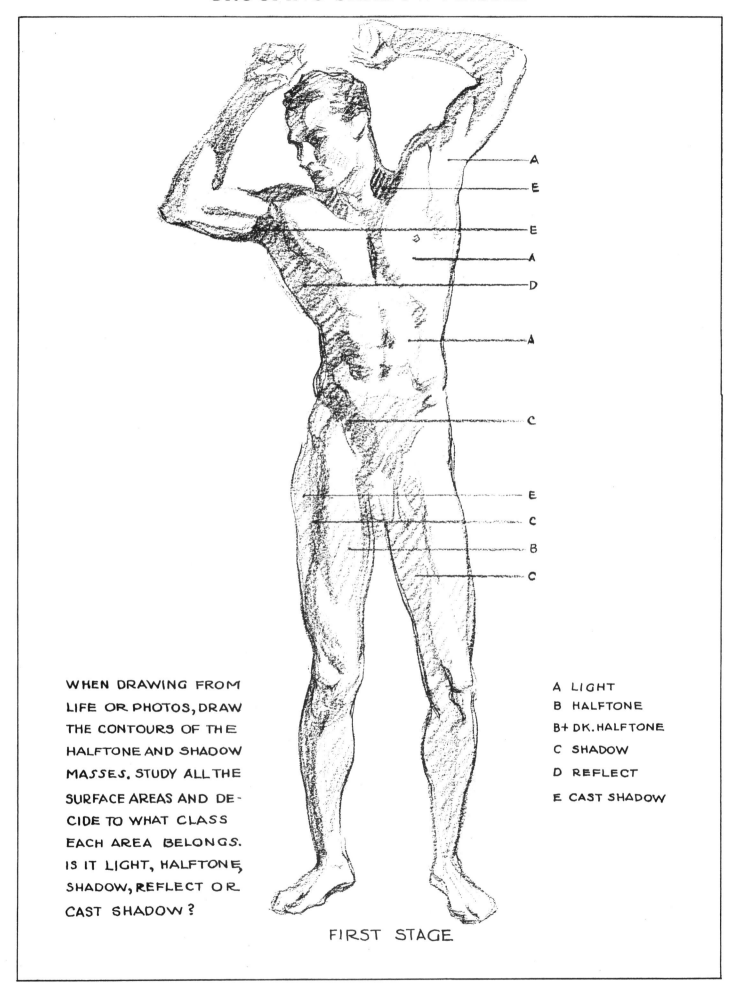

A

E

E

J

A

D

A

C

E

C

B

C

WHEN DRAWING FROM
LIFE OR PHOTOS, DRAW
THE CONTOURS OF THE
HALFTONE AND SHADOW
MASSES. STUDY ALL THE
SURFACE AREAS AND DE-
CIDE TO WHAT CLASS
EACH AREA BELONGS.
IS IT LIGHT, HALFTONE,
SHADOW, REFLECT OR
CAST SHADOW?

A LIGHT
B HALFTONE
B+ DK. HALFTONE
C SHADOW
D REFLECT
E CAST SHADOW

FIRST STAGE

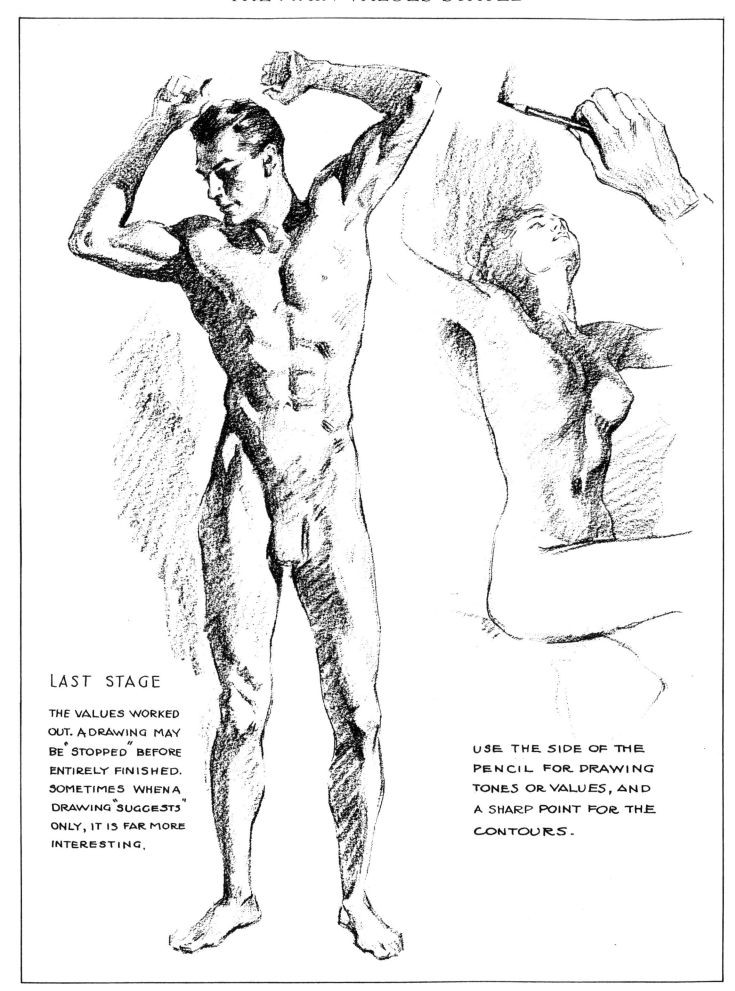

LAST STAGE

THE VALUES WORKED
OUT. A DRAWING MAY
BE "STOPPED" BEFORE
ENTIRELY FINISHED.
SOMETIMES WHEN A
DRAWING "SUGGESTS"
ONLY, IT IS FAR MORE
INTERESTING.

USE THE SIDE OF THE
PENCIL FOR DRAWING
TONES OR VALUES, AND
A SHARP POINT FOR THE
CONTOURS.

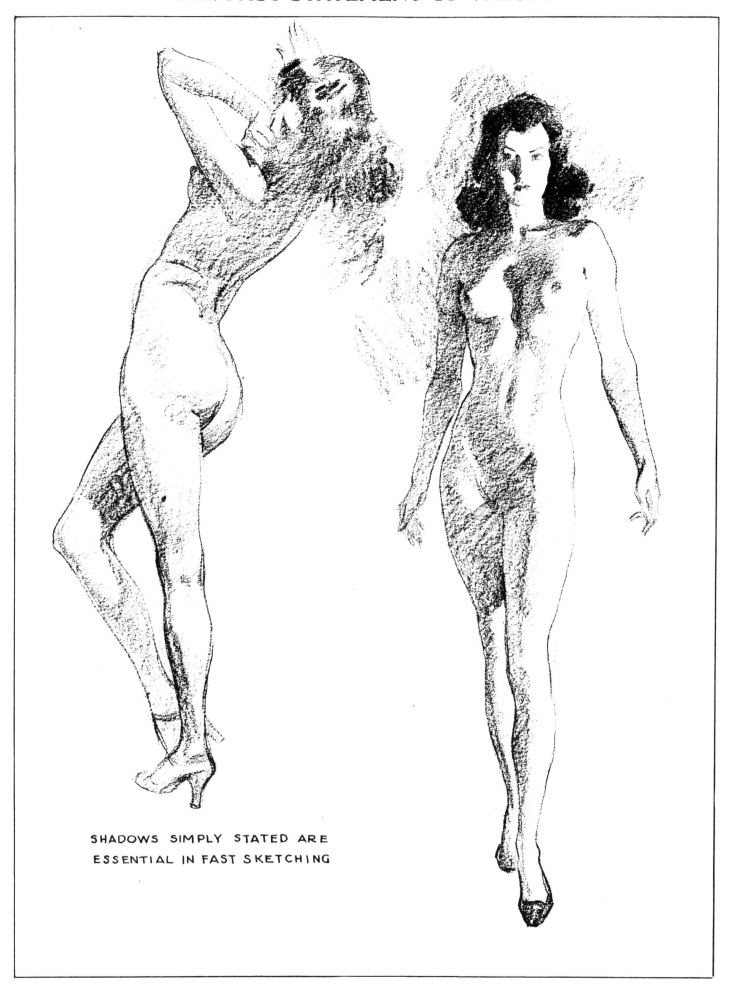

SHADOWS SIMPLY STATED ARE
ESSENTIAL IN FAST SKETCHING

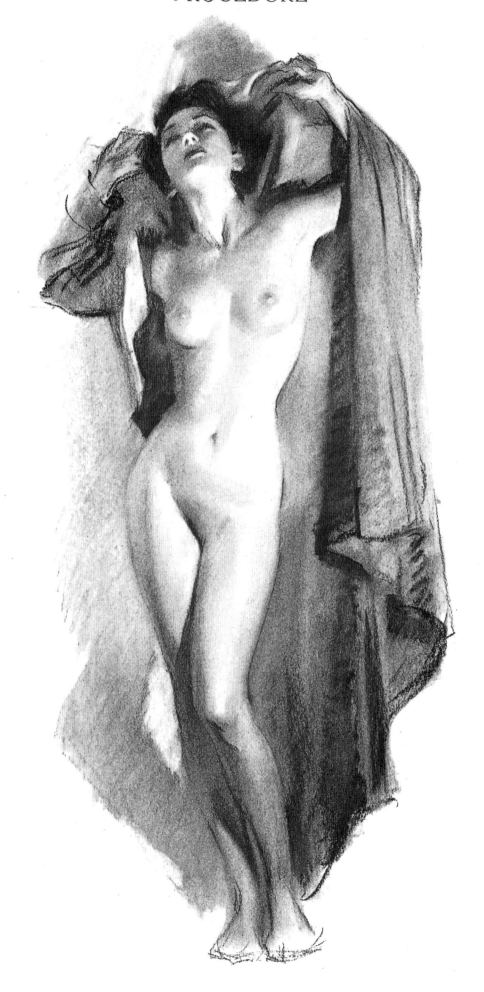

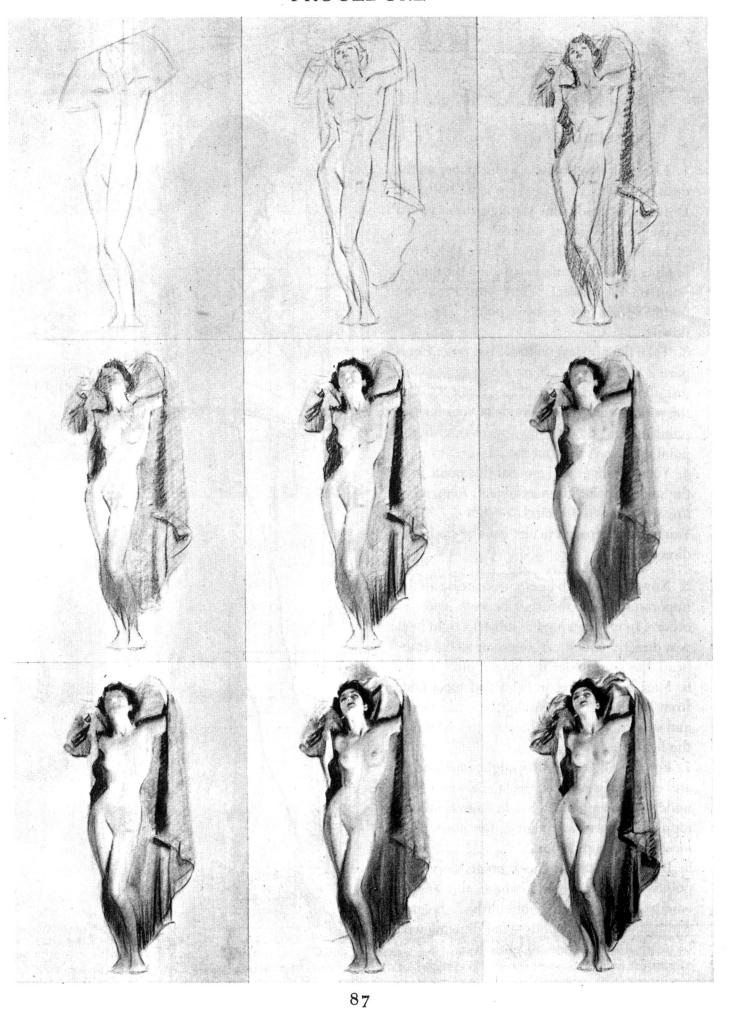

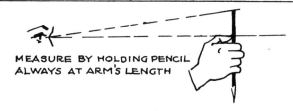

MEASURE BY HOLDING PENCIL
ALWAYS AT ARM'S LENGTH

MEASURING THE SUBJECT

1. Establish two points on your paper as the desired height of pose (top and bottom). Draw a perpendicular through these points as the middle line of subject.

2. Locate the middle point of line (½). Now, holding pencil at arm's length, find the middle point on the subject before you. From the middle point get quarter points (up and down).

3. Take the greatest width of the pose. Compare it to the height. In my drawing it comes just above the right kneecap (about ⅓). Lay the width equally on each side of your middle point up and down. Now locate the middle point crossways on your model.

4. Your two lines will cross at this point. It is the middle point of your subject. *Remember this point on the model.* You work out from it in all directions.

5. Now, with plumb line, or eye, locate all the important points that fall beneath one another. (In my drawing the subject's right heel was directly underneath her hair at the forehead, the knee under the nipple, etc.)

6. Start by blocking in head and torso and, from the head, sight straight up and down and straight across, all the way up and down the figure.

7. For the angles, sight straight on through and establish a point on the line where it falls under a known point. (See line of chest and nipples. The known point is the nose. This locates right nipple.)

8. If you constantly check points opposite, points underneath, and where the angles emerge, after having established height, width, and division points—your drawing will be accurate, and you will know it is!

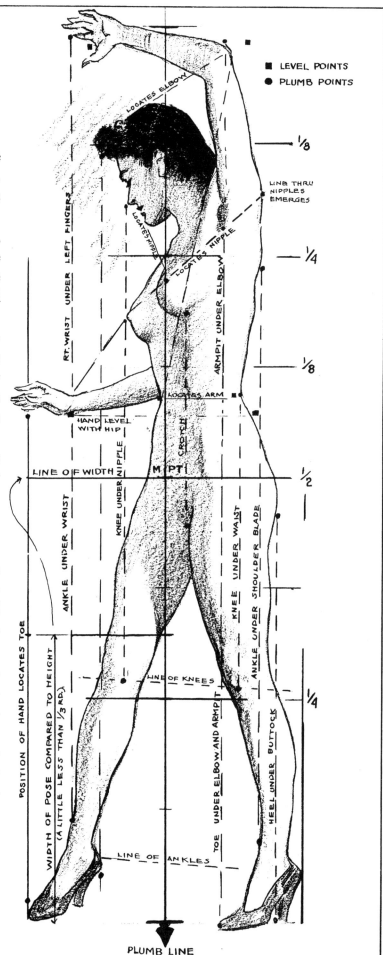

■ LEVEL POINTS
● PLUMB POINTS

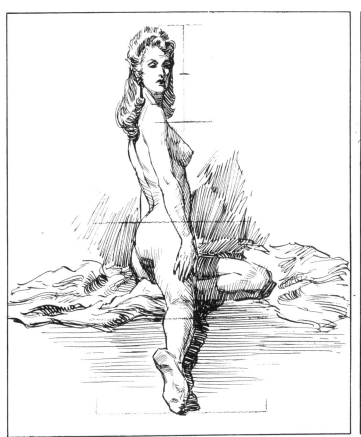

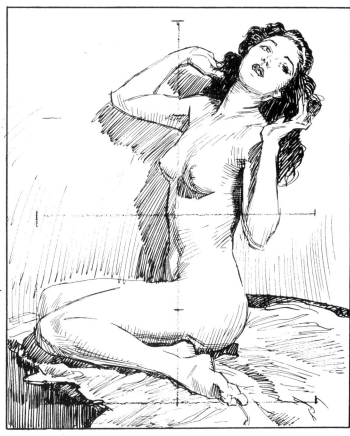

MAKE A "FINDER"

REMEMBER THIS PLAN GIVES THE ACTUAL LIVE PRO-
PORTIONS. MAKE ANY ADJUSTMENTS YOU WISH
AS YOU GO ALONG. USUALLY ADD A LITTLE IN LENGTH.

CUT TWO RIGHT ANGLES FROM SOME STIFF CARDBOARD,
MARK OFF IN INCHES AND CLIP TOGETHER. THIS CAN BE
ADJUSTED. IT GIVES PROPORTIONATE WIDTH TO HEIGHT.

V. THE STANDING FIGURE

Much of the essential equipment for professional figure drawing is described in the preceding chapters. You have now learned a "means of expression," but your use of that knowledge is just beginning. From this point onward you must learn to express yourself individually, showing your particular taste in the selection of models, choice of pose, dramatic sense and interpretation, characterization, and technical rendering.

Routine knowledge and fact thus become the basis for what is often referred to as inspiration, or spiritual quality, subjects that are little discussed in art textbooks. The truth is that there are no hard-and-fast rules. The best advice is to watch for the individual spark and fan it into flame when you find it. For my part, I have found that most students possess initiative, are open to suggestion, and are thoroughly capable of being inspired to express themselves ably. I believe that when the qualities necessary for acceptable drawing are pointed out, you may be helped tremendously to bridge the gap between amateur and professional drawing.

Two broad approaches are needed: First is the conception, or "What have you to say?" Second is the interpretation, or "How can you say it?" Both call for feeling and individual expression. Both call for initiative, knowledge, and inventiveness.

Let us take the first step. Before you pick up your pencil, or take a photograph, or hire a model, you must understand your problem and its purpose. You must search for an idea and interpret it. If the job at hand requires a drawing designed to sell something, ask yourself the following: To whom must this drawing appeal? Shall it be directed toward a selected or general class of buyer? Are the buyers going to be men or women? Is there a dramatic way of expressing the subject? Will a head or whole figure best serve to emphasize the idea? Should several figures make up the composition? Will a setting and locale help or can the message be conveyed better without these? Where and how will it be reproduced—newspaper, magazine, poster? You must take into account which advertising medium is to be used. A billboard, for example, will require a simple, flat background and the use of large heads, since the message must be taken in at a glance. Newspaper drawings should be planned for reproduction on cheap paper—i.e., line or simple treatment without subtlety in the halftone. For the magazine, where the reader has more time, you may use the complete figure and even background, if needed. The tendency, however, is to simplify and to strip drawings of all that is not of major importance.

With the second step you advance to the practical interpretation of the idea. Eliminate what you know to be impractical. For instance, do not approach a billboard subject with several complete figures, for their expressions will not carry from a distance. Granting, then, that you rightly choose large heads, what are the types you want? What are the expressions? What are the poses? Can you do better if you get out your camera and nail down an expression that you know cannot be held by the hour? Can you put Mother over here and have room for the lettering also? Would she be better over there? What will you choose for a background? What will be the style and color of her dress? You begin, at this point, to experiment with thumbnail impressions on a tissue pad until you can say, "That's it," and then, with all the vigor that is in you, proceed to prove that "that's it."

VARIETY IN THE STANDING POSE

There is no book in the world that will do a job for you. There is no art director who can do your job. Even though the art director may go so far as to lay out the general idea, space, and placement, he still is asking for your interpretation. Again, there is no piece of copy that you can lay down in front of you which will completely answer your needs. Another man's work was done for his own purpose and for another problem. The principal difference between the amateur and the professional is that the latter courageously strikes out in his own way, while the former gropes for a way of expressing himself.

Endless variety in posing is possible. People stand up, kneel or crouch, sit or lie down; but there are a thousand ways of doing these things. It is surprising, for example, to observe how many ways there are in which to stand up.

Plan the standing figure carefully, remembering that, although standing still is a static pose, you can suggest that the standing figure is capable of movement. Only when you portray a tense moment demanding rigidity in the figure do you arrest the latent movement. To relieve the static feeling, put the weight on one leg, turn the torso, tip and turn the head, or allow the figure to lean upon or be supported by something. A fairly good rule is never to have face and eyes looking straight ahead and set squarely on the shoulders, unless you are trying for a definite "straight-from-the-shoulder attitude" to suggest defiance, impudence, or a pitting of one personality against another. This attitude reminds one too much of the old photographs in which Grandpa's head was held in a clamp during the process of getting his likeness.

See that either head or shoulders are turned or tipped, or both. With the standing figure everything is relaxation, balance, and a distribution of weight. Any sort of gesture is a relief from hands hanging motionless at the sides. A self-conscious girl has the feeling that she never knows what to do with her hands. The unimaginative artist, too, does not know what to do with the hands of his figures. But the girl can put her hands on her hips, finger her beads, fix her hair, pull out her vanity case, apply lipstick, smoke a cigarette. Hands can be most expressive.

If you show legs, let them be interesting even in the standing pose. Drop one knee. Raise a heel. Do anything except keep them glued to the floor side by side. Twist the body, drop one hip, get the elbows at different levels, clasp the hands, put one hand up to the face, do anything that keeps your drawing from looking like a wooden dummy. Draw a lot of little "funnies" until you find one that is interesting. *Make every standing figure do something beside just standing.* There are so many natural gestures possible, to combine with the telling of a story, to express an idea or emotion, that it should not be hard to be original.

When I illustrate a story, I usually read significant parts of the manuscript to the models. I try to get them to act out situations as naturally as possible. At the same time I try to think of how I would act under the circumstances in the story. There is, of course, the danger of overacting, or of using gestures that go beyond the natural or logical, which is almost as bad as being static.

Experiment with the lighting on the model to express best what you have in mind. Give importance to a portion of the figure by getting the strongest and most concentrated light upon it. Sometimes parts of a figure can be lost in shadow to advantage. Sometimes a silhouette may be stronger and more compelling than a brightly lighted subject.

The whole gamut of expression is there for you to choose from. Don't form a few habits that you continually repeat. Try to make each thing you do just as original in conception and execution as you possibly can.

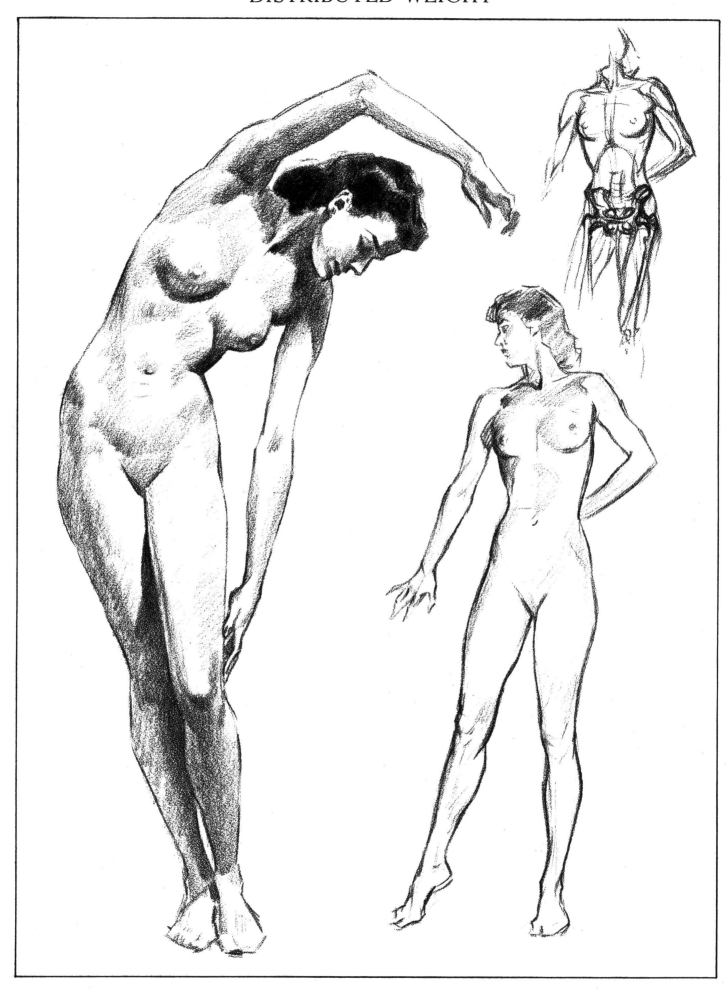

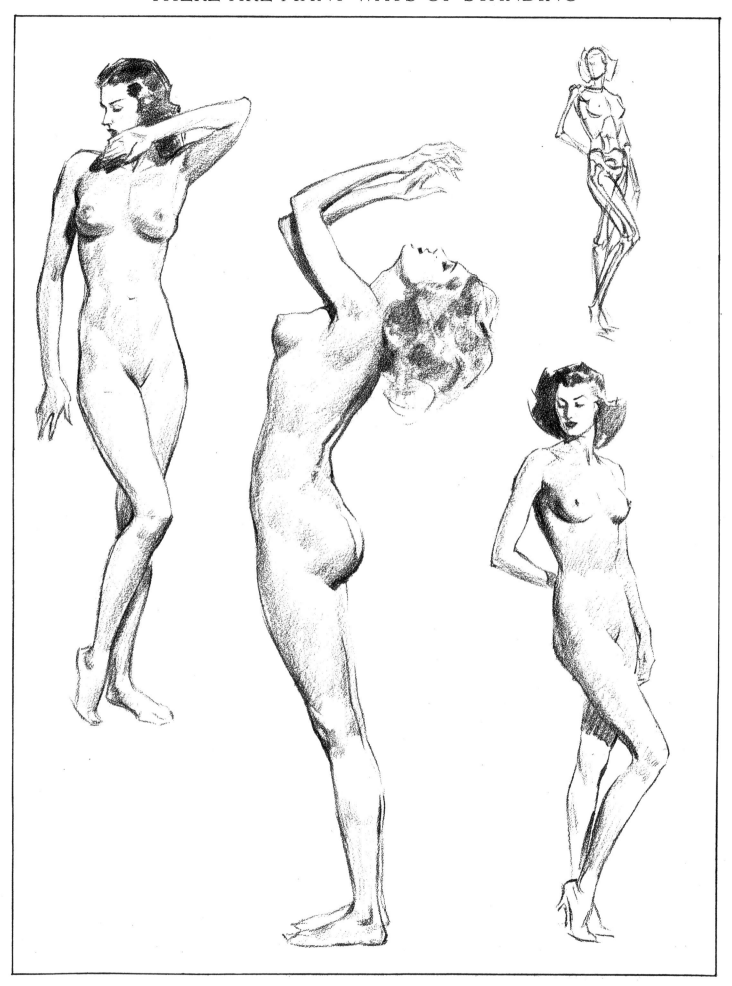

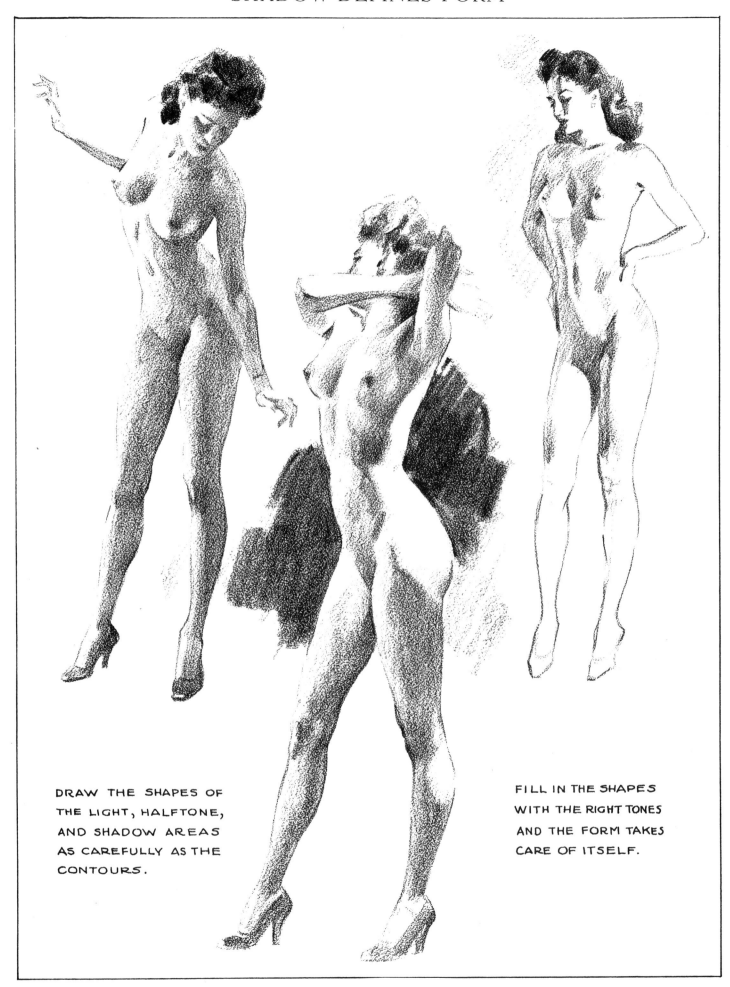

DRAW THE SHAPES OF
THE LIGHT, HALFTONE,
AND SHADOW AREAS
AS CAREFULLY AS THE
CONTOURS.

FILL IN THE SHAPES
WITH THE RIGHT TONES
AND THE FORM TAKES
CARE OF ITSELF.

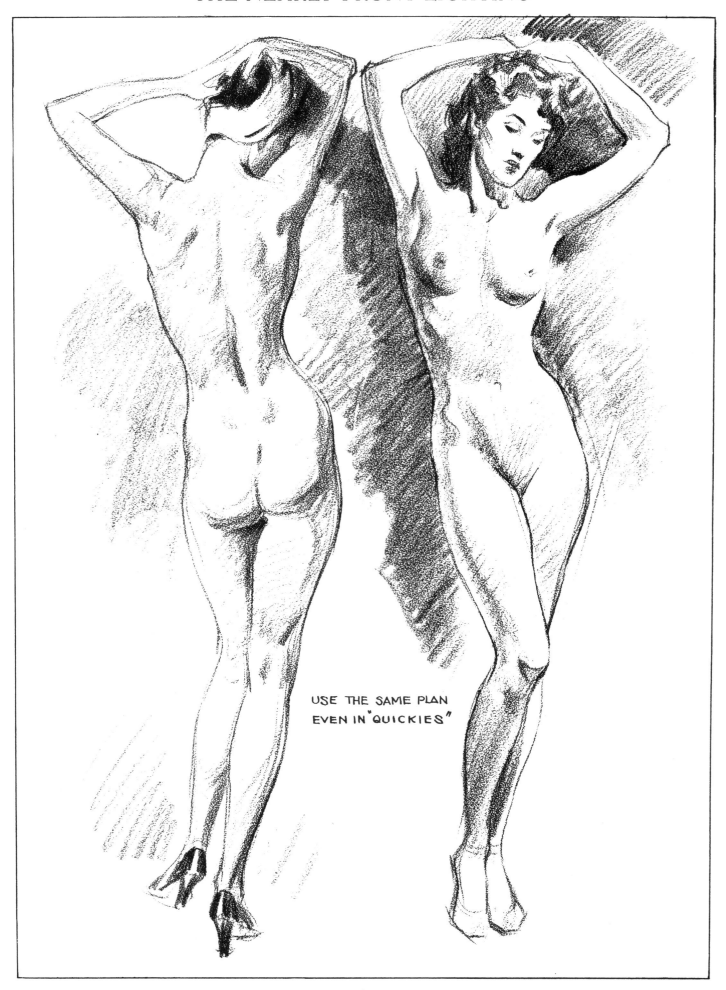

USE THE SAME PLAN
EVEN IN "QUICKIES"

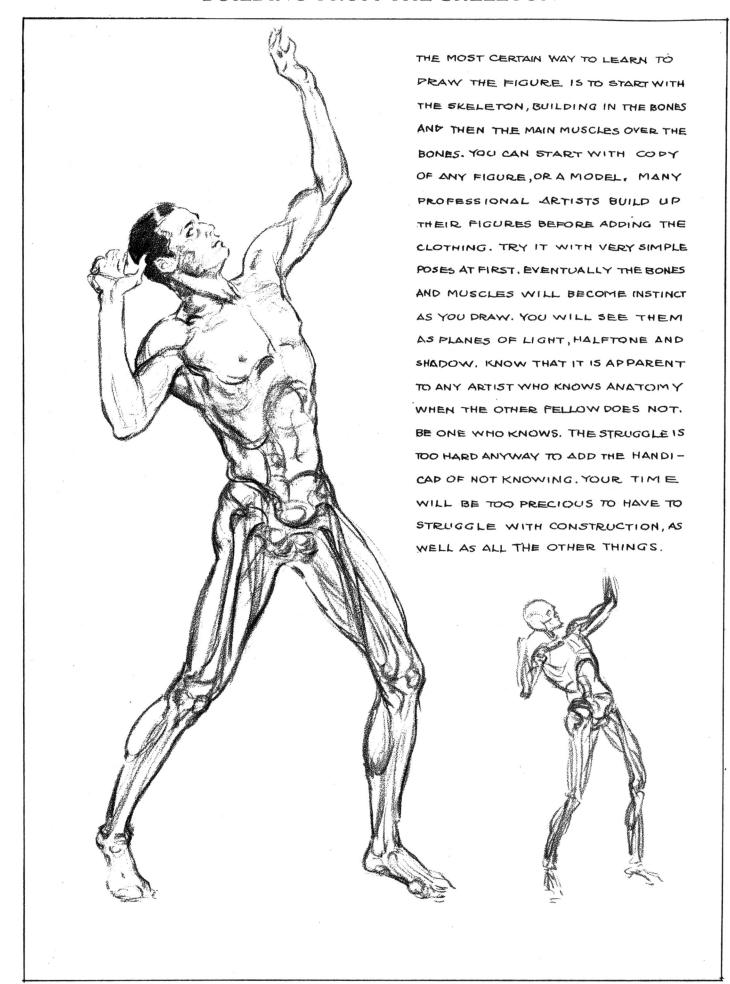

THE MOST CERTAIN WAY TO LEARN TO
DRAW THE FIGURE IS TO START WITH
THE SKELETON, BUILDING IN THE BONES
AND THEN THE MAIN MUSCLES OVER THE
BONES. YOU CAN START WITH COPY
OF ANY FIGURE, OR A MODEL. MANY
PROFESSIONAL ARTISTS BUILD UP
THEIR FIGURES BEFORE ADDING THE
CLOTHING. TRY IT WITH VERY SIMPLE
POSES AT FIRST. EVENTUALLY THE BONES
AND MUSCLES WILL BECOME INSTINCT
AS YOU DRAW. YOU WILL SEE THEM
AS PLANES OF LIGHT, HALFTONE AND
SHADOW. KNOW THAT IT IS APPARENT
TO ANY ARTIST WHO KNOWS ANATOMY
WHEN THE OTHER FELLOW DOES NOT.
BE ONE WHO KNOWS. THE STRUGGLE IS
TOO HARD ANYWAY TO ADD THE HANDI-
CAP OF NOT KNOWING. YOUR TIME
WILL BE TOO PRECIOUS TO HAVE TO
STRUGGLE WITH CONSTRUCTION, AS
WELL AS ALL THE OTHER THINGS.

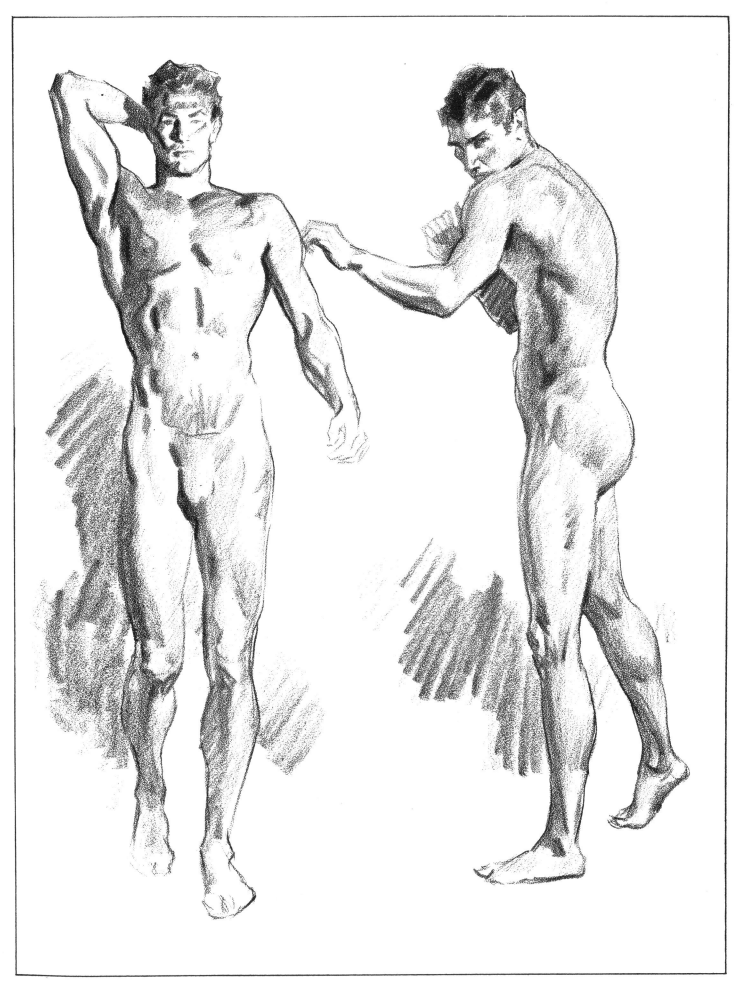

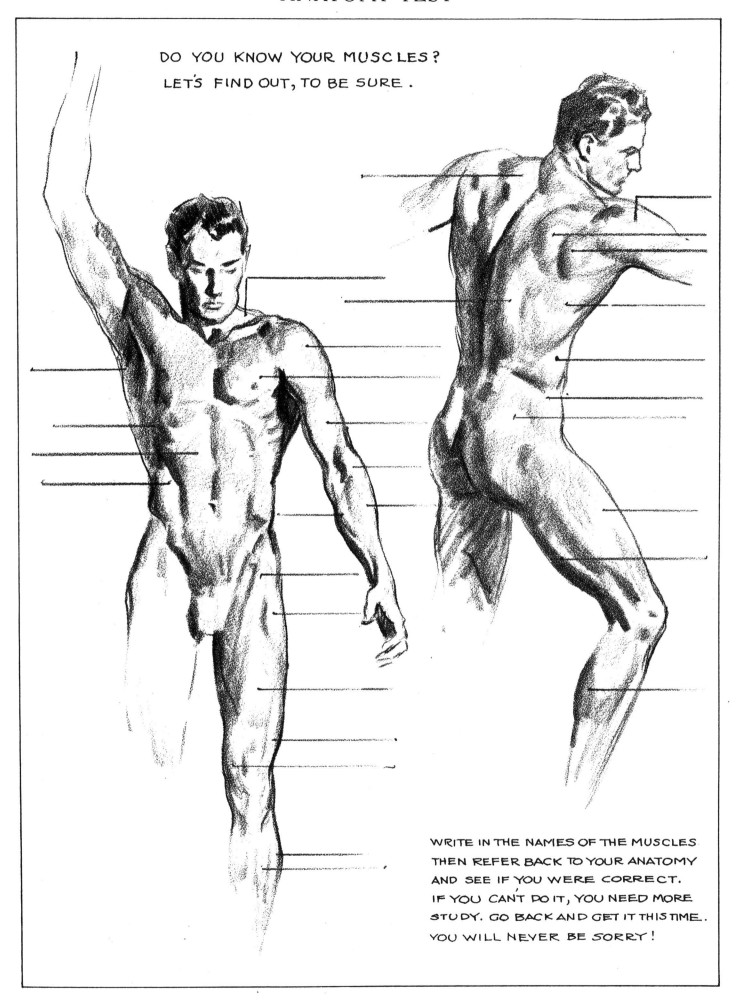

DO YOU KNOW YOUR MUSCLES?
LET'S FIND OUT, TO BE SURE.

WRITE IN THE NAMES OF THE MUSCLES
THEN REFER BACK TO YOUR ANATOMY
AND SEE IF YOU WERE CORRECT.
IF YOU CAN'T DO IT, YOU NEED MORE
STUDY. GO BACK AND GET IT THIS TIME.
YOU WILL NEVER BE SORRY!

A typical problem worked out with an advertising art director:

"Please rough out some little figures for pose only," an art director says to you, "to show to the Blank Knitting Company, suggesting our next ad. Indicate a one-piece bathing suit. Details of the bathing suit will be supplied later. Use a standing pose. The figure will be cut out against a white background, and the ad is to occupy a half page up and down in the Satevepost."

When you have made a series of roughs, show the two you like best to the art director, who takes them to his client. Afterward the art director tells you, "Mr. Blank likes these. Please draw them actual size for the magazine. The page size is nine-and-three-eighths by twelve-and-one-eighth inches. You are to have the left half of the page up and down. Pencil will do. Use light and shadow on the figure."

Mr. Blank O.K.'s one of your pencil sketches, and the art director says, "Get your model and take some snaps. Our client wants outdoor sunlit lighting and cautions us against getting a squint in the model's eyes."

The next step is to photograph a friend in a bathing suit. The chances are you will have to idealize her figure when you make your drawing from this photograph. Make her eight heads tall. Raise the crotch to the middle of the figure. Trim the hips and thighs if necessary.

She might be smiling over her shoulder at you. Have her hair blowing, perhaps. Find some use for the hands. Make the whole drawing as appealing as possible.

Since your drawing will be reproduced by halftone engraving, you have a full range of values with which to work. You may use pencil, charcoal, litho pencil, Wolff pencil, or wash. You can rub if you prefer. You also have the choice of pen and ink, brush, or drybrush. The drawing should be made on Bristol or illustration board and should be kept flat. Never roll a drawing that is to be reproduced.

VI. THE FIGURE IN ACTION: TURNING AND TWISTING

Every good action pose should have a suggestion of "sweep." Perhaps I can best describe sweep by saying that the movement which immediately precedes the pose is still felt. On the following pages I have tried to show this sweep or the line that the limbs have just followed. The cartoonist can add terrifically to the sense of motion by drawing his sweep with lines back of a moving hand or foot.

The only way to get sweep in the line is to have your model go through the entire movement and observe it carefully, choosing the instant that suggests the most movement. Usually the action can be best expressed if you use the start or finish of the sweep. A baseball pitcher suggests the most action either as he is all wound up, ready to throw, or just as he lets go of the ball. A golfer expresses movement best at the start or finish of the swing. If you were to show him on the point of hitting the ball, your drawing would have no action pictorially, and he would appear only to be addressing the ball in his ordinary stance. A horse seems to be going faster when his legs are either all drawn up under him or fully extended. The pendulum of a clock appears to be moving when it is at either extreme of its swing. A hammer raised from a nail suggests a harder blow and more movement than if it were shown close to the nail.

For psychological effect in drawing, it is essential to acquire the full range of movement. The observer must be made to complete the full motion, or to sense the motion that has just been completed. You would instinctively duck from a fist drawn 'way back from your face, whereas you might not withdraw at all from a fist two inches away. The prize fighter has learned to make good use of this psychology in his short punches.

Another means of illustrating action is to show its result or effect, as, for instance, a glass that has fallen over and spilled its contents, with an arm or hand just above it. The actual movement has been completed. Another example is that of a man who has fallen down after a blow, with the arm that hit him still extended.

There are instances, however, when the middle of the action is best. This is called "suspended action." A horse in the act of clearing a fence, a diver in mid-air, a building collapsing—are all examples of suspended action.

Fix in your mind the whole sweep of action and make little sketches at this point. At times you can help the action with a bit of blur, some dust, a facial expression. The cartoonist can write in, "Swish," "Smack," "Zowie," "Bing," "Crash," but you may not.

If you perform the action, it helps to give you the feel of it. Get up and do it, even if it does seem a little silly. If you can study the action in front of a large mirror, so much the better. There should be a mirror in every studio.

Some of your "action" camera shots may be disappointing unless you keep these facts in mind; knowing them helps you click the shutter at the precise moment.

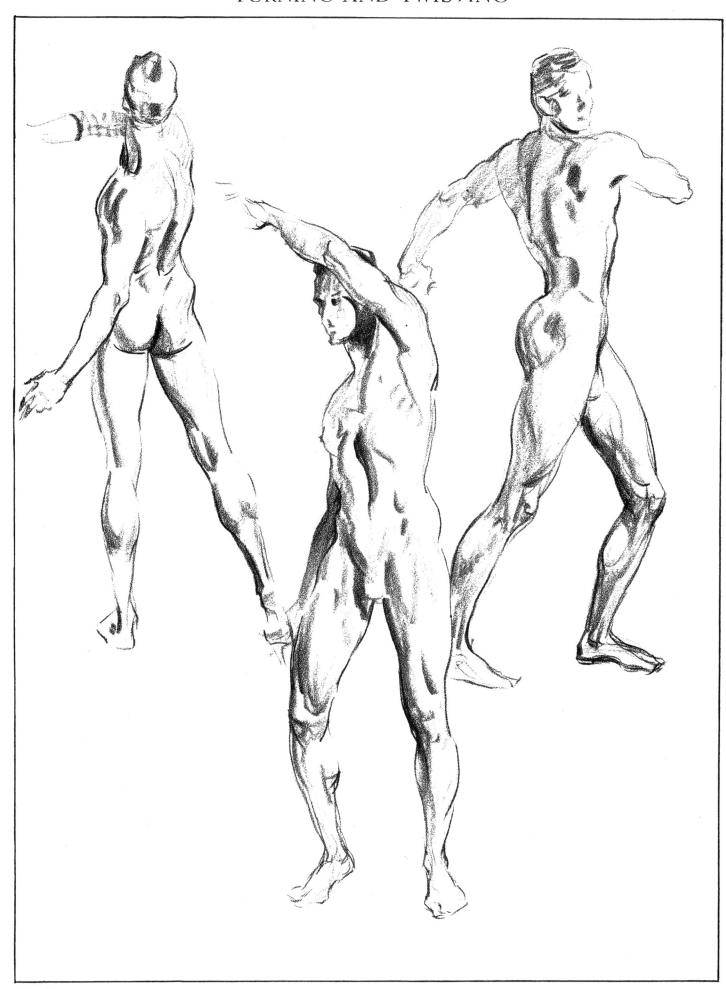

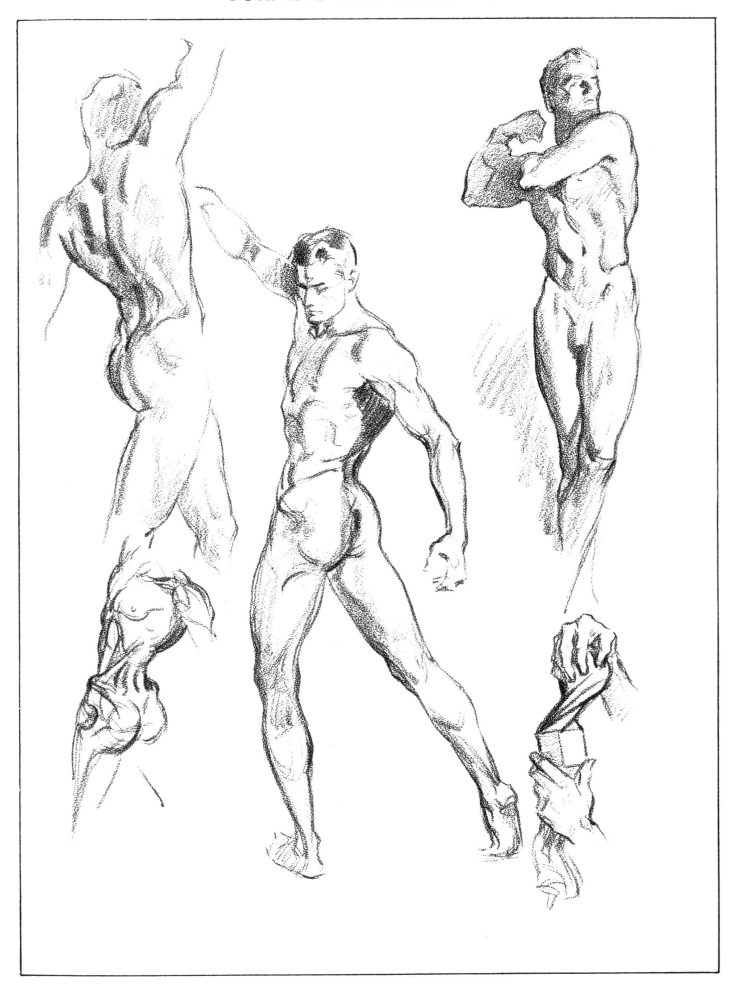

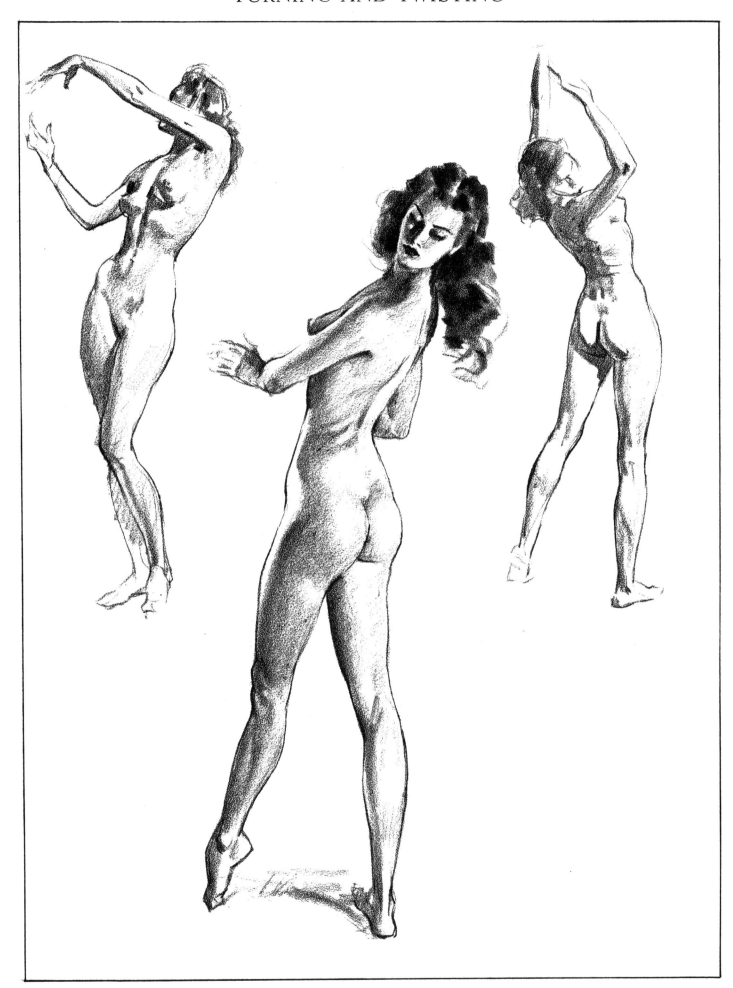

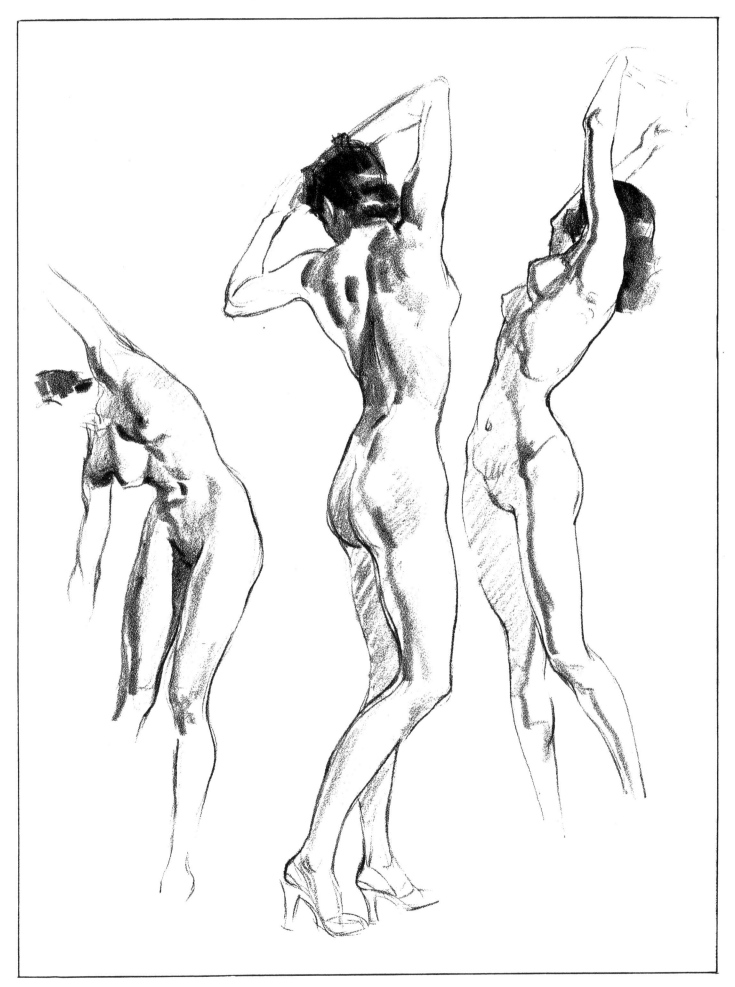

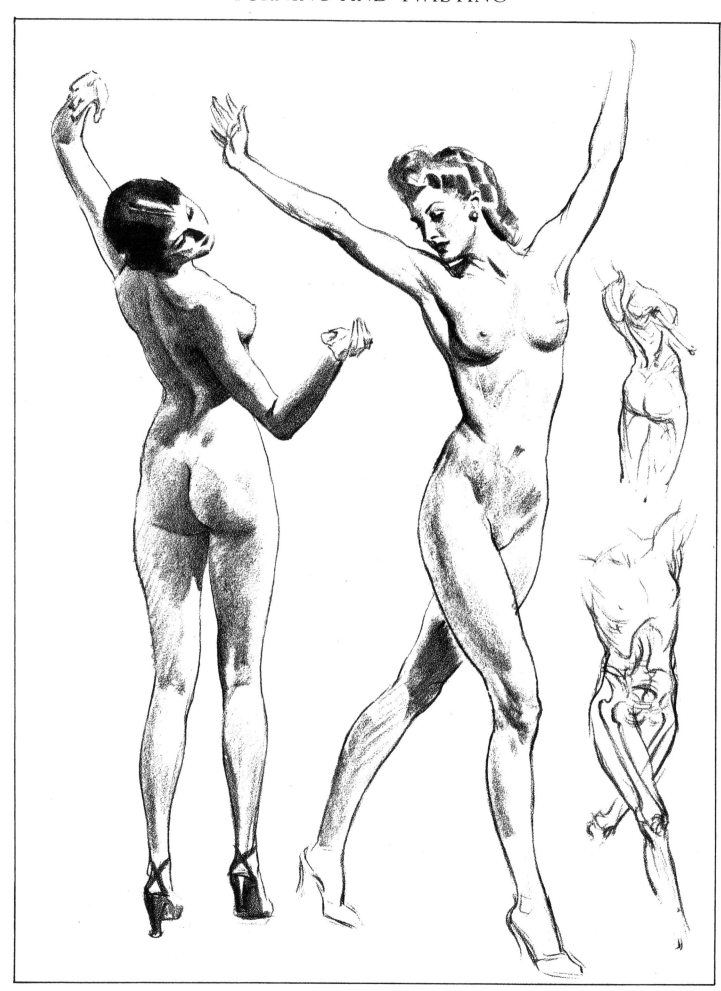

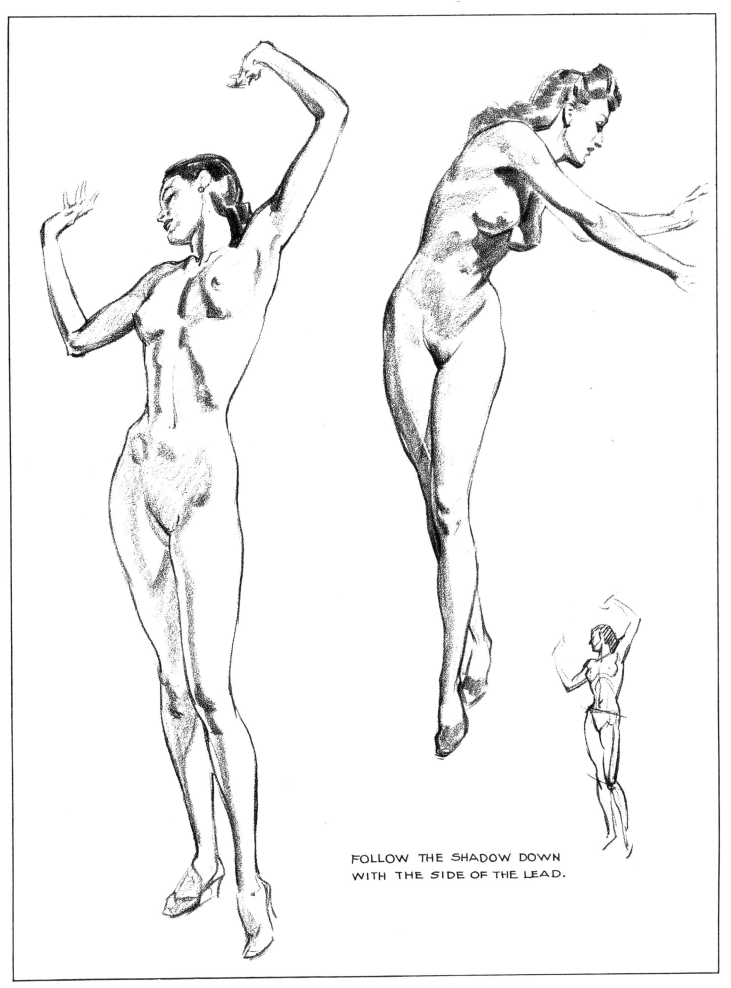

FOLLOW THE SHADOW DOWN
WITH THE SIDE OF THE LEAD.

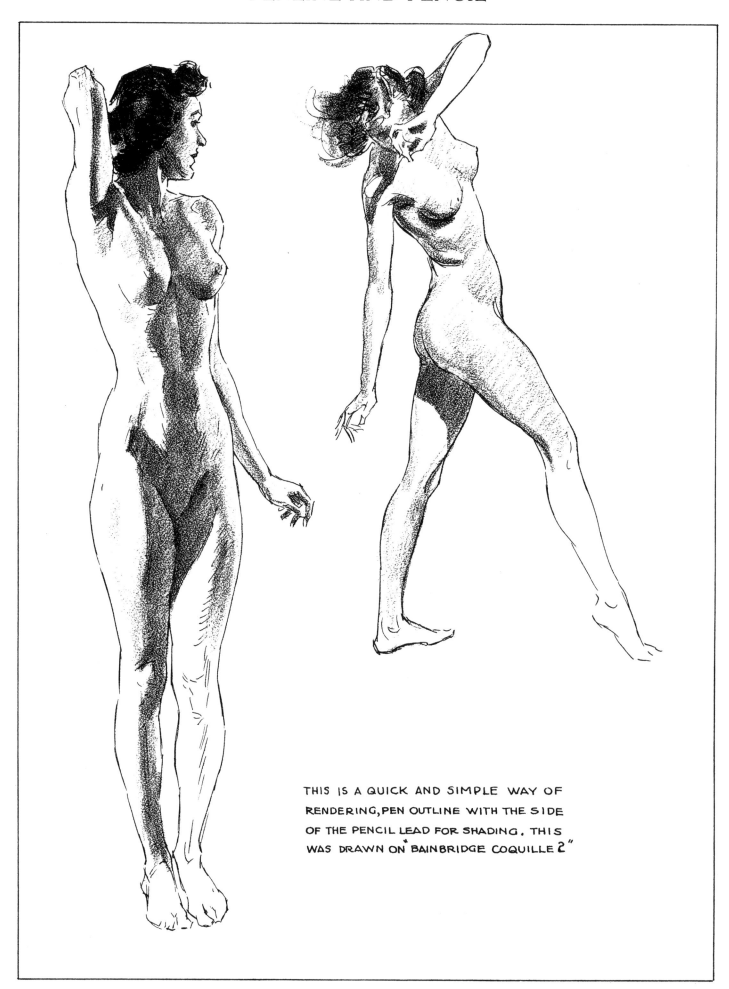

THIS IS A QUICK AND SIMPLE WAY OF
RENDERING, PEN OUTLINE WITH THE SIDE
OF THE PENCIL LEAD FOR SHADING. THIS
WAS DRAWN ON "BAINBRIDGE COQUILLE 2"

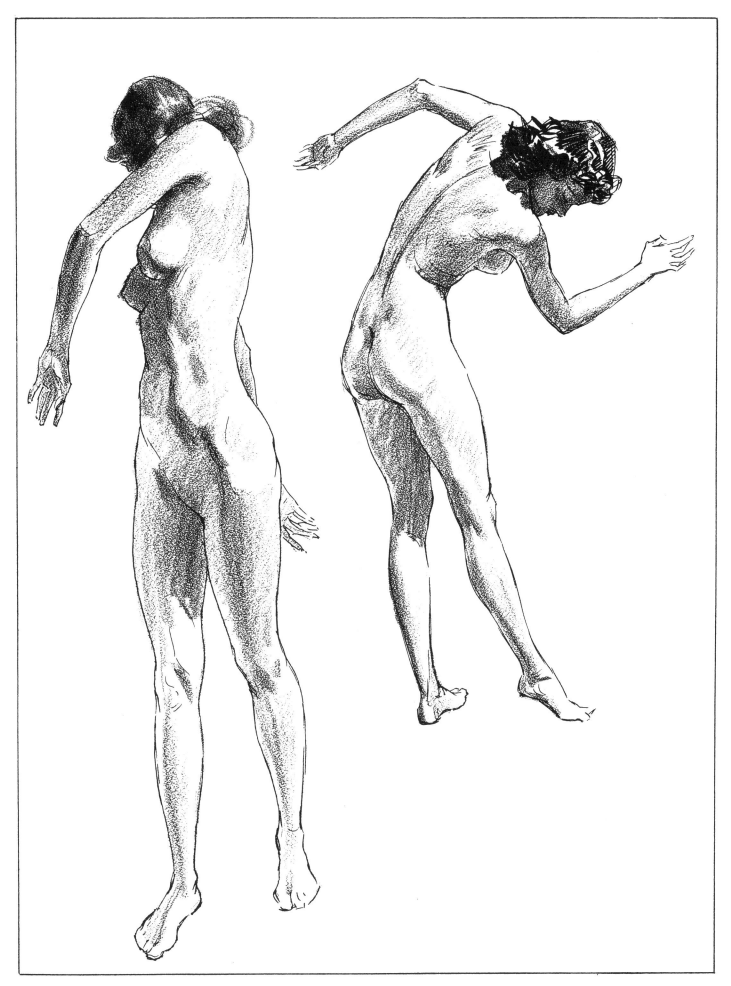

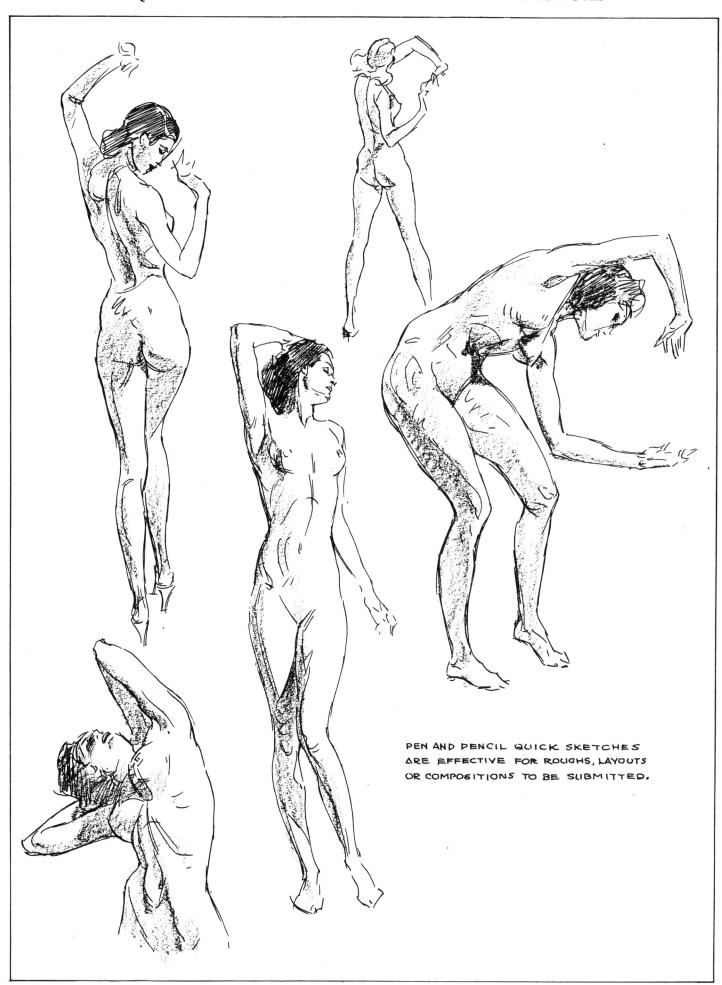

PEN AND PENCIL QUICK SKETCHES
ARE EFFECTIVE FOR ROUGHS, LAYOUTS
OR COMPOSITIONS TO BE SUBMITTED.

A TYPICAL PROBLEM

A typical problem worked out with an art editor of a fiction magazine:

The art editor says, "I have picked for illustration this paragraph from the manuscript":

" 'The last act was over. Jackie was removing the scant costume she had worn in the final chorus. She was alone in her dressing-room, or so she thought, until, by some inexplicable instinct, she turned quickly toward the jumble of costumes hanging in her wardrobe. There was unmistakable movement in the glitter of sequins.' "

"Now," continues the editor, "I'd like to see a rough or two in pencil on this before you go ahead. I think we can use a vignette shape better than a rectangular picture. Take about two-thirds of the page. The girl should be featured, bringing her up large in the space. We want something with action and punch and sex appeal but nothing offensive. Very little background necessary—just enough to place her. The girl, you know, has black hair and is tall, slender, and beautiful."

Proceed to make several roughs or thumbnail sketches for your own approval. It is clear that the girl is frightened and has been caught off guard. Someone is hiding—a rather sinister situation. The emotion to communicate and dramatize is fear. The story says she turned quickly, and that she was removing her scant costume, and the editor has said there must be nothing offensive in the drawing. You must put across the fact that she is in a dressing-room at the theater. A bit of the dressing table and mirror might be shown, and, of course, the closet or wardrobe where the intruder is hiding.

Project yourself into the situation and imagine her gesture, the sweep of movement. She might have pulled off a slipper, looking around with a startled expression. Perhaps the hands can do something to emphasize fear.

To get an idea of a chorus costume, go to a movie of a musical comedy. Look up some clips of chorus girls. After you have decided on a pose or arrangement of the subject, get someone to pose for some studies or snaps. Use a photo flood lamp. Plan the light as though it were the only light in the room, shining over the dressing-table. You can get dramatic effects with your lighting. Go at the problem as seriously as though it were an actual commission, for if it does become a reality, you will have to be ready for it. You cannot start being an illustrator with your first job. You will have to be judged an illustrator before you can get the assignment.

Take a paragraph from any magazine story and do your version of an illustration for it. Better, take one that was not illustrated by another artist, or, if it was, forget entirely his interpretation and style. *Don't under any circumstances copy another illustrator and submit the result as your own drawing.*

After you have read this book, come back to this page and try the illustration again. Save your drawings for samples.

The paragraph quoted for illustration is, of course, fictitious. The art director's demands, however, are altogether real. Most magazines pick the situation. Some even send you layouts for arrangement, for space filling, text space, et cetera. All send the manuscript for you to digest. Some ask you to pick the spots and show them roughs first. Most like to see what they are going to get before you do the final drawings. You may work in any medium for black and white half-tone reproduction.

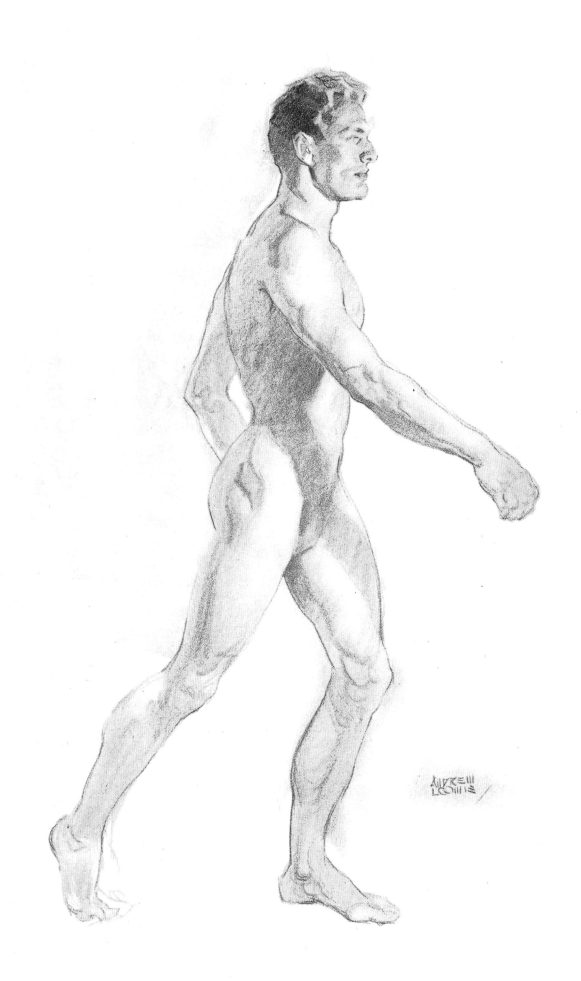

VII. FORWARD MOVEMENT: THE TIPPED LINE OF BALANCE

The theory of depicting forward movement (any action that carries the whole body forward) requires that the top always be shown ahead of the base. If you balance a pole on your hand, you must follow with your hand the movement of the top of the pole. If it leans in any direction and you move the base in the same direction at the same speed, the pole maintains a constant slant between base and top. And the faster it goes the greater the slant.

So with figures in forward movement. A line drawn down through the middle of the forward-moving figure will slant exactly as the pole does. If you think of a picket fence with all the palings slanted and parallel, instead of vertical, you have a clear idea of the line of balance in forward movement. On pages 118 and 119 is a series of pictures taken with a fast lens, for the motion picture camera is actually too slow to stop movement for "still" reproduction and enlargement. The separate shots were taken at split seconds apart and pieced together to show the progression of the movement. I wished particularly to have the figure remain the same size throughout the sequence. The photographs reveal many facts, not apparent to the naked eye, about what takes place in the acts of running or walking.

In walking or running, the line of balance remains a constant forward slant as long as the same speed is maintained and tips more as the speed is increased. This change is hard to see because the moving arms and legs distract one's attention from the action. A person must lean the body forward to take a normal step. The balance is caught by the forward foot. The forward push comes from the foot in back. The arms move in reverse of the legs, so that, when

the left leg goes forward, the left arm goes back. The center of the stride expresses the least movement. Note the last picture on page 119. For this photograph my model stood still and tried to pose as if he were moving. You will see at once how unconvincing the motion is. It is not the fault of the model but the fact that the important principle of forward movement is not working in the pose. Movement drawn without consideration for the tipped line of balance will not give the impression of forward movement. The drawing, no matter how anatomically correct, will resemble the movement of a jumping-jack suspended from a string.

The tipped line may be placed lightly on your paper and the figure built upon it. Technically, a heel should never be placed directly under the head but in back of it, to give motion. The foot that is carrying the weight and pushing should always be in back of the line of balance.

We think of the act of walking as if the foot describes an arc with the hip as center. What actually happens is that the hip describes the arc with the foot as center. Each step is a center with a fanlike movement going on above it. The foot that is *off* the ground swings in an arc forward from the hip, whereas the foot *on* the ground reverses the arc. As we walk along, what happens is this: foot moves body, body moves foot, foot moves body, body moves foot. Each leg takes the job over as soon as it is put on the ground, and the other leg relaxes and swings forward, mostly by momentum, until it takes over. Both actions go on simultaneously.

Hip and knee drop on the relaxed side. The leg carrying the weight is straight as it passes under the hip and bends at the knee as the heel

THE MECHANICS OF MOVEMENT

comes up. Photographs illustrate this clearly. The relaxed leg is bent at the knee as it swings forward. It does not straighten out until after it has passed the other knee. This is very well defined in the side views of the walking poses. The legs are both fairly straight at the extremes of the stride. Here again is that paradox, that the legs seem to express most motion at the start or finish of the sweep described in the last chapter. Note particularly how much the girl's flying hair adds to the movement in the running poses. Also, the girl runs with arms bent, although in walking they swing naturally as they hang down.

Try to base walking and running poses on photos of actual movement. They are well worth obtaining—and those given here will prove valuable for reference in a pinch. To get all the action that is in a stride would require a slow-motion sequence, with page after page of pictures reproduced to any practical size. I feel this is hardly necessary; careful study of the two following pages should suffice.

Start drawing mannikin poses. See if you can, in a series of small framework sketches, draw all the way through a complete stride. In drawing back views of walking poses, remember that the pushing leg in back of the figure is straight until the heel leaves the ground, the heel and toes being lifted by the bending knee.

The use of cameras by artists is a controversial subject. Yet the demands on the present-day artist for action, expression, and dramatic interpretation are so exacting that it seems a bit ridiculous to fake these things when the actual knowledge is so easy to obtain by means of a camera. I do not admire a photographic-looking drawing, but I certainly detest a drawing that is meant to have virility and conviction but is inane and static through ignorance or laziness on the part of the artist. The fact that you can learn things of value from the camera is reason enough for you, as an artist, to have and use one.

The source of your knowledge, as mentioned before, is immaterial. Why put a model through the ordeal of trying to keep a vivacious smile on by the hour? No one can hold such a pose. We can learn more about a smile from the camera in five minutes than we can in five years of trying to "catch" it with the eye alone. Limbs move too fast for the naked eye to record. Expressions change and are gone in an instant. The camera is the one means of nailing these down so that we can study them by the hour. It is an unpardonable sin merely to copy. If you have nothing of your own to add, have no feeling about it, and are satisfied, technically, with the manner of treatment and have no desire to change this, then throw away your pencils and brushes and use the camera only. There will be many instances where you won't know what else to do but to copy, but these instances will be fewer as you try to express what you feel and like through your increasing technical knowledge.

Use your camera for all it's worth as part of your equipment. But keep it as equipment—not the end, but a means, just as your knowledge of anatomy is a means. Every successful artist whom I know, though it may be heresy to say so, has a camera and uses it. Many artists I know are expert photographers, taking their own pictures and developing them. Most use the small or candid variety of camera and enlarge their prints. The camera broadens their scope tremendously in securing data outside the studio. Start saving for a camera right now if you have not already made it one of your "means."

Going on with our line of balance, there are times when this line may be curved. In a sense, then, the line of balance is like a spring. For instance, a figure may be pushing very hard against something. The pushing would bend his figure backward. Again, if he were pulling hard, it would bend the figure the other way. Dancing poses can be built on the curved line, as well as

swaying figures. Movement can be straight as an arrow, or curved like the path of a skyrocket. Either suggests powerful motion.

The vital quality to have in your drawing is the "spirit" of movement. You cannot be successful as an artist if you remain seated in your chair, nor can your drawings be successful if the figures you draw remain static. Nine times out of ten the picture you are asked to do will call for action. Art buyers love action. It adds zest and pep to your work. A number of prominent artists recently revealed the fact that the "drapey" figures are out as definitely as the First World War "flapper." Ours is an age of action. A model cannot be left to pose herself. You will have to think hard: "What can I do with her to make this drawing sing?"

The solution is not easy, for it is a matter of feeling and interpretation. Today a girl on a magazine cover cannot just be sweet. She must be vital in every sense and doing something besides sitting in front of you and having a portrait painted. She cannot just be holding something; the magazine-cover girl has already held everything from cats and dogs to letters from the boy friend. Let her swim, dive, ski through flying snow. Let her do anything, but don't let her be static.

Pictures have changed, and it may be that the camera and photography have been the cause. This does not mean that a drawing cannot be just as vital as a camera study. Only ten years ago the artist did not fully realize what compelling interest lay in action. He had not seen photographs snapped at one thousandth of a second and never dreamed that he could do this himself. Not only magazine covers but any drawing you do will have added selling power with good action. To make it the right kind of action, you will have to find out what action really is and then study it as you would anatomy, values, or any other branch of drawing.

A word of warning must be added against too much duplication of action. If you are drawing several figures, all walking, unless they are marching soldiers, do not make them all walk alike. Interesting action derives from contrast. All the variety you can achieve is needed. A figure appears to move faster if he is passing a stationary or slow-moving figure.

Important, also, is the handling of mass action: soldiers in battle, race horses grouped together, figures scattering away from some danger. Always pick out one or two as the key figures. Put all you have in these. Then group and mass the rest. If you define the individuals equally, the drawing becomes monotonous. Battle pictures should concentrate on one or two figures in the foreground, the rest becoming subordinated to these. It is safe to handle subjects filled with action in this way, since too much attention to the individuals who make up the mass makes for confusion. A group is more powerful than many units.

There is a trick you must learn in order to capture poses that cannot be otherwise obtained —for example, a falling figure in mid-air. You pose the figure, as you want it, on the floor. Use a flat background, get above the figure with the camera, and shoot down. Place him head first, feet first, or any way you want your model. I once did a swan-dive subject by having the girl lie face up across the seat of a chair, and from the top of a table I used a downward shot. You can take the figure this way and then reverse it. By shooting from a very low viewpoint or a high one, many seemingly impossible action shots may be obtained. They must be skillfully done. The artist can disregard the shadows that fall on his background, but the photographer cannot.

Do a lot of experimenting from imagination, from the model, and with your camera. If you can draw well, that is good. If you can add convincing movement, so much the better.

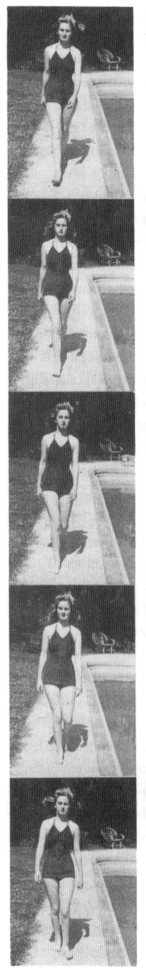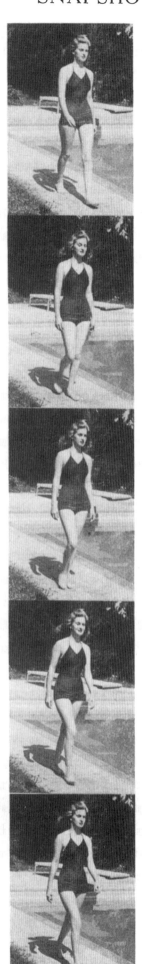

SNAPSHOTS OF RUNNING POSES

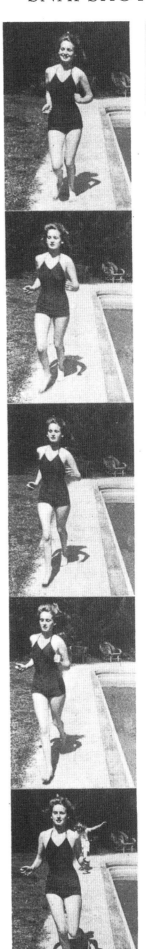

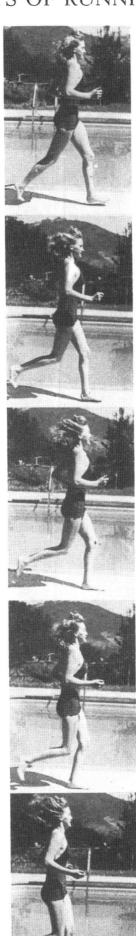

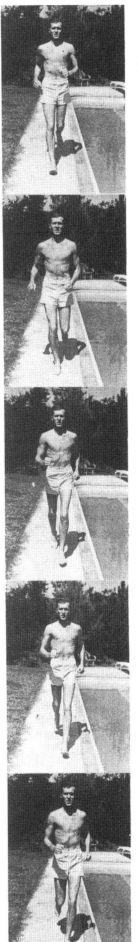

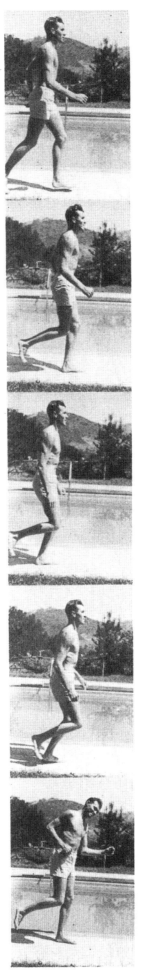

REMEMBER
ARMS MOVE OPPOSITE
TO LEGS. BACK FOOT DOES
NOT LEAVE GROUND UNTIL
FRONT FOOT IS PLANTED.
ARMS PASS HIPS AT SAME
TIME KNEES PASS. HIP IS
HIGHER ON SIDE OF FOOT
CARRYING WEIGHT. KNEE
DROPS ON LEG OFF GROUND.
ACTION IS BEST EXPRESSED
AT EXTREMES OF STRIDE.
ALWAYS TIP LINE OF BAL-
ANCE. MAKE THUMBNAILS
OF THESE AS ABOVE.

119

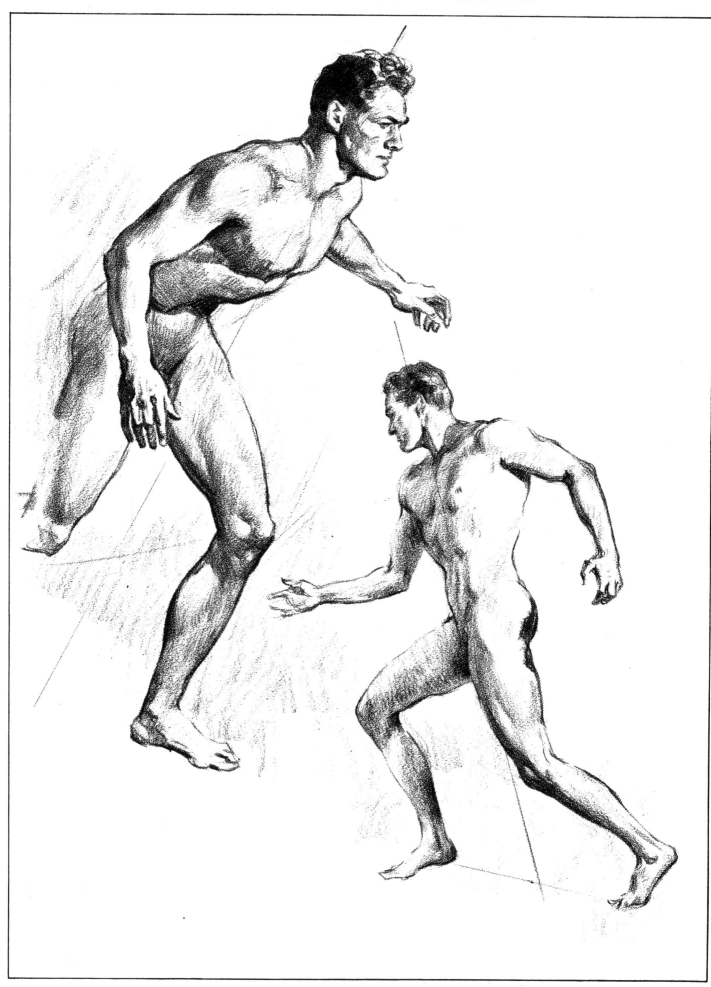

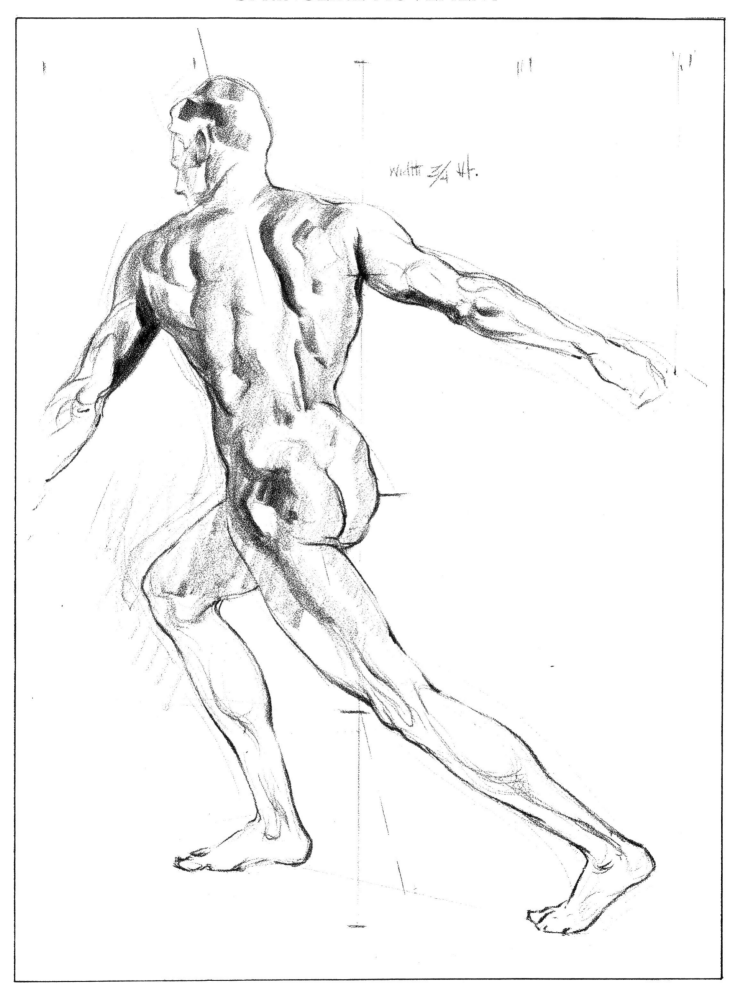

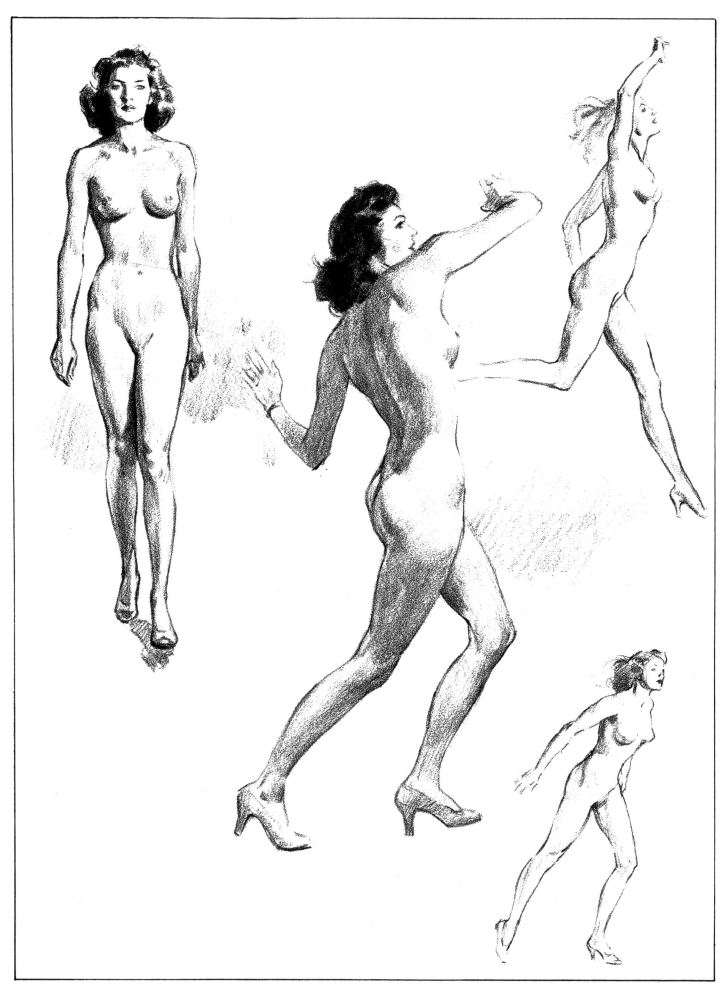

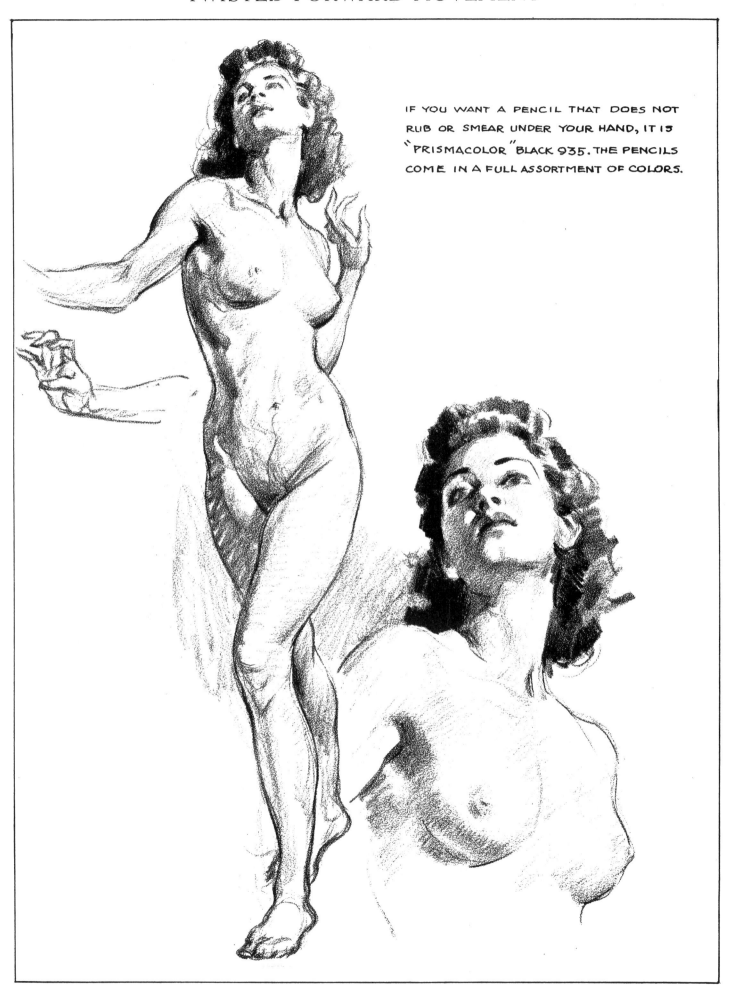

IF YOU WANT A PENCIL THAT DOES NOT
RUB OR SMEAR UNDER YOUR HAND, IT IS
"PRISMACOLOR" BLACK 935. THE PENCILS
COME IN A FULL ASSORTMENT OF COLORS.

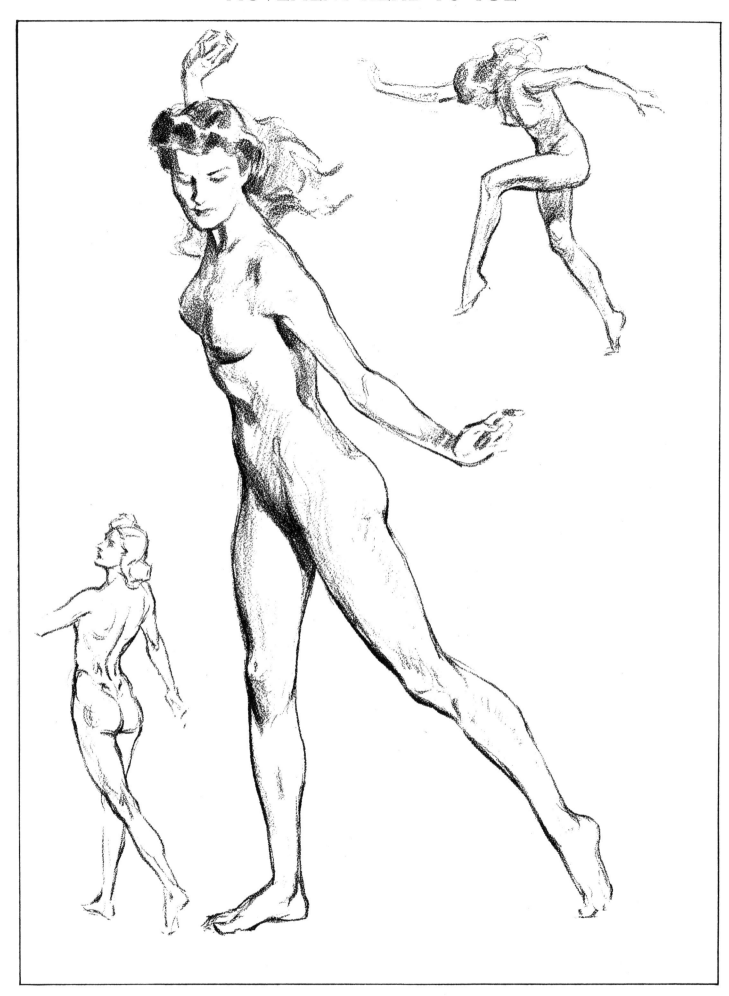

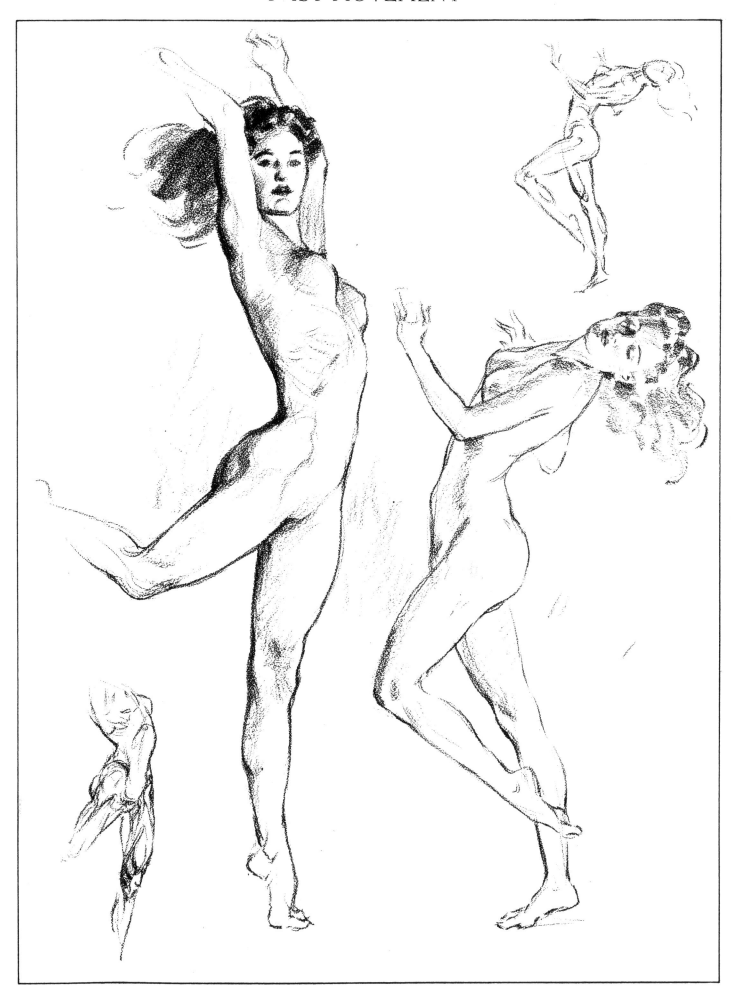

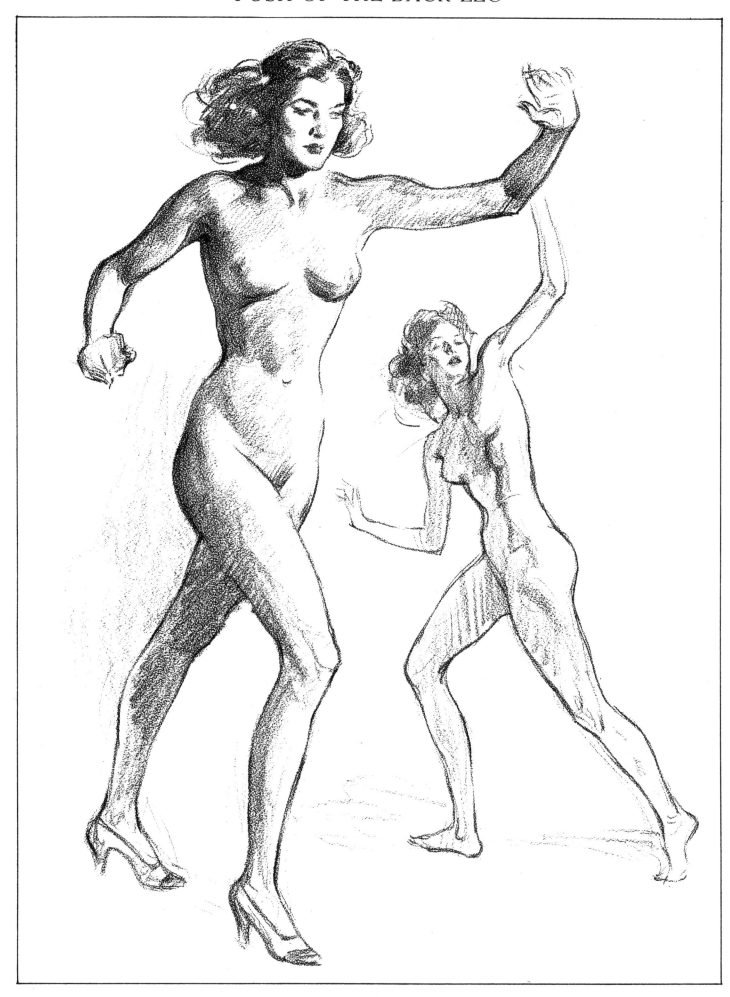

A TYPICAL PROBLEM

A typical problem based on the assumption that you are employed by an art service:

You are wanted in the front office.

"Good morning. I've called you in to meet Mr. Saunders. I'd like you to get the information from him firsthand."

Mr. Saunders: "To make this brief, I am organizing a new company for parcel delivery. We are starting out with a fleet of new trucks. All will be painted a bright red. Our name will be, 'Saunders' Snappy Service'; our slogan, 'We'll deliver anything, anytime, anywhere.' We want a trade-mark designed to display prominently on our trucks, in our advertising, and on our stationery. We'd like a figure of some kind within a circle or triangle, or some other odd shape. It ought to be symbolic of speed. You can include any kind of device, such as wings, an arrow—anything that would get across the idea of speed.

Please don't make another winged Mercury. It's been done to death. It can be dignified or clever. We cannot use a messenger-boy device because it is not typical of the company. Our men will wear uniforms and a cap bearing our trade-mark. Please submit some rough ideas in pencil."

Take one or two of your best roughs and finish them in black and white for a line cut. Do not use halftone. Keep them very simple.

Make a flat design in black and one or two other colors for the design to go on the trucks.

Design a small sticker to be pasted on parcels. This will incorporate the trade-mark and the lettering, "Delivered promptly, safely, by Saunders' Snappy Service." Size to reduce to two by three inches.

Design some direct-by-mail postcards for possible use. These should be simple, original, striking.

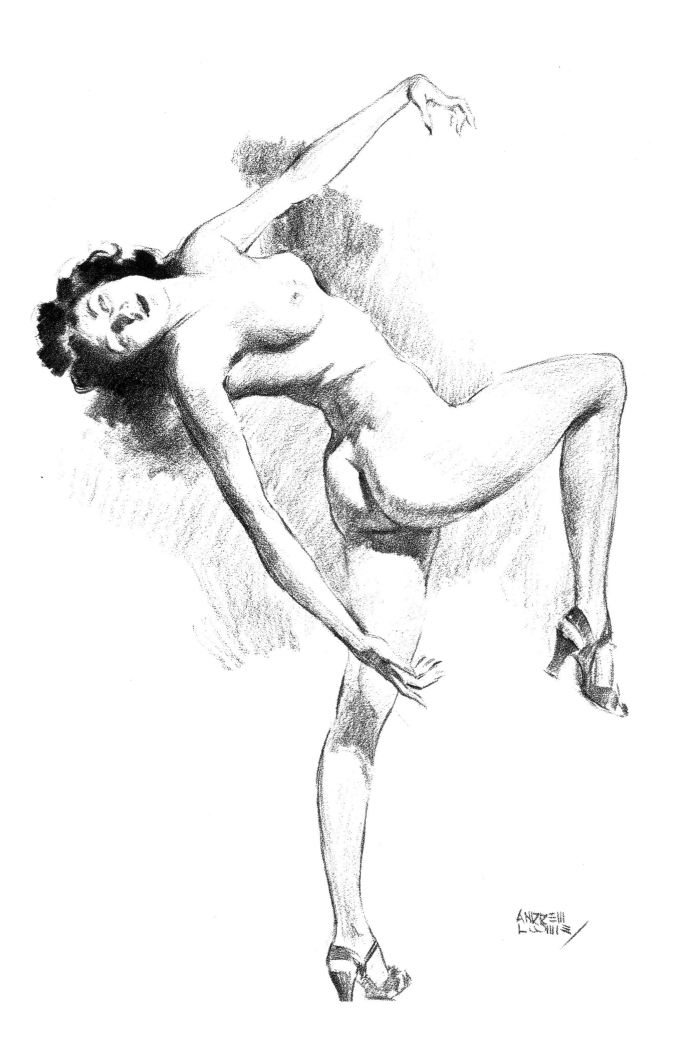

VIII. BALANCE, RHYTHM, RENDERING

Balance is a physical attribute each of us must possess. If a figure is drawn without balance, it irritates us subconsciously. Our instinct is to set firmly on its base anything that is wobbling and likely to fall. Watch how quickly a mother's hand grasps the teetering child. The observer recognizes quickly that a drawing is out of balance, and his inability to do anything about it sets up a negative response.

Balance is an equalized distribution of weight in the figure as in anything else. If we lean over to one side, an arm or leg is extended on the opposite side to compensate for the unequal distribution of weight over the foot or two feet that are the central point of division for the line of balance. If we stand on one foot, the weight must be distributed much as it is in a spinning top. The figure will then fit into a triangle. If we stand on both feet, we make a square base for the weight, and the figure will then fit into a rectangle.

This should not be taken too literally since an arm or foot may emerge from the triangle or rectangle, but the division line through the middle of the triangle or rectangle will show that there is approximately a like amount of bulk on each side of it.

When you are using a live model either for direct sketching or for camera shots, she will automatically keep in balance—she cannot help it. But in drawing action from the imagination balance must be watched carefully. It is easy to forget.

Before going into the problem of rhythm, the fundamentals of rendering must be taken into account. Suggestions for rendering technically in different mediums will appear throughout the rest of the book. Technique is an individual

quality, and no one can positively state that a technical treatment popular or successful today will be so tomorrow. The fundamentals of rendering, however, are not so much concerned with how you put your strokes on paper or canvas as with correct values rendered intelligently for the specified reproduction and a clear conception of the use of tone and line in their proper place.

On page 132 are two drawings that I believe will be self-explanatory. In the first, tone is subordinated to line; in the other, line is subordinated to tone. This gives you two jumping-off places. You can start a drawing with the definite plan of making it either a pure line drawing, a combination of line and tone (in which either can be subordinated to the other), or a purely tonal drawing like the one on page 133. I suggest that you do not confine yourself to a single manner of approach and treat all your work in the same way. Try pen and ink, charcoal, line drawing with a brush, watercolor, or whatever you will. The broader you make your experience in different treatments and mediums, the wider your scope becomes as a practicing artist. If you are making a study, then decide first what you want most from that study. If it is values, then make a careful tonal drawing. If it is construction, line, proportion, or anatomy, work with these in mind. If it is a suggestion for a pose, the quick sketch is better than something labored over. The point is that you will have to labor when you want a detailed or tonal statement. You need not labor quite so hard to express a bit of action. If your client wants a sketch, see that it remains a sketch and that you will have something more in the way of finish to add to your final drawing.

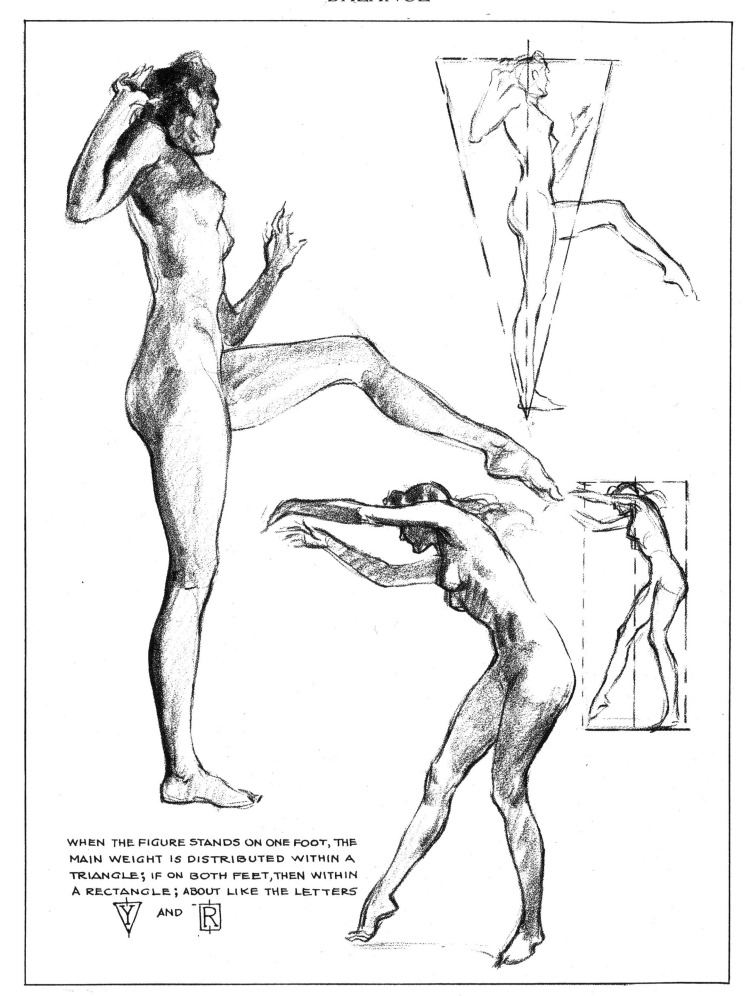

WHEN THE FIGURE STANDS ON ONE FOOT, THE
MAIN WEIGHT IS DISTRIBUTED WITHIN A
TRIANGLE; IF ON BOTH FEET, THEN WITHIN
A RECTANGLE; ABOUT LIKE THE LETTERS
ⱴ AND Ɽ

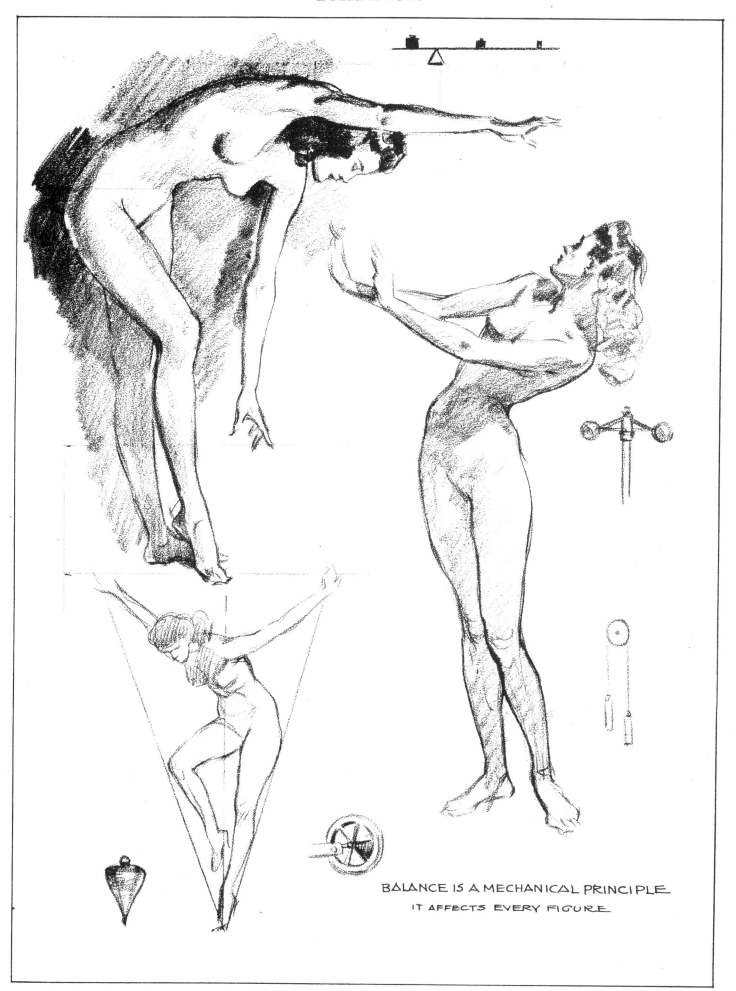

BALANCE IS A MECHANICAL PRINCIPLE
IT AFFECTS EVERY FIGURE

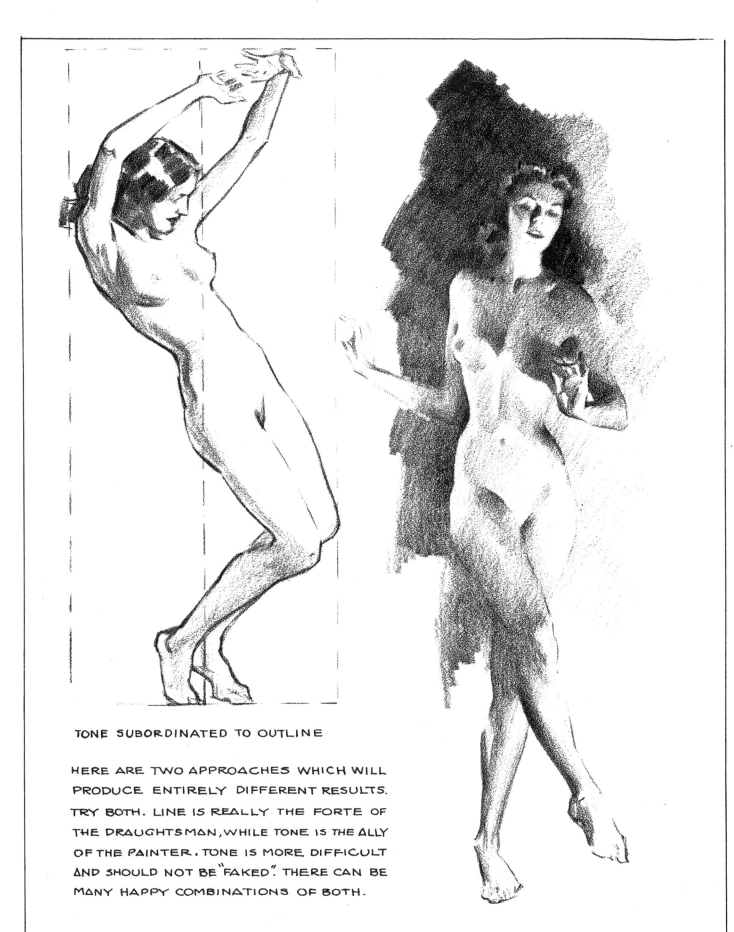

TONE SUBORDINATED TO OUTLINE

HERE ARE TWO APPROACHES WHICH WILL
PRODUCE ENTIRELY DIFFERENT RESULTS.
TRY BOTH. LINE IS REALLY THE FORTE OF
THE DRAUGHTSMAN, WHILE TONE IS THE ALLY
OF THE PAINTER. TONE IS MORE DIFFICULT
AND SHOULD NOT BE "FAKED". THERE CAN BE
MANY HAPPY COMBINATIONS OF BOTH.

OUTLINE SUBORDINATED TO TONE

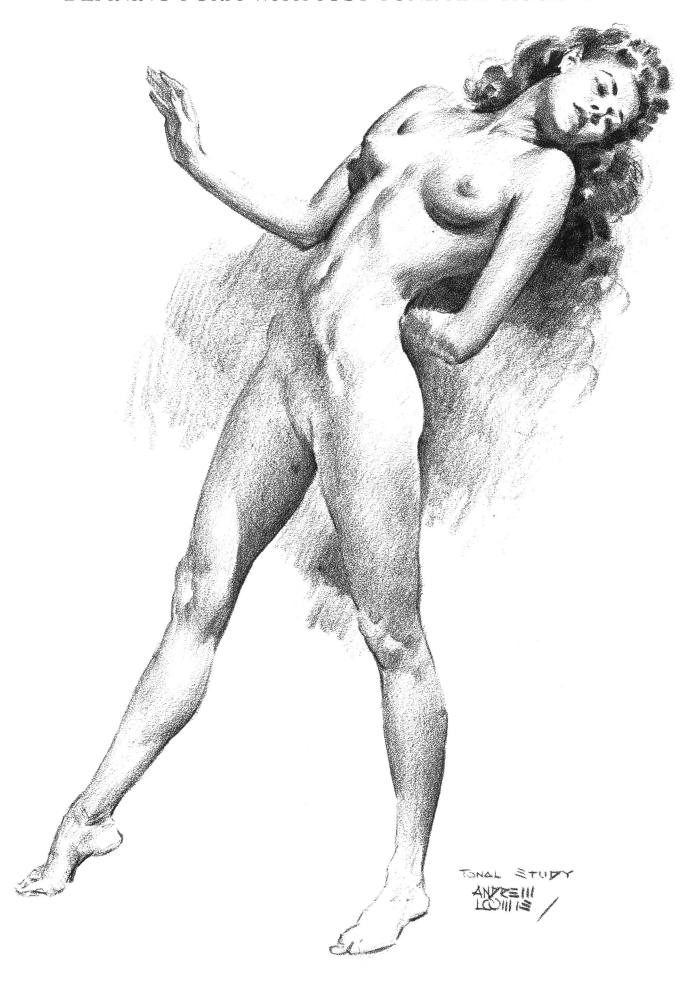

TONAL STUDY
ANDREW
LOOMIS

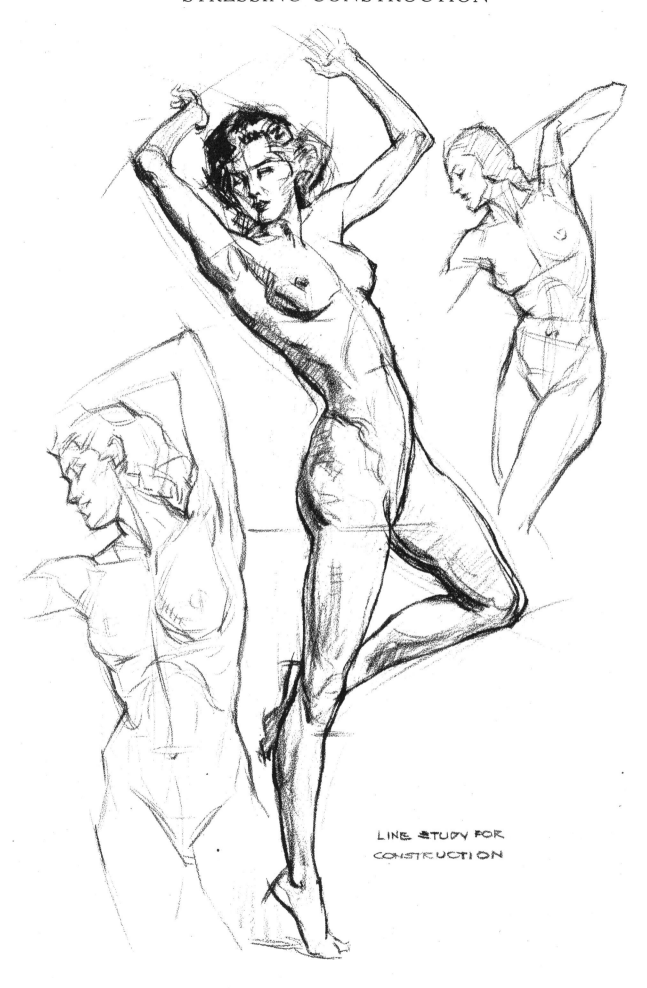

LINE STUDY FOR
CONSTRUCTION

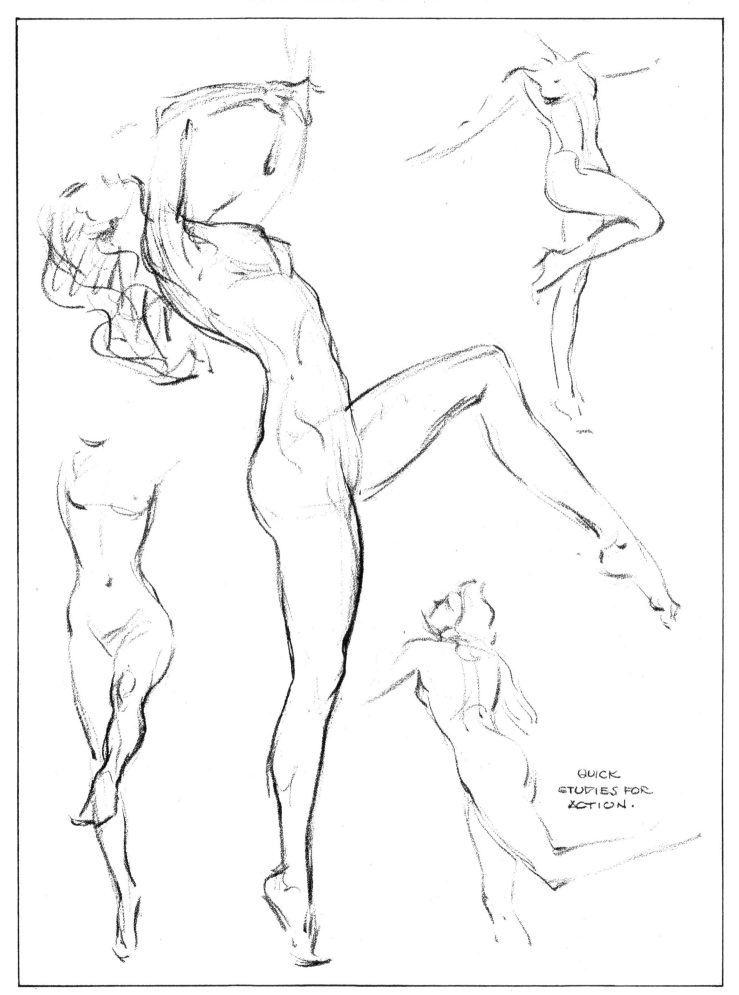

QUICK
STUDIES FOR
ACTION.

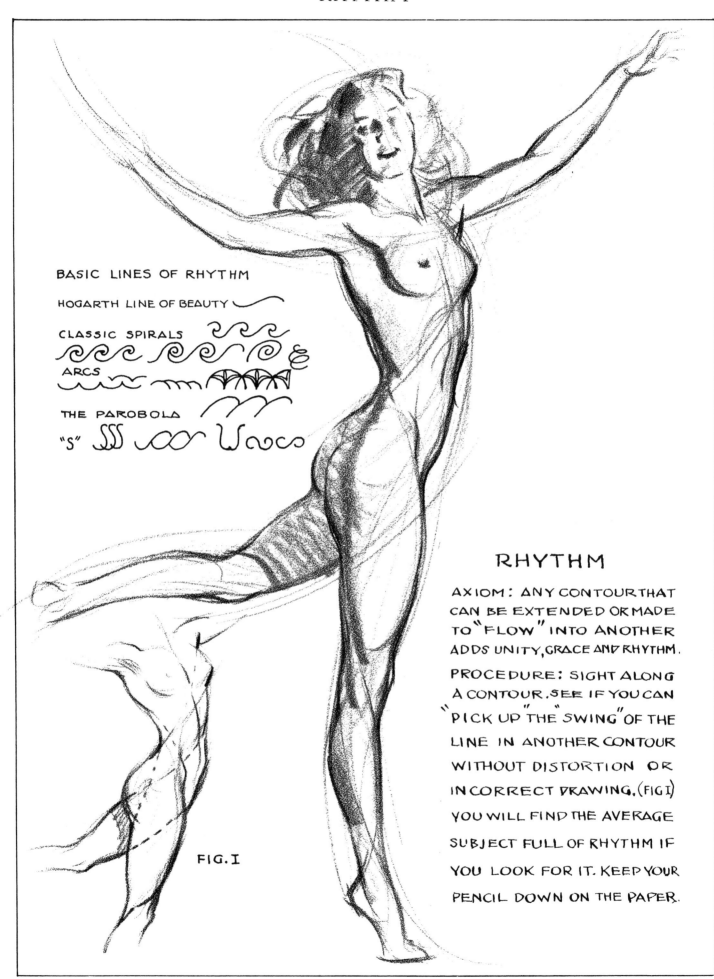

BASIC LINES OF RHYTHM

HOGARTH LINE OF BEAUTY

CLASSIC SPIRALS

ARCS

THE PAROBOLA

"S"

RHYTHM

AXIOM: ANY CONTOUR THAT CAN BE EXTENDED OR MADE TO "FLOW" INTO ANOTHER ADDS UNITY, GRACE AND RHYTHM.

PROCEDURE: SIGHT ALONG A CONTOUR. SEE IF YOU CAN "PICK UP" THE "SWING" OF THE LINE IN ANOTHER CONTOUR WITHOUT DISTORTION OR INCORRECT DRAWING. (FIG I) YOU WILL FIND THE AVERAGE SUBJECT FULL OF RHYTHM IF YOU LOOK FOR IT. KEEP YOUR PENCIL DOWN ON THE PAPER.

FIG. I

RHYTHM

The feeling of rhythm is of tremendous importance in figure drawing. Unfortunately, it is one of the easiest things to miss. In music we feel tempo and rhythm. In drawing it is much the same. Considered technically, rhythm is a "flow" of continuous line resulting in a sense of unity and grace.

We call the rhythmic emphasis on a line or contour "picking up." The line of an edge, observed across the form, will be picked up and continued along another contour. The next few drawings may serve as examples. Look for this phenomenon of rhythmic line, and you will find its beauty in all natural forms — in animals, leaves, grasses, flowers, sea shells, and in the human figure.

We are conscious of the rhythm that pulses through the universe, beginning with the atom and ending with the stars. Rhythm suggests repetition, flow, cycles, waves, and all are related to a unified plan or purpose. The feeling of rhythm in drawing, aside from the abstract, is a "follow-through" in line, just as it is in the movements of various sports. A bowler or golfer, a tennis player, or any other athlete must master the smooth "follow-through" to develop rhythm. Follow your lines through the solid form and watch them become part of a rhythmic plan. When a drawing looks clumsy, the chances are that the trouble lies in its lack of "follow-through." Clumsiness in action—and in drawing —is lack of rhythm that results in a jerky, uneven, disorganized movement.

There are some basic lines of rhythm for which we can be constantly on the alert. The first is called the "Hogarth" line of beauty. It is a line that gracefully curves in one direction and then reverses itself. In the human form, it is present everywhere: in the line of the spine, the upper lip, the ear, the hair, the waist and hips, and down the side of the leg to the ankle. It is like the letter S in variation.

A second line of rhythm is the spiral, a line starting at a point and swinging around that point in a spreading, circular movement. This rhythm of line is apparent in sea shells, a whirlpool, or a pinwheel.

The third line of rhythm is called the parabola, which is a sweep of line continually bending to a greater curve, like the course of a skyrocket. These three lines are the basis of most ornamentation. They can also be made the basis of pictorial composition. They seem to be so thoroughly a part of all graceful movement that they should be given great consideration in all drawing of movement. The lines of rhythm in animals are easily observed and hence easily comprehended.

Rhythm may be forceful, as in great waves beating upon a coast, or gentle and flowing, as in the ripples of a pond. Recurrent rhythm moves and stirs us, or gives us a feeling of restfulness and composure, pleasing to the senses. The so-called "streamline" is rhythm applied to ugly contour. The commercial application of this principle has been eminently successful. The lines of our trains and ships and motorcars, our planes, and our household appliances have been built upon this concept first recognized in nature—in the dolphin among other fish, in birds, and in all living things designed for swift motion.

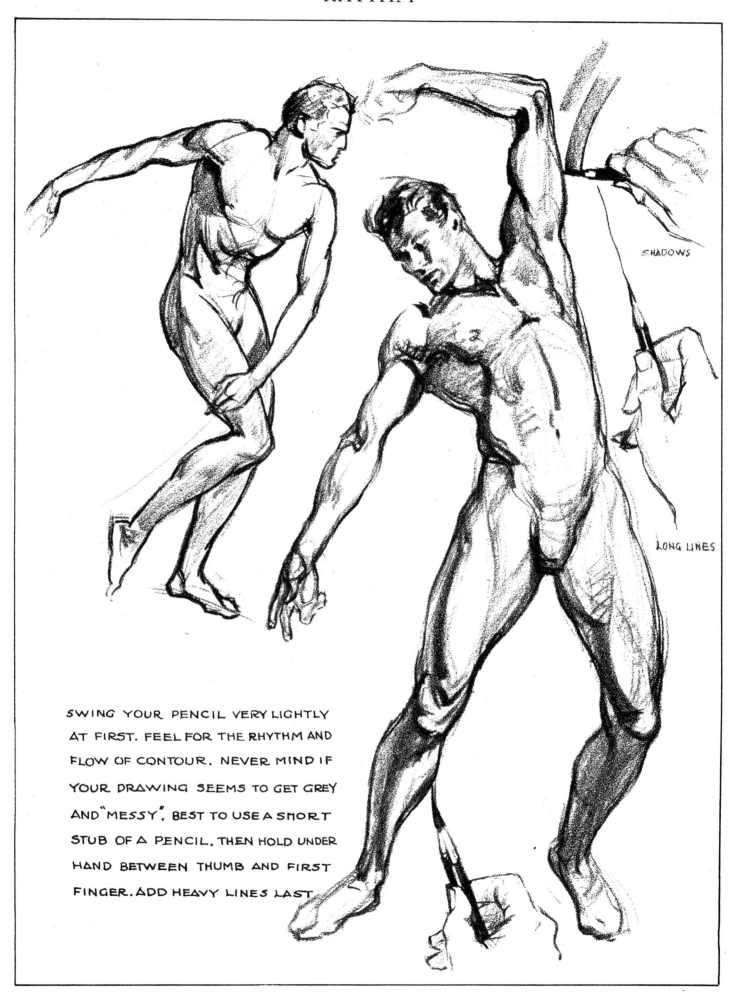

SHADOWS

LONG LINES

SWING YOUR PENCIL VERY LIGHTLY
AT FIRST. FEEL FOR THE RHYTHM AND
FLOW OF CONTOUR. NEVER MIND IF
YOUR DRAWING SEEMS TO GET GREY
AND "MESSY". BEST TO USE A SHORT
STUB OF A PENCIL. THEN HOLD UNDER
HAND BETWEEN THUMB AND FIRST
FINGER. ADD HEAVY LINES LAST

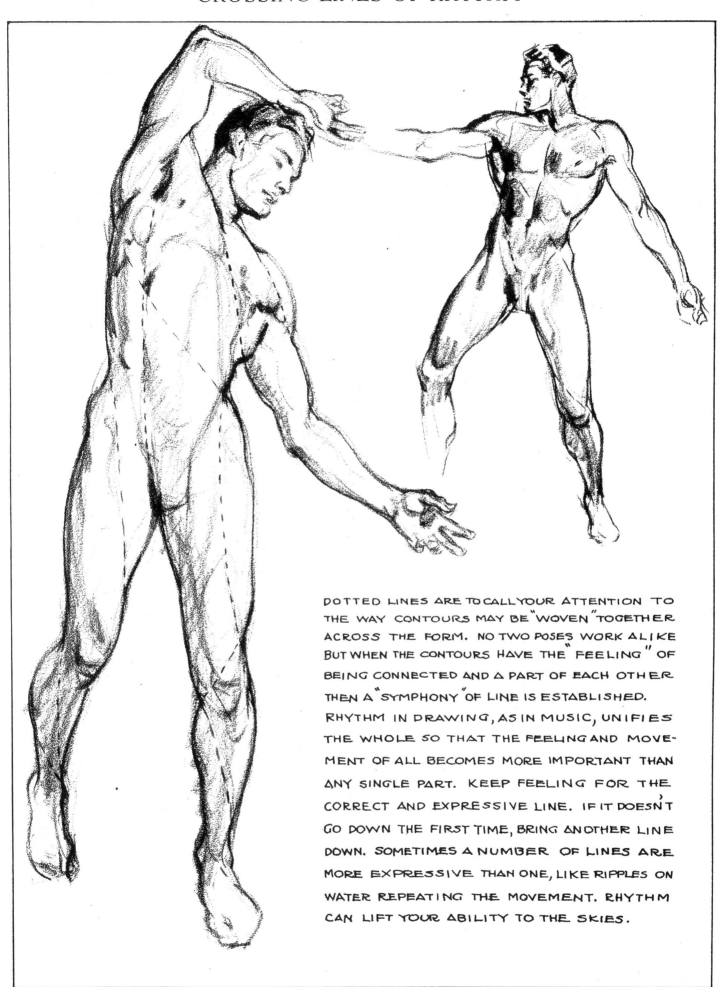

DOTTED LINES ARE TO CALL YOUR ATTENTION TO THE WAY CONTOURS MAY BE "WOVEN" TOGETHER ACROSS THE FORM. NO TWO POSES WORK ALIKE BUT WHEN THE CONTOURS HAVE THE "FEELING" OF BEING CONNECTED AND A PART OF EACH OTHER THEN A "SYMPHONY" OF LINE IS ESTABLISHED. RHYTHM IN DRAWING, AS IN MUSIC, UNIFIES THE WHOLE SO THAT THE FEELING AND MOVEMENT OF ALL BECOMES MORE IMPORTANT THAN ANY SINGLE PART. KEEP FEELING FOR THE CORRECT AND EXPRESSIVE LINE. IF IT DOESN'T GO DOWN THE FIRST TIME, BRING ANOTHER LINE DOWN. SOMETIMES A NUMBER OF LINES ARE MORE EXPRESSIVE THAN ONE, LIKE RIPPLES ON WATER REPEATING THE MOVEMENT. RHYTHM CAN LIFT YOUR ABILITY TO THE SKIES.

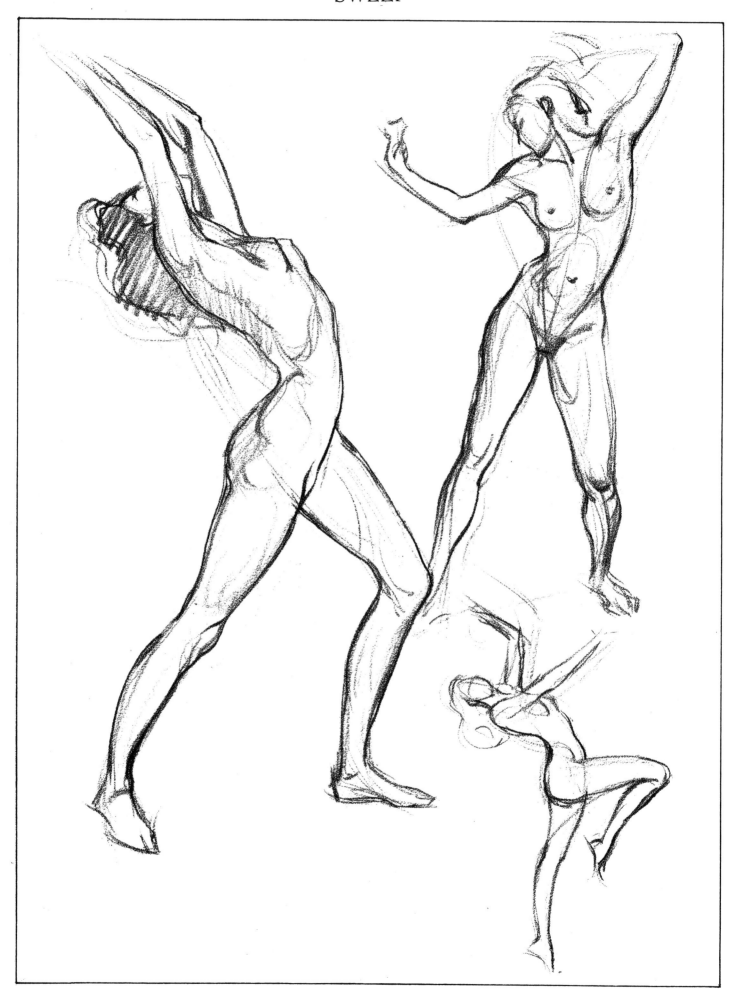

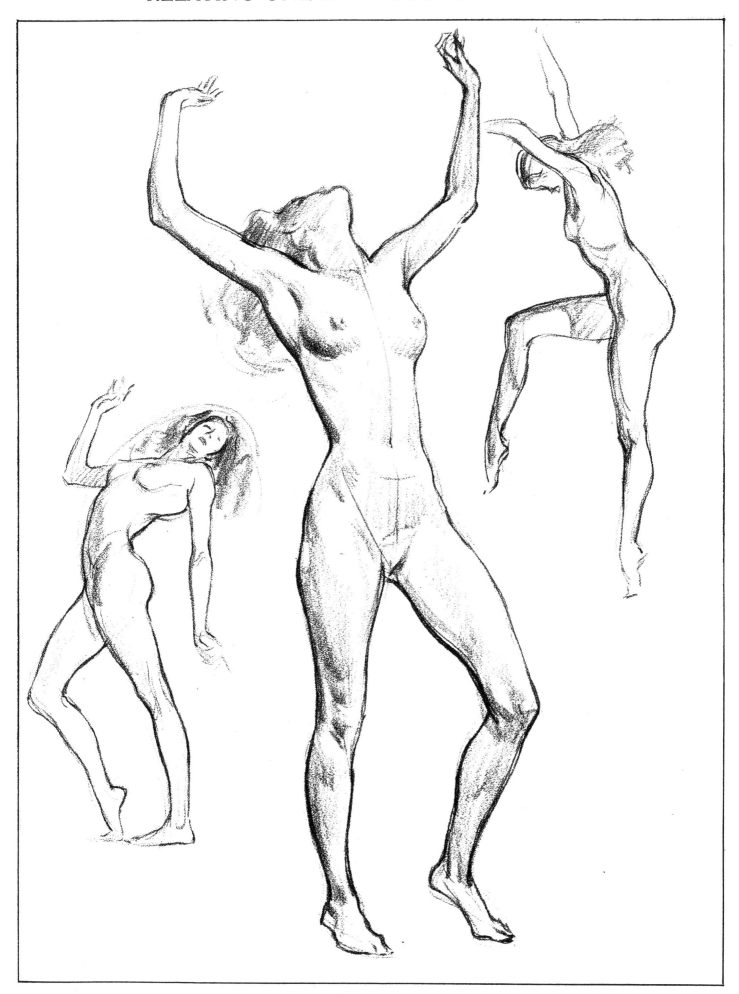

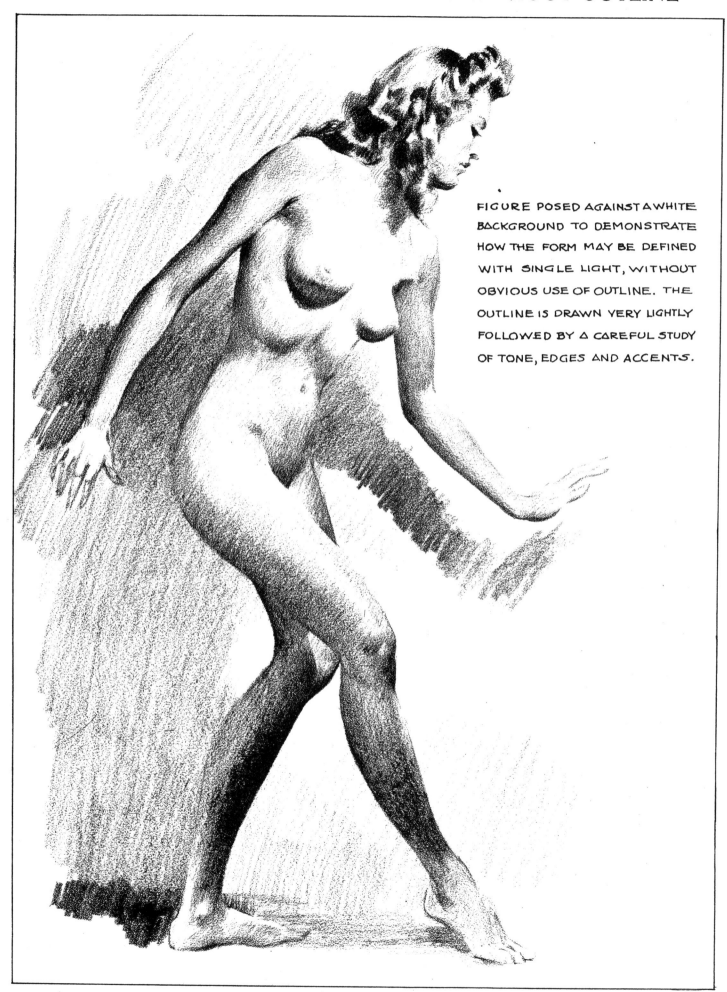

FIGURE POSED AGAINST A WHITE
BACKGROUND TO DEMONSTRATE
HOW THE FORM MAY BE DEFINED
WITH SINGLE LIGHT, WITHOUT
OBVIOUS USE OF OUTLINE. THE
OUTLINE IS DRAWN VERY LIGHTLY
FOLLOWED BY A CAREFUL STUDY
OF TONE, EDGES AND ACCENTS.

A typical problem worked out with an account executive in an advertising agency:

"Your work has come to my attention," says the executive of an advertising agency, "and, from what I have seen of it so far, I like it very much. I have a new gasoline account, for which we must have a fresh approach. I want to use a new man in the field, and he must be good. We will cover all advertising mediums pretty thoroughly, but the initial punch will come from outdoor advertising in a series of bill posters. Whether or not we give you this series to do depends upon what you can show us in the way of art work in roughs and sketches. We are willing to pay five hundred dollars per poster to the right man, this price to include all preliminary work. The name of the product is Sparko Rhythm Motor Fuel. As a starter, here are some captions we have thought up: *Tune Your Motor to Sparko Rhythm; Heard Everywhere…Sparko Rhythm; Sparko Rhythm Sounds Sweet in any Motor; "Swing" to Sparko Rhythm; Always in Step with Sparko Rhythm; Let Your Motor Sing to Sparko Rhythm; In Time, Every Time, That's Sparko Rhythm; Keep in Tune with Sparko Rhythm.* You will note that we are thinking in musical terms, but we will be glad to consider any ideas that associate rhythm with a motor fuel."

The width of an outdoor poster is two-and-a-quarter times the height. Make several small roughs on tissue for ideas that could be used to illustrate the above. You do not have to show an automobile, or a motor, but bear in mind that it is a motor fuel. The words "motor fuel" must be somewhere on the poster. You will probably want to use a base line of lettering across the bottom of the poster: "America's Greatest Motor Fuel." The sheets in a poster run four across, and two and a half up and down. The half-sheet may be placed either at top or bottom. Try to avoid cutting through a face at the joining place of two sheets. If the face is very large, see that the joining places do not cut through the eyes. Sometimes the sheets vary a little in color, and the bill poster cannot be relied upon not to get one sheet pasted a little off.

Work up in color your best ideas in sketch form. Size of poster for sketch is ten by twenty-two and one-half inches. A margin of white goes around the poster about two inches at top and bottom, and three at the sides.

I am not going to suggest what to do, but what not to do, as far as your design is concerned.

Do not make the name Sparko Rhythm too small.

Do not put dark lettering on a dark background.

Do not put light lettering on a light background.

Get some good copy for your style of lettering; don't "originate."

Keep lettering very simple and readable; don't get fancy.

Don't fake your figures; get good copy.

Don't make small figures or too many.

If you would like to experiment, draw or paint the finished poster: the size will be, in inches, sixteen by thirty-six or twenty by forty-five. Paint a white margin at least two inches top and bottom and three or more at sides.

Save your effort as a sample.

IX. THE KNEELING, CROUCHING, SITTING FIGURE

In this chapter we are concerned with qualities other than motion. Almost the whole gamut of feeling can be expressed in a seated figure. It can suggest alertness or composure, fatigue, dejection, aggressiveness, timidity, aloofness, uneasiness, boredom. Each would be expressed differently. Sit down or have someone do so, and see how you would dramatize each of these.

It is of paramount importance, at this point, to understand the shifting of the weight from the feet to the buttocks, thighs, hands, elbows, back, the neck and head. Important, too, is the correct understanding of foreshortened limbs that assume other than usual contours. In such poses limbs become props or braces rather than complete supports. The spine has a tendency to relax in a concave manner toward such bracing. When you are sitting on the floor, one of your arms usually becomes a brace, and the spine relaxes toward the bracing shoulder. One shoulder is high and the other one drops; the hips lean toward the brace; the weight is carried on one side of the buttocks, the side of the supporting arm.

When you are sitting in a chair, your spine may lose its S-shape and become a C. The thighs and buttocks take the weight. Both flatten a good deal, particularly a woman's thighs. The position of the head over the body should be carefully placed, since it has much to do with what the pose suggests. The draftsman must decide whether the sitting pose should be erect or relaxed. Remember that the figure is always subject to the law of gravity. It should have weight, or it cannot be convincing.

Foreshortening will require subtle observation, for no two poses are quite alike. Every pose off the feet will be a new problem and probably one you have not solved before. The variations of viewpoint, lighting, perspective, the unlimited variety of poses, all keep the problems of drawing new and interesting. I cannot think of anything less animated or more boring to look at or to draw than a model who is "just sitting." This, to me, means both feet close together on the floor, arms resting alike on the arms of the chair, back flat against the chair, eyes looking straight ahead. Your model might half-turn toward you, hang an arm over the back of the chair, cross her feet, stretch them out, or hold a knee. Use plenty of imagination to change a dull pose into an interesting one.

Let the whole pose of the model as well as the hands and facial expression tell the story. Do you want her to show animation or weariness? If she sits at a table, talking to her fiancé, let her lean forward, absorbedly, or show displeasure if they are quarreling.

Watch carefully for contours arranged in front of each other and draw them that way; if you do not, a thigh will not recede, a part of an arm will look too short or stumplike. Remember that if the hands or feet are close to the camera, they photograph too large. Any figure that is quite foreshortened should be photographed from a distance if possible, and then enlarged for copy. If you are planning a portrait, find a natural gesture or pose for your sitter. Turn the chair at an odd angle, get an unusual viewpoint, don't have the head stiffly above the neck. Let her drop comfortably into the corner of the chair, feet drawn back or even drawn under her, or feet extended and knees crossed. Don't let the legs make a perfect right angle with the knees.

You must stir yourself on to invention.

IT SHOULD BE REPEATED OVER AND OVER TO THE
STUDENT NOT TO "FAKE" LIGHT AND SHADOW ON
THE FIGURE. DRAW FROM THE MODEL OR FROM A
GOOD PHOTO. FIVE MINUTES OF "SEEING" IS
WORTH DAYS OF FAKING. SHADOWS CAN BE SEEN
FLATTER AND SIMPLER THAN THEY ARE.

DENCIL POINT RENDERINGS

ABOVE: VERTICAL LINE MODELING

RIGHT: A PENLIKE TREATMENT

A PEN TREATMENT PLANNED IN
PENCIL SAVES TIME AND TROUBLE.

MODELING WITH THE PENCIL POINT IS SLOWER AND MORE DIFFICULT. IT IS
ALSO MORE LIMITED AS TO TONE VALUES. HOWEVER IT SHOULD BE OFTEN
PRACTICED TO DEVELOP THE KNACK OF PEN DRAWING.

A COMBINATION OF BLACK AND GRADED TONE OFFERS UNIQUE POSSIBILITIES. DRAWING WAS DONE ON "BAINBRIDGE COQUILLE NO. 2". THE BLACKS ARE HIGGINS INK. THE TONES ARE DONE WITH "PRISMACOLOR" BLACK 935 PENCIL. REDUCTION IS ONE THIRD.

AN EXAMPLE OF LINE DRAWING AND PENCIL IN COMBINATION. DRAWN ON BAINBRIDGE COQUILLE NO 3, WITH A FINE POINTED SABLE BRUSH AND HIGGINS AMERICAN INDIA INK. A WASH COULD BE USED WITH THIS INK.

PEN AND INK STUDIES

THE STROKES PLANNED WITH A SHARP
PENCIL, INKED IN, AND DRAWING CLEANED
WITH KNEADED ERASER. IT IS A GOOD
PLAN TO "FOLLOW THE DIRECTION OF
THE PLANE OR FORM" WITH THE STROKES.

PEN SKETCHING

FORGET YOURSELF, YOUR
PEN AND YOUR STROKES.
LOOK FOR RHYTHM, MASS,
ACTION. NOBODY EXPECTS
A SKETCH TO BE COMPLETE.

FINE POINT BRUSH DRAWING

DRAWN WITH A SMALL CAMELS HAIR BRUSH AND DRAWING INK ON BRISTOL BOARD

A TYPICAL PROBLEM

A number of typical problems in a contest for sculptural designs:

1. The problem is to design a group of figures for a large fountain to be placed in the center of a circular pool fifty feet in diameter. The subject is, "I am America. I give thee liberty and a free life." The drawings are to be submitted for interpretation of idea only. The group may contain a heroic figure symbolizing the Goddess of Liberty. The work should be American in spirit. Figures can typify agriculture, mining, industrial life, the home, et cetera. The artist, however, is not limited in any way.

2. Design a large drinking fountain. Somewhere upon the base will be the inscription: "I am America. From my lakes and streams I give thee the waters of freedom."

3. Design a sun dial to be placed within the botanical gardens, bearing the following inscription: "I am America. I give thee my soil."

4. Design a statue for the zoological gardens, the inscription to be: "I am America. I give all living things the right to life."

5. Design a soldiers' and sailors' monument. The inscription to read: "I am America. These of my sons I gave for thy security."

Here are unlimited opportunities to express yourself. One interesting manner of handling these designs, after having worked out rough tissue sketches, would be to draw on toned paper with charcoal and white chalk. In these there would be considerable study of the figure, action, drapery, dramatic interpretation. Work out your ideas with your pencil, your camera, material gathered by research, et cetera.

There is no objection to using allegorical or semi-nude figures, but do not stick too close to the Greek. Make it American.

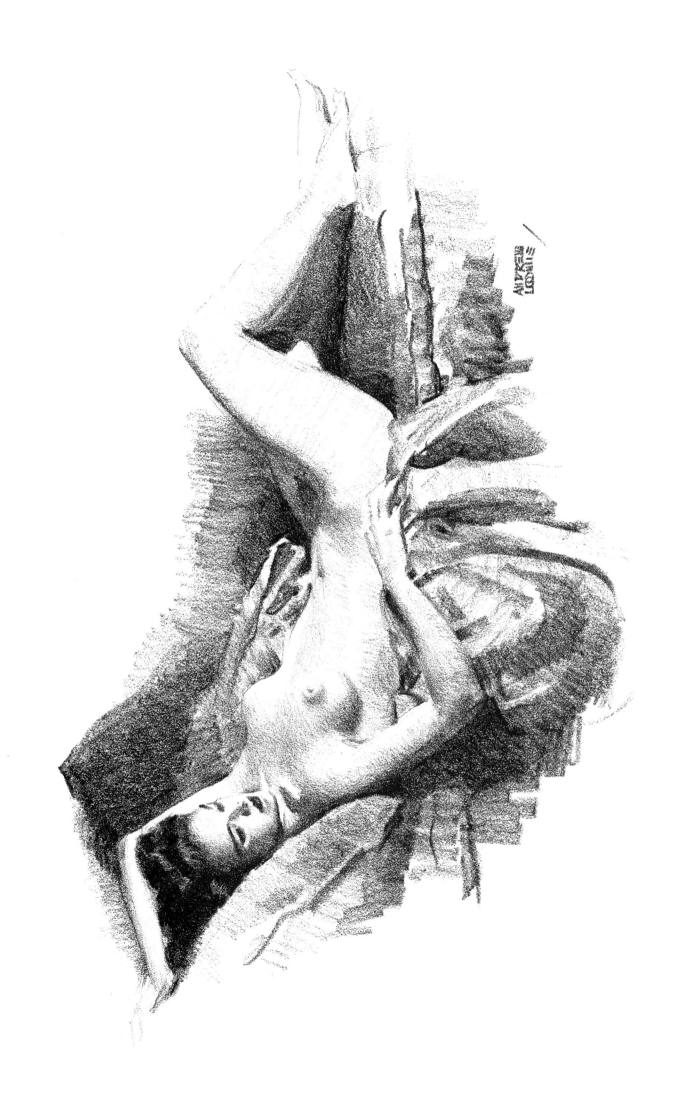

X. THE RECLINING FIGURE

One of the most challenging phases of figure drawing is that of the reclining pose. It offers the best opportunity of all for design, interesting pose, pattern, and foreshortening. We forget the body as an upright figure for the moment and think of it as a means of flexible pattern for space-filling. The head may be placed anywhere within the space at your disposal. The torso may be regarded from any viewpoint. In the drawing of the reclining figure, as in the standing and sitting poses, avoid straight, uninteresting poses —the legs straight, the arms straight, the head straight. I call these "coffin poses," for nothing appears quite so dead. Unlimited variety is possible with the reclining or half-reclining poses. We brought the figure out of the "proportion box" early in this book. Never fit a box around anything that is an interpretation of life.

The impression is that reclining poses are extremely difficult to draw. If you are accustomed to measuring off so many heads, you must discard the method in drawing the reclining figure, for it may be foreshortened to so great an extent that it cannot be measured in heads. But there is still height and width in any pose. You can still find the middle and quarter points and make comparative measurements. From here to there is equal to from there to another point. Measurements are not standard and apply only to the subject before you.

Reclining poses are often neglected in art schools. The reason is usually the crowded room in which one student obstructs the view of another. Consequently the most delightful and interesting phase of figure drawing is passed over, and many students leave the school without the slightest idea of how to go about drawing a reclining figure.

The appearance of complete relaxation is of first importance. A stiff-looking pose gives the observer the reaction of discomfort. The rhythm of the pose should be sought very carefully. You know now how to look for it. Almost any model looks better in a reclining than in a standing pose. The reason is that the stomach falls inward and appears more slender; the breasts, if inclined to droop, return to normal roundness; the chest becomes full and high; the back, lying flat, is straighter; even a double chin is lost. Perhaps nature purposely adds beauty to the reclining pose. If glamorous appeal is needed in a drawing, nothing can give it more than the reclining figure.

If you are using your camera, do not place it too close to the model, for distortion will result. Reclining poses should be selected with good taste. Crudity can send you and your drawing out the door in a hurry. See that the pose does not hide parts of the limbs so that they look like stumps; for instance, a leg bent under with nothing to explain it may look like the fellow with the tin cup. You cannot tell whether or not he has a leg. An unusual pose is not necessarily good, but a figure can be twisted about for interesting design, or combined with draperies for unusual pattern. The hair can be made a nice part of the design. If the pose is complex, keep the lighting simple. Cross-lighting on an unfamiliar pose may complicate it and make it look like a Chinese puzzle. If bizarre effects, however, are wanted, it may work out at that. A high viewpoint may lend variety.

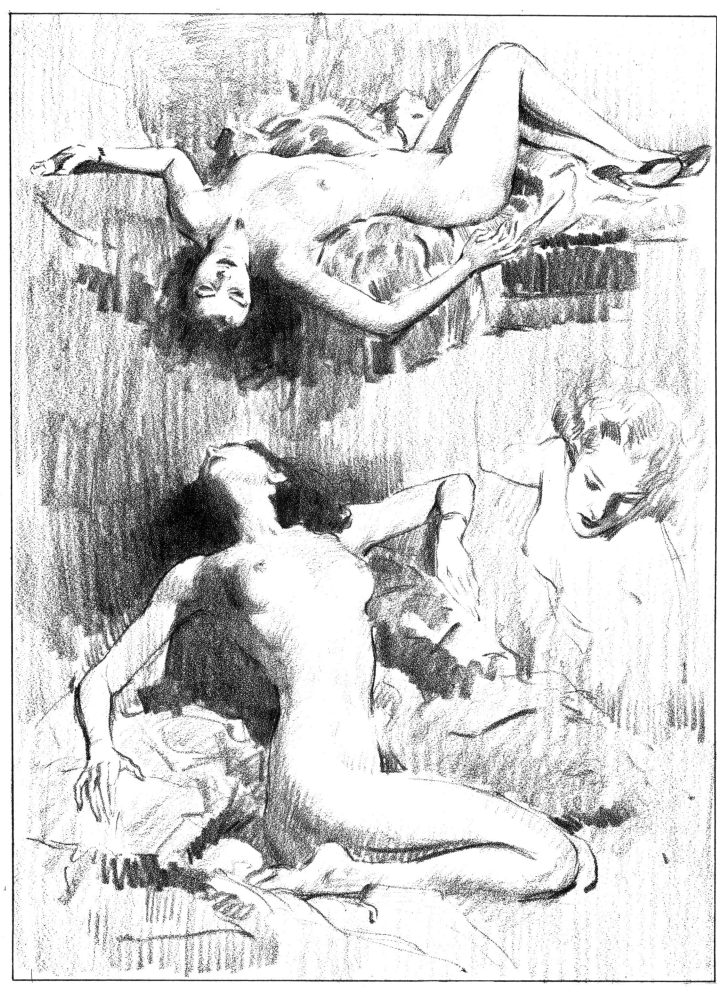

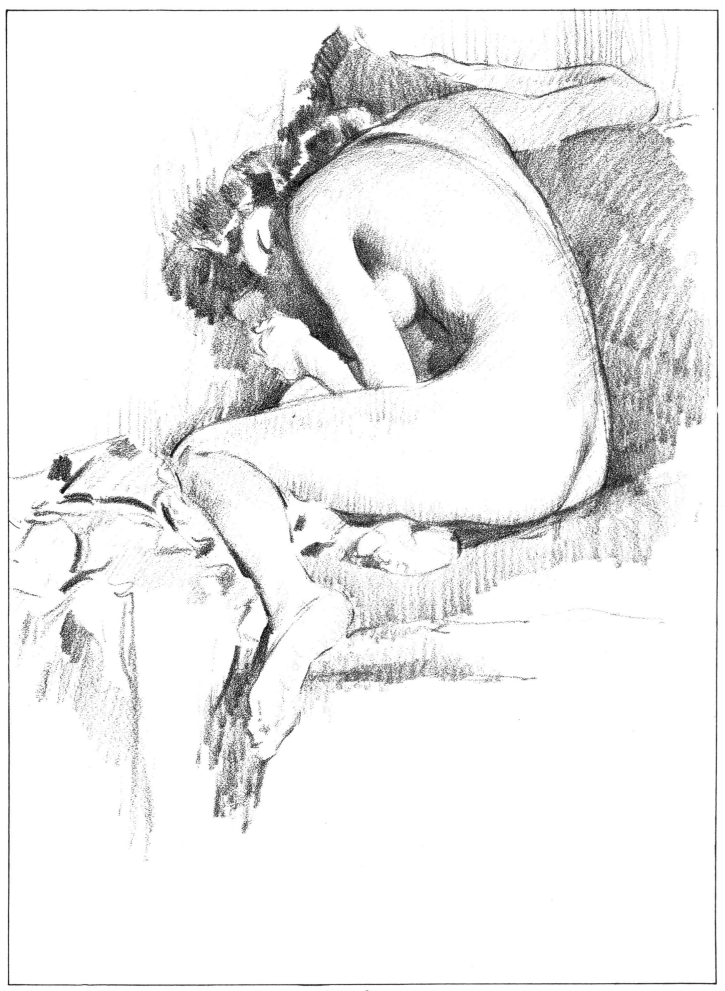

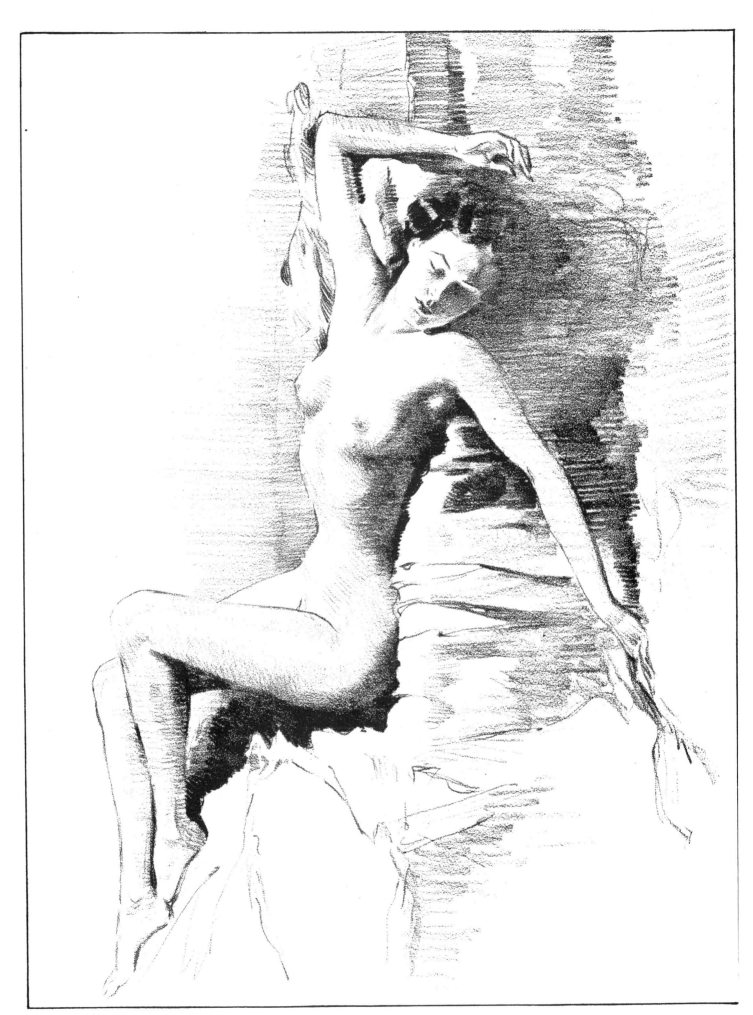

162

THE DRAWINGS ON THESE TWO PAGES ARE
INTENDED TO DEMONSTRATE HOW THE
TEXTURE OR "GRAIN" OF THE PAPER MAY BE
UTILIZED TO ADVANTAGE. THE DELICATE
MODELING IS DONE WITH THE POINT AND
THE BROADER MASSES WITH THE SIDE OF
THE LEAD. ATTENTION IS CALLED TO THE USE
OF DARK ACCENTS. YOU CANNOT "INVENT" LIGHT
AND SHADOW. DRAW FROM LIFE OR GOOD COPY.

A TYPICAL PROBLEM

Typical problem to solve with an art dealer and representative:

"I have a particular commission in mind that I believe you could handle," says an art dealer. "My clients have organized a new country club. They are building a beautiful clubhouse. They want two mural decorations for their new dining room. The woodwork will be done in ivory, with a slightly deeper tone of ivory on the walls. There are two doorways into the dining room, over each of which there will be a lunette. The lunettes are half-circles, the radius of each being five feet, making the base or span of the mural ten feet, five feet in height at the middle point. The club is to be closed between the months of October and May for the winter, and, since the club activities start in May, a spring mural will be used over one door and a fall subject over the other.

"The subject selected for the first lunette is awakening spring. A reclining figure lies upon the woodland soil, amid wildflowers that have burst into bloom, blossoming bushes, and trees. There are small animals about, such as squirrel, deer, rabbit, and birds. The figure is in the act of awakening and about to rise. Her hair is long, and perhaps there is a garland of early spring flowers about her head. The figure may be partly covered with flowers.

"A female figure lying down to rest for the winter is the fall subject. Brilliant autumn leaves are falling and have drifted over the figure, cov-ering it partly. In the hair are drooping and wilted flowers. A squirrel with an acorn in its paws, a rabbit burrowing down into the soil, birds flying—all may be shown. The grass is brown and dry; perhaps some red berries are on a branch. The thought that is conveyed is that summer has ended and Nature prepares for winter."

Make many rough pencil compositions. Do not only fill the space with the figure stretched stiffly across it. Proceed to work up some small thumbnail roughs in color. Then pose your model, make studies, or take camera shots. It would be wise to make some studies of trees and foliage in the woods. The little animals should also be studied. The subject could be given modern, simple treatment. When your preliminary material is ready, begin the sketch you will submit. This sketch is called a cartoon. It should be done well enough so that it can be squared off. You may then work from it, if necessary, directly upon the walls, or on a canvas mounted to fit or to be glued into place.

Since the room is light and airy, the paintings should be keyed fairly high, rather than dark and heavy. Gray your colors a little so that your picture will not jump out of the wall like an advertisement. Treat the flesh delicately and simply. Do not try for brilliant or even strong light and shadow. You will gain valuable experience if you will paint these subjects on a small scale.

XI. THE HEAD, HANDS, AND FEET

The head, perhaps, has more to do with selling a drawing than anything else. Though the figure drawing you submit may be a splendid one, your client will not look beyond a homely or badly drawn face. I have often worried and labored over this fact in my own experience. Once something happened that has helped me ever since. I discovered *construction*. I discovered that a beautiful face is not necessarily a type. It is not hair, color, eyes, nose, or mouth. Any set of features in a skull that is normal can be made into a face that is interesting and arresting, if not actually beautiful. When the face on your drawing is ugly and seems to leer at you, forget the features and look to the construction and placement of them. No face can be out of construction and look right or beautiful. There must be a positive balance of the two sides of the face. The spacing between the eyes must be right in relation to the skull. The perspective or viewpoint of the face must be consistent with the skull also. The placement of the ear must be accurate, or a rather imbecilic look results. The hairline is extremely important because it not only frames the head but helps to tip the face at its proper angle.

The placement of the mouth at its proper distance between nose and chin can mean the difference between allure and a disgruntled pout. To summarize, draw the skull correctly from your viewpoint and then place the features properly within it.

In my first book, *Fun with a Pencil,* I set about to work out a plan for head construction that I consider almost foolproof. I repeat the general plan as a possible aid here.°

Consider the head a ball, flattened at the sides, to which the facial plane is attached. The plane is divided into three equal parts (lines *A*, *B*, and *C*). The ball itself is divided in half. Line *A* becomes the earline, *B* the middle line of the face, and *C* the line of the brows. The spacing of the features can then be laid out on these lines. The plan holds good for either male or female, the difference being in the more bony structure, the heavier brows, the larger mouth in the male. The jaw line in the male is usually drawn more squarely and ruggedly.

In this chapter are studies of the skull and its bony structure, as well as the muscular construction and the general planes of the male head. The individual features are worked out in detail. The heads are of varying ages. Since no two faces are alike, for you the best plan is to draw people rather than stock heads. Perhaps an artist of another era could repeat his types endlessly, but there is no advantage in that today. It tends to make an artist's work dated in short order. The artist who can keep his types fresh and true to purpose will last.

It pays in the long run to hire models, though there is always the temptation to save money. The danger in using clips from magazines is that the material is usually copyrighted. Advertisers pay movie stars for the privilege of using their photos. Both the star and the advertiser will resent having them "swiped" for another advertiser. Your client will not be happy about it either. The same is true of fashion models who have been paid for their services. You cannot expect to use them for your own purposes. Practice from clips, but don't try to sell your copies as originals. Once you learn to draw heads, it will be your life-long interest to portray character.

°A strikingly similar method was originated independently by Miss E. Grace Hanks. (See *Fun with a Pencil*, p. 36.)

171

HEAD BUILDING

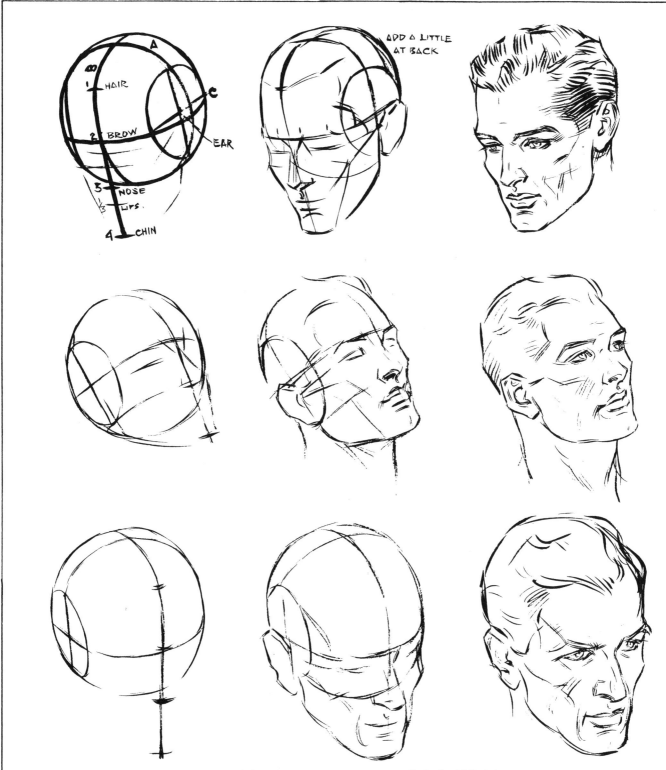

HOW TO CONSTRUCT A HEAD.

DRAW A BALL. DIVIDE BALL INTO SECTIONS SO THAT YOU HAVE A MIDDLE LINE DIVIDING BALL 3 WAYS (LINES A, B AND C). TAKE ONE FOR MIDDLE LINE OF FACE. THE OTHER TWO WILL BE AN EAR LINE AND A LINE OF BROWS. DROP MIDDLE LINE OF FACE OFF BALL. DIVIDE INTO 4 PARTS THAT APPEAR EQUAL, EACH PART EQUAL TO HALF OF THE DISTANCE FROM BROWLINE TO TOP OF BALL. SLICE OFF SIDES BY DROPPING EAR LINE STRAIGHT DOWN. PLACE EAR AT INTERSECTION OF LINES A AND C. NOW BUILD IN JAW AND FEATURES. THIS PLAN IS MORE THOROUGHLY COVERED IN "FUN WITH A PENCIL".

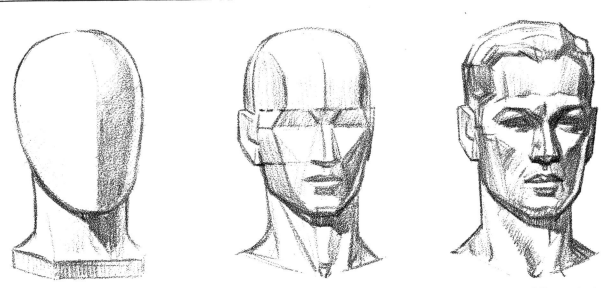

THE SIMPLE FORM DEVELOPED TO THE COMPLEX, THROUGH THE USE OF PLANES.
THESE AVERAGE PLANES SHOULD BE LEARNED. THEY ARE THE BASIS FOR LIGHTING.

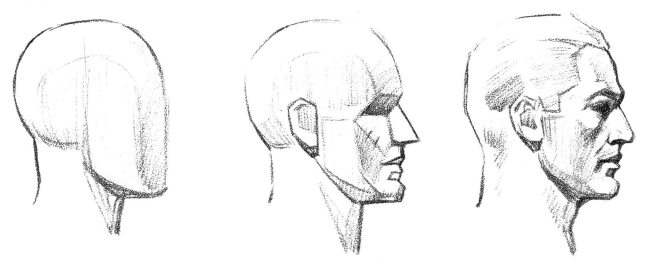

THE PLANES SIDE VIEW. GET SOME CLAY AND MODEL THE PLANES SO YOU CAN
LIGHT THEM DIFFERENT WAYS. THEN DRAW THEM. REFER BACK TO PAGES 72 AND 73.

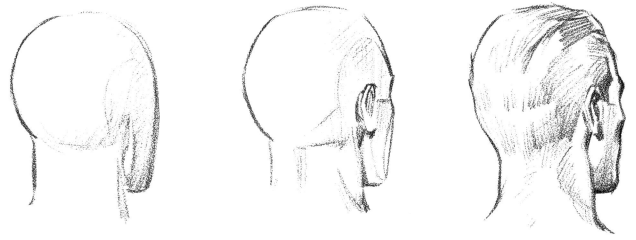

BACK VIEWS ARE MOST DIFFICULT UNLESS FORM AND PLANES ARE UNDERSTOOD.

BONES AND MUSCLES OF THE HEAD

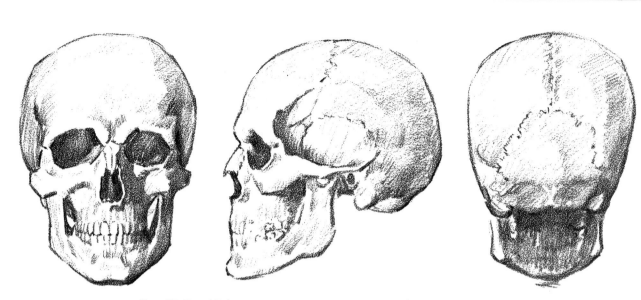

GRUESOME! BUT TRY TO DRAW IT CAREFULLY.

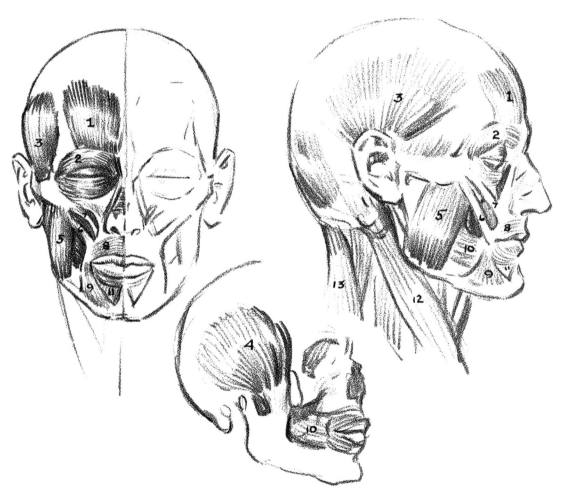

1 FRONTALIS	5 MASSETER	10 BUCCINATOR
2 ORBICULARIS OCULI	6-7 ZYGOMATICUS	11 DEPRESSOR
3 AURICULAR MUSCLES	8 ORBICULARIS ORIS	12 STERNO MASTOID
4 TEMPORALIS (DEEP)	9 TRIANGULARIS	13 TRAPEZIUS

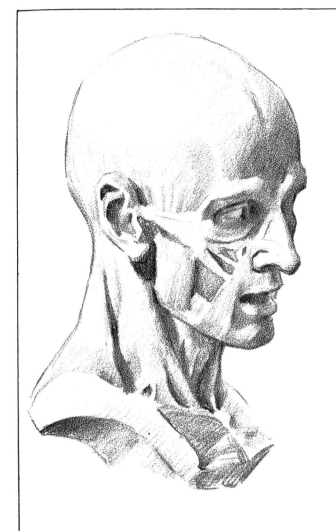

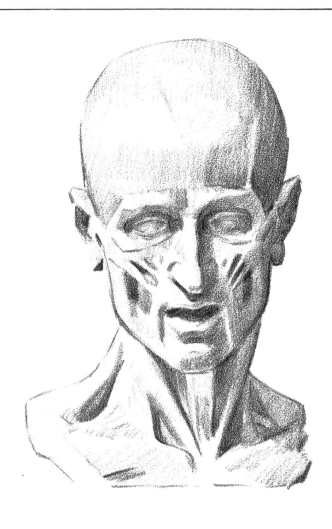

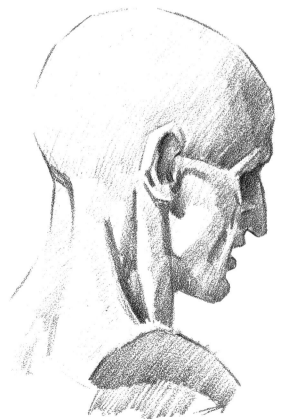

STUDIES OF AN ANATOMICAL CAST (WHITE)

THESE ARE TO SHOW THE ANATOMY OF
THE HEAD IN ITS SOLID ASPECT, OR AS FORM
IN LIGHT AND SHADOW. IF YOU CAN DRAW
FROM CASTS, IT IS RECOMMENDED TO DO
SO. MANY STUDENTS SKIP THE ANTIQUE
CLASS, NOT REALIZING ITS TRUE VALUE.
IT'S ADVANTAGE IS THAT THE SUBJECT
REMAINS FIXED FOR CAREFUL STUDY. IT
DEVELOPS SOLIDITY AND EXCELLENT
FOR STUDY OF VALUES. I SUGGEST YOU
MAKE SOME CAREFUL FREEHAND
DUPLICATIONS OF THESE DRAWINGS
IF YOU HAVE NO SIMILAR CASTS NEAR.

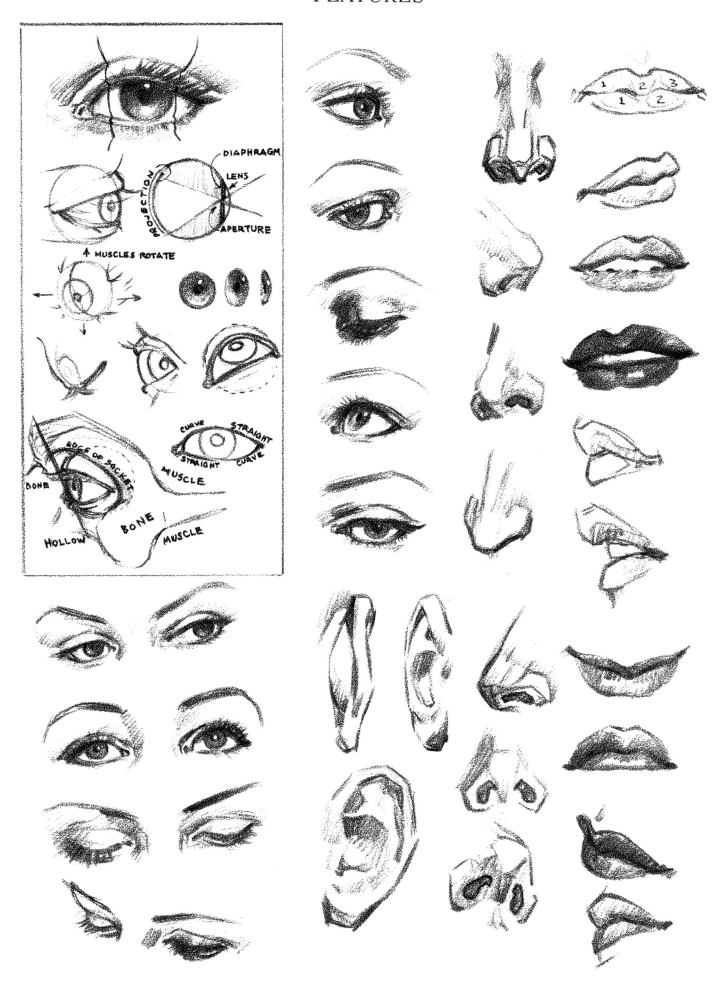

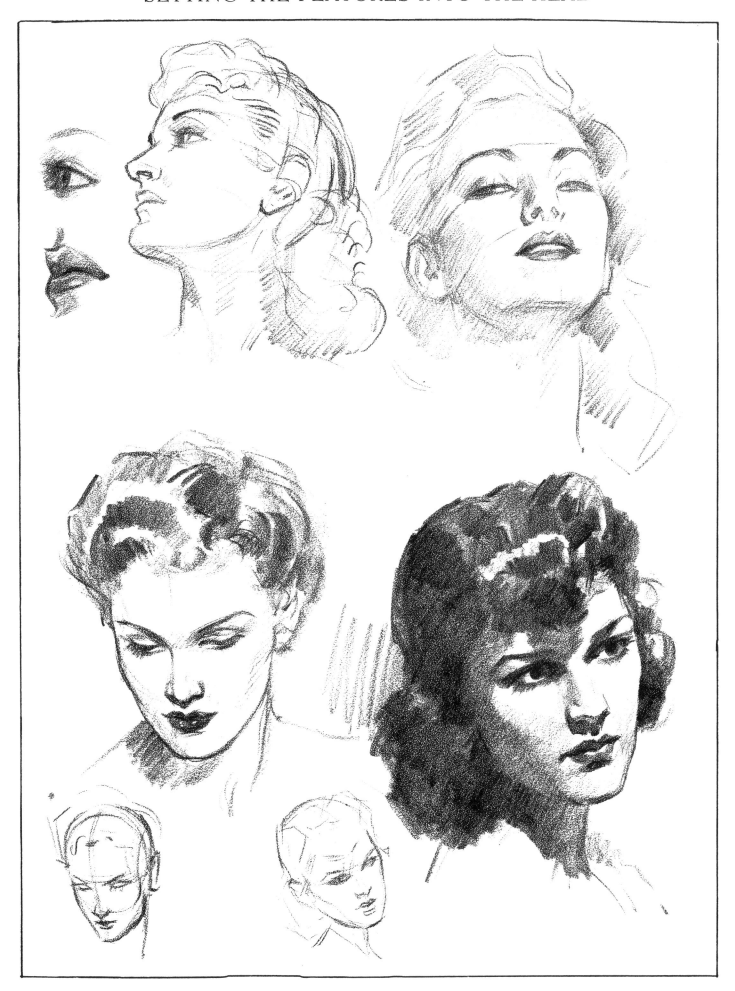

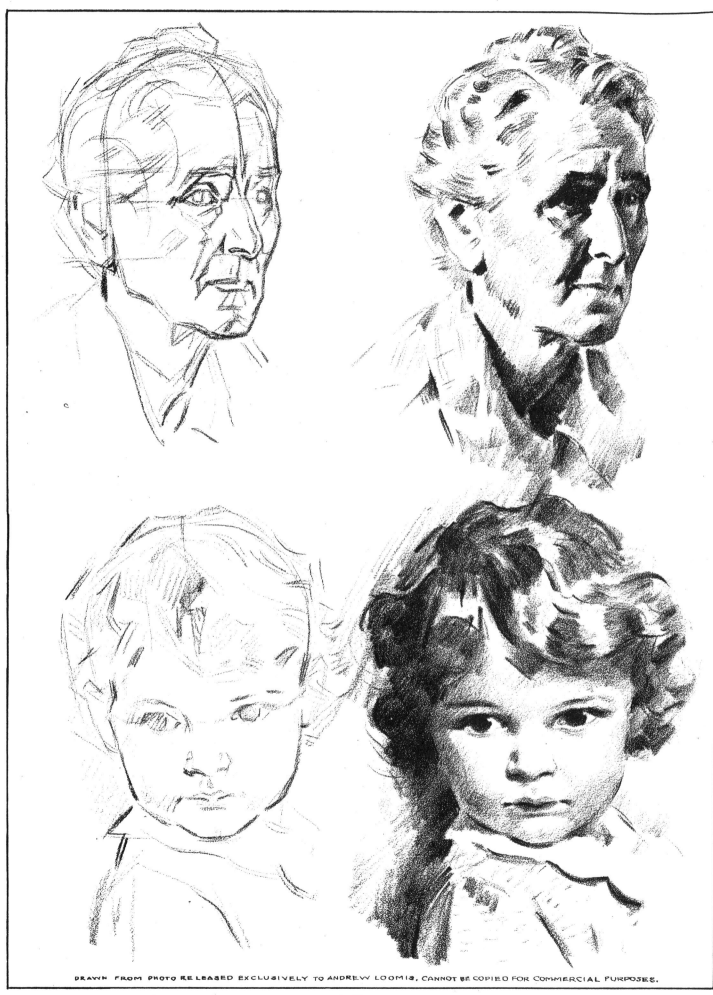

DRAWN FROM PHOTO RELEASED EXCLUSIVELY TO ANDREW LOOMIS, CANNOT BE COPIED FOR COMMERCIAL PURPOSES.

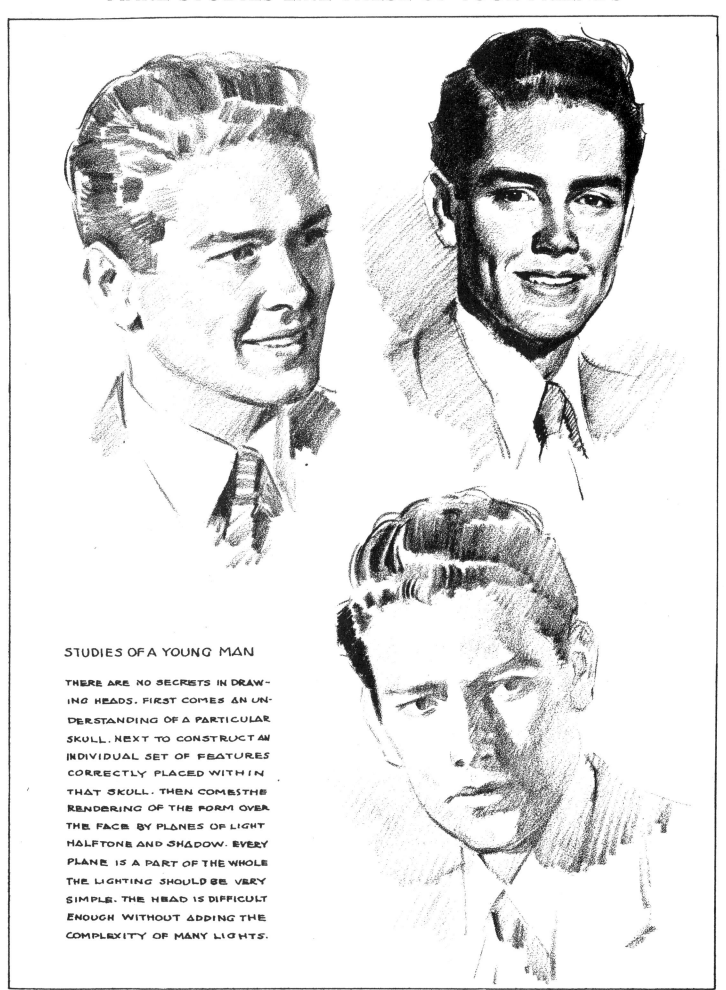

STUDIES OF A YOUNG MAN

THERE ARE NO SECRETS IN DRAW-
ING HEADS. FIRST COMES AN UN-
DERSTANDING OF A PARTICULAR
SKULL. NEXT TO CONSTRUCT AN
INDIVIDUAL SET OF FEATURES
CORRECTLY PLACED WITHIN
THAT SKULL. THEN COMES THE
RENDERING OF THE FORM OVER
THE FACE BY PLANES OF LIGHT
HALFTONE AND SHADOW. EVERY
PLANE IS A PART OF THE WHOLE
THE LIGHTING SHOULD BE VERY
SIMPLE. THE HEAD IS DIFFICULT
ENOUGH WITHOUT ADDING THE
COMPLEXITY OF MANY LIGHTS.

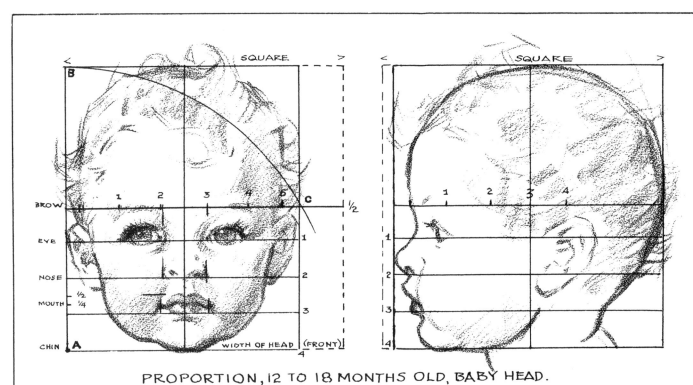

PROPORTION, 12 TO 18 MONTHS OLD, BABY HEAD.

FRONT

DRAW A SQUARE. DIVIDE IT IN HALF HORIZONTALLY. USING SIDE AB AS A RADIUS, DRAW ARC BC. THE ARC CROSSING MIDDLE LINE GIVES THE WIDTH OF HEAD IN PROPORTION TO HEIGHT. DIVIDE LOWER HALF INTO 4 EQUAL PARTS. PLACE FEATURES.

SIDE

THERE IS GREAT VARIETY OF SIZE AND SHAPES IN INFANT SKULLS. HOWEVER, THE AVERAGE WILL APPROXIMATELY FILL A SQUARE. YOU CAN USE THE BALL AND PLANE BY USING ABOVE PROPORTIONS.

CHARACTERISTICS TO REMEMBER

FACE IS RELATIVELY SMALL, ABOUT 1/4 OF WHOLE HEAD FROM BROWS TO CHIN. EAR DROPS BELOW HALFWAY LINE. THE EYES AND MOUTH ARE A LITTLE ABOVE THE HALFWAY POINT BETWEEN BROW, NOSE AND CHIN DIVISIONS. THE CHIN DROPS WELL UNDER NOSE AND MOUTH. THE UPPER LIP IS LARGER AND LONGER AND PROTRUDES. THE FOREHEAD DROPS INWARD TO THE NOSE. BRIDGE OF NOSE CONCAVE. EYES ARE LARGE IN THEIR OPENINGS AND SLIGHTLY MORE THAN WIDTH OF AN EYE APART. NOSTRILS SMALL AND ROUND AND SET WITHIN THE INSIDE CORNERS OF EYES AND THE CORNERS OF MOUTH ON A LINE FROM THESE POINTS .

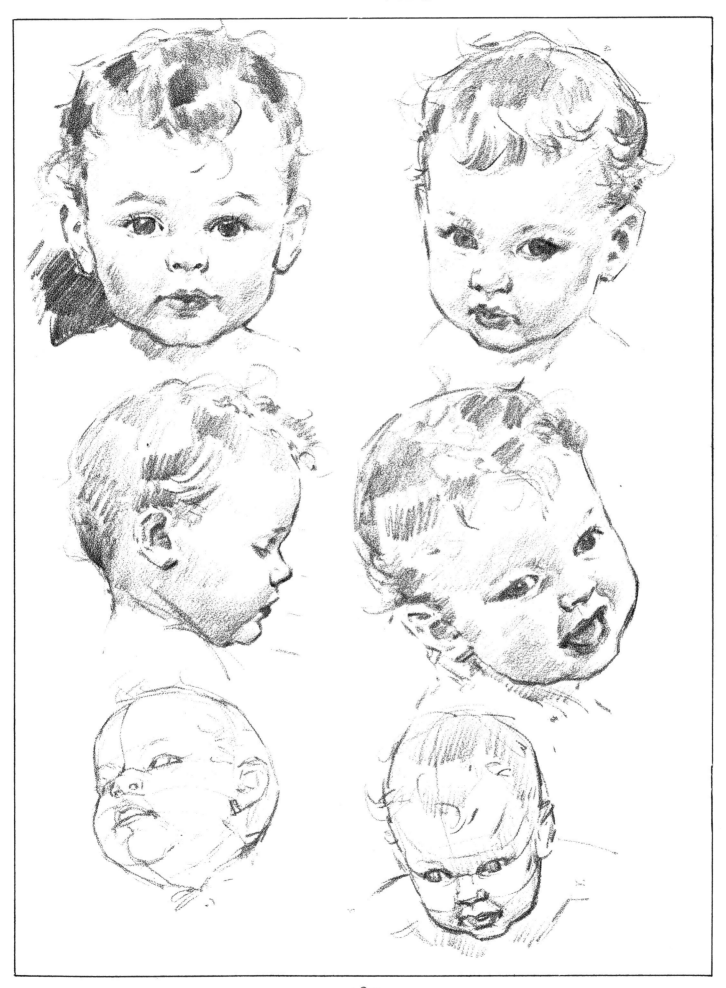

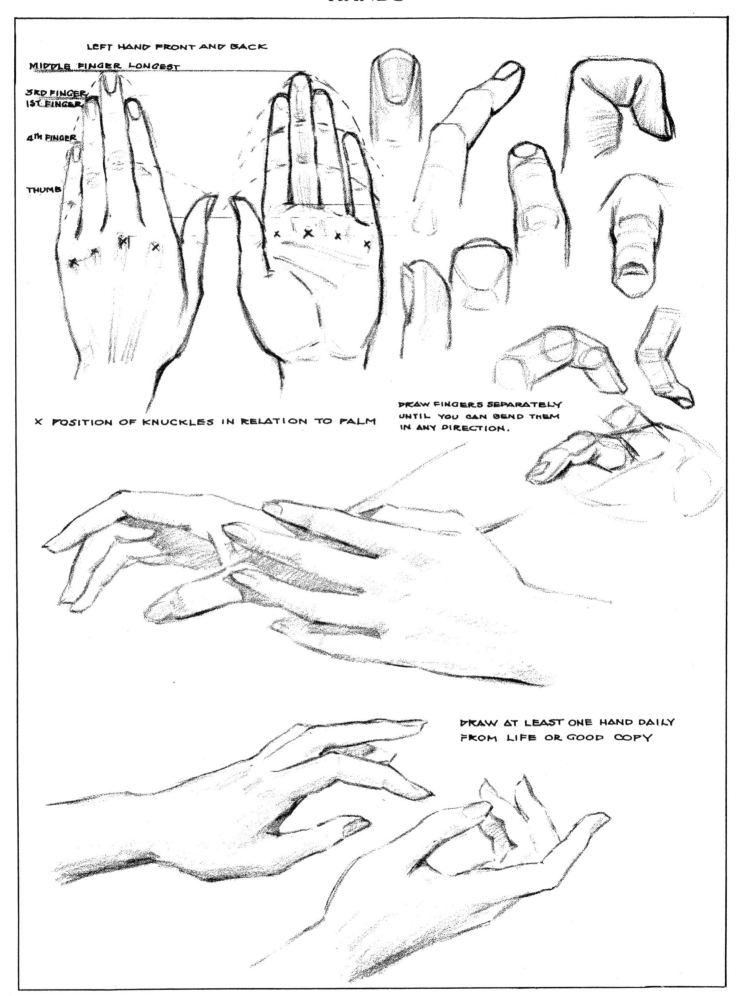

LEFT HAND FRONT AND BACK

MIDDLE FINGER LONGEST

3RD FINGER.
1ST FINGER.

4TH FINGER

THUMB

X POSITION OF KNUCKLES IN RELATION TO PALM

DRAW FINGERS SEPARATELY
UNTIL YOU CAN BEND THEM
IN ANY DIRECTION.

DRAW AT LEAST ONE HAND DAILY
FROM LIFE OR GOOD COPY

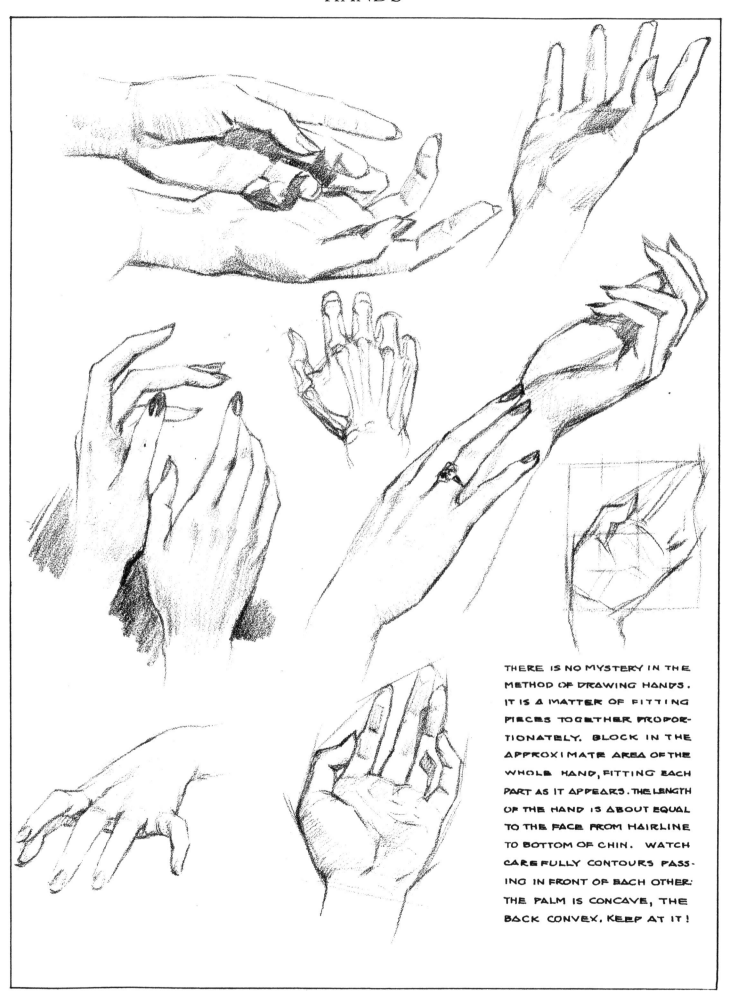

THERE IS NO MYSTERY IN THE
METHOD OF DRAWING HANDS.
IT IS A MATTER OF FITTING
PIECES TOGETHER PROPOR-
TIONATELY. BLOCK IN THE
APPROXIMATE AREA OF THE
WHOLE HAND, FITTING EACH
PART AS IT APPEARS. THE LENGTH
OF THE HAND IS ABOUT EQUAL
TO THE FACE FROM HAIRLINE
TO BOTTOM OF CHIN. WATCH
CAREFULLY CONTOURS PASS-
ING IN FRONT OF EACH OTHER.
THE PALM IS CONCAVE, THE
BACK CONVEX. KEEP AT IT!

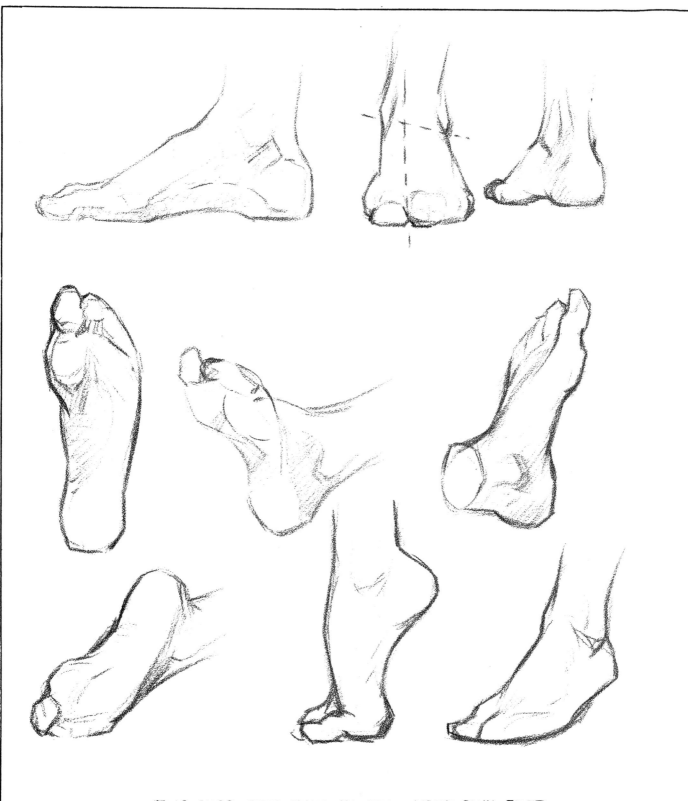

IT IS SUGGESTED THAT YOU DRAW YOUR OWN FEET
IN MANY POSES, SETTING A MIRROR ON THE FLOOR.
ALSO, THAT YOU SET UP SHOES AND DRAW THEM FROM
MANY ANGLES AND VIEWPOINTS.

A TYPICAL PROBLEM

A typical problem outlined by an art buyer:

"We always need artists who can draw heads well. Good drawings of heads are required in almost all advertising, for illustrations on magazine covers, and litho displays. An acceptable head must be in good drawing, to be sure, but that's only the beginning of its job. If it's a pretty girl's head, the pose, the animation, the hair-do, the costume, the color, the type, the expression, the age, the idea behind it, all count. For character drawing, I shall expect you to find a living type to work from, for the sake of authenticity, and, if necessary, add whatever particularized qualities the job specifies. I cannot tell you what to do or how to paint it. Do the necessary work, bring it in, and, if I like it, I'll buy it. That's the only way our firm buys art work. When you have convinced me that you can do a good head, I may give you further commissions, but I must reserve the right to reject any work and may even ask you to redraw a job."

Begin with a magazine cover and experiment until you have arrived at a good idea. Work it out small, in color, until you feel the little sketch has carrying power and attention value. Then work up your final drawing. Keep it as simple as possible. Don't try to sell a faked, or "cribbed," head. No magazine will buy it. Do not send work to a magazine that already employs one artist regularly, since he is probably working under contract.

Other suggestions are: Make a number of studies of the people around you. Draw yourself in the mirror. Draw a baby, a child, a young man and girl, a middle-aged person of each sex, and an old person of each sex also. Spend most of your time drawing heads—your market demands them.

187

XII. THE COMPLETE FIGURE
IN COSTUME

Costumes will keep changing, but the human figure remains the same. You must know the form beneath the folds of the clothing. You must familiarize yourself with the methods of cutting flat material and fitting it over the rounded figure. The drape of the material is caused by the manner in which it is cut and joined. Material cut on the bias drapes differently from that cut on the weave. Try to understand what makes the material do what it does in the ruffle, the pleat, the flounce, and in gathering; what is the purpose of a dart; and why the seams and joinings cause the flat material to shape itself. You do not have to know how to sew, but you must look for the construction of the clothing, just as you look for the structure of the figure under it. It takes only a few extra minutes to find out which folds are due to the construction of the garment and which are caused by the underlying form. Find the "intention" of the drape. Discover what the designer has worked for—slimness or fullness. If a seam is smooth, it was intended to lie flat. If there is a shirring or gathering at some point, take note that it was *not* intended to lie flat. You must not slavishly copy each tiny fold, but neither must you disregard folds entirely. Indicate the shirring at that point.

Learn how the female figure affects the folds: the fabric falls away from the most prominent forms underneath shoulders, breasts, hips, but-

tocks, and knees. When material is loosely draped over these, the folds start with them and radiate to the next high point. When the material is fitted, if there are any folds at all, the folds will run around the prominent forms, pulling at the seams. The male form molds the clothes in a like manner. In a man's suit, for example, the material over the shoulders, over the chest, and over the top of the back is cut to fit. The only folds you find then come from the pull at the seams. The bottom of the coat and the trousers are draped loosely. The trouser folds radiate from the buttocks to the knee in sitting poses and from the knee to the calf and the back of the ankle.

An overmodeled garment is just as bad as an overmodeled figure. Watch to see that your light and dark values stay within the color value of the material itself and that its unity is not broken by lights and shadows that are more strongly stated than necessary.

Do not draw every seam, every fold, and every button, but try to understand constructive principles and interpret them correctly in what you do put down, instead of being careless in these matters or remaining totally ignorant of them.

No matter what you draw—figure, costume, furniture—learn its construction, so that you *can* draw it.

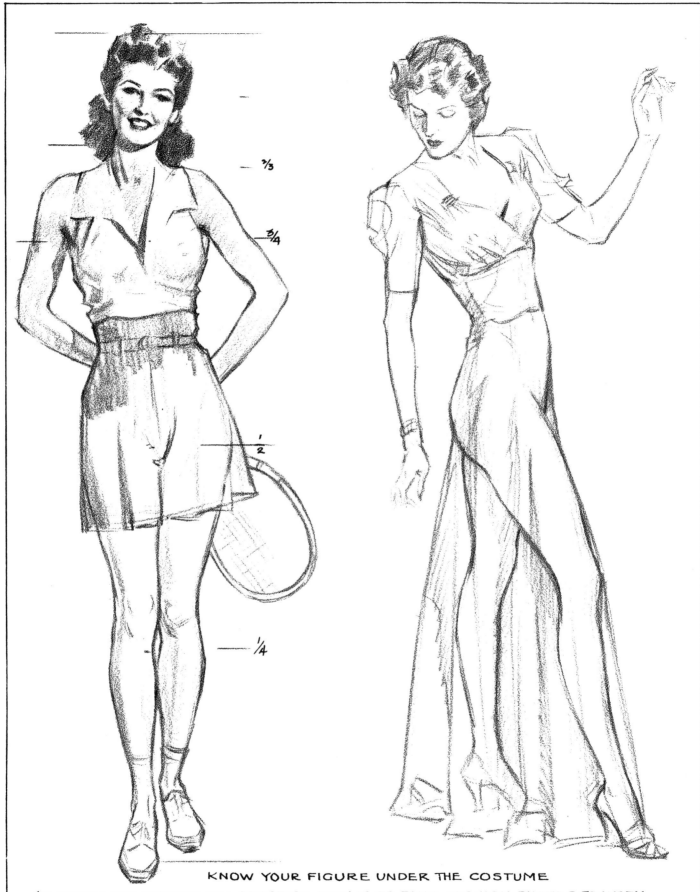

2/3

3/4

1/2

1/4

KNOW YOUR FIGURE UNDER THE COSTUME

AN EXCELLENT METHOD FOR PRACTICE NOW IS TO TAKE FASHION PHOTOS TO WORK FROM, AND, AS INDICATED ABOVE, DRAW BOTH COSTUME AND FIGURE UNDERNEATH, AS IF CLOTHING WERE TRANSPARENT. YOU WILL UNDERSTAND THEN THE RELATIONSHIP OF THE DRAPE TO THE FORM UNDERNEATH. YOU MUST BE ABLE TO RECONSTRUCT A CLOTHED FIGURE.

THE RENDERING OF DRAPERY IS SO COMPLICATED AT BEST, THAT ONLY A VERY SKILLED
ARTISAN COULD ANTICIPATE WHAT DRAPERY WILL DO IN A GIVEN INSTANCE,
UNDER CERTAIN LIGHT AND WITH CERTAIN TEXTURE. "FAKED" CLOTHING USUALLY LOOKS
IT, AND WILL NOT SELL THE AVERAGE ART BUYER. MAKE IT A RULE ··· RIGHT NOW!

RENDERING OF DRAPERY IS AN ARTICULATION OF PLANES ARRANGED IN PROPER VALUES.

STUDY FOR A STORY ILLUSTRATION. HERE IS A TYPICAL PROCEDURE
OF DRAWING HALFTONES AND SHADOWS ONLY, LEAVING LIGHTS WHITE.

STUDY FOR STORY ILLUSTRATION. HERE A BACK LIGHTING PROVED EFFECTIVE FOR A VIGNETTE.

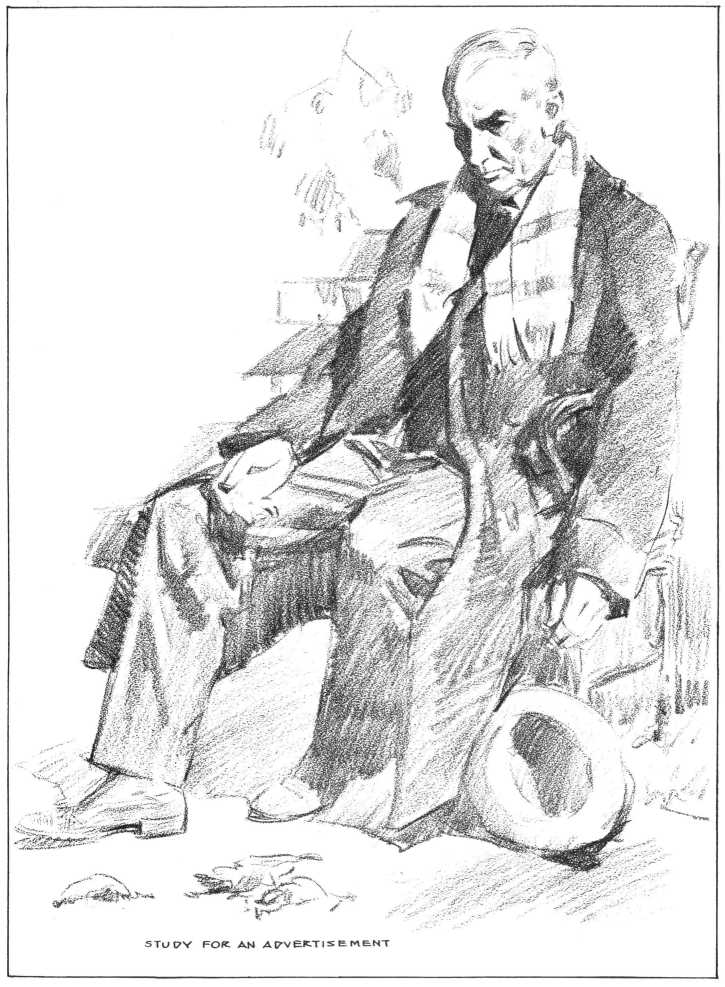

STUDY FOR AN ADVERTISEMENT

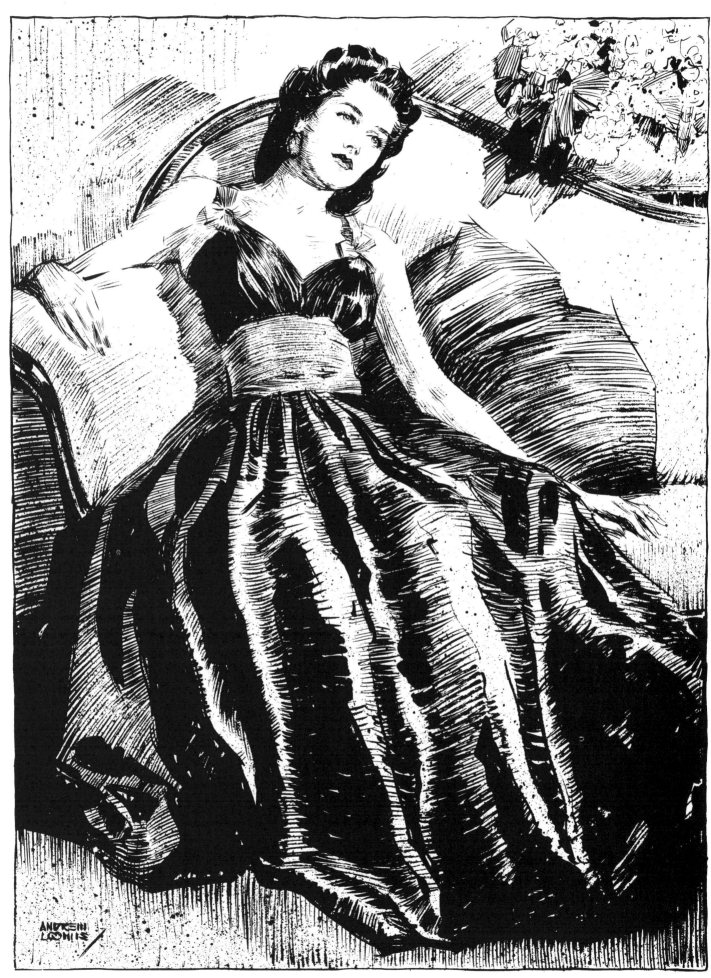

A TYPICAL PROBLEM

The problem of equipping yourself to do your job well:

What is the next step? you may inquire.

Look about at the kinds of work you see displayed everywhere. What kind of work do you want to do? Once you make up your mind, practice that kind of drawing with brush or pencil. You are going to need mental equipment as well as skill with your hand. Try to know more about your subject than the other fellow. Remember you can borrow only a little; most of your knowledge must come from your own observation, your determination, and your plain courage.

Find a way that you can allow yourself one, two, three, or even four hours a day for drawing. Next, supply yourself with materials and a place to work. Keep a fresh sheet of paper on your drawing board at all times with other materials at hand.

Hunt for subjects that interest you. Note them down and pin the notes to your board. If you can do nothing better, set up an interesting still life and work from it until you have learned something from it.

Start a portfolio of samples of your best work. Don't take out a drawing and throw it away until you have a better one with which to replace it. When you have a dozen good drawings, show them. Don't wait for an expensive collection.

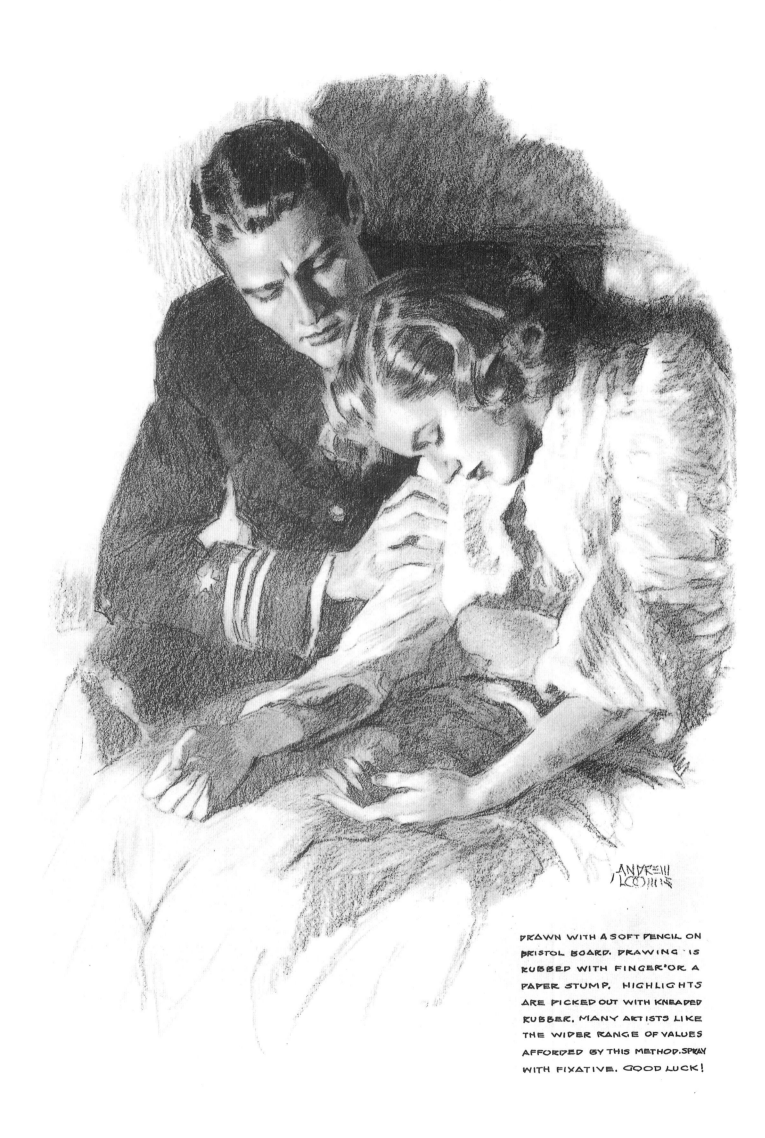

DRAWN WITH A SOFT PENCIL ON
BRISTOL BOARD. DRAWING IS
RUBBED WITH FINGER'OR A
PAPER STUMP, HIGHLIGHTS
ARE PICKED OUT WITH KNEADED
RUBBER. MANY ARTISTS LIKE
THE WIDER RANGE OF VALUES
AFFORDED BY THIS METHOD. SPRAY
WITH FIXATIVE. GOOD LUCK!

CLOSING CHAT

There is always a hesitation before turning in a finished job. It occurs to me as I complete this book, and it will occur to you when you look over a piece of your work: Could it not have been done better? It may seem to you that you should have used a different approach, or a better method of construction. My own philosophy is to do the best I am capable of within the time requirements, and then to make the decision that the drawing is now finished and must be turned in. Lack of decision is a harmful thing. You can learn by your mistake and make amends, but the energy must go into a fresh effort.

Learn to use time wisely. You will not always have the time to do a drawing twice or three times in order to select the best example. While you are a student, use precious hours to the best advantage. A bit of anatomy misunderstood in an important job that must go tonight, a problem in perspective that remains unsolved, ruins a painting on which you have spent days and paid expensive models' fees.

When, early in your career, an art director asks you to re-do a drawing, be grateful that you are granted the time. It is a tragedy when your drawing ought to be done over and cannot be for lack of time. You deliver something you do not like, and the publisher is forced to accept it. He is generous if he gives you another job.

The term "talent" needs clarifying. To any man who has slaved to acquire skill in his art, it is most irritating to have his ability referred to as a "gift." Perhaps there is one genius in a hundred years or more who can achieve perfection by "divine inspiration." I have never met such a man, and I do not know any successful artist who did not get there by the sweat of his brow. Again, I do not know of a single successful artist who does not continue to work hard.

There is no formula in art that will not break down as soon as the effort behind it ceases. But, to compensate, there is no reward on earth that can compare with a pat on the back for a hard job well done. Talent, in its underclothes, is a capacity for a certain kind of learning. Talent is an urge, an insatiable desire to excel, coupled with indefatigable powers of concentration and production. Talent and ability are like sunlight and a truck garden. The sun must be there to begin with, but, added to it, there must be plowing, planting, weeding, hoeing, destroying of parasites—all have to be done before your garden will yield produce. According to those one-inch ads we see so often, you can be an artist, play the piano, write a book, be compelling, convince anybody, make friends, and get a high-salaried job if you'll just sit down and answer it—and, of course, "kick in."

If you want to draw, if you want to gamble all your chips for stakes that are really worth while, you have an excellent chance of winning. If you just dabble, you will certainly lose your ante, for the others in the game are playing their hands for all they are worth. I have met students who have said they would like to learn drawing as a "sideline." There are no sidelines. You are either in the game or out of it. "Well, then, how do I know I'm going to be good enough to make a go of it?" No one can possibly be assured that he is going to be good enough at anything to make a go of it. Faith in yourself and industry are all that any of us have got to go on.

An honest book on drawing can only point the way and suggest procedure. A book of downright promise can be nothing but downright fake. It is natural for young men and women to look for the "secrets" that allegedly assure success. It is even reasonable to feel that these

secrets are somewhere hidden away, and that to reveal them would assure success. I confess I thought so myself at one time. But there are no such secrets, jealously guarded by the older generation so that it need not give way to the younger. There is not a craft in all the world that opens its doors so wide to the young and lays its knowledge so freely at its feet. Note that I say knowledge, for all the secrets are knowledge. Everything about this craft is fundamental. Expert use of the fundamentals is the only basis there is for learning to draw. These fundamentals can be listed, studied, and carried out in your own way. They are: proportion, anatomy, perspective, values, color, and knowledge of mediums and materials. Each of these can be the subject of infinite study and observation. If there is a secret, it is only in your individual expression.

The artist obtains his work in different ways, depending on the branch of the craft in which he specializes:

In an advertising agency there is usually a creative or art department. Here the layouts or visualizations are made. There is a copy writer, an account executive, and a layout man who together have planned an individual ad or a whole campaign. An appropriation has been made by the advertiser. The magazine space has been decided upon and contracted for. As the ideas are worked out, in sketch or layout form, they are submitted to the client and O.K.'d or rejected. It has been decided that either photographic or art work shall be used. All this has taken place before you are called in. By this time, a closing date has been set, and it is usually not far off, since the preparatory work has taken a good deal of time.

You are handed the layout as O.K.'d or with instructions for changes. Most agencies give you considerable leeway for pictorial interpretation, but your drawing must fit the space in the layout. If you are working with an art organization, you will not see the agency at all, but will get your instructions and the agency layout from one of your company's salesmen.

Proceed, then, to look up what data you need, get necessary photos or models, and go ahead with your job. If you are a free-lance artist, you work in your own studio. In that case you will have agreed upon a price with the art director, and you will bill the agency when the job is complete and accepted. In an art organization you will either be working at a set salary, or on a split basis, usually fifty-fifty. Most artists spend considerable time in organizations before setting up a free-lance studio.

The magazine illustrator usually works in his own studio. He may have an agent or sales representative, especially if he does not live in New York City, where most of the magazine houses are located. Without an agent he deals directly with the art director. The artist is handed a manuscript. As a general rule, if the magazine has not supplied him with layouts, he is asked to make roughs for general composition and treatment of the subject. The magazine may pick the situation to illustrate or may ask the artist to read it, pick the situations, and submit several roughs for selection. When these are O.K.'d, the artist proceeds with his drawings. When the magazine picks the situation and gives the artist a rough from the art department, he may go to work at once. This is usually the most satisfactory arrangement, but it does not give the artist so much freedom as when he makes his own selection. If you have an agent, the agent bills the work; otherwise you are paid directly. An agent's commission is approximately twenty-five per cent of the billing price. There are several firms and guilds in New York that act as artists' agents. Work must be of proven quality, however, before they will represent an artist.

Outdoor posters are handled through advertising agencies or through lithographers. The artist seldom deals directly with the advertiser. There are also outdoor advertising companies that buy art work and in turn sell it to the advertiser. In the latter case the lithographer is called in on a competitive basis.

Newspaper drawing may be done in art organizations, by the paper's staff, by the advertiser's own department, or in the free-lancer's own studio. Displays are done in the lithographer's art departments or are bought from organizations or free-lance artists.

Magazine covers are usually speculative. You simply make them, send them in, and most of the time you get them back. You are expected to send return postage or express charges. Sometimes you can send in a preliminary sketch. If the magazine is interested, you may be asked to make a final drawing or painting, but the art editor reserves the right to reject it unless you are so well known in the field and so dependable that you can be relied upon to bring in an acceptable cover design.

Comics are handled speculatively, as are magazine covers, except in the case of newspapers. There they generally come through feature syndicates. In this case you work on a salary or royalty basis, or both. You must have several months of your feature completed on a strip before your work will be considered. Sometimes royalty is paid by the comic magazine or syndicate, in addition to the purchase of first serial rights.

First-rate advertising may pay more than story illustration. Methods of reproduction are so accurate today that almost anything painted or drawn may be reproduced with fidelity. Knowing these methods is valuable information. Most engraving houses are glad to show their equipment and methods to the artist. They know that if he understands their problem, he can help

them by producing clean copy. This is also true of lithographers. It is important to remember that a newspaper uses line or coarse-screen halftone. Pulp magazines must use a coarser screen than other magazines. This means keeping fairly contrasting values to assure good reproduction. In all halftone reproduction the whites of your subject gray down somewhat; the middle tones flatten a little; and the darks become somewhat lighter. Watercolor is about the best medium for reproduction since it has no shine, is usually made small, and therefore requires less reduction. Any of the drawing mediums, however, can be reproduced well. Never submit a drawing on flimsy paper.

The artist should, early in his career, form the habit of orderliness. Keep things where you can find them. Your drawing, when submitted, should be scrupulously clean and matted with a flap to protect it from dirt. Keep your file in order and clip whatever you think will make it as complete in information as possible. I have a method of filing that works out nicely: I make an index in alphabetical order of what I have filed and then give my folders consecutive numbers. In this way I put several subjects in one file. For instance, I list bedrooms under *B*, and the file number for this subject is put alongside the listing. I also list sleeping poses under *S* and give it the same number. My folders go from one to three hundred. I can add as many more as I wish or add more subjects within the present folders by simply listing the additional subjects alphabetically and assigning a folder number. I have gradually learned the folder numbers, and, as soon as I see a subject, I find it without referring to the index. For instance, I know that airplanes go in number sixty-seven. On every clipping I jot down the file number and put the clip into the drawer that contains the number. I have filled seven filing cabinet drawers. I can now go directly to a file that contains a school

classroom by looking it up alphabetically under S and getting the file number. Without a filing system, hours upon hours can be lost looking through hundreds of clippings to find a single one. It is a good investment for the artist to subscribe to a number of magazines. By keeping your copies in order, they eventually become valuable. For instance, if I should need material to illustrate a story laid in 1931, I could go back to the styles worn in that period without difficulty. Or to interiors. Or to the automobile that the characters owned. Some day you may want to know what they were wearing during the Second World War. What were the soldiers' helmets like? The magazines are brimming over with that material now. When the war is history, it will be hard to find.

Develop an orderly procedure in your work. Get the habit of making small studies before you start something big. Your problems will appear in the sketches and can be worked out then, so that you will not be stumped later on. If you are not going to like a color scheme, find it out before you have put in days of work. I remember a poster I once painted. When I was through, I began to wonder how a different color background would have looked. When I had put the second background on, it looked worse. By the time I had tried about six, I was resigned to going back to the first. It was all lost motion that could have been avoided by making thumbnail sketches first. I could have done several posters in the time wasted, and my work would not have lost its original freshness.

If you once decide on a pose, stick to it. Don't let yourself muddy up a subject by wondering if the arm might not have been better some other way. If you must change it, start over and so keep it fresh. The more clearly you have a drawing defined in your mind and in the preliminary sketches, the better the result will be. Many drawings will have to be changed to

please your clients. The changes are often unreasonable and are matters of opinion, but do not grumble, at least aloud. A chronic grumbler is an unpopular fellow, and soon the jobs go to the man who seems to be more cheerful, especially if his work is equally good. Again, enthusiasm and cheerfulness add their own qualities to your work. Robert Henri said, "Every stroke reflects the mood of the artist at the moment." He is confident or hesitant, happy or somber, certain or perplexed. You cannot hide mood in a creative work.

On the subject of prices, it is better in your early years to get your work published and circulated than to quibble over price. The more you get published, the better known you become. The better known you are, the more work you get. The more work you get, the better will be your price. Eventually you find your price level, since you can keep raising your price as long as more people want your work than you can supply. If nobody will pay the price you are asking or if you cannot keep busy at your prices, you'd better come down. It's just plain business.

I admit you are apt to run into a buyer who will take advantage of your youth or your lack of work, but, if you are capable, his very use of your work may boost you clear out of his class. There is no way to place a value on a piece of your work. The chances are that you will get a fair deal from a reputable client. If you do not, it won't be long before you will discover it. You will soon find out if you are asking too much. Posters can go all the way up the ladder from fifty dollars to one thousand. Magazine illustrations range from ten or twenty to five hundred or more a picture. The purpose, the client, the artistic merit—all these influence the price.

Attend an art school if you can, but carefully consider the instructors. If you can get a man to teach you who is active in his field, well and

good. Ask for the names of some of his former pupils. If the school can show a convincing list of professional men who were formerly his students, fine. If not, hunt up another school.

Let me make a suggestion or two about the preparation of an artist's samples. There is slight possibility of being accepted as a professional artist without a well-executed group of samples. I have urged throughout this book that you retain the best of your practice work for samples. Do not limit yourself to my problems alone. If you want to do figure work, prepare your samples for that purpose. Do not submit nudes, however, since there is no possibility of their being used. The excellence of your figure drawing, however, should be present in your costume drawing. Submit one or two girl subjects, perhaps a man, or a man and a girl. A child subject is always of value. Keep your subjects on the happy side for advertising, and don't forget glamour appeal.

All of the foregoing also holds true for story illustration, although magazines are interested in characterization, action, and drama as well. If you want to do posters, your approach must be different, since here simplicity is of first importance. Do not mix up your presentation, by which I mean that you should not submit a drawing obviously designed for a poster or advertising illustration to a magazine editor of fiction. Try to fit your presentation to your client's needs. Don't submit a great raft of drawings. An art director can see from your first two or three samples what he can expect of you. He is a busy fellow. He will keep looking as long as your subjects, treatments, and mediums are varied, if they are at all good. If he looks at twenty drawings, he is just being polite. Don't impose on the man.

A very good method of introducing yourself is to make up small packets of photographic copies of your samples. These may be mailed to many prospective clients, together with your address and telephone number. Interested people will get in touch with you. I followed this scheme when I set up my own studio after working for several years in various art organizations. I photographed proofs of the work I had done for or through the organizations. The result proved well worth the expense. Many new customers were brought to light.

It is advisable to start a library. There are many good books on art: anatomy, perspective, the work of the old masters, and modern art. Buy all you can afford. Read art magazines. Many valuable suggestions will come to you this way.

Although I have emphasized the figure, part of your time should be devoted to other subjects for drawing. Draw animals, still-life subjects, furniture, interiors, or whatever else is likely to be an accessory to the figure. Outdoor sketching and painting is wonderful for training your eye to color and value as well as form.

Painting will help your drawing, and vice versa. The two are so interrelated that they should not be thought of as distinct and separate. You can paint with a pencil and draw with a brush.

For color practice, use some of the color photography you find in the magazines to render in oil or water color. Pastel is a delightful medium for practice. There are many kinds of color crayons and pencils with which to experiment.

It is a constant challenge of the profession that you never know what you will be called upon to do next. It may be anything from a lemon pie to a Madonna. As long as it has light falling upon it, color, and form, it can be made interesting. I recall an advertising campaign some years ago for so prosaic a subject as enameled kitchenware. But what the artist made of it was exquisite. I recall the Henry Maust water colors that advertised hams and foodstuffs. They

were as beautifully executed as any fine English water color.

Simple things such as a few garden vegetables, a vase of cut flowers, an old barn, present all the problems there are to master. Each of these may be a vehicle for your individual expression. Each can be so beautiful as to be worthy of a place in a fine arts gallery. That is the scope of things to be seen, felt, and set down. Clouds were there for Turner; they are here for you and will be here for your great-grandson. The qualities of light on flesh are present for you as they were for Velasquez, and you have as much right to express yourself as he had, and much less superstition and prejudice to combat. You can set up the almost identical pan of apples with which Cézanne gave a lasting message to the art world.

You can look for yourself at the haze of atmosphere that entranced Corot or the burst of late-afternoon light that enthralled Innes. Art will never die—it just awaits eyes to see and hands and brain to interpret. The paintable waves will not cease breaking with Frederick Waugh, nor will pictures be forgotten with the continuing rise of radio. You will also have materials never dreamed of, subjects that we cannot now imagine. You will have new purposes for art that have never before existed. I believe the human body has been increasing in beauty, although it is hardly discernible to us. Think of how standards change, for example, and of a modern girl beside a buxom maid of Rubens' time. It would be a little hard to imagine one of his beauties walking down Main Street in slacks. I doubt whether his favorite model could get to the judges' stand in one of our innumerable beauty contests.

All the things have not been done in art that can and will be done. I don't think our bones and muscles will change much and that light will shine differently, so all the good rules will still hold. I can only say that you must have the courage of your convictions, believing that your way is right for you and for your time. Your individuality will always be your precious right and must be treasured. Take from the rest of us all that you can assimilate, that can become a part of you, but never still the small voice that whispers to you, "I like it better my way."